MR. LUMAN REED'S PICTURE GALLERY

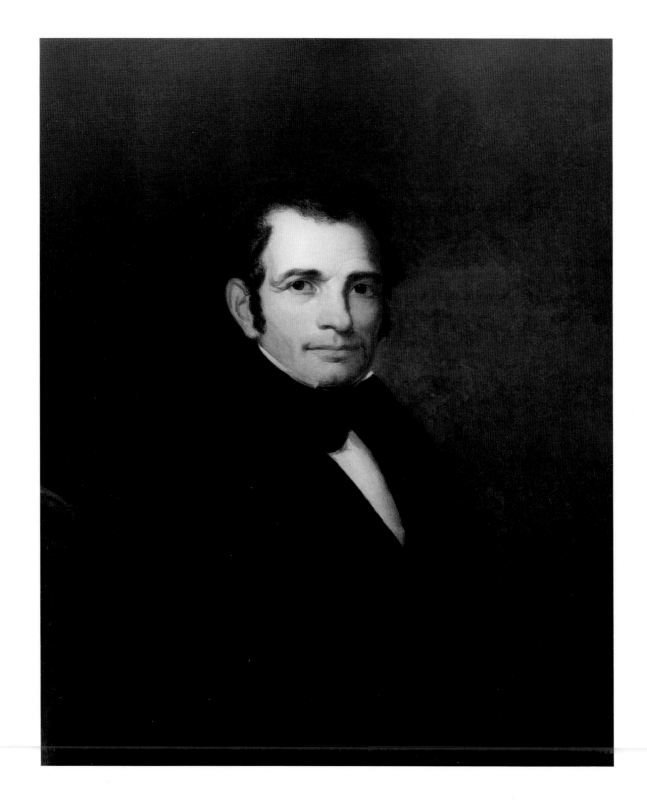

MR. LUMAN REED'S PICTURE GALLERY

A PIONEER COLLECTION OF AMERICAN ART

ELLA M. FOSHAY

INTRODUCTION BY WAYNE CRAVEN
CATALOGUE BY TIMOTHY ANGLIN BURGARD

HARRY N. ABRAMS, INC., PUBLISHERS, NEW YORK
IN ASSOCIATION WITH THE NEW-YORK HISTORICAL SOCIETY

Made possible by generous grants from the Luce Fund for Scholarship in American Art, a
program of the Henry Luce Foundation, Inc., and the National Endowment for the
Humanities, a federal agency

Frontispiece: Asher Brown Durand. *Luman Reed*. 1835. Oil on canvas, 30 × 25″. The New-
York Historical Society. Gift of the New York Gallery of the Fine Arts

Editor: Kathleen Luhrs
Editor, Abrams: Eric Himmel
Designer: Maria Miller

Library of Congress Cataloging-in-Publication Data

Foshay, Ella M., 1948–
Mr. Luman Reed's picture gallery: a pioneer collection of American art/by Ella M.
Foshay; introduction by Wayne Craven; catalogue by Timothy Anglin Burgard.
p. cm.
Includes bibliographical references.
ISBN 0–8109–3751–4
1. Painting, American—Catalogs. 2. Painting, Modern—19th century—United States—
Catalogs. 3. Painting, European—Catalogs. 4. Reed, Luman, d. 1836—Art collections—
Catalogs. 5. Painting—Private collections—New York (N.Y.)—Catalogs. I. Reed, Luman,
d. 1836. II. New-York Historical Society. III. Title.
ND210.F65 1990
759.14′074′7471—dc20 90–32371

Published in 1990 by Harry N. Abrams, Incorporated, New York
A Times Mirror Company

Printed and bound in Japan

CONTENTS

———

FOREWORD

The Luman Reed collection occupies a special place in the development of American art; in the history of taste, collecting, and patronage; as well as in the history of New York and the New-York Historical Society. This volume, the first full treatment of the paintings, and the first installation since Reed's day of the collection as originally conceived, allow us to assess this singular group of works from many points of view.

Containing such seminal works of American painting as Thomas Cole's *The Course of Empire,* the collection is a basic resource for study and enjoyment. That Reed's holdings survive virtually intact offers us rare insight into the taste and interest of a self-educated and accomplished New Yorker of the 1830s. Indeed, the quality of this collection signaled and set the tone for New York's emergence as a major art center.

The Luman Reed collection, acquired in 1858, established the society as a major repository of American painting and a collectors' institution. It marked the beginning of our dual being as both library and museum and makes us the oldest museum in New York. Later acquisitions enriched the holdings but essentially only elaborated on the themes established by the Reed collection.

The Luman Reed project proved a wonderful opportunity to study an early New York art collection—one which included both American and European paintings. Work on the paintings was a paradigm of cooperation between conservator and curator. Complex and sensitive decisions regarding restoration were made with constant curatorial input. The overall goal was to restore the collection to its appearance in Luman Reed's time. There were many challenges: locating the painted gallery door panels and reconstructing the doors; finding proper picture frames, for many of the original ones had not survived; and providing an appropriate architectural setting. Thomas Cole had once noted that Reed's galleries were dark and inadequately lighted. The need to balance proper lighting of the paintings—some of which are the gems of the society's collections—while maintaining the effect of period lighting was most important.

The restoration of the paintings, the publication of this catalogue, and the re-creation of Luman Reed's galleries proved to be a wonderful opportunity for a team of curators, conservators, exhibition designers, and architects to achieve a balance between the historical character of the rooms and modern museum standards, and to bring an entire collection with a single history to public attention.

BARBARA KNOWLES DEBS
President and Director

HOLLY HOTCHNER
Director of the Museum

ACKNOWLEDGMENTS

A complex project which has as its aim the documentation of a large collection of paintings and the installation of a permanent gallery to exhibit them in a period style is an exhilarating undertaking. It is also—from start to finish—a cooperative venture, and I am pleased to acknowledge the help of those who shared in it with me.

The re-creation of the 1830s private picture gallery of Luman Reed, one of New York's earliest galleries and certainly the most highly regarded of its time, has put me in the debt of Margaret Preston Symonds, Luman Reed's great-great-granddaughter. Mrs. Symonds, who must be described as a nonfiction fairy godmother, provided me with a complete family genealogy of Luman Reed's descendants, including those who still held in their possession objects and manuscript material essential to the project. This critical research was not conjured up by the wave of a magic wand, but resulted from years of work. Through her generosity and persuasive good humor, much of the valuable material that emerged has come to the New-York Historical Society, where it supplements the collection of Luman Reed's paintings that came here in 1858. Mrs. Symonds has demonstrated the same kindness, strength of character, and capacity for hard work as Luman Reed once did, and I am blessed to count her as a friend.

I am pleased to acknowledge on Mrs. Symonds's behalf the guidance and support she received from family members and others in assembling research concerning Luman Reed. She is especially grateful to Kathleen Luhrs, Metropolitan Museum of Art; Barbara Buff, Museum of the City of New York; Raymond Beecher, Greene County Historical Society; Clifford Buck; James T. Callow, University of Detroit; Miranda Marvin, Wellesley College; Mr. and Mrs. Frederick Sturges III; Catharine Reed Henriques Frost; and Richard van Cortlandt Parker, all of whom generously shared their time and knowledge with her. Other family members who responded with valuable information and enthusiasm to encourage her efforts were the late Sarah Sturges Parker; the late Horace Fuller Henriques; Mr. and Mrs. John Benjamin Wolff; Mrs. Ralph Fuller Wolff; Elinor M. Parker; Mrs. Dual A. MacIntyre; Luman Reed Fuller; Christine Fuller Henriques Dodge; and Horace Fuller Henriques, Jr.

Virtually every member of the New-York Historical Society's museum and library staff has contributed to the project in some way. Timothy Anglin Burgard, who was hired to provide research for this catalogue and is now associate curator, made scholarly contributions well beyond the comprehensive catalogue entries and bibliography that bear his name. He brought his intellectual gifts to bear upon every facet of the undertaking from funding to fruition. He is responsible for many exciting new discoveries and has been a constant source of support and scholarly insight.

Barbara K. Debs, president of the society, inherited and supported the project to install the New-York Historical Society's founding collection of paintings in a permanent gallery. Holly Hotchner, previously chief conservator and now also director of the museum, has collaborated on the Luman Reed exhibition since the inception of the project. The complex task of reassembling and conserving all the Luman Reed paintings, prints, and furniture has come under her care. Some seventy-five paintings and frames were conserved for the project under her direction. Paintings conservator Richard Gallerani was the principal conservator for the Luman Reed collection. Paintings conservator Robert Sawchuck and associate conservator Richard Kowall also collaborated in the restoration of paintings and door panels. Paper conservator Reba Fishman ensured that all works on paper were renewed and made exhibitable. Glenn Castellano captured the paintings on film with acute sensitivity for both conservation records and catalogue reproduction. Annette Blaugrund, senior curator, embraced the project and saw it to completion with unflagging enthusiasm and wisdom.

With the superb organizational skills and dedication that have characterized all her work, Karen Stiefel Manier coordinated plans and personnel during the project's early years. Monique Richards Pettit accomplished the final preparation of the catalogue text with precision and dedication. Jean Ashton, Tom Dunnings, James Mooney, Wendy Shadwell, Robert Thompson, and the library staff at the New-York Historical Society were unfailingly helpful. Kristin Leesement, Barat Ellman, and Karen Buck worked to fund the project. Support for the idea of installing the New-York Historical Society's founding collection of paintings in a permanent gallery was given wholeheartedly by James B. Bell, former director at the society.

The Luman Reed catalogue benefited from the informed and genuinely interested eye of Kathleen Luhrs. Her extensive knowledge of American art and her considerable editorial expertise are pressed into every page. Elizabeth Gemming assisted in the final editing of the manuscript. Wayne Craven, University of Delaware, eloquently described the historical context that places Luman Reed's accomplishments in proper perspective. I am deeply grateful to Lillian B. Miller, National Portrait Gallery, for bringing her extensive knowledge about patronage in America to bear on the text. Gloria Deák read the manuscript and made elegant suggestions. Lorelei Rowars offered practical advice with characteristic good humor. David Hull was always ready to help. Special thanks go to Doris Palca who smoothed over some contractual knots. Paul Gottlieb, president and publisher at Harry N. Abrams, Inc., took a leap of faith in support of this book when it was most needed. Eric Himmel, senior editor, deftly guided the book to completion.

For the catalogue and the reconstruction of Luman Reed's gallery, the expertise of numerous scholars and consultants has been enlisted. Ellwood C. Parry III, University of Arizona, graciously permitted us access to sections of his Thomas Cole monograph before it was published. Luman Reed's Sketch Club connections were illuminated by James T. Callow, University of Detroit. Deborah Gardner, managing editor, Encyclopedia of New York City, New-York Historical Society, and David Hammack, Case Western Reserve University, offered many useful guidelines to New York history. Robert Rainwater, New York Public Library, made informed judgments about the quality and character of Luman Reed's print collection. David B. Combs, New York Public Library, ferreted out background material that is elusive to all but the connoisseur. Daniel M. C. Hopping provided an

informed and elegant reconstruction of the gallery. Kevin Stayton, Brooklyn Museum, contributed his considerable expertise in New York decorative arts and interior design of the 1830s.

Others, but not all, who made useful contributions were: Linda Ayres, Wadsworth Atheneum; Istvan Deák and David Freedberg, Columbia University; Allan Greenberg and his staff at Allan Greenberg, Architects; Egbert Haverkamp-Begemann, New York University; Morrison Heckscher and Walter Liedtke, Metropolitan Museum of Art; Pat Hildebrand and the late Joseph Roberto, Old Merchant's House, New York; Deborah Johnson, Museums at Stony Brook; Ian Kennedy, Christie's; William K. Emerson and George Harlow, American Museum of Natural History; Alan Wallach, College of William and Mary; Maybelle Mann; Mishoe Brennecke, Jean L. Druesedow, and Kimberly Fink, Metropolitan Museum of Art; Sally Mills, Fine Arts Museums, San Francisco; Richard J. Koke, curator emeritus, New-York Historical Society; David B. Lawall, University of Virginia Art Museum; Joan Barns, Masco Corporation; Sandra Repp; John Davis, Center for Advanced Studies in the Visual Arts; and Marla Prather, National Gallery of Art. In addition, every credit line should be read as a note of thanks to the people who have graciously lent their objects to the exhibition.

For the generous support of donors who made this catalogue and exhibition possible, I am most grateful. My personal thanks go to Henry Luce III, Robert Armstrong, and Mary Jane Crook at the Luce Fund for Scholarship in American Art, a program of the Henry Luce Foundation, Inc. They first recognized the significance of the Luman Reed exhibition and provided the initial support that both launched the project and saw it through. Profound thanks also go to Marsha Semmel and Andrea Anderson at the National Endowment for the Humanities; J. Carter Bacot, Katherine Hastings, Jacqueline McSwigan, and Allis Wolfe at the Bank of New York; Leonard Milberg and Isabel Malkin; and the Dunlevy Milbank Foundation.

I am grateful, as always, to Barbara Novak, Columbia University, who continues to provide the model and support for all my scholarly work. Thanks, too, to Priscilla R. Brewster who helped in special ways.

During the past several years, Luman Reed has become a common name in my household, and I am delighted that Michael, Ella, and Augusta have adopted him as part of the family.

ELLA M. FOSHAY

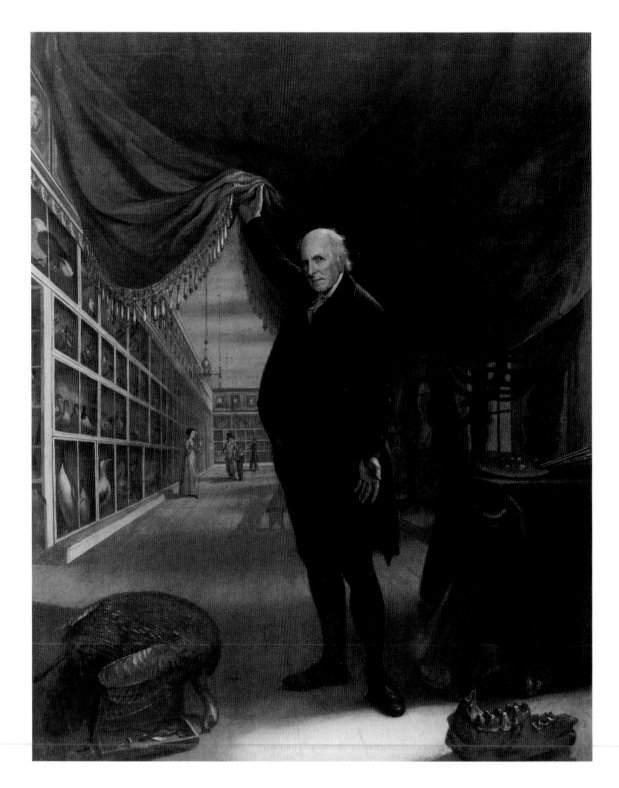

CHARLES WILLSON PEALE. *The Artist in His Museum*. 1822. Oil on canvas, 103¾ × 79⅞″.
The Pennsylvania Academy of the Fine Arts, Philadelphia. Presented by Mrs. Joseph Harrison

INTRODUCTION:
PATRONAGE AND COLLECTING
IN AMERICA, 1800–1835

WAYNE CRAVEN

"Do not laugh at my Connoisseurship as I am not at the profession."[1] So wrote Gulian Verplanck from London on April 20, 1773, to his brother Samuel in New York, revealing the uncertainty that many Americans felt insofar as knowledge of the fine arts was concerned. But if there was a self-consciousness about their inexperience in such admissions, there was also an indication that they recognized the essential role of art and patronage in the establishment of taste and culture in the United States. Sixty years later, Luman Reed (1785–1836) met Thomas Cole at an exhibition in New York City, and a second phase of patronage of painting in this country was inaugurated.

Although he was neither the first American to collect European art nor the first to patronize American artists, Reed occupies a special place in the nation's rise in patronage. The artists whom he befriended found in this extraordinary benefactor a remarkable ability to select choice specimens of their work. This is evident in the re-creation of his beautiful galleries at the New-York Historical Society, in which masterpieces by his protégés Thomas Cole, Asher B. Durand, William Sidney Mount, and others are represented. It seems almost beyond belief that Reed accomplished all that he did in the brief span of only about four years, between 1832 when he began collecting and his death in 1836. His story becomes all the more fascinating when seen against the backdrop of the rise of patronage and collecting in America in the first three decades of the nineteenth century.

The art collector was rare in colonial America. An occasional young man on his grand tour of Europe might acquire a few works of art to bring home, but in general the patronage of artists before the Revolution meant the commissioning of portraits of one's family, and "a collection" usually meant a group of such works. The transition to the true patron, collector, and connoisseur as he had existed in Europe for centuries was a slow process in America, perhaps because a certain attitude prevailed which saw art as an unnecessary indulgence and the plaything of an idle aristocracy. In 1780, John Adams wrote to his wife, Abigail, from Paris: "It is not indeed the fine arts which our country requires: the useful, the mechanic arts are those which we have occasion for in a young country."[2]

Throughout the first third of the nineteenth century, however, there was a continuing shift away from this position as Americans became increasingly aware of their cultural deficiencies, of which they were constantly

reminded by visiting foreigners whose frequently biting comments both nourished a feeling of cultural inferiority and spurred on further efforts to remedy the situation. Frances Trollope, an English writer who spent three years touring the United States in the early 1830s—about the time Luman Reed began collecting—acidly observed:

> I visited all the exhibitions in New York. The Medeci [sic] of the Republic must exert themselves a little more before these can become even respectable. The worst of the business is, that with the exception of about a half dozen individuals, the good citizens are more than contented, they are delighted. . . . I should be hardly believed were I to relate . . . the utter ignorance respecting pictures to be found among persons of the first standing in society.[3]

At times Mrs. Trollope even seemed to bait Americans in the matter of their knowledge and judgment about art. When an American gentleman announced to her, "There is no use in disputing a point that is already settled, madam; the best judges declare that Mr. [Chester] H[ardin]g's portraits are equal to that of [Sir Thomas] Lawrence," she queried,

> "Who is it that has passed this judgement, sir?"
> "The men of taste of America, madam."
> I then asked him, if he thought it was going to rain?[4]

Alexis de Tocqueville, who arrived from France in 1831 for a two-year tour of America, concluded that democracy itself was at fault for the low state of the fine arts here, declaring that there was a leveling of quality under that social system: "The number of consumers increases, but the opulent and fastidious consumers become more scarce . . . , the productions of artists are more numerous, but the merit of each production is diminished."[5] The English author Harriet Martineau was condescendingly amused when she noted, while traveling in New York in 1835, that a newspaper editor had predicted the rise of a great age of sculpture in America because marble had been discovered in New England and a statue by Antonio Canova (for the North Carolina State Capitol) had recently arrived from Italy.[6]

Americans, thus frequently reminded of their cultural deficiencies in regard to the fine arts, decided to address the situation by trying to improve their knowledge of the old masters—by traveling to Europe to see them and by importing them to form collections at home. In 1815, young Nathaniel Appleton Haven of Boston visited London, where he saw the celebrated Elgin marbles from the Parthenon and made the usual pilgrimage to Benjamin West's studio, where didactic conversation on art and taste was properly elevating.[7] Another Bostonian, the rich merchant Thomas Handasyd Perkins, made several visits to Paris between 1795 and 1835. He loved to wander for hours in the Louvre and other Parisian galleries and became exasperated with his two sons who found such pastimes boring.[8] Several ships in the China trade had given Perkins the means to play the role of patron and collector, and he seldom returned from Europe empty-handed. The New York diarist Philip Hone, who visited Perkins's house in Boston in 1838, noted that the great merchant "lives *en prince,* and has a fine collection of

Pictures, to which he made many valuable additions during his last visit to Europe."[9] Mercantile fortunes were often the basis for collecting.

Perkins's position as a leading scion of Boston society made his involvement with the arts almost obligatory; indeed, patronage came to be considered a civic responsibility. Perkins took great interest, for example, in the affairs of the Boston Athenaeum's new art gallery, and he was head of the committee for its opening exhibition in May 1827. Also of considerable significance is the fact that Perkins's own collection contained the works of many contemporary American artists, such as Alvan Fisher, Thomas Sully, Gilbert Stuart, and Robert Salmon. He knew and enjoyed the company of many artists of his day and found special pleasure as the patron of Washington Allston and the young sculptor Horatio Greenough.

Americans at this time were discovering the value of patronage in a quest to establish social position. A wonderful example of the attempt to rise in society by becoming an art collector instantly possessed of a house full of old masters is found in the story of Stephen and Betsy (or Madam) Jumel. Stephen Jumel, a coffee planter who had escaped from Santo Domingo during Toussaint L'Ouverture's slave rebellion, had installed his mistress, Betsy Bowen, in his fine New York house. To the surprise and chagrin of both, they were ostracized by the old Knickerbocker families. So Betsy, as the story goes, pretended to be dying and persuaded Stephen to marry her, pleading that she wished to enter the next life an honest woman; after he did so, she sprang from her deathbed in a miraculous recovery.[10] But still, even though they were now decorously man and wife, the Jumels were not accepted. The next effort for acceptance came when Stephen bought an even finer house, the splendid Robert Morris house with its vast grounds in Harlem, and proceeded to redecorate it, about 1810. Five years later, the Jumels went to Paris to live, and there their wealth finally brought them the social acceptance they desired. But Madam Jumel managed to spend money on a scale that outdistanced even her husband's ability to make it, so he packed her off to New York in 1816. When she arrived, she had with her nearly one hundred old master paintings. Spurious though the attributions of many of these works may have been, it was surely the largest collection of art assembled in New York up to that time. It reportedly contained pictures by (or copies after) Rubens, Van Dyck, Murillo, Tintoretto, Rosa, Parmigianino, Massys, and a host of lesser-knowns. Madam Jumel hoped to make a great splash by having her complete collection shown at the American Academy of the Fine Arts in 1817, which she arranged with the institution's new president, the painter John Trumbull. But her conniving reputation was well known, and even an extraordinary exhibition could not open old Knickerbocker doors to her. So, having failed in her purpose, she sold the collection in 1821, for she had no use for it otherwise.

There were those in New York who found a happier, more intimate, even moral and nationalistic relationship with the fine arts. For example, Gulian C. Verplanck, the grandnephew of the man whose self-conscious quote commences this essay, codified the social value of cultivation of the arts, aside from the intrinsic enjoyment they offered. In *An Address Delivered at the Opening of the Tenth Exhibition* [1824] *of the American Academy of the Fine Arts,* he observed that the fine arts "are fitted to add to the comforts and multiply the innocent enjoyments of life, to adorn and dignify the aspect of society, to give impulse and exercise to the latent talent, and fresh lustre to the glories of our nation; and by their moral influence upon all classes, to animate patriotism, 'to raise the genius, and

to mend the heart.'"[11] Verplanck stressed that in a democracy, "taste must become popular. It must not be regarded as the peculiar possession of painters, connoisseurs, or dilletanti." He remarked that history painting becomes "a teacher of morality," and it assists "in the education of our youth." He thereby recognized the didactic value of the fine arts. Emphasizing the necessity of patronizing living artists and providing them with the means to perfect their art, he told his audience that in so doing, "You have given a great man to your country. His name, his fame, his genius . . . belong to us all and to our children." Older nations, he noted, "in summing up the long catalogue of their statesmen, poets, and scholars, are proud to add to it such names as [Michel] Angelo, Canova, Raffaelle, Rembrandt, Poussin, Claude, Murillo, Reubens, Reynolds. Why should we not do the same? The natural talent is here."[12]

In all of this we find a very different attitude toward the fine arts, artists, and the concept of collecting from that expressed earlier by John Adams. Verplanck had toured the famous galleries of Europe in search of cultivation and enlightenment, and he considered the fine arts essential in a way that the old colonial merchants of John Adams's generation would seldom have understood. Verplanck was a member of a new breed of Americans, and Luman Reed would soon appear upon the scene to demonstrate that within the democratic social system of America, that new breed could produce a connoisseur and patron from the humblest origins.

The new collector and mentor typically took a genuine interest in public institutions devoted to the arts and showed a real concern for contemporary artists. Verplanck, for example, was a friend of the artists Samuel F. B. Morse and Asher B. Durand, he was a founder of the Sketch Club, and he was an officer of both the American Academy of the Fine Arts and the National Academy of Design; moreover, when he served in Congress, he was chairman of the House of Representatives Public Buildings Committee and was therefore in charge of procuring the large history paintings for the Rotunda of the U. S. Capitol in the mid-1830s.[13]

There were actually quite a few Americans who were caught up in the new spirit that Verplanck personified and who set the stage for the appearance of Luman Reed. Many of them collected both old masters and the work of living American artists. Just as Thomas Handasyd Perkins introduced the spirit of collecting to Boston, Robert Gilmor, Jr., first established the precedent in Baltimore. Gilmor's interest in the fine arts was awakened during the years of his grand tour, and as early as 1797 he wrote that, "My fondness for [art] may perhaps prove dangerous, but as long as I can restrain it with[in] the bounds of prudence and reason, I am convinced it will prove one of the greatest sources of pleasure, amusement and relaxation from the serious concerns of life."[14] These are the words of a true son of a prosperous merchant, which he was, but a mercantile scion possessed of a new spirit, to be sure. With cultivated taste and an impeccable eye, Gilmor formed an extraordinary collection that ranged from illuminated manuscripts to paintings by, or at least attributed to, Rubens, Hals, Van Dyck, Ruysdael, Cuyp, Caravaggio, Rosa, Teniers, Velázquez, Raphael, and Holbein, among the old masters. Thomas Cole, John Trumbull, Thomas Doughty, Washington Allston, Thomas Sully, Gilbert Stuart, several of the Peales, William Guy Wall, and William Groombridge were among the contemporary American painters represented. About 1833 Gilmor sent William Dunlap a catalogue of his collection in which he itemized more than 110 pictures and indicated there were 130 more, "not mentioned, being either by the same masters, or of doubtful character, or not

of sufficient importance to be thus noticed."[15] That American artists benefited from the presence of such a collection is verified by Horatio Greenough, who worked at the Gilmor residence while modeling a bust of Mrs. Gilmor in 1828, near the time when Luman Reed began to become interested in collecting:

> I work in Mr. Gilmore's [sic] library, finished in the Gothic style, receiving the light through a painted window. The air of art is around me. Exquisite pictures of Italian and Flemish masters fill the compartments between the bookcases; books of prints load the side tables; little antique bronzes, heads, and medals crowd each other on the mantelpiece. I work till I tire, and then sit reading and gazing about.[16]

Greenough enjoyed the refined conversation about art that he shared with his sophisticated patron. He noted in a letter to his brother Henry in April 1828:

> I have just completed the bust of Mrs. Gilmore, and, am happy to add, to the satisfaction of her husband, whose intelligence and love of art have made the work doubly interesting to me. He not only sympathizes with me as an artist, but enters into all my views with the interest of a true friend.[17]

Gilmor was indeed a sophisticated connoisseur, well traveled among the great art galleries of Europe, with a cosmopolitan flair and knowledge about matters related to art. In this respect he was different from Luman Reed, who had spent his youth working in a grocery store rather than traveling in Europe; Reed also lacked the benefits of a classical education such as Gilmor had enjoyed.

The City of New York was clearly going through a cultural awakening insofar as the fine arts were concerned in the decades just before Reed began collecting. John Trumbull exhibited his own work at the American Academy after 1817, and in that same year, as we have seen, the Jumel collection was shown to the public. Exhibitions of old masters occurred frequently. One correspondent wrote to Asher B. Durand on March 26, 1830, to tell him about the large collection of European paintings then being shown at the American Academy, brought over from London by a picture dealer of dubious reputation named Richard Abrams.[18]

Again, the effect of such collections on American painters becomes obvious when we read Thomas Sully's comments as reported to William Dunlap:

> On careful inspection of several good pictures of the old masters in Abraham's [sic] collection, at New-York, I find that the practice of touching the whole picture with a warm colour, like terra de sienna, and, in some instances, with a dark colour like asphaltum, was common to their practice. A fine copy of Correggio's Magdalene, and a portrait by Velasquez (rather doubtful) were much toned. In the landscape by Hobbima [sic], asphaltum has been used over all the surface. . . . In a landscape, said to be by Claude, I found much scumbling, of a lilac neutral tint. . . . The best picture in this collection is a Murillo.[19]

A fifty-four page descriptive catalogue that accompanied the exhibition informs us that, in addition to the masters mentioned by Sully, there were also pictures by (or claimed to be by) Leonardo da Vinci, Raphael, Andrea del Sarto, and Titian, among others.

It was inevitable that the newfound interest in collecting would attract the art dealer, where before only small-time print sellers had existed. Abrams was evidently untrustworthy; for Dunlap reports the following:

> In March was exhibited a collection of the best pictures from old masters which America had seen. The gallery of the American Academy . . . was hired by a man named Abrams . . . who was a picture dealer and cleaner from London; and having, in conjunction with another dealer, of the name of Wilmot, collected a number of good pictures, under various pretenses, they concerted the scheme of flying with them to New York. Here they were stopped, and Abrams imprisoned. Wilmot . . . escaped the catchpoles, and embarked for London. . . . On his arrival he was recognised . . . and seized by those he had defrauded. Abrams made some compromise, by which he was permitted to exhibit the pictures for the benefit of the proprietors; and he did it adroitly, with an impudence worthy of a picture dealer.[20]

There was always the haunting suspicion that clever dealers from Europe put together collections of third-rate pictures, made the most spurious attributions, and brought them to the United States, where they believed they could pass them off to men of wealth who knew nothing of art but who were eager to buy pictures. One way of avoiding being duped, of course, as many an American collector who was new to the game (including Luman Reed) found out, was to collect the work of living artists who could be visited in their studios and whose works could be observed as they progressed; one could thereby be certain of getting the original he was paying for.

New York had its own picture dealers, foremost among them Michael Paff and Pierre Flandin, although very little is known about either man. Dunlap tells us that Paff "has long possessed a valuable collection, which varies with the sales and purchases he makes."[21] His gallery was a place visited frequently by artists and collectors alike, and Luman Reed began his initial collection, of old masters, with Paff as his agent.[22] As early as 1812, we find publication of a thirteen-page *Catalogue of M. Paff's Gallery of Paintings* (New York: Conrad), and as late as 1838, a *Catalogue of the Extensive and Valuable Collection of Pictures, Engravings, & Works of Art . . . collected by M. Paff. . . . The Whole of which will be Disposed of at Public Auction* (New York: Vinten) which was forty-two pages in length.

Pierre Flandin was a member of the board of directors of the American Academy of the Fine Arts from 1829 to 1836, but was evidently sympathetic to the cause of the young painters who challenged the academy's president, John Trumbull; for he was one of the delegates sent to negotiate terms with Trumbull for the unification of the academy with the fledgling organization of artists that eventually became the National Academy of Design. From the catalogues of the American Academy's exhibitions, especially those of 1817 and 1818, we learn that Flandin traded in old masters, with pictures belonging to him listed as by such artists as Gaspard Poussin, Joseph Vernet, David Teniers, and Nicolas Lancret.

The art dealer now provided the service of broker in the collection of works of European old masters. But by the early 1830s, no dealer specialized in handling the works of contemporary American painters, nor did any dealer maintain a gallery where such works could be viewed and purchased. If a collector were to buy a picture by a living artist such as Thomas Cole, Asher B. Durand, or William Sidney Mount, he would either acquire it from the annual exhibition of the National Academy of Design or he would deal directly with the artist, either in person

or by correspondence. It was not until mid-century that dealers like Doll and Richards in Boston or Goupil & Co. (which later became M. Knoedler) in New York appeared to represent the artists and sell their paintings.

There were actually a good many rather sizable collections formed in New York in the decades just before and during the years that Luman Reed turned to that activity. Two of the most important were those of Dr. David Hosack and Philip Hone. Dr. Hosack owned works by or thought to be by Correggio, A. Carracci, Raphael, and Van Dyck, among other old masters, but also several landscapes by Thomas Cole (including the *Expulsion from Paradise,* now at the Museum of Fine Arts, Boston), two views of Niagara Falls by John Trumbull (now in the New-York Historical Society), and numerous portraits by Trumbull, Stuart, Jarvis, Vanderlyn, Sully, and others.[23] Hone's collection was also large and varied, as we know from the list he provided for William Dunlap's *History of the Arts of Design.*[24] Therein one finds a few works ascribed to European artists—Ruysdael, Ostade, Teniers, Canaletto, and Turner—but most of the entries are for pictures by living American painters: three landscapes by Thomas Cole, two by William Guy Wall, and another by Thomas Doughty; genre scenes by Robert Weir, Rembrandt Peale, and Gilbert Stuart Newton; Samuel F. B. Morse's portrait of the Danish sculptor Bertel Thorwaldsen and the study for Morse's grand *Lafayette* in City Hall, all of which had been assembled between about 1824 and 1832.[25] Hone expressed his views on art frequently in the pages of his diary, noting, for example, his opinion on the pictures by Morse and Cole in the National Academy's exhibition of 1833:

> Morse and Cole have contributed the pictures which they painted and brought from Europe. The former are hard and cold as ever; the warmth of the sunny skies of Italy does not appear to have had any effect upon the worthy president [Morse was the first president of the National Academy of Design]. He is an excellent fellow and is well acquainted with the principles of his art; but he has no imagination. He makes good portraits . . . but he cannot design. There is no poetry about his paintings, and his prose consists of straight lines, which look as if they had been stretched to their utmost tension to form clothes-lines. [Cole's] pictures are admirable representations of that description of scenery which he has studied so well in his native forests. His landscapes are too solid, massy, and umbrageous to please the eye of an amateur accustomed to Italian skies and English park-scenery, but I think every American is bound to prove his love of country by admiring Cole.[26]

Once again, patriotism and love of country are associated with an art which the patron-critic takes to be truly American. The example of Philip Hone—in collecting works by American artists, rendered in a style and of a subject matter he considered purely American—was probably of considerable influence on Luman Reed when he turned his attention to collecting around 1830; for Reed emphatically preferred works by American artists and of American scenes.

As America began to come of age culturally, the large number of works by European old masters that flowed into New York, Boston, and Philadelphia played a very important role for both painter and patron. They established a corpus of fine art where little had existed in earlier years, and they showed that there was more to art than family portraits. They defined an artistic tradition, and Americans were forced to decide whether they

wanted to embrace that tradition or not. Critical issues were posed: Did one wish to own a nude Venus by Titian, or a nude Ariadne by Vanderlyn, or was one more comfortable with a genre scene by William Sidney Mount? But one thing the old masters unquestionably did was to give stature to the visual arts and thereby to contemporary artists and their works. Time and again we have seen references to pictures of domestic Dutch scenes by Teniers, Ostade, and the like; these gave validity to the making of scenes of ordinary life in a democratic society, and they can be seen as the foundation for such genre scenes by William Sidney Mount as *Undutiful Boys* (Plate 32) and *Farmer's Bargaining* (Plate 31), both of which were favorites of Luman Reed.[27]

Luman Reed was undoubtedly aware of the patronage and collecting activities of Daniel Wadsworth of Hartford, Connecticut.[28] Wadsworth's wife was the niece of the painter John Trumbull, and the wealthy philanthropist owned several portraits and two views of Niagara Falls of 1807–8 by Trumbull. Trumbull became Wadsworth's adviser in collecting and patronage and, upon his discovery of Thomas Cole's landscape paintings in 1825, urged Wadsworth to acquire works by the young artist. Wadsworth obtained such well-known pictures by Cole as *Landscape, Composition, Saint John in the Wilderness* (1827); *Scene from "The Last of the Mohicans," Cora Kneeling at the Feet of Tamenund* (1827); and *View of Monte Video, the Seat of Daniel Wadsworth, Esq.* (1828). All of these works are now in the Wadsworth Atheneum in Hartford, which became the repository of the bulk of Wadsworth's collection after his death, in 1848. After a flurry of correspondence with and acquisition of works by Cole, Wadsworth's interest in collecting ceased in 1828, shortly before Luman Reed began to collect.

The foregoing discussion has attempted to set the background against which Luman Reed commenced his own activities in the art world. In the quarter century before Reed's interest in art was first aroused, collecting and patronage in the United States had undergone a remarkable advance beyond what it had been in colonial days. The often condescending comments of foreigners visiting the United States around 1830 reveal that cultivation of the fine arts still left much to be desired; but those comments also indicate that Americans had recognized not only the pleasure of art but also its necessity, and this was a major step for a democracy dominated by a mercantile mentality. It was in this period, about 1800 to 1835, that works by European old masters began to flow into Boston, New York, Philadelphia, and elsewhere. These masterworks, suddenly present by the hundreds, transplanted the European grand manner of painting to American soil. The newly rising breed of patron was forced to consider whether to foster the foreign tradition or to encourage the rise of an art that was truly America's own, one created by living American painters. Reed played a prominent role in this exciting new atmosphere, and after commencing with the old masters, he soon turned to contemporary American artists to fill the walls of the gallery he had built in his new house in Manhattan. This quiet, gentle, retired dry-goods merchant gave, by his example in the mid-1830s, a new impetus to the patronage of American art, just at a time when it was needed.

LUMAN REED:
NEW YORK PATRON AND HIS
PICTURE GALLERY

ELLA M. FOSHAY

In a biography of Asher B. Durand, written in 1894 not long after the artist's death, his son John devoted a chapter to a man called Luman Reed (1785–1836). He described the important role that Reed had played in the formation of his father's artistic career and in the lives and careers of a number of other artists of his generation through his support of their work. Indeed, according to John Durand, Luman Reed's collection of art, consisting principally of contemporary paintings by American artists, was responsible for making "native art the fashion." It encouraged younger artists to enter the profession and it encouraged men with means to support them. Less than sixty years after the death of Luman Reed, John Durand lamented that his name was forgotten and the important group of paintings that he gathered was unknown and inaccessible. "The collection of works of art made by Mr. Reed now reposes in the attic of a building where no ray of sunlight ever reaches the pictures," wrote Durand, "and where the few who visit it know nothing of the origin and purpose of the collection."[1]

The gloomy and uninviting place to which John Durand referred was the New-York Historical Society. It was then located at Second Avenue and 11th Street. When the building opened almost fifty years earlier, there was no hint of gloominess; the galleries devoted to art and books were praised for their commodious size and fine design. "The vast apartment devoted to these objects is admirably planned and finished," wrote a journalist in 1857. "The proportions are good; the alcoves and shelves are durable and elegant; the decorations in white and gold are chaste and pretty; and an abundance of light is let in from above." The same writer called the collection of paintings on display at the New-York Historical Society, which included the recently acquired Luman Reed collection, "one of the best exhibited in the city."[2]

After Reed's death, in 1836, the works of art that he had gathered were not put on public display as a group until 1844. That year, when Reed's house at 13 Greenwich Street was sold, the collection was purchased by an association of Reed's friends to serve as the nucleus of New York's first permanent gallery of art, called the New-York Gallery of the Fine Arts.[3] The catalogue introduction to the New-York Gallery's first exhibition, held at the National Academy of Design, then located at the corner of Broadway and Leonard Street, indicates that the memory of Luman Reed was alive and the reputation of his art collection intact. Calling the collection "unequalled in our city," the association resolved "to keep the collection entire, to retain it in our city, to make it the foundation

of a great Gallery of Art, and at the same time a monument to the memory of Luman Reed."[4] The installation of the "Reed Gallery" was assigned to the artist Francis W. Edmonds, who was reluctant to perform the task. "I tried to avoid this responsibility," he wrote, "for I know I shall give cause of complaint." He included a diagram of his preliminary exhibit design in a letter to Asher B. Durand, and it shows a typical nineteenth-century, multilevel hanging as well as some decorative swags of drapery that Edmonds conceived "to fill up the space" on top of the pictures. Although to the modern eye the gallery has a crowded appearance, Edmonds complained that there were "but few pictures, for the large room [of the National Academy of Design], and I am striving to hang all the best 'on the line of the eye.'"[5] The drawing indicated that none of Reed's European pictures was included in the central exhibition room, possibly reflecting the mid-nineteenth century distrust of old master paintings.[6]

While the New-York Gallery of the Fine Arts held exhibitions in a number of locations in the city during the years that followed Edmonds's vernissage, the institution did not survive as a separate entity for a variety of

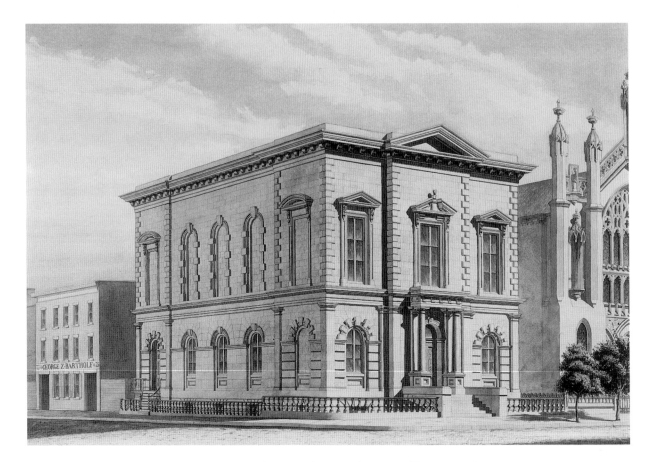

CHARLES METTAM AND EDMUND A. BURKE. *The New-York Historical Society Building at Second Avenue and 11th Street, c. 1860.*
Watercolor on paper, 22½ × 31⅝". The New-York Historical Society

reasons, including an admission fee perceived as too high, competition from new galleries, and the lack of a sufficient number of new paintings demonstrating the significant artistic advances made since the core collection was assembled. The collections, including the original Reed holdings and subsequent additions, were given to the New-York Historical Society in 1858.[7] In that year, George Templeton Strong, a thirty-eight-year-old life member of the society, viewed the newly installed and very impressive gallery of paintings. With characteristic understatement, Strong recorded his impression of the society's remarkable collection of books and art, the most distinguished in the city. "Looked thro the premises," he wrote. "The 'N.Y. Gallery of the Fine Arts' is deposited in the cockloft. Old *Luman Reed*'s collection is its nucleus. . . . The Hist. Soc.y owns some nice books. My 'LIFE MEMBERSHIP' is not absolutely valueless."[8]

Together with the opening of its commodious new building, the addition of this collection transformed the society from a repository of books, manuscripts, and historical miscellanea related to New York City, New York State, and the nation into a treasury of art. Since the society's founding in 1804, the art collections that had been acquired were limited almost exclusively to portraits of famous men and family portraits that accompanied estate bequests or other donations. The Reed collection and the works subsequently added to it gave the society, in addition to portraits, a significant group of landscape and genre paintings by the leading contemporary American artists and some notable examples of European old master works. It was, in effect, the Luman Reed collection that established the New-York Historical Society as a first-class museum of its day, worthy to receive and acquire many other collections and individual works of art in the years that followed.[9]

Between 1858 and 1894 the collection of artworks gathered by Luman Reed in the early 1830s gradually lost its distinctive reputation as a pioneer collection of American art. The original private collection had been enlarged by donations of works by artists and patrons, and in that way the contour of the Reed collection was blurred and its identity subsumed into the New-York Gallery of the Fine Arts.[10] When that larger venture failed and its holdings came to the New-York Historical Society, its important core was recognized in the introduction to the first published catalogue of the society's collections (1862), which stated proudly that "the Gallery of Art now embraces the entire collection of the New York Gallery of Fine Arts, which has been permanently placed in the custody of the Society. Any notice of this collection would be deficient which should fail to commemorate the name of Luman Reed, whose taste, judgment, and generosity found the nucleus of what may now be justly regarded as the foundation of a great Gallery of Art."[11]

The society's 1915 catalogue mentions Reed's name in passing in reference to a series of special collections that constituted the holdings of the institution.[12] The recognition of the Reed collection was diluted by an expanding range of holdings. During the second half of the nineteenth century, collections of European art, most notably that acquired by the connoisseur Thomas J. Bryan, and a distinguished collection of Egyptian antiquities, including sculpture, jewelry, and even mummified bulls, came to the society. A wide spectrum of decorative arts, from utilitarian household objects to fine presentation silver and high-style furniture, as well as swords, medals, textiles, and glass paperweights, broadened the collecting focus as the institution developed.

Since the gift of the New-York Gallery of the Fine Arts to the New-York Historical Society, selections from the

Luman Reed collection, most notably Thomas Cole's series of five paintings entitled *The Course of Empire* (Plates 6–10), had been on display almost continuously in the society's galleries. The aesthetic quality of Reed's examples of early American portraiture, landscape, and genre art has been revealed in a variety of topical exhibits. Until now, however, the collection as a whole has never been shown nor its history and significance fully documented.[13]

The installation planned for 1990 of the Luman Reed Gallery at the New-York Historical Society reclaims this important art collection from the dusty obscurity in which John Durand described it in 1894 and offers a reinterpretation of its origin and purpose, as well as of the significant role that it played in the development of American art. The gallery will present, in period style, the double parlor at Luman Reed's house at 13 Greenwich Street in Manhattan, built from 1831 to 1832 on the site now occupied by the Cunard Building, at 25 Broadway. The paintings hanging in the gallery and the other objects included in the installation follow an inventory listing made a few months after Reed's death, in June 1836.[14] While none of the original furniture or other decorative objects listed in the inventory came to the New-York Historical Society, all of the paintings with the exception of three minor works by George Flagg and some sketches by George Cruikshank did, and these constitute the present exhibition.

LIFE AND TIMES OF LUMAN REED

The June 7th, 1836, entry in Philip Hone's vivid, twenty-eight-volume diary recording New York life from 1828 to 1851 noted that "Mr. Luman Reed died this morning—a respectable citizen, an upright merchant, and, what does not always follow, a man of taste and a liberal patron of the arts." This succinct notation recognized the essential qualities of a man whose rather short life—Reed died at fifty-one—can be described as a model American success story.[15]

Luman Reed was born at Green River (now Austerlitz) in Columbia County, New York, in 1785. He was the youngest of six children in the family of Eliakim Reed II and Rebecca Fitch, who owned and operated a farm in that area which they had purchased for £300 in 1779. Eliakim Reed's great-grandfather, John Reed, a commissioned officer in Oliver Cromwell's army, had emigrated from Cornwall, England, after the restoration of Charles II. He settled in Norwalk, Connecticut, and succeeding generations of his family stayed there until Eliakim bought the farm in Columbia County.

In the fall of 1792 Luman Reed entered school in Coxsackie. He walked the two miles from the family farm every day in the company of his elder brother Abijah. In honor of the event, Eliakim Reed bought his younger son a wool hat, the first article of clothing ever purchased for the young man, who was outfitted, as was customary for a family living on a farm during that period, in homespun clothes. Abijah recalled that this hat probably gave his brother more pleasure than any other possession that he would acquire in the course of his life. The Coxsackie school was the first in a series of district schools that Luman attended; the schools, according to Abijah, were all "of rather a common cast," and, since Luman was not "fond of study," the young man "did not acquire any more than an ordinary school" education.[16]

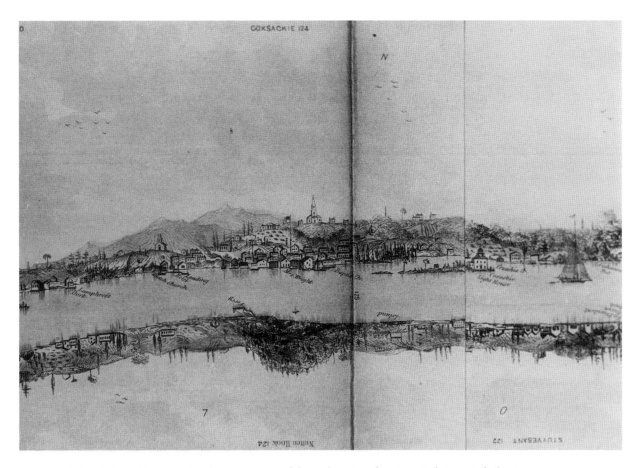

View of Coxsackie, engraving from *Panorama of the Hudson River from New York to Waterford* (1847)
The Hudson River Museum of Westchester. Gift of Michael Papantonio, 1968

Soon Eliakim Reed entered a partnership with his first cousin Roswell Reed of Coxsackie where he moved his family during the latter part of 1792. They built a wharf and a small storehouse on the banks of the Hudson River, on a ledge of rocks that became known as Reed's Landing. Luman's first job was working for his father in the store during the hours after school. "Luman was in Constitution & natural habits a good deal like his father," remembered Abijah. "Naturally bright energetick & active & a good Judge of Character & if anything in his bringing up contributed to his after career it was the Constant example of Care, economy, industry & perseverance of his parents." Even during his earliest school years, Luman Reed's mother was concerned that none of his time should be spent in idle pursuits. She sent him during the summer months to work on the farm of Sylvester Ford, her husband's brother-in-law, who lived in Westerlo, New York. There, in return for room and board, he helped clear the land of the new farm for cultivation and performed other chores. Ford said that "he never had a better boy to work than Luman," including those who received a salary.[17]

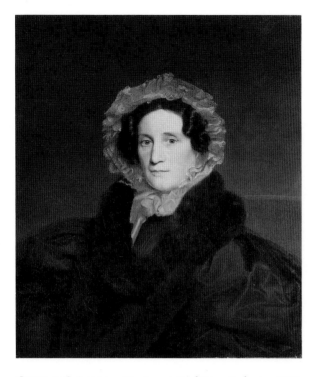

CHARLES C. INGHAM. *Mrs. Luman Reed [Mary Barker]*. c. 1835.
Oil on canvas, 30⅛ × 25″. The Metropolitan Museum of Art,
New York. Bequest of Frederick Sturges, Jr., 1977

JAMES FROTHINGHAM (ATT.). *Catharine Reed*. c. 1831.
Oil on wood, 30¼ × 24½″. Private collection

After his father's business was sold, Luman continued to work for the new owner, Ralph Barker. In 1808 he married his employer's sister, Mary (Polly) Barker, in the First Dutch Reformed Church at West Coxsackie. It was probably the responsibilities of married life and the birth of two daughters, Catharine and Mary, that prompted Reed to open his own business in Coxsackie with a partner, Theron Skeel. It was a produce and freighting business, the areas Reed knew best from his family's enterprises, and it frequently required him to make trips to New York City as master of the company sloop. In 1815, after the close of the War of 1812, he opened his first store in the city in an old frame building at 13 Coenties Slip on the corner of Water Street and took up residence at 3 Bridge Street. Later in his life, Luman Reed told his brother Abijah that when he moved to New York he had about $8,000, of which $2,500 was given to him by his father and the rest earned from previous ventures.[18]

Those who knew Luman Reed felt that the remarkable achievements of his business career were fostered principally by his personal character. As a young man John Durand, with the encouragement of his father, Asher, was employed as a clerk by Reed for a short time. It was this experience and his father's recollections that formed the basis of his biographical sketch of Reed later in the century. John Durand listed the following virtues as those responsible for Luman Reed's financial success: "Sagacity, promptness, self-reliance, remarkable organizing

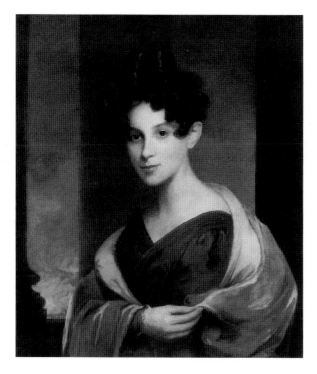 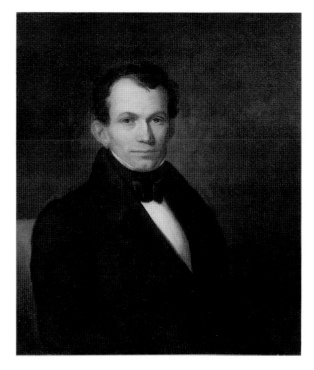

JAMES FROTHINGHAM (ATT.). *Mary Reed.* c. 1831.
Oil on wood, 30¼ × 24¾″. Private collection

ASHER BROWN DURAND. *Jonathan Sturges.* c. 1840.
Oil on canvas, 30¼ × 24½″. The Metropolitan Museum of Art,
New York. Bequest of Frederick Sturges, Jr., 1977

power, and strict discipline in relation to his subordinates, accompanied with great solicitude for their interests and welfare." Reed's direct approach to managing his employees was vividly described by Durand. He said that "one morning the clerk whose duty it was to open the store very early in the morning overslept the customary hour; on reaching the store he found 'L. Reed, 5 o'clock,' in chalk on the door."[19] Perhaps it was John Durand himself who was the tardy clerk, and the lesson that he learned that day remained vivid in his memory.

Between 1815 and 1821, Luman Reed entered into a series of business partnerships to trade and ship dry goods, all of which prospered due to good management and the climate of commercial growth which followed the War of 1812. In 1821 Reed formed a new partnership, with David Lee, and moved their firm to 125 Front Street. In that same year he hired Jonathan Sturges of Southport, Connecticut, as a clerk. Sturges would later become Reed's partner in business and successor in art collecting. The business expanded during the following years, ultimately occupying another building on Front Street and surviving a number of threatening events. The partners eluded the yellow fever epidemic of 1822 by moving their goods and office up to Greenwich Village, which was then a suburban district. Other merchants made the same move uptown in order to flee the spread of the infection. However, unlike his competitors who left their produce at home, Reed, anticipating an increased demand for goods despite the paralysis of business in the city as a result of the disease, brought his goods with

him.[20] The firm also escaped the financial panic of 1825 and was therefore able to profit during the next few years from the expanding markets provided by the opening of the Erie Canal.

It was in response to the legendary New York fire of 1835 that Luman Reed demonstrated his most inventive business sense, as well as the careful but decisive nature that his family and acquaintances often described. Late in the evening of December 16, a bitter cold night, fire broke out in New York. This historic and devastating fire was pictured in a dramatic series of watercolors by Nicolino Calyo and described by Philip Hone in his diary entry dated Thursday, December 17:

> *Unparalleled Calamity by Fire.* How shall I record the events of last night, or how attempt to describe the most awful Calamity which has ever visited these United States. The greatest loss by Fire, that has ever been known, with the exception perhaps, of the conflagration of Moscow, and that was an incidental Concomitant of War. I am fatigued in body, disturbed in mind, and my fancy filled with Images of horror which my pen is inadequate to describe. Nearly one half of the first ward is in ashes. 500 to 700 Stores, which with their contents are valued at 20 to 40 millions of dollars, are now lying in an indistinguishable mass of Ruins.[21]

Luman Reed's buildings on Front Street, "only a few doors above Wall Street," were very near the fire "and at times in danger."[22] Although his business escaped harm, Reed responded to the threat of a recurrence of fire with decisive intelligence. While the destructive consequences of the fire in terms of personal and property losses were easy to see, other results were not so obvious. In the struggle to control the blaze, almost all of the city's fire equipment was damaged and needed repair to become operative again. The fire insurance companies instantly became bankrupt or at least ineffectual, rendering fire insurance valueless. Recognizing that these conditions left his property completely vulnerable, Reed loaded all of his most valuable goods, including "teas, coffee, spices and foreign liquors," onto a schooner, which set out and dropped anchor in the harbor. Reed took out marine insurance in the amount of about $30,000 to cover the cargo, and the goods were thus stored safely at sea. Three weeks later, when the danger of a recurrence of fire had passed, the ship weighed anchor and the cargo was returned to the Front Street storehouses.[23]

Although Reed took charge of the decision-making during the crisis of the fire, some of the day-to-day responsibility for managing the dry-goods business had been delegated since about 1832 to Jonathan Sturges, who had become a partner in the firm in 1830. By this time Reed had amassed a significant fortune and could be counted among New York City's wealthiest five hundred citizens, a distinction he shared with such notable New Yorkers as Philip Hone, Dr. David Hosack, Robert Lenox, Peter Schermerhorn, and James Roosevelt.[24] His worth in 1828 was estimated at between $100,000 and $250,000. In recognition of both his financial success and his acceptance in the business community of his day, Luman Reed was elected to membership in the Chamber of Commerce of the State of New York in 1834.

During the years that Reed was actively building his business, he began to expand his social connections and interests by supporting the arts in a variety of ways. A silver bread basket, which was a gift to Reed from the actor James Henry Hackett, bore the inscription:

AMICUS CERTUS IN RE / INCERTA CERNITUR / TO / Luman Reed esq. / This trifling tribute of / respect for a most disinterested act of kindness proffer'd in the / hour of need is presented / by his / Obligated & Grateful Friend / J.H.H. / N. York 1831.

In 1825 Hackett had opened a business on Front Street adjacent to Reed's establishment, but not long after, he went into bankruptcy. "Unexpectedly and spontaneously," according to Hackett, Reed came to his assistance with a loan of $1,000.[25] The money enabled Hackett to pursue his longtime desire for an acting career. He was soon playing roles that ranged from Rip Van Winkle to Falstaff, and he received acclaim both in England and America. "Hackett has been doing wonders," a critic noted in the *New-York Mirror.* "His Yankee characters have succeeded admirably, and he has even reaped laurels in the personation of Falstaff."[26]

A friendship developed between Hackett and Reed, which was a model of the subsequent associations between the patron and the painters whom he supported during the 1830s. When traveling abroad, Hackett wrote letters to Reed. He recounted the ups and downs of his career on various London stages, the good and bad

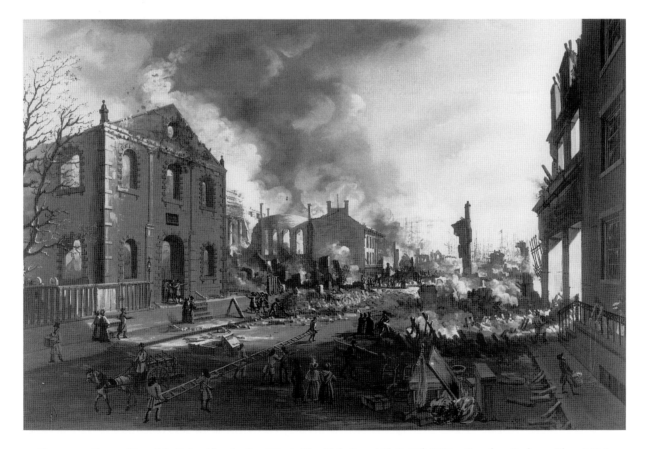

NICOLINO CALYO. *View of the Ruins After the Great Fire in New-York, Decr. 16th & 17th 1835 as Seen from Exchange Place.* 1836. Gouache on paper, 18 × 25″. The New-York Historical Society

notices of his performances, and other details of his personal life. The letters show that the actor was confident that Reed would be interested in his concerns and would take pride in his artistic development.[27]

One of Hackett's letters to Luman Reed suggests that the patron took an interest in opera as well as the dramatic arts in New York. In 1835 Hackett was exploring the possibility of purchasing the failing Italian Opera House in New York and transforming it into a theater. He broached the idea first to Reed, whom he addressed as "one of the original supporters of the scheme [the Italian Opera House]."[28] The opera house had been built just two years earlier at the corner of Leonard and Church streets by a group of sixteen subscribers to the Italian Opera Association. It was supported by well-to-do New Yorkers, including Peter Schermerhorn, the collector Gardiner Greene Howland, and the builder of Reed's house, Isaac G. Pearson. In return for their support, the shareholders drew lots from a hat for private boxes in the second tier. Philip Hone was not a subscriber, but he shared a box with Peter Schermerhorn and James A. Jones. After the opening night performance on November 18, 1833, Hone admitted that he preferred the lavish decor of his box to the "tiresome," four-hour-long opera.[29] It is not clear what kind of support Reed lent to the Italian Opera House; for despite Hackett's words Reed was not one of the subscribers nor was he a principal boxholder. His strong interest in music, however, makes it reasonable to assume that he supported the opera in some private way that Hackett knew about. Reed encouraged both of his daughters to play instruments and took great pleasure in informal, musical evenings with friends. "It was a great

enjoyment to Mr. Reed to attend our entertainments," Mrs. Jonathan Sturges remembered, "where none but those who enjoyed music were invited, and a good supper crowned the whole."[30]

In 1834, Luman Reed was elected an honorary member of the National Academy of Design, an organization founded in 1825 by artists dissatisfied with the attitudes and practices of the American Academy of Fine Arts. Two of the American artists whom he patronized, Asher B. Durand and Thomas Cole, had been members since the beginning and attained administrative roles at the academy in the election of 1834. By this time, Cole had established a reputation with collectors as an accomplished landscape artist, and Durand was viewed as a master engraver. It was probably due to Reed's support of and friendship with these two artists that he was also elected to membership in the prestigious Sketch Club, sometimes known as the Twenty One.[31]

The Sketch Club had been formed during the late 1820s by a group of "artists, authors, men of science and lovers of art." They wanted to hold informal regular meetings to practice their arts, to engage in conversation with

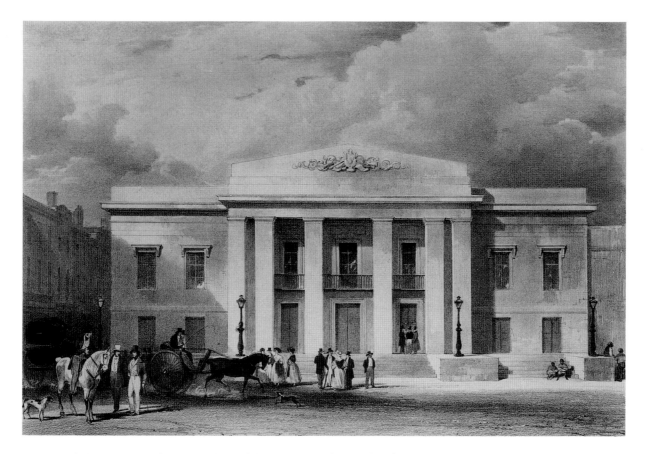

National Theatre, New York. 1836. Lithograph by Days & Hughe, London, from a watercolor by R. Bengough, 10¼ × 13″.
The New-York Historical Society

The National Theatre was originally the Italian Opera House, located on the corner of Leonard and Church streets

each other, and to enjoy "eatables and drinkables" that were "simple but good," and in that spirit of simplicity they resolved that, "set suppers shall be discountenanced."[32] The group met on alternate Friday evenings from November through April, at the home of one of the members, and Reed reportedly served as the host on a number of occasions.[33] The evenings opened with informal sketching and the writing of verses and continued with lively discussions and the meal. The mingling of artists and patrons at these congenial Sketch Club evenings helped encourage and broaden support for the contemporary American artists. Membership for Luman Reed, one of the relatively few amateurs included during the early years, broadened his social circle of artistic friends and introduced him to the current issues and trends in the arts of his day, including painting, writing, and music.

The Sketch Club host for the evening would select a subject to engage the imagination and skills of the artists and writers in attendance. They would devote about an hour to producing spontaneous visual and literary compositions inspired by a wide range of topics. Passages from romantic literature and poetry were often read to evoke specific images from the sketchers. Sometimes such general topics as "the emotions," "character," or "the abduction" were offered. On one occasion, the philosophical concept of "the sublime" challenged the literary members to describe an idea so important to the developing genre of landscape art in America. The artists Thomas Cole and Charles C. Ingham spent one Sketch Club evening discussing "the nature of clouds." Sometimes mock criticisms were produced by reviewers who had not visited the exhibition under discussion.[34] No doubt the predominance of landscape and narrative subjects in Luman Reed's collection of paintings reflects, in part, the influence of his involvement in the Sketch Club. The preoccupation with ideas about nature and its associative meanings and the delight in romantic literature that these evenings conveyed surely shaped Reed's developing taste for art.

Reed's own disposition to avoid ostentation and self-indulgence was very much in tune with the Sketch Club's style. The club was a successor to an earlier club formed by James Fenimore Cooper called the Bread and Cheese Club or the Lunch. In contrast to the Lunch, which was highly exclusive and conservative in its membership and enjoyed lavish meals at a hotel called the Washington Hall, the Sketch Club had a more heterogeneous roster and discouraged both formal and extravagant entertaining. Moreover, the Sketch Club had been formed by that group of artists who had rebelled against the staid American Academy of Fine Arts and set up the rival National Academy of Design. Politics were not a dominant concern of the members, but those who had political convictions were generally of a liberal frame of mind.[35]

Although there is little evidence to prove Luman Reed's political attitudes and party affiliation, most New York merchants during the Jacksonian period were Democrats and agreed with the party's support of free trade and opposition to the United States Bank.[36] Reed's association with the Sketch Club also suggests a Democratic allegiance, for its members mostly supported that party rather than the Whig. One family member recalled that Reed "exhibited very little interest in politics—he however liked the decission [sic] and actions of President Jackson." More specifically, he "did not favor the policy and doctrines of [Daniel] Webster and [Henry] Clay [Whigs and staunch opponents of Jackson], especially in respect to a 'U.S. Fiscal agent' or U.S. Bank—he said that the people's government should exhibit more *individuality* and freedom from combinations and greedy leaders."[37]

Washington Hall. Broadway corner of Reade Street. Lithograph by George Hayward from David Thomas Valentine,
Manual of the Common Council of the City of New York, 1853

Reed met President Jackson at least once, and the congenial character of the men's interaction suggests
political as well as personal regard. In 1831, Reed and his family paid a call on Jackson during a trip to
Washington. Catharine Reed recalled the president's gracious reception: "It was past the usual hours of the
president[']s receiving company but he very politely received us," she wrote. He apologized for the disarray of his
house, which was being painted and cleaned, and he offered roses to both of Reed's daughters. As he handed the
flower to Catharine, "he stop[p]ed and said it would not do to present a young lady a rose with thorns so he took
them off with his knife then presented them very politely." Four years later, Reed commissioned Asher B. Durand
to paint a portrait of "our President & distinguished fellow citizen" Andrew Jackson. It would be the first in a
series of seven presidential portraits. The president, apparently, was not as polite toward the artist as he had been
toward Catharine Reed and her sister, Mary. He obliged grudgingly to very infrequent sittings, and during them
he smoked his pipe, read, wrote, and attended to various other activities, much to Durand's displeasure. "The
General has been part of the time in pretty good humour," wrote the artist, "but sometimes he gets his 'dander
up.'"[38]

It was not politics but membership in artistic organizations, however, that reflected the focus of Reed's
concerns outside his business pursuits during the early 1830s. He directed his energy to two important new

interests. He built a fine new house for himself and his family, and he gathered a significant collection of art for that house, creating something that was remembered as "the wonder of its day." As his wife's nephew recalled:

> Certain it is; that in his subsequent and mature business career, he spent time and much money upon himself in musical instruments and teachers. . . .
>
> Certain it is: that his words and money encouraged and advanced toward success and renown the comedian (subsequent tragedian) Hacket[t]!
>
> Certain it is; that his tastes, his knowledge, his mind and his purse guided the hands & brushes of Durand, Cole, & Flagg.[39]

THE HOUSE AT 13 GREENWICH STREET

That grand old house at No. 13 Greenwich street . . . was the wonder of its day. The doors were of solid mahogany. He had a gallery of paintings in the upper story. It was considered superior to any in the city of New York. The marble was purest Italian. The mahogany was the old, black, costly St. Domingo, now so rare.[40]

The success of Luman Reed's business during the 1820s allowed him to embark upon a new project—the design and construction of a new house for himself and his family. The only known drawing of the house at 13 Greenwich, which was remembered as one of the finest residences of the day, is an inch-high sketch. It was inscribed on February 24, 1831, in the daybook of the draftsman and architect Alexander Jackson Davis.[41] Davis wrote that he was engaged in drawing a three-story city residence for the builder, Isaac Green Pearson (sometimes

Sketch of a house for Luman Reed in Alexander Jackson Davis's daybook, February 24, 1831. Alexander Jackson Davis Papers, Rare Books and Manuscripts Division, The New York Public Library. Astor, Lenox and Tilden Foundations

Bird's-eye View of New York and Brooklyn (detail). c. 1852. Lithograph by C. Matter, from a drawing by J. H. Locher,
26¾ × 33¼″. The New-York Historical Society

Luman Reed's home was on Greenwich Street, two blocks east of the Hudson River and just north of Battery Park

spelled Pierson). The charge was $5.00, and a marginal inscription related that this was the "house for Luman Reed."[42] Small as it is, the thumbnail sketch provides essential information about the structure of the house. It was a three-story house, four bays wide, with the door located in the third bay and a cupola. The low price that A. J. Davis recorded for the design work of this substantial but not grandiose residence suggests that he was responsible for the facade drawing only and not for the interior plan and details. Probably, Pearson provided Reed with the principal design for his house, including some standard town-house features and a variety of options from which Reed could make selections.

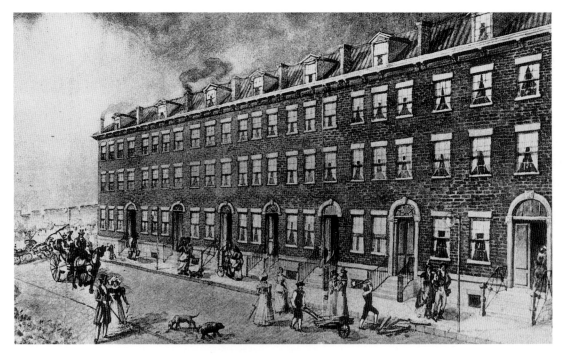

Millionaire's Row in 1825, plate from Henry Collins Brown, *Valentine's Manual of the City of New York for 1916-1917*

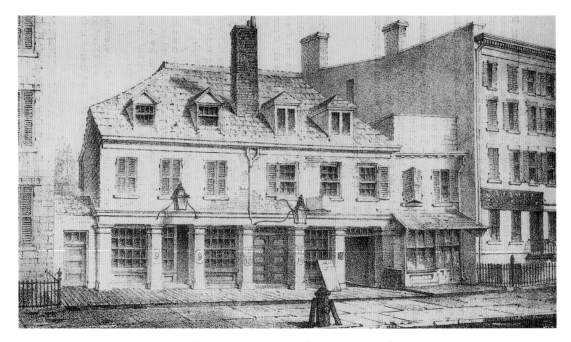

Atlantic Garden House (Burn's Coffee House in 1765), Broadway, opposite Bowling Green. 1858. Lithograph by Weingartner's Lithography from David Thomas Valentine, *Manual of the Corporation of the City of New York for 1858*

The single-lot site for the house was located on the east side of Greenwich Street at the south end between Battery Place and Morris Street. It was a prosperous neighborhood, which counted many merchants among its inhabitants. In fact, the opposite side of the street, lined with distinguished Federal-style houses built during the 1820s and occupied by successful merchants, lawyers, stonecutters, and druggists, was called "Millionaire's Row."[43] The plot adjoining Reed's was occupied by the Atlantic Garden, an outdoor resort where people gathered to enjoy popular music and refreshments. "For years Mr. Reed enjoyed the luxury of listening to the choice music in the summer time, and witnessing the happiness of hundreds of couples who, at one time, made it a place of regular resort to get their ice cream and talk of sweet things."[44]

Construction of Luman Reed's house probably began in the spring of 1831, but the complicated task was not completed until August of the following year when the family moved in. As might be expected of a pragmatic businessman, Reed incorporated a number of innovative structural systems into the construction of his house: gas lighting, a simple furnace to provide heat, and a rudimentary drainpipe system for plumbing. But despite the elegance and innovations of the appealing three-story dwelling that Catharine Reed, the owner's daughter, called "our mansion," the sewage system apparently did not work too well; the "foul air of the house" was, at one time, blamed as the cause of Reed's death.[45]

People who saw Reed's residence when it was completed remembered it as a fine building with some impressive, opulent details. Even the sidewalk stones in front of it were worthy of mention. They were "immense" in size, and people used to "stop and admire their great dimensions"; it was apparently common knowledge that "each cost $250."[46] However, Luman Reed's house was not considered an extravagant residence for its day. The owner was interested in quality, not in the showy display of wealth. This attitude is reflected in a letter from his son-in-law Theodore Allen, who was at pains to reassure Reed that he and his wife were not being extravagant during their European travels. "One word about our expenses," wrote Allen. "I believe I need not tell you that we are as economical as possible. We only seek to be comfortable & appear respectable—Not a cent is expended for show."[47]

The neoclassical town house was ample for a successful man but hardly ostentatious. It measured thirty-six feet across the front and fifty-six feet in depth, leaving a thirty-seven-foot garden in the back, where "three beautiful white marble cisterns" were located to catch the rain water.[48] It was far more modest than the house built during the same years by Samuel Ward, a banker who also used the combined talents of A. J. Davis and Isaac Pearson. If it differed from dwellings built by wealthy contemporaries, it was "only in being . . . better constructed, the materials being of the very best quality and the mechanics employed 'the best that money could procure.'"[49] Reed was not interested in constructing a palace; he wanted a well-built house with a good design that would provide a beautiful and comfortable home for his family.

To insure that his children would enjoy the family home he was building for them, Reed involved them in design and furnishing decisions as the house was developing. He closely supervised the structural construction of the building himself. "The House goes on as well as the cold weather will permit," he wrote to his daughter Catharine in December 1831. "The cornices are all run in the 3rd story & the hard finish on the Ceiling, & some

of the rooms in the garret are finished." Catharine responded with some relief to the delay as she clearly had some comments to make about the new developments that were taking place in her absence. "I should really like to talk over the new ideas you and Mr. Pearson have been contriving," she remarked. "I have been quite puzzled to think what you are going to put in place of pier tables."[50] The following winter Reed became ill. Apparently he caught cold during the hours spent in the cellars of his new home directing the installation of the waterworks.[51]

In the spring of 1832, Reed and his family gave up their old house at 106 Greenwich Street and took rooms in the City Hotel on Broadway just north of Trinity Church while their new house was being completed. Since they sold most of the "heavy furniture" from their old house, Reed, with the advice of his daughters, was engaged in shopping for furniture for the new house.[52] "Pleasant, out all the morning with Father," Catharine noted in her diary. "Bought a pair of mantel lamps at Gardner's."[53] She was probably referring to Baldwin Gardiners', a well-known retailer, located at 149 Broadway, who carried Argand oil-burning mantel lamps and other items in the

ABRAHAM HOSIER. *The Samuel Ward Mansion in 1835. c. 1856–77.* Watercolor on paper. 4⁹⁄₁₆ × 6″.
Museum of the City of New York. J. Clarence Davies Collection

City Hotel, Trinity and Grace Churches, Broadway. Drawn and engraved by A. Dick for *Fay's Views of New York, 1831.*
The New-York Historical Society

latest styles. An entry in Duncan Phyfe's account book records payments from Luman Reed indicating that some of the furniture in Reed's house was custom-made by that leading New York cabinetmaker.[54] Some of the carpets were ordered from Cincinnati, according to Catharine, but probably others came from mills in England, which was customary for the day.

The most remarkable feature of Luman Reed's house, however, was not its furniture or fine design. It was the gallery of paintings located on the third story that distinguished the residence. Reed had not conceived of including a gallery in the original design for the house, but sometime before its completion in 1832, he adapted the double parlor on the top floor "to the purposes of a picture-gallery, as well as this could be done without a skylight in the roof."[55] The decision clearly coincided with his new interest in art. He had probably begun to buy paintings around 1830, and by the time of his death just six years later, he had enriched his holdings to more than fifty paintings, about two-thirds of which were works by contemporary American artists. This number did not include the specially commissioned scenes painted on the door panels of the rooms.

While Luman Reed was not unique in forming a collection of art during this period, nor even in building a private gallery in which to install his holdings, he was extraordinarily generous in providing access to the gallery. Outside of exhibitions at the academies, the collections of a handful of private dealers, visits to artists' studios, and occasional exhibitions of collections from abroad, there were very few opportunities to view original works

of art in New York. Private collectors were criticized for their lack of public spirit in discouraging visits by all but close friends. "New York is rich in pictures and statuary, to which there is no access except by acquaintance with the proprietor," complained a writer in the *Home Journal*. "Europeans are more republican than we, in this respect, for there are days set apart, by every owner of a fine gallery, when the public can be admitted." Like his European counterparts, Luman Reed did open his gallery one day a week to visitors, almost certainly with some form of introduction.[56] Many people commented upon and praised the regular accessibility of the Reed collection without mention of others who provided this opportunity to the public, suggesting that he may have been the only New York collector at the time to do so.[57] This public-spirited openness reflected Reed's concern for promoting cultural education in the United States by supporting the work of native artists and sharing the fruits of his own new enthusiasm for art with a relatively broad audience.

THE GALLERY

Luman Reed's gallery, during the few years that it was open prior to his death in 1836, served as a congenial place for artists and writers to become acquainted and to discuss matters of mutual cultural interest. It provided a kind of much-needed salon for the small but enthusiastic artistic community in New York and its visitors. "What delightful reunions took place there," recalled Henry Tuckerman, the critic and raconteur of artistic life in the nineteenth century. "What a mingling there was of artists and literary men, such as [Samuel F. B.] Morse, [Thomas] Cole, [Robert] Weir, [Henry] Inman, [Asher B.] Durand, with [James Fenimore] Cooper, [Washington] Irving, [William Cullen] Bryant, etc."[58] After Reed's death, notable figures continued to come and visit the gallery as word spread of its quality and significance. The sculptor Horatio Greenough was on a visit back to the United States from Florence to examine the site for his statue of George Washington in 1836. Before his return abroad, he made sure to include a stop at "the house of the late Mr. Reed," where he found "a gallery of American works of which New York may well be proud." Former President John Quincy Adams visited the gallery in the fall of 1840 to admire his own portrait (Plate 17) in the collection that Reed's widow and family continued to make available to distinguished visitors.[59]

The gallery consisted of two symmetrical rooms divided by a large pair of paneled wooden doors. Two single doors on one wall connected each of the rooms to the hallway and to the small bedrooms that shared the third story with the double-parlor gallery. In a letter, dated 1835, to the artist William Sidney Mount, Luman Reed included a drawing of one of the single doors.[60] The drawing indicated the overall dimensions of the door and the relative proportions of its interior recessed panels. The simple carving of the door frame and molded corner pieces was in keeping with the restrained version of neoclassical architectural decoration that characterized the overall design of the rooms. A patterned crimson carpet complemented the understated surface treatment of the walls and doors.[61]

Lighting for the gallery came from four windows, two at the east end and two at the west end. Gas chandeliers hung from the center of each room, and a pair of gas mantel lamps stood on the mantel cornices

crowning the fireplaces in each of the rooms. The lighting in certain areas may have been dim; Thomas Cole suggested to Reed that paintings could be "hung on swings in order to be brought into good light."[62]

The gallery was sparsely furnished as was suitable for a space that was designed expressly for exhibiting paintings. It included pairs of ottomans and twelve mahogany chairs, as well as "long, low mahogany tables . . . where the large books of engravings could be conveniently laid and examined," and a print rack to store separately matted prints.[63] There were two globes in the rooms, possibly of the tabletop variety representing the terrestrial and celestial realms. Six cases contained specimens of shells and minerals for examination and study,

Sketch of a small door in Luman Reed's art gallery, enclosed in a letter from Luman Reed to William Sidney Mount, November 23, 1835. The Museums at Stony Brook, New York

and additional examples could be stored in a cabinet of drawers. A large portion of the minerals were purchased from the collection of Baron Louis Lederer, the Austrian consul general. Others came from family members and, probably, ship captains on Reed's trading ships or dealers traveling in the Caribbean, the Pacific, and the Mediterranean. From Naples Theodore Allen, Luman Reed's son-in-law, who encouraged and guided the development of his collection, wrote that one of the boxes he was sending home contained miscellaneous shells and minerals. "The greater part of the specimens [were] procured alive," according to Allen. "[I] removed the

animal myself."[64] On that same trip, Allen also purchased for Reed cork models of the three temples at Paestum which re-created the buildings as they appeared in their current ruined state. It is not known whether the shipment containing these objects arrived before Reed's death, for the models are not listed in the estate inventory. It is certain, however, that they would have fascinated Reed, who never had the opportunity to travel abroad but collected a number of paintings containing references to classical civilization.

The inclusion of valuable natural specimens such as minerals and shells in a gallery devoted principally to paintings did not reflect Luman Reed's personal interest in science but rather the traditional concept of a collection. "Cabinets" of art and natural curiosities had been maintained in ancestral homes on the European continent for centuries. In Germany these were known as *Wunderkammern* or *Kunstkammern*, and they included antiquities, curiosities, medals, gems, statuary, and paintings. Educated English travelers on the continent in the eighteenth century came in contact with these princely treasuries and began to form their own cabinet collections. One of the most celebrated of these composite collections of art and natural history specimens was the duchess of Portland's "Portland Museum," which was sold at auction in 1786.[65]

In that same year, in Philadelphia, the *Pennsylvania Packet* ran an advertisement for the artist Charles Willson Peale:

> Mr. Peale, ever desirous to please and entertain the Public, will make a part of his House a Repository for Natural Curiosities—The Public he hopes will thereby be gratified in the sight of many of the Wonderful Works of Nature which are now closeted but seldom seen. . . .
> N.B. All the Portraits are now removed into the former Exhibition Room; and Exhibitions of the *Moving Pictures with Changeable Effects,* will only be made for private companies, consisting of twenty or more persons, on previous notice being given.[66]

Peale painted a self-portrait (page 10) many years later that shows the artist in his museum, which was America's first systematic, continuous, and public museum and included works of art and a great variety of natural history specimens. Peale's Philadelphia museum spawned a number of competitive ventures in New York. The American Museum, organized by the Tammany Society, was opened to the public in 1791 at the Pantheon Building at 80 Greenwich Street. The natural history specimens of the American Museum were later incorporated into the Columbian Gallery of Painting, which also had its site on Greenwich Street during the early 1800s.[67] Thus, when Luman Reed built a gallery into his house on Greenwich Street and included specimens of both art and nature, he was following a tradition that in New York had begun on the very street where he lived. In making his collections accessible to the public, he can also be compared with Gardiner Baker and Edward Savage, the proprietors of these early New York museums. However, unlike them, Luman Reed did not sell tickets, because he was motivated not by profit but by a sense of public responsibility.

In addition to shells and minerals, Theodore Allen sent Luman Reed other objects from abroad, to acquaint him with earlier forms of art and to enhance his collections. From Italy, he sent a box containing "*Miniature facsimiles* of Greek, Egyptian and Etruscan vases." He advised Reed that they were sent "not as toys, though I fear

they may be at first deemed mere gewgaws, but as specimens . . . whose scale give a [illeg.] & exact idea of ancient vases than can be formed from seeing engravings of them."[68] In other words, these tourist knickknacks provided Reed with three-dimensional models that could better educate him about early sculptural forms than other kinds of reproductions.

Similarly, to educate himself about the styles and subjects of old master paintings, Reed acquired a substantial collection of engravings, for the most part with Allen's help.[69] The inventory of Reed's estate recorded "unbound engravings" in the library valued at $1,000. A selection of these was, no doubt, kept in the gallery to be viewed by visitors in the print rack located in that room. When the collection was given to the New-York Gallery of the Fine Arts in 1844, it was said to contain about two hundred and fifty items comprising "many rare and valuable engravings by eminent artists of celebrated pictures of the first masters, from the earlier stage of the art, about the year 1500, to those of our own time."[70]

Almost all of the surviving prints from Reed's collection, about one hundred in number, are reproduction engravings after popular works of art from the Renaissance and baroque periods. With the exception of one work by Wenzel Hollar and a late impression of a Rembrandt etching depicting *Peter and John Healing the Cripple at the Gate of the Temple,* these were not original compositions conceived for the print medium.[71] Italian artists form the bulk of the collection, with works by Raphael, Michelangelo, Titian, Guido Reni, and Salvator Rosa included. There are a number of engravings after Flemish artists, Rubens being the most popular. Additionally, there is a sampling of engravings after originals by German, French, and English artists. Only one American artist is represented by an engraving, and that is John Singleton Copley, who, by Luman Reed's day, was categorized as an "old master" in exhibition catalogues. It is an English-period work and a historical subject, namely *The Siege and Relief of Gibraltar.*

Luman Reed's collection of engravings was acquired for study. It provided examples of great artists' styles, important subjects from history, and commemorative portraits of noteworthy figures and places. The prints served as substitutes for painted copies after masterpieces that could not be bought but were required as models of artistic achievement and possibility. While critics in America had begun to discourage the collection of old master copies, they allowed that "most of us can never see the immortal works of Europe except in engravings; and that if these convey no adequate idea of their originals, they do afford us a knowledge of their composition and drawing which is better had so than not at all."[72] Engravings after more contemporary artists, such as mezzotints from portraits by Sir Joshua Reynolds, introduced Reed to the work of recent masters. Probably the most valuable engraving was purchased by Reed himself when he paid the family of Raphael Morghen, the leading English reproductive engraver, $400 for his copy of Leonardo's *Last Supper.* Reed's collection also included such tourist mementos as "colored views of Naples, Eruptions of Vesuvius & costumes" of Italy that were sent home by Allen.[73] These views conjured up images for Reed of places that he did not have the opportunity to visit.

Luman Reed also accumulated a library to complement his specimens of nature and of art. It contained books on a broad range of subjects, as befitted a man who, although not well educated, was determined to

Charles William Henry, Earl of Dalkieth. 1778. Mezzotint by N. Green
after Sir Joshua Reynolds, 23¾ × 17¼″. The New-York Historical Society

acquire knowledge in his many areas of interest. Reed owned books on art, history, literature, religion, science, medicine, viticulture, and household management, as well as a book by Sir Richard Phillips entitled *A Million of Facts, Connected with the Studies, Pursuits, and Interests of Mankind, Serving as a Commonplace Book of Useful Reference on all Subjects of Research and Curiosity* (1832) to pursue subjects not covered in the volumes at hand. It is surprising that the inventory does not record volumes devoted to music, which was a subject that had interested Reed since his youth.

It was Theodore Allen who sent Reed a nine-volume work on Herculaneum and a large folio of the frescoes and mosaic pavements at Pompeii. The works on art in Reed's library were few. They included catalogues of works in such European art galleries as the Louvre, the Luxembourg Gallery, the Uffizi, and Forster's Gallery in London, a volume of engravings after Raphael's *Hours* (now at the New-York Historical Society) at the Vatican in Rome, and John James Audubon's *The Birds of America* (1827–1838).[74] The most notable art references that surely aided Luman Reed in his developing interest in art were William Dunlap's *History of the Rise and Progress of the Arts of Design in the United States* (1834) and the works of Sir Joshua Reynolds.

Dunlap's history of American art, developed through a series of biographies of artists who were born in the United States or who received their formative artistic education there, offered Reed a broad introduction to the development of art in America from the colonial period to his own time. Dunlap's judgments about the merits and failures of the various artists and his quotations from numerous other sources provided Reed with a variety of subjective attitudes about the accomplishments of artists of his day and their predecessors. However, by the time Dunlap was delineating the lives of the particular American artists whom Reed patronized—Cole, Durand, Mount, and Flagg—the collector was already familiar with their work through his connections at the Sketch Club.

Reynolds's famous *Fifteen Discourses,* first delivered as lectures to students at the Royal Academy in London, was published collectively in 1769 and had a lasting influence on the development of taste in America as well as abroad. "Sir Joshua's lectures are not only instructive to artists," Luman Reed once remarked, "but they furnish rules of life."[75] It could have been from Reynolds that Reed acquired a conviction about the importance of original works of art as the essential models for the development of artistic skill and appreciation. According to Reynolds, it was through the study of "great examples of the art," or what he also called "authentic models," that the "idea of excellence which is the result of the accumulated experience of past ages, may be at once acquired."[76] While Reynolds was promoting the value of a collection of original works of art for the students at the Royal Academy in London, Reed applied the same principle to his private collection, in which "authentic models" predominated. In the formation of his art collection, Luman Reed also shared with Reynolds a public purpose. He wanted his collection of old masters and contemporary works to contribute to the promotion of artistic excellence in America.

Another book that contributed to Reed's self-education in art was John Burnet's *Practical Treatise on Painting* (1830). Reed shared an appreciation of that book with William Sidney Mount, one of the artists whom he admired and sponsored.[77] A disciple of Sir Joshua Reynolds, Burnet isolated three principal technical components of painting, namely, composition, light and shade, and color, and selected various artists as models of achievement in each of these areas, using illustrations of specific works. According to Burnet, a successful composition required "that the story be well told; that it possess a good general form; that it be so arranged as to be capable of receiving a proper effect of light and shade; and that it be susceptible of an agreeable disposition in colour."[78] Reed's preference for narrative paintings representing commonplace subjects, exhibited in his enthusiasm for the works of Asher B. Durand and William Sidney Mount and in the topics he proposed for the painting of

Plate of an engraving by Adriaen van Ostade, from John Burnet, *A Practical Treatise on Painting* (1830).
Avery Architectural and Fine Arts Library, Columbia University in the City of New York

his gallery doors, could have been derived, in part, from Burnet's advice. The first plate in Burnet's *Treatise* included an etching of a domestic interior by the Dutch artist Adriaen van Ostade. The author praised the composition, saying that an imprint "ought to be in the possession of every artist, for its beautiful arrangement of light and shade, and the skilful way in which they are woven together."[79] This image, particularly the detail of the mother and child, is similar to Asher B. Durand's painting *The Pedlar* (Plate 20), one of several works in Reed's collection inspired by examples of earlier Dutch genre painting.

Like his mentor Sir Joshua Reynolds, Burnet espoused the importance of studying works by the old masters. Quoting Reynolds, he wrote: "Invention is one of the great marks of genius; but, if we consult experience, we shall find that it is by being conversant with the inventions of others that we learn to invent, as, by reading the thoughts of others, we learn to think."[80] The conflict of this attitude with the romantic view of genius as an inherent and mysterious component of artistic creation and the developing notion of the importance of direct experience with nature was part of the fabric of cultural debate in Reed's day. Through reading sources on art in his library and his associations with artists and writers at the Sketch Club, Luman Reed absorbed the current critical attitude and controversies of the fledgling art world in New York, and the character of his holdings reflected these influences. The highlight of Reed's gallery was his collection of paintings. The collection reflected Reed's pioneering attitude about patronage and provided an impetus to future generations of artists and collectors in the United States.

ART COLLECTION PRECEDENTS

In "a slight sketch of the life and times of Luman Reed," the art editor John Durand cited 1830 as the date that Mr. Reed began to interest himself in the cause of art.[81] By that time he had achieved financial success and had established his business operations on a secure enough footing to delegate daily supervision to subordinates. He therefore had the means and leisure time to devote himself to other pursuits.

Between 1830 and 1836, Reed is known to have acquired at least sixty-five works of art either by direct purchases or by commissions (he may have bought and sold additional works before his death, but no records of such transactions have come to light). When the inventory of the estate was taken, about one-third of the collection consisted of European paintings, mainly from the seventeenth and eighteenth centuries, and the other two-thirds were paintings by contemporary American artists.

It is certain that Reed's earliest acquisitions were European old master pictures that he bought principally from the New York dealer Michael Paff. Others were purchased from private European collections that were exhibited in the United States; for Reed himself never traveled abroad. *Italian Scene, Composition* (Plate 1), which he commissioned from Thomas Cole in the winter of 1833, was the first painting Reed acquired from a contemporary American artist.[82] During the three years that followed, he turned his attention almost exclusively to the work of American artists. In addition to his letters to Cole, Reed's correspondence with Asher B. Durand, William Sidney Mount, and George Whiting Flagg reveals his enthusiasm for their work as well as a growing passion to satisfy his desire "of getting fine pictures to fill my Gallery."[83] He acquired paintings directly from the artists themselves by purchase, commission, or subsidy.

A story that has been often repeated about Reed's developing taste for art was that his new interest in American art caused him to reject his earlier affection for the old masters. It was said that he bought European paintings first out of a traditional but untutored notion that old masters were the best that money could buy. Then he discovered that he was "purchasing counterfeit 'goods' and he got rid of his acquisitions in much less time than it took to buy them."[84] Clearly, this story is incorrect; for about eighteen European works remained in the

collection at his death and were hanging in his gallery when the inventory of his estate was taken. While the bulk of his acquisitions between 1832 and 1836 was American, Reed continued to buy European works. In 1835, just a year before his death, he purchased a Flemish still-life picture by Jan Fyt depicting dogs and game after the hunt (Plate 38). He described the painting by the seventeenth-century artist as "a first rate specimen of the art & I must say I never knew what could be done in painting before." While the subject of dogs and game was not to Reed's taste, the quality of the painting caused him to admit that "I am now a believer in the old masters."[85]

From the manuscript sources that are known, there is no direct reference to what first inspired Luman Reed's interest in art or his desire to form a collection. While it is true that private collections of art were rare in America prior to 1830, there were precedents that could have served as models, and there were contemporaries of Reed in New York who were engaged in collecting.[86]

In 1751, Governor James Bowdoin II of Massachusetts acquired a number of copies of European paintings from the estate of the Scottish artist John Smibert. Smibert had painted most of these copies after Raphael, Titian, Tintoretto, and Van Dyck during a trip to Italy. He brought these pictures with him to America in 1728, and they hung in his studio, where they provided models for such budding artists as John Singleton Copley.

Later the governor's son James Bowdoin III enlarged the collection to about seventy paintings and over one hundred and forty drawings, including European works that the younger Bowdoin purchased when he lived abroad from 1805 to 1808, principally in France, where he was involved in negotiations with Napoleon concerning the acquisition of Florida. Bowdoin's collection also contained notable examples of colonial and Federal portraits by Joseph Badger, John Smibert, Joseph Blackburn, and Robert Feke—many of them of members of his family—and likenesses of Presidents James Madison and Thomas Jefferson commissioned from Gilbert Stuart. (It was this portrait of Madison painted from life by Stuart that served as the model for Asher B. Durand when Reed commissioned him to paint presidential portraits for his collection [Plate 15]. Writing to his wife from Brunswick, Maine, on October 19, 1835, Durand noted that in spite of a very unpleasant and long ride in a stagecoach, his work was going well. "I have met no delay in getting access to the portrait of Madison having commenced my copy in the course of an hour after making known my object.") Bowdoin's important, early art collection was bequeathed to Bowdoin College in 1811 but remained in storage for the most part until 1850, when the college built a small art gallery to house it.[87]

During the colonial and Federal periods, Thomas Jefferson was another notable devotee of the arts. In this respect, he was unusual among the cultivated and well-read founders of the republic. Prior to his stay in Paris (1785–1789), his knowledge of art came mainly from books and from his acquaintance, beginning about 1766, with the eminent Philadelphia physician and classicist Dr. John Morgan. Morgan had a collection of natural curiosities and of copies after famous European masterworks that hung in his fine Philadelphia house.[88] As early as 1771, Jefferson began to make lists in his notebook of the casts and copies after famous works that he wanted to acquire to adorn his house at Monticello, including thirteen classical statues, among them the Apollo Belvedere and Farnese Hercules in Rome and the Medici Venus in Florence. Painted copies were cited by their titles alone, without mention of the artists' names, reflecting an interest principally in the subjects portrayed. In later

additions to the list of desirable old master works from which Jefferson wanted modern copies made, he included some of the artists' names: "Belisarius from Salvator Rosa; Jeptha meeting his daughter—[Giuseppe] Zocchi; St. Ignatius at Prayer; The Prodigal Son from Salvator Rosa; Susanna and the two Elders—[Peter Paul] Rubens; Curtius leaping into the gulph—from [Pier Francesco ?] Mola; Paul preaching at Athens; The Sacrifice of Iphigenia."[89] As the range of artistic approach indicates, it was the moralizing character of the subjects depicted, then so much valued, that inspired the selection more than aesthetic or stylistic considerations.

Jefferson considered the arts an essential component in the development of the nation. A man of the Enlightenment, he saw art, along with science and politics, as a thread in the fabric of freedom and happiness. While architecture was his chief passion, he valued painting and sculpture, too, for their memorial and symbolic functions. These arts could embody the virtues of earlier civilizations and the accomplishments of great men and thereby serve as models of public and private conduct. Historical and portrait subjects, in Jefferson's view, served symbolic and educational as well as decorative purposes. In 1785, Thomas Jefferson defended his enthusiasm for the arts, in a letter to James Madison, as one "of which I am not ashamed, as its object is to improve the taste of my countrymen, to increase their reputation, to reconcile to them the respect of the world and procure them its praise."[90]

A selection of Thomas Jefferson's collections was exhibited at the Boston Athenaeum in 1828, and his paintings, "many of them by the old masters," were exhibited and sold in Boston in 1833.[91] While it is not known whether Luman Reed was acquainted with Jefferson's collection through this sale, it was during just these years that Luman Reed was developing an interest in art and had begun to buy old master works. Reed shared with Jefferson a belief in the value of art as a symbolic expression of the ideals of the republic. The example set by this revered founder of the nation and its third president, would surely have encouraged Reed's own disposition as a collector of art.

It was both during and after his stay in France that Thomas Jefferson began to recognize the value of original works of art and to acquire works by fashionable living artists, European and American. This shift was demonstrated in the public commissions of art for which he was responsible and in the accumulation of work for his own collection at Monticello. He enlisted Jean-Antoine Houdon to do busts of Lafayette and of himself for the state of Virginia and plasters for Monticello of Benjamin Franklin, John Paul Jones, Voltaire, and others. After the death of Houdon, he patronized Antonio Canova and Giuseppe Ceracchi. He owned several works by Benjamin West and John Trumbull, and his own portrait was taken by Gilbert Stuart, Rembrandt Peale, and Mather Brown.[92]

Jefferson consented to pose for portraits as part of his duty as a public figure, but he did not enjoy it and felt himself to be a poor judge of the results. "The ladies from the studies of their looking glasses may be good judges of their own faces," remarked Jefferson, "but we see ours only under a mask of soap suds and the scrappings of the razor." However, Jefferson liked to surround himself with commemorative portraits of the men whom he admired. At Monticello, there hung portraits of Isaac Newton, Francis Bacon, and John Locke, as well as Columbus, Raleigh, Vespucci, Adams, Washington, Lafayette, and Franklin.[93]

Reed shared with Jefferson the belief in the salutory effect of art on the nation, in its symbolic and commemorative functions. His commission of Asher B. Durand to paint the likenesses of the first seven presidents of the United States (Plates 12–18) was inspired by a desire to acknowledge their achievements and to communicate them to the public, present and future. "Their portraits will occupy a conspicuous place in the public institution that I intend to present them to," wrote Reed to Durand, "where they will be seen by all distinguished men of the nation as well as foreigners."[94] Reed sponsored American artists, especially young and promising ones, in the hope of bringing glory to his country. He sent the eighteen-year-old George Flagg abroad, exposing him to earlier examples in art in the hopes of enhancing his innate abilities. "I really look to you to give a spring to the art in this country," Reed told Flagg, "you must not disappoint me in becoming the greatest painter of the age."[95] The success of the artist, in Luman Reed's estimation, would reflect favorably upon both his own personal judgment and the reputation of the new nation.

While James Bowdoin III and Thomas Jefferson provided respectable models as art collectors for Luman Reed and others of his generation, the two predecessors differed in significant ways. The ancestry and educational opportunities of Bowdoin and Jefferson were not shared generally by Reed and such contemporary collectors in Boston and New York as Charles Codman, Harrison Gray Otis, Philip Hone, and Samuel Ward. James Bowdoin III could trace his ancestry back to Baldwin, count of Flanders in the ninth century. From Flanders, the family moved to France. After the Edict of Nantes was revoked in 1684, Dr. Pierre Baudoin and his family, who were Huguenots, fled to America. James Bowdoin II inherited the largest fortune of his time in the state of Massachusetts, where he served as governor. He was president of the American Academy of Arts and Sciences, a fellow of the Royal Society of London, and a strong supporter of the revolutionary cause.[96] James Bowdoin III was well educated and well traveled. He was born in Boston, graduated from Harvard College in 1771, and studied at Christ Church, Oxford. He was a member of the convention of 1788, where he spoke and voted for ratification of the federal Constitution. A Jeffersonian Republican, he spent several years abroad during Jefferson's tenure in diplomatic capacities.[97] He was a landholder and was not engaged in trade.

While not as wealthy as Bowdoin, Jefferson also inherited land from his father, Peter Jefferson, who was a local magistrate in Goochland County, Virginia. He inherited social standing from his mother, Jane Rogers, who was descended from the most distinguished family in the province. Jefferson had a classical education and graduated from the College of William and Mary. He studied legal history and was admitted to the bar in 1767, but he gave up the legal profession on the eve of the Revolution.[98] Jefferson's distinguished career as a statesman, scholar, and patron of learning is well known.

The collectors of the next generation were not large landholders engaged in agriculture, but city dwellers active in business. Charles R. Codman, Harrison Gray Otis, Isaac P. Davis, and Thomas Handasyd Perkins were listed in Boston Athenaeum catalogues as "proprietors," who lent portions of their collections for exhibitions there during the late 1820s. Of these men, Codman, Davis, and Perkins were all listed as merchants in the Boston directories.[99] Although Perkins and Otis inherited their fortunes, Codman and Davis were self-made men. Their counterparts in New York, who began collecting slightly later, Philip Hone, Samuel Ward, and Luman Reed, were

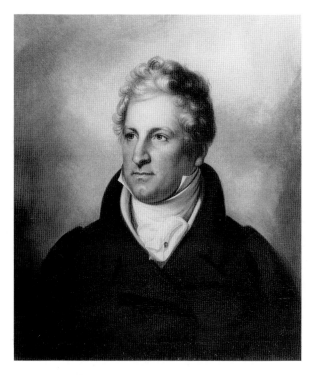

REMBRANDT PEALE. *Philip Hone*. c.1823-26. Oil on canvas, 30¼ × 25″. The New-York Historical Society

SHOBAL VAIL CLEVENGER (ATT.). *Samuel Ward*. c. 1838. Marble, height 29″. Collection of the Newport Historical Society, Rhode Island

also merchants. Reflecting a shift in the economic and social profile of the American collector that was not limited to New York or Boston, all three men acquired their own fortunes rather than inheriting them. They did not have distinguished family trees, and their educational backgrounds were limited in comparison to those who preceded them. Philip Hone, for example, was the son of a joiner of limited means. At sixteen he went to work for an elder brother in the auction business and became a partner three years later. The firm became one of the most profitable in New York, and Hone was able to retire in 1821 at forty years of age. After a tour of Europe, he settled with his family in a fine house on Broadway overlooking City Hall Park, where he kept his art collection. His interest in art was subsidiary to his activities in public affairs, his busy involvement in numerous social clubs, and the careful recording of New York life in his diary.[100]

As with Philip Hone, Samuel Ward did not inherit wealth. Ward's father, also named Samuel, was descended from a governor of Rhode Island but a failure at business. The younger Samuel received a common-school education, and, as the family's income was insufficient to pay for college, he began work as a clerk in the distinguished New York banking house of Prime and Sands at the age of fourteen. Just eight years later, he became a partner in the bank, which was then renamed Prime, Ward and King. Ward was a successful and prominent

THOMAS COLE. *The Voyage of Life: Childhood.* 1839-40. Oil on canvas, 52 × 78″.
Munson-Williams-Proctor Institute Museum of Art, Utica, New York

member of the banking community throughout his life, but after the death of his wife in 1824 his character changed. He gave up smoking, became a devout churchgoer, frowned on fashionable entertainment, and became an active supporter of educational and religious causes. He helped found New York University (then called the University of the City of New York) and in 1836 became the first president of the New York City Temperance Society.[101]

In 1826, Ward bought a piece of land at the corner of Broadway and Bond streets that had reputedly once been part of a farm owned over the years by de Peysters, Kips, and other well-to-do families. He sold off smaller plots, including one to Philip Hone, to help subsidize the purchase. Like Reed, Ward engaged Isaac G. Pearson, in 1831, to build his house at 16 Bond Street, and A. J. Davis provided drawings for the facade.[102] Ward's interest in art had commenced some years earlier, and, as was typical of the period, he first sought out works by European masters. His business partner Rufus Prime, traveling in Italy in 1829, advised him that it was more economical to buy works of art in the United States. "They cost but a trifle there," Prime assured him, "whilst in Europe, everybody knows their value and they bring a good price."[103]

THOMAS COLE. *The Voyage of Life: Youth.* 1840. Oil on canvas, 52½ × 78½″.
Munson-Williams-Proctor Institute Museum of Art, Utica, New York

Like Philip Hone and Samuel Ward, Luman Reed came from a modest family of limited means. As we have seen, he had little formal education and made his own fortune in business. His financial success enabled him to reduce his business activity and develop an interest in the arts, including music and drama as well as painting. To varying degrees, Reed and his self-made contemporaries demonstrated a collecting emphasis that differed from that of most of the collectors of the preceding generation.

For Jefferson and Bowdoin, it was a mark of taste and distinction to own casts after classical sculpture and copies of old master paintings. It was such works that appeared on Jefferson's wish list for his personal collection. The copies demonstrated exceptional achievement and could serve as ideal models. John Vanderlyn echoed the attitude that motivated Jefferson in his collecting when he wrote that, in the development of public collections, the acquisition of "copies . . . would be infinitely preferable in every respect, to originals of inferior masters. They would in exhibiting the various excellencies, which respectfully distinguish each of the masters, serve as a comparison to the student and lover of the art."[104]

American collectors of the 1820s and 1830s like Hone and, to a lesser extent, Reed continued to buy original

THOMAS COLE. *The Voyage of Life: Manhood.* 1840. Oil on canvas, 52 × 78″.
Munson-Williams-Proctor Institute Museum of Art, Utica, New York

European old master paintings and copies of unattainable masterpieces, and extolled their teaching value. The catalogue of Hone's collection includes several works of art annotated with the names of both the artist and the copyist. His diary recorded that, like Thomas Jefferson, he admired the work of Salvator Rosa and bought copies of his paintings.[105] On occasion, Reed, who did not go abroad, partly due to his active business and partly because he was not convinced it was essential to his cultural education, felt obliged to use copies to inform himself about European artists and works. "I want you to copy the likeness of Claude in the Louvre. I want the portrait to hang up," Reed wrote to George Flagg during the artist's trip abroad. "I also want you to make for me drawings in Crayon of three of the best antique statues in the Louvre."[106]

Both Hone and Reed, however, emphasized the value of original works of art, European and American, when acquiring them for their collections to a degree that Jefferson and Bowdoin had not done. It is ironic that, at the same time that collectors began to cherish original works of art for their intrinsic aesthetic value, the authenticity of what was available for purchase was coming into question. A review of an exhibition of old masters that appeared in the *Knickerbocker Magazine* in 1835 voiced doubts about the works being offered for sale in the

THOMAS COLE. *The Voyage of Life: Old Age*. 1840. Oil on canvas, 51¾ × 78¼".
Munson-Williams-Proctor Institute Museum of Art, Utica, New York

United States that were "presented as 'undoubted originals' by various celebrated old masters." The critic wondered why people continued to be seduced by these claims in spite of the "extreme difficulty of establishing the paternity of a painting after the lapse of one or two hundred years, and the still greater improbability that works of such immense value as originals by great masters bear in Europe, should come to the United States begging for a purchaser." By 1855, initial doubts had clearly been confirmed. Both those who sold so-called old masters and those who bought them were regarded with contempt. "A gentleman who could not be taken in by a horse-jockey, and who would not even buy a pig in a poke, will yet suffer himself to be cheated by a picture-vender," lamented a writer describing picture-buying trends in the *Crayon*.[107]

The Hone collection, much of which was sold at auction in 1852, included more than 125 paintings and drawings, as well as prints, enamels, statues, and medals. Only about one-quarter of the paintings were by contemporary artists, both European and American. But while works by contemporary artists were comparatively few in Philip Hone's collection, it was those works that he valued most. In 1834, William Dunlap requested that Hone furnish him with a catalogue of his collection so that he could include it in his forthcoming book. Hone

provided Dunlap with a list of about twenty-five works, all "of artists now living, and I do not know of a finer collection of modern pictures," the collector asserted proudly. "I have several old pictures, some of which are dignified by the names of celebrated painters," he continued, "but I do not esteem them sufficiently to induce me to furnish you with a catalogue."[108] William Dunlap may have found these works less distinguished than others of the period; he merely printed the list of works that Hone sent him without commenting on the quality of the collection, which he did in the case of such other collectors as Robert Gilmor of Baltimore and Luman Reed. By 1845, the Hone collection continued to be recognized, primarily for the works by modern artists that it contained, but it was judged with only modest enthusiasm: "The collection of Philip Hone, esq., . . . comprises one or two of the happiest efforts of [Charles] Leslie and [Gilbert] Stuart Newton, and a fair representation of American art by Weir, Cole, Dunlap, Morse, and others."[109]

Samuel Ward's collection of art was not as well known as that of Philip Hone, in spite of the fact that Ward, like Reed, installed a picture gallery in his New York house.[110] Ward's name is not mentioned in Dunlap's concluding chapter about early collections of paintings that contributed to the "Rise of the Arts of Design in the United States." Samuel Ward inherited some family portraits, including two of his ancestor Governor Richard Ward, which were then attributed to John Smibert and John Singleton Copley. A portion of the paintings that hung in his gallery were copies that were purchased for him abroad, and some contemporary European paintings were probably included as well. A "Magdalen" and a "Dying Hercules," along with paintings by such contemporary artists as Robert Walter Weir and Charles Robert Leslie, were recorded in his collection.[111] Like Reed, therefore, Ward gathered both European paintings and contemporary American art, but he did not exhibit such a profound and continuous support for the latter.

Undoubtedly, Samuel Ward's most important commission of contemporary art was for a series of four paintings to be executed by Thomas Cole entitled *The Voyage of Life* (Munson-Williams-Proctor Institute, Utica, New York). "I have received a noble commission from Mr. Samuel Ward, to paint a series of pictures, the plan of which I conceived several years since, entitled The Voyage of Life," Cole recorded in his diary on March 24, 1839. "I sincerely hope that I shall be able to execute the work in a manner worthy of Mr. Ward's liberality, and honourable to myself." It is likely that Ward's interest in supporting such a project from the hand of Thomas Cole was inspired by Luman Reed's earlier commission from the same artist of *The Course of Empire. The Voyage of Life* was not completed during the patron's lifetime. "There would seem almost a fatality in these commissions. Mr. Reed died without seeing his series completed," wrote Cole in his diary, and "Mr. Ward died soon after his was commenced."[112]

While Reed sponsored American artists to further the cultural development of the nation, the primary purpose of Ward's art collection seems to have been to enhance the private education of his children. He was determined to provide them with the best teachers and other resources for learning that he had lacked in his own youth. There is no record of his providing public access to his gallery. Ward's neighbor Philip Hone was more impressed by the quality of Ward's library, which he termed "one of the finest . . . in the City," than he was by his collection of art.[113]

Ward's austere personal character may have contributed to the diminished acquaintance with, and, therefore, recognition of, his collection. He disdained all kinds of fashionable entertainments and discouraged his family from indulging in social pleasures. Ward rarely entertained at his home, and his contemporaries, therefore, had little opportunity to view his collection. Philip Hone suggested that Ward's strict and joyless attitudes did not just diminish the reputation of his collection. "His own habits were subjected to a system of government too rigid for his constitution," wrote Hone on the day of Ward's death. "He became all of a sudden a total abstinence man at a time of life when the experiment was dangerous, and drank nothing but water, when, in my Judgement a moderate use of the good wine which he had in his cellar would have been more congenial to his health."[114]

Philip Hone was well acquainted with prominent collectors and collections of American and European art outside of New York. "In the course of this visit [to Boston]," he wrote in an 1828 diary entry, "I have seen nearly all the fine Pictures in the private collections." He mentioned particularly those belonging to Harrison Gray Otis, Thomas Handasyd Perkins, and Charles Codman, who had "no productions of living artists but a splendid Gallery of ancient paintings, many of which are originals of great artists."[115] Robert Gilmor, of Baltimore, who collected works by both European and American artists, dined frequently at Philip Hone's house when he visited New York to view exhibitions at the National Academy of Design. When Philip Hone traveled to Baltimore, he attended a party at Gilmor's house which he thoroughly enjoyed. "This Gentleman lives in handsome style," wrote Hone, "nobody in America gives better Dinners, or more exquisite Wines. His collection of Pictures is very fine and his House is filled with specimens of the fine arts, and objects of Taste & Virtue." Hone was a longtime friend of John Trumbull, who had installed his paintings in a gallery at Yale University in New Haven in 1832. Through Thomas Cole, who was his favorite painter, Hone certainly knew of Daniel Wadsworth's collection in Hartford.[116] It is clear that Luman Reed and Philip Hone were acquaintances, if not friends. They were both nonartist members of the National Academy of Design, and they shared numerous friends, including Washington Irving and Thomas Cole. At a dinner at the City Hotel honoring James Brown, the returning American minister to France, Philip Hone delivered a toast to the "Fine Arts," saying that "Republican simplicity is not opposed to Taste and Refinement," and Reed certainly would have raised his glass to join him.[117]

THE LUMAN REED COLLECTION

Luman Reed's collection reveals a taste for the fine arts that was different in emphasis from that of Philip Hone or the preceding generation of collectors. It reflected independent thinking and a new measure of cultural assurance. While it took Thomas Jefferson several decades to develop an appreciation for original works of art, almost from his first acquisition Luman Reed preferred to have original paintings rather than copies of old masters. Only a small portion of Jefferson's collection was devoted to original works by living artists, and of those just a handful were by Americans. By contrast, contemporary paintings by American artists dominated Reed's collection.

The European works that remained in Luman Reed's collection provide insights into his stylistic preferences, his fondness for specific subjects, and his concept of originality. As in his collection of engravings, paintings with Italian and Netherlandish school attributions predominated. They constituted fourteen out of a total of eighteen works. John Burnet's *Practical Treatise on Painting,* which Reed had read appreciatively, extolled the specific virtues of these two schools. "Painters should go to the Dutch school to learn the art of painting, as they would go to a grammar school to learn languages," Burnet advised. "They must go to Italy to learn the higher branches of knowledge."[118] It was the fine "finish" of the Dutch style of painting, with its attention to the clear definition of every detail and its arrangement of forms to fill the canvas, that appealed to Reed's sensibility.

The remaining four European works in Reed's collections were by English or Scottish artists. These rustic genre and topographical landscape scenes by George Morland and Andrew Richardson employed Reed's favorite subjects for paintings, a preference that reflected the contemporary romantic idealization of the rural classes and preoccupation with nature. Romantic ideas about the virtues of country folk, as well as his own rural upbringing, also shaped Reed's American paintings collection. For example, the entrepreneurial independence of the itinerant peddler is represented favorably in Asher B. Durand's *The Pedlar* (1836; Plate 20), and William Sidney Mount extols the finely tuned bargaining instincts of the farmer in *Farmer's Bargaining* (1835; Plate 32). No examples of contemporary French painting were included, undoubtedly because Reed found French art to be ostentatious and contrived. Writing to George Flagg when the young artist was studying in Paris, Reed said, "I am much pleased to hear you denounce the French school of Painting, pure simple nature is the school after all."[119]

Reed's commendation of nature as the artist's primary guide and his liking for recognizable landscape settings were encouraged by the artists and writers of the Sketch Club. The *Talisman* gift book series, written and illustrated by several Sketch Club members, contained numerous picturesque illustrations of landscape sites to accompany richly detailed and romantic verbal descriptions of their evocative beauty. The New Jersey shores of the Hudson River, opposite New York City, according to one writer for the *Talisman,* presented a "singularly picturesque outline of indented coves and wood-fringed promontories, with a bold background of heights." In the autumn, the lush and various hues gave the stretch of the shore an appearance so beautiful that "the painter throws down his brush, and the poet abandons his vocabulary in despair."[120]

Reed did not purchase any plaster casts after antique sculpture to exhibit in his gallery, and original paintings rather than copies after the old masters predominated in his European holdings. While he sometimes admired copies in other collections, he preferred to show original paintings in his own gallery. William Sidney Mount confirmed this preference when he wrote approvingly to Reed that "I think your plan of getting original pictures a good one and I wish you success with all my heart."[121] Using their nineteenth-century attributions, only two works were clearly purchased as traditional copies of old master paintings. These were the *Saint Mary Magdalen Reading* (Plate 46) after Correggio and the *Madonna and Child* (Plate 34) after Raphael.[122] These copies were valued at $200 and $150 respectively in Reed's inventory, which was not much less than the highest values assigned to such old master originals as Jan Fyt's *The Huntsman's Tent* (Plate 38) and Jacob Marrel's *Wreath of Flowers* (Plate 43), each estimated at $250. It is unclear whether Luman Reed bought some of the minor European

works, such as the *Interior—Dutch Apothecary Shop* (Plate 42), as acknowledged nineteenth-century pastiches produced for the tourist trade or as original works whose subjects suited his fancy.

The subjects of the European paintings were diverse and reflect no special focus on Reed's part, but rather a sampling of traditional imagery. The works provided the collector authentic examples of the various subjects of art that Sir Joshua Reynolds organized into a hierarchical scheme in his *Discourses*.[123] They included religious compositions, mythological themes, portrait, landscape, genre, game, and still-life subjects. Many probably struck Reed's untutored eye as intriguingly old and pleasing, and, as a neophyte collector, his choices were no doubt guided by the persuasive dealer Michael Paff, who was renowned for "transforming many a dark mass of undefinable objects into the sunlit Landscape of Ruisdael or Poussin, and recovering from the thick veil of antiquated varnish the graceful forms of Correggio and the rich tints of Guido [Reni]."[124]

The thirty-four extant paintings by American artists inventoried in Luman Reed's gallery after his death were, with one exception, the work of four artists: Thomas Cole, Asher B. Durand, William Sidney Mount, and George Whiting Flagg. The motivating force that guided Reed's patronage of these men was a belief in the capability of American artists to produce works equal, if not superior, to those of their European forebears. Reed wanted the country to be as self-reliant in art as he thought it should be in commerce, where, for example, he opposed protective tariffs. George Flagg wrote to Reed from Europe that he was on his way to Rome and expected to spend only a short time viewing the works of Raphael and Michelangelo. Full of youthful disdain for the accomplishments of the great masters, he asserted that he considered them "so much trash." While Reed may not have completely agreed with Flagg's artistic judgment, he liked his independent spirit.[125] He was proud that after all his exposure to the seductive and awesome accomplishments of the old masters, Flagg could say that America was still the place for him and that he wanted "no better nature than we have to study from."[126] Expressing his strong and competitive nationalistic feelings, Reed exhorted American artists to be independent: "Let us make something of ourselves out of our own materials & we shall then be independent of others. It is all nonsense to say that we have not got the materials."[127]

It was Thomas Cole, often considered the founder of the Hudson River school of landscape painting, who first attracted Luman Reed to the work of contemporary American artists. Louis L. Noble, Cole's biographer, judged their meeting to be "one of the most fortunate incidents of his [Cole's] life; an incident which may be called the harbinger of a friendship which influenced his success, as a painter, more than any other." Noble described a silent encounter at No. 1 Wall Street in the rooms that Cole used for painting and exhibition. "There came in, one day, a person in the decline of life," he wrote, "[who] took rather a hasty turn round the room, serving for a gallery, and went out without a word." While the place may have been accurate, the rest of the story seems doubtful.[128] At the time, Reed was not yet fifty and was in good health, leading an active life. Moreover, he was always described as a gracious and friendly man who, with his interest in art already formed, surely would have introduced himself to the artist and engaged in conversation.

It is not known exactly how Reed was introduced to Cole, soon after the artist's return from Europe, but it is known that Reed's first commission was *Italian Scene. Composition* (Plate 1), painted during the summer of 1833,

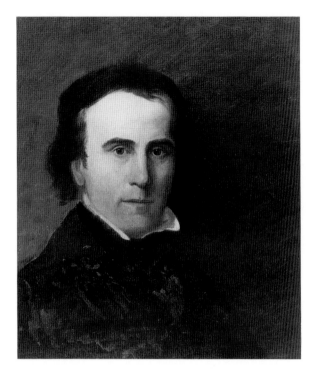

and it was followed by nine more landscapes. Like the Italian scene, the majority of these landscapes were imaginative compositions rather than realistic views. They were not representations based on sketches made of a specific site but the combination of direct experience and artistic imagination. Cole, an artist with a poetic and literary sensibility, preferred this branch of landscape art to the more prosaic topographical view because it emphasized essence rather than surface. "A vivid picture of any object in the mind's eye," in his opinion, was "worth a hundred finished sketches made on the spot."[129] Cole's admiration for the beauty of old-world landscapes and their poetic and historical associations was expressed in these compositions. Whether suffused with moonlight or under the bright midday sun, the Italian *campagna,* with its evocative ruins, is portrayed as Cole described it in his *Essay on American Scenery,* published in 1836. For him, "the glorious scenes of the old world," with its "vestiges of antiquity, whose associations so strongly affect the mind," constituted the "ground which has been the great theatre of human events—those mountains, woods, and streams, made sacred in our minds by heroic deeds and immortal song—over which time and genius have suspended an imperishable halo."[130] Reed often reiterated his liking for more direct transcriptions of nature, but his inclusion of these historical landscape compositions in his collection indicates that he also admired the more romantic and poetic branch of landscape art. He had tried to commission a work from the premier American romantic landscape artist, Washington Allston, but the commission was never fulfilled.[131]

In Luman Reed's collection there are also three topographical landscapes by Thomas Cole, all sunset scenes

(Plates 2, 4, and 5). Cole considered American skies equal if not superior in magnificence to those in Italy which he so admired. During all seasons and atmospheric conditions, the twilight hours held a special magic for Cole. In Italy, "at sunset the serene arch is filled with alchymy that transmutes mountains, and streams, and temples, into living gold. But the American summer never passes without many sunsets that might vie with the Italian, and many still more gorgeous—that seem peculiar to this clime."[132] As William Cullen Bryant had done in his essay *The American Landscape* (1830), Cole sought out the particular beauties of the scenery and alluded to its special associative powers. Both artist and writer were immersed in the contemporary view of nature as the direct evidence of spirit, and the American landscape, untouched as it was by the hand of civilization, held particular possibilities for the revelation of God's word. As a fellow member in the Sketch Club and friend of these two men, Luman Reed was undoubtedly aware of the transcendental view of nature as a reflection of God's creation and of the claim that America was the new Eden.

The most complex composition in Reed's collection, both aesthetically and symbolically, was a series of five paintings entitled *The Course of Empire* (Plates 6–10), which was begun in 1833 and was not completed until after Reed had died, in 1836. The series possessed an intricate iconography that explored the relationship between nature and civilization. While the work was in process, the correspondence between artist and patron

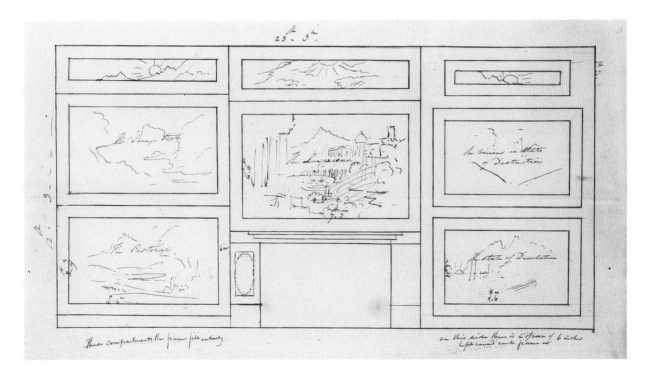

Drawing by Thomas Cole, showing his plan for the installation of the *The Course of Empire*. 1833. Pen and brown ink over pencil, 10½ × 12¾". Detroit Institute of Arts. Founder's Society Purchase, William H. Murphy Fund

revealed that Reed encouraged Cole to be his own guide. In contrast to such other collectors of contemporary American painting as Robert Gilmor, Reed did not dictate the selection of subjects or the manner of their execution. Again, it was probably Reed's belief in the importance of independence in the fulfillment of goals that allowed him to give Cole free rein. Fully appreciative of this rare, unintrusive support, Cole could barely contain his excitement at the prospect of undertaking a project that he "had been cherishing for several years" but for which he was unable to get support. "Your liberality has opened an opportunity," he wrote to Reed, "& I trust that nothing will now prevent me from completing what I have so long desired."[133]

One of the reasons that Cole had not been able to get support for these historical landscape compositions from such early patrons as Philip Hone, Gulian Verplanck, Daniel Wadsworth, or Robert Gilmor was that informal views of recognizable landscape settings were more popular.[134] Expressing an attitude that pervaded the periodical literature, Gilmor said simply, "I prefer real American scenes to compositions, leaving the distribution of light, choice of atmosphere and clouds, and in short all that is to render its natural effect as pleasing and spirited as the artist can feel permitted to do, without violation of its truth." Reed shared this view. He, too, preferred informal and direct transcriptions of recognizable subject matter in all genres of painting. In his opinion, the artist's goal was to minimize dramatic effects in order to "bring out nature itself to view." For him it was not the subject but the execution of a work of art that determined its quality. "A cat well painted is better than a venus badly done," Reed asserted.[135] Despite his own preference for realistic representations of familiar subjects, however, he undertook to support Cole in the painting of the most ambitious ideal landscape series of its day. Luman Reed believed in providing artists with the means of accomplishing the goals that they set for themselves.

Already in 1833, Cole could envision his *Course of Empire* installed in the front room of Luman Reed's third-floor gallery. In a letter to him, Cole enclosed an installation diagram. It shows schematic renderings of the five paintings hung in an asymmetrical configuration around the mantelpiece. It shows, in addition, three horizontal pictures above the series representing the progress of a day from sunrise to high noon to sunset. But this was not all. Cole mentioned that he would supply two more paintings for that wall, and then "to fill the other side of the Room & the ends will require 18 or 20 pictures, five of which will be larger than your Italian Scene." Luman Reed responded with characteristic tact to the proposal of this grand scheme for filling one entire room of his two-room space exclusively with Cole's work. He did not say "no." He did commission the five paintings and offered to discuss the additional works when he had the pleasure of seeing Cole again.[136]

In his relationship with the artist, Luman Reed often provided moral support and encouragement when Cole lost courage and became overwhelmed by the tasks he undertook. *The Course of Empire,* particularly the central painting, was daunting in the magnitude of its conception. *The Consummation* (Plate 8), with its dense and intricate combination of architecture, sculpture, figures, and animals, in a barely visible landscape setting, tested every facet of this self-trained artist's technique. It often caused him to doubt that the finished painting could live up to his expectations. "The picture in my mind's eye may be sadly dimmed by its embodyment on canvass," he wrote. "I am in great fear that this picture [*Consummation*] which I hoped would be my best will fall far short of

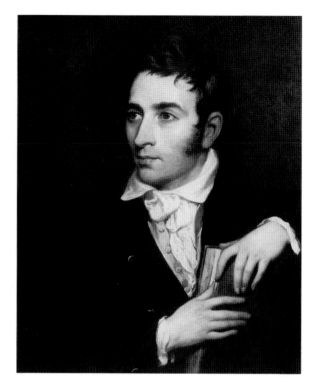

John Trumbull. *Asher B. Durand*. 1826. Oil on wood,
20 × 15⅞″. The Museums at Stony Brook, New York.
Gift of Mr. and Mrs. Ward Melville, 1958

my intentions & perhaps your expectations." Luman Reed went to Catskill in November 1835 to observe progress on the picture and to lend support to Cole's flagging confidence. On his return home, Reed wrote him that "the picture you are engaged with more than meets my expectations. . . . I consider your success in this undertaking as sure."[137]

Reed did on occasion advise Cole about ways of exposing his art to the public and the press. He disliked publicity himself and made efforts on several occasions to keep his own name out of the papers. When the *New York Evening Star* gave advance notice of Cole's work on *The Course of Empire,* saying that "Mr. Cole intends to exhibit three or four glorious landscapes, which will utterly astonish and amaze all the New York connoisseurs," and that Reed might prevent their exhibit in order to show them in his gallery first, Reed became angry. He was angered by the injury to Cole more than to himself. He felt that the article raised expectations so high that the public could only be disappointed. He also judged it improper to show the series in incomplete form. In his view, "merit is often overlooked when expectation is disappointed." Cole responded that he agreed with Reed's judgment "as to the effect of such articles on the public mind" but was more distressed that Reed "should be brought before the public in such an unwarrantable manner."[138]

In his relationship with Asher B. Durand, Luman Reed offered both inspiration and support. He encouraged Durand, who was older but less established than Cole, to expand his vocabulary. It was Reed's commission to Durand, in March 1835, to paint the portraits of the seven presidents who had served the United States to that

date (Plates 12–18) that launched his career as a painter.[139] Prior to that time, although Durand had begun to paint, his reputation rested principally upon his work in engraving, ranging from banknotes to distinguished copies of such well-known paintings as John Trumbull's *Declaration of Independence*.

Unlike the *Course of Empire* commission, the idea for the presidential portraits was conceived by Reed rather than by the artist. Reed wanted a portrait taken from life of President Andrew Jackson and asked Durand to accomplish it when he was in Washington working on another portrait. The thought of commissioning a complete set of the presidents followed quickly on the heels of this initial portrait. "I . . . feel much gratified that you are going to bring me the portrait of our President & distinguished fellow Citizen," wrote Reed to Durand. "If possible to get that of the Hon. John Quincy Adams do get it for me. Jefferson I must have also . . . Monroe if to be had in Washington from Stuart do me the favor to take also. Madison & Washington you have . . . I forgot John Adams I must have that too."[140]

The motivation for this commission was clear in Luman Reed's mind. The portraits were to commemorate national heroes and their achievements for posterity. The didactic purpose of the portraits reflects the continuation of the eighteenth-century view of the importance of the portrait as a moralizing instrument. Reed intended "to make presents of them to one of our publick institutions of science and Natural History," and he did give them to the United States Naval Lyceum in Brooklyn while keeping a second set in his gallery. He wrote to the president of the Brooklyn lyceum, the first of the navy's museums for the education of naval officers, that he felt "honored in their reception by an institution . . . whose character is so truly national."[141] In keeping with his patriotic goal was Reed's desire to produce the best portraits that money could buy. He wanted original portraits from life of the two presidents who were still living, Jackson and John Quincy Adams, and copies of the best surviving original portraits of the other five. He went to much trouble to secure adequate sittings for Durand so that he could produce excellent likenesses. Reed also wanted the copies taken from the best of Gilbert Stuart's originals and would not settle for anything less. He agreed with Durand who suggested that, although other portraits of Monroe were available, "if the very original of Stuart can be had, and that at Baltimore is doubtless the one, I should prefer on my own part."[142]

The commission engendered a feeling of historical responsibility in Reed. He engaged Durand, the American artist whom he considered most qualified for the job, and offered unstinting support in terms of time and money to enable him to achieve the best likenesses possible. He even felt compelled to document precisely for the records of the lyceum the sources of all the images.[143]

During the eight months that Durand spent in producing the presidential portraits, Luman Reed offered frequent praise and support. Just two months after Durand embarked upon this, his first major commission as a painter, Reed wrote to him confidently, "you are now, in my opinion, fairly under way in your new profession, and I believe your success is certain." He accompanied the artist to Boston to help him gain access to the best originals and make introductions. According to Durand, "Mr. Reed . . . seems to think of nothing else while here but to promote my best interests." After Reed left him in Boston, Durand acknowledged that it was Reed's strong encouragement that gave him confidence in his own talents.[144]

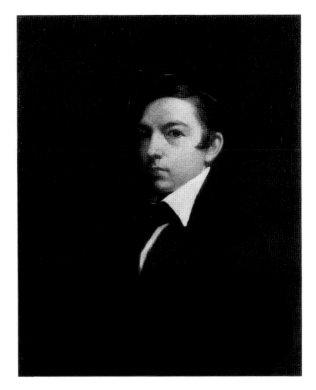

George Flagg. *Self-portrait*. c. 1833. Oil on canvas,
30 × 24″. Museum of the City of New York.
Bequest of Florida Friebus

Reed enabled Durand to test his artistic skills further by purchasing from him two genre scenes. In this case, the subjects for the *Peter Stuyvesant and the Trumpeter* (Plate 19) and *The Pedlar* (Plate 20) were chosen by the artist, not the patron.[145] Reed must have been delighted with the selection; for Durand chose scenes based on New York history and contemporary American life. The historical subject depicted New York's Dutch governor in a rage that propelled him to recapture New Amsterdam from the Swedes and secure it for the Netherlands. This was a heroic moment in New York's past, and it had been dramatized in *A History of New York, from the Beginning of the World to the End of the Dutch Dynasty* (1809), by New York's preeminent writer, Washington Irving. It was Irving's description of the scene that served as the literary source for Durand's image. Irving was a frequent visitor to Reed's gallery and took an interest in the progress that the American artists were making in producing paintings for it.[146] The second subject, an itinerant peddler exhibiting his wares to a family in a happy domestic scene, was a romantic idealization of contemporary rural life. In Reed's view, it was just this independent commercial spirit that gave rise to the prosperity, strength, and well-being of the United States. Like the presidential portraits, Durand's genre scenes commemorated the spirit of the new nation and thereby met Reed's patriotic goals for his collection of art.

The inventory of Luman Reed's estate shows that George W. Flagg was the artist responsible for the greatest number of paintings in the collection, a predominance that does not necessarily reflect Reed's preference in painting. It was, instead, the result of an agreement between the two men. When, in 1834, Reed was introduced

to Flagg's work, probably at the National Academy of Design exhibit of that year, Flagg was just seventeen years old. He was the nephew of the respected American painter Washington Allston, with whom he studied from 1831 to 1833.[147] One of the three paintings that Flagg exhibited, the *Murder of the Princes in the Tower* (Plate 21), was the first picture Reed purchased from the artist. Almost immediately, he offered Flagg a most generous form of support. He would completely subsidize the artist's living and educational expenses (including European travel) for a period of seven years. In return, Flagg was obliged to do nothing more than give Reed the paintings he produced during that time. He was allowed, however, to accept lucrative portrait commissions from other patrons. Reed outlined the terms carefully, but added gently that he did not consider them binding by law, but "kept up by mutual attachment & friendship." Reed did develop a close relationship with Flagg, serving as his sponsor, mentor, and, virtually, adoptive father.[148] After Reed's death, Flagg failed to live up to Reed's expectations.

With Reed's support, Flagg set off for Europe in October 1834 and stayed for a period of eight months, traveling to England, France, and Italy. Reed wanted the promising young artist to have every opportunity to improve his craft through study of the old masters and introduction to the contemporary European painters of note. In warnings that reflected his own artistic bias, Reed reminded Flagg that he had left America "with a good idea of the general tone of color & I hope it may never be corrupted." He said it was fine to admire and study the work of Paolo Veronese and Titian, which were Flagg's favorites, but more as an incentive to rival their achievements than to copy their means. He wanted Flagg to improve his "execution" so that it might be "as good as theirs some day or other." During the European trip, Flagg wrote Reed a number of times asking him to come abroad and join him. "You know that they wont allow that a man has any taste in America until he has been in Europe," Flagg said as a means of provoking the reluctant collector. But he went on to assure Reed that he did not share that attitude. "The people here are just as stupid as we are," he wrote bluntly, "and I do not know but a little more so."[149] Surely, one thinks, Reed could have joined his young friend had he been passionate to do so. In addition to the demands of work and family, Reed may have chosen not to travel to Europe for fear of corrupting his own native-grown attitudes about art.

All of the paintings that Flagg produced for Reed, both in Europe and after his return home, were figure subjects. Several were large compositions based on historical events interpreted through literary sources. The *Murder of the Princes in the Tower* (Plate 21) and *Falstaff Playing King* (Plate 22) were taken from Shakespearean plays. *Lady Jane Grey Preparing for Execution* (Plate 24) depicted a subject from British history.[150] A niece of Henry VIII, Lady Jane (1537–1553) was illegally crowned queen of England by her ambitious father-in-law, the duke of Northumberland, after the death of Edward VI (1536–1553). She reigned for nine days before her execution by opposing forces. Flagg's image described the courage of a seventeen-year-old woman in the face of a death that was the undeserved result of political machinations. Subjects from history conveying lessons in moral conduct were the special forte of Flagg's uncle Washington Allston and were considered subjects of the highest rank in Sir Joshua Reynolds's hierarchy of suitable topics for painters. In attempting these complex compositions, Flagg demonstrated his ambition to rank with the old masters. Reed supported him in this effort, partly out of respect for Reynolds's ideas, although this line of painting would not have been his own choice.

It was the more informal and realistic subjects by Flagg that appealed to Reed's taste. Flagg painted a number of small-scale genre subjects, including *The Match Girl* (Plate 26), a portrait of a London street urchin, taken from life. In the tradition of Dutch genre painting, the girl is rendered with sympathetic accuracy, right down to the details of her shoes, with worn through toes and missing laces. Reflecting the nineteenth-century admiration for naturalistic rendering and amply filled compositions, Reed wrote to Flagg, "I hope you will not turn off a picture until the work is masterly executed; one picture finished in that way will be of more service to you than fifty that lack detail."[151] It was this same appreciation for "finish" that made Reed delight in Jan Fyt's game picture, although he found the subject distasteful.

The match girl in Flagg's painting is seated in a crumbling stone setting, signifying a dilapidated part of town. In her hand she clutches the bunch of matches that is her meal ticket. More than the high-blown moral subjects from Shakespeare, it was this image of the London street seller that Reed considered "the best by far of anything he [Flagg] has done."[152] The tight finish in the execution of the work suited Reed's taste, and he was, no doubt, sympathetic to the moral sentiment that the image conveys. During the Jacksonian period, publications calling for reform in the nurture and education of children abounded. John Hall, an American writer on education, asserted that a "current of popular treatises on this subject . . . almost daily issues from the press."[153] Reed was surely aware of the current focus on issues of child raising, and the topicality of this image probably held special appeal for him. His correspondence with his daughter Catharine reflects his strong and concerned role as a parent. He would have been sensitive to the problems of urban children who were not blessed with parental care and support and were left to make their own way in the streets. Perhaps Reed also considered this image to be a criticism of the English problem of child labor. As such, it would have appealed to his competitive national spirit. In June 1835, Reed wrote to Durand saying that "my young friend Flagg has returned from Europe brim full of enthusiasm & says America is the place [for] him & wants no better nature than we have to study from." And he concluded, in an understated way, "now I like this."[154]

While William Sidney Mount also painted portraits, his reputation rests on rural genre subjects, the branch of art that was Luman Reed's favorite. *The Rustic Dance After a Sleigh Ride* (1830, Museum of Fine Arts, Boston) was one of Mount's first compositions in that line, and he continued to produce such narrative scenes until his death in 1868. Reed bought only two paintings from Mount, *Undutiful Boys* (Plate 33) and *Farmer's Bargaining* (Plate 32), but, because of his special affection for the artist's work, he wanted many more. "I pride myself on having now two of your Pictures & what I consider your best productions," he told the artist in December 1835, "and hope yet to have more."[155] At the time, Mount had other commitments to fulfill and was unable to supply another example of his work before Reed's death.

When Reed received *Farmer's Bargaining* (Plate 32), which he referred to as the "Bargain," he declared that he was "very much pleased" with the result.[156] Mount depicted a familiar rural scene that includes two farmers and a horse posed in front of his family's farm at Stony Brook, New York. The painting shows the men whittling in apparent nonchalance but clearly engaged in an amicable but long debate over a fair price for the animal. A woman, the small figure in the distance at the left, is calling after them, and probably not for the first time. Mount's

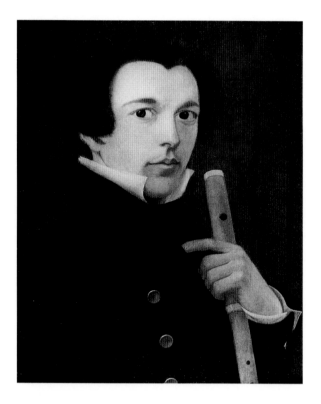

WILLIAM SIDNEY MOUNT. *Self-portrait with Flute.* 1828.
Oil on wood, 20 × 15⅞″.
The Museums at Stony Brook, New York.
Gift of Mr. and Mrs. Ward Melville, 1858

skill at telling a story through precise observation and representation of details is everywhere evident in this picture. It starts with the texture of the various materials depicted. Sleek and rough surfaces are carefully differentiated by Mount's inventively precise use of the materials of his art. Mount applied the same degree of exactitude to the illustration of his subject that he did to its execution. From the sagging roof of the shed to the pitchfork resting prominently against one of its support beams to the array of discarded corn husks, hay, and wood shavings dispersed upon the dry dirt ground, the artist presented an image of reality so convincing that the viewer almost senses he has been there. This ability to convey a shared familiarity was appreciated by the critics of the day. "This picture is true to nature," a newspaper writer observed, "and the oldest farmer is an old acquaintance of every beholder of the picture."[157] For Reed, convincing detail was critical to the success of a painting. "You must not forget the detail," he had written on another occasion, "a whole is worth in proportion as it possesses detail." The subject also, no doubt, appealed to Reed. It depicted honest American farmers engaged in competitive bargaining which, for Reed, was the backbone of economic prosperity. The subject was a national one in its commendation of Yankee ingenuity, and it confirmed the current romantic idealization of the essential morality of the rural classes. Reed recognized the implicit humor that Mount wanted to convey in the feigned nonchalance of the two farmers, and he liked it. "The subject 'comick' is a pleasing one," he wrote to Mount, "I would rather laugh than cry any time."[158]

No sooner had Reed received this picture than he was looking forward to the next. *Undutiful Boys* (Plate 33) arrived just a few months later, and he was again pleased with the result. In the commission of this painting, however, Reed made specific demands of the artist. This was not customary for him, but it was the typical approach of other patrons of the period. First, Reed asked Mount to leave the work unvarnished. He felt that the "blending of the colors" maintained a "richness & a softness" that would be lost over time with the application of varnish.[159] Mount apparently complied to the request without objection. Next, Reed asked for an alteration in the composition of *Undutiful Boys*. He made it clear that Mount did not have to go along with his request. Just what he wanted to have changed is not known, but Mount did it, and Reed paid him an extra $50 above the original $250 price agreed upon for the picture. Reed was considerately aware that he might have "taxed" the "generosity" of the artist with this intrusion, and he expressed his strong gratitude for Mount's "willingness to gratify me in an alteration when the picture was good enough & perfectly satisfactory without." The finished product represented for Reed an American work of art that rivaled the best that Europe could produce. "I do not believe that Ostade or Teniers ever did anything better than some parts of this picture," he wrote, confirming again his personal preference for narrative subjects rendered in fine, naturalistic detail.[160]

While Cole, Durand, Flagg, and Mount were working on their individual commissions for Reed, he conceived of a collaborative project that would involve all of them in the decoration of his gallery. Two small doors opened into each of the two rooms in his double parlor, and two larger doors divided the two rooms. All six doors had recessed panels of various sizes. With the passion of a true collector, Reed resented the space that these doors eliminated for the hanging of art. "They make too much space," he complained, and to solve the problem he decided "to have them painted." Writing to William Sidney Mount in November 1835, he suggested that each of the four artists be responsible for the painting of one of the small doors. "Cole has one door, Durand one, Flagg one & you the other, the large Doors that divide the Rooms are also under consideration."[161]

Reed did not consider the painting of the doors as an elaborate commission with an intricate, iconographical program. He thought of it as a decorative project that would engage the talents of the artists he admired, bring them into congenial contact with one another and himself, and enhance the overall appearance of the gallery. His informal approach to the subject matter and style of painting that he wanted for the door panels was expressed in his correspondence with Mount. He thought the panels should not be "highly finished paintings but good sketches, a single figure, a head, a cat, hen and chickens." In other words, he expected simple subjects from everyday life painted in a free and uncomposed manner. For the small doors in the back room, he had a vague idea of "having statues painted," but said, "that is not entirely concluded upon as yet."[162]

Between November 1835 and the end of February 1836, working right in the gallery, George Flagg and Asher B. Durand completed their panels on each of the small doors in the front room. Durand also completed four panels on one of the large doors. Thomas Cole subsequently finished four panels for the other large door.[163] By May 4, 1836, Mount had still been unable to come to town to work on the doors. Just a few days later, Reed became ill and died within weeks. The panels for the gallery were, therefore, never completed. The painted panels were not listed in the inventory of Reed's estate, presumably because they were considered part of the building.

Some of them must have been removed from the doors later by members of the family, perhaps just before the sale of the house in 1844.

Fourteen of the original panels survive (see pages 119–20). Four panels for one of the large doors, *The Mullein Stalk, The Ruined Castle, Balloon Ascension,* and *Seascape with a Waterspout,* have been securely attributed to Thomas Cole.[164] In a letter to Cole, Reed identified the subjects of three panels completed by Durand. These were *Woman Churning Butter, School Let Out,* and *Blind Man's Bluff.* Reed mentioned a fourth subject, "farmers eating under a tree," which is lost.[165] Of the remaining seven surviving panels, the rustic subjects have been alternately attributed to Asher B. Durand and William Sidney Mount.[166]

The recent discovery of one of these panels, *Boy Riding a Horse,* has made it possible to attribute the others more accurately. With the original panels assembled at the New-York Historical Society, it became clear that the figure types, the use of color, the handling of brushwork, and other details in *Boy Riding a Horse* could be found in four of the other works: *Woodchopper, Man Reading at a Table, Haying Scene,* and *Barn Builders.* These four panels were certainly by the hand of a single artist. Recently, the horse depicted in *Boy Riding a Horse* was found to have a counterpart in the lower left corner of a large work by Asher B. Durand, called *Dance of the Haymakers,* or *The Morning Ride* (private collection), painted in 1851.[167] The horse depicted in the larger composition has the same pose as the horse in the panel painted fifteen years earlier. It is possible that both images were based on a lost sketch by Durand that served as a model for the difficult subject. Durand's foreshortening of the horse, particularly the graceful curve of the neck, in *Dance of the Haymakers* is more accomplished than in the panel painting. It reflects a mastery of perspective drawing that the artist had gained during the intervening years. At the center of the 1851 painting, there is a peasant also depicted astride a horse. The hat and the facial type of this figure compare closely to *Boy Riding a Horse.*

Boys Playing Marbles and *Boys Chasing a Pig* (the only horizontal panel) are most likely also the work of Durand, although the brushwork is more loosely handled than in his other panels. The panels that George Flagg completed for one of the small doors are lost. Because of prior commitments and a reluctance to leave Long Island for the city, William Sidney Mount did not have the chance to participate in painting the gallery doors before Luman Reed's death.[168]

In this collaborative commission, Reed allowed the artists the same independence that he generally offered in his individual commissions. He outlined his general conception but left the final decisions to them. Cole, for example, sketched out a grandiose idea for a series of panels relating to the cosmic scheme of nature. The conception ultimately expanded to include sixteen panels, many more than Reed had requested, and in no way followed the guidelines for informal sketches of down-to-earth subjects. Nevertheless, Reed did not reject the proposal outright. Instead, he gave it serious consideration and encouraged Cole to pursue the idea on a smaller scale. "The plan would please me as well as any thing & I think better than any that could be suggested," he wrote, "if the space was sufficient to carry it out."[169]

Luman Reed's art collection reflects the taste of a man in close contact with the cultural issues of his day. He inherited some eighteenth-century ideas about the didactic purpose of old master art, and these ideas influenced

ASHER BROWN DURAND. *Boy Riding a Horse*. 1836.
Oil on wood, 23¹⁵⁄₁₆ × 10¾″.
Collection Mr. and Mrs. Dual MacIntyre

ASHER BROWN DURAND. *Dance of the Haymakers* (detail).
1851. Oil on canvas, 36 × 54½″.
Private collection

the selection of European pictures that he retained in his collection. The small percentage of copies in his holdings demonstrated his preference for the inherent aesthetic quality of an original work of art and its unique capacity to develop an informed artistic eye. Only a handful of New York collectors shared this advanced view. Reed's contemporary American paintings, in their emphasis on landscape and genre subjects, were representative of the taste of his time. They reflected the nineteenth-century preference for naturalism, tempered by associative romantic ideas. The aesthetic quality of the American paintings in Reed's collection was exceptional, and this was recognized in the many contemporary published praises of the collection. The caliber of work that Reed acquired resulted from his liberal attitude toward the artists whom he sponsored. He neither second-guessed their ideas nor directed their stylistic approaches. What distinguished Reed more than anything else from the collectors of his time was his expansive vision. He believed firmly in the critical role of art in the future development of the nation. It was this vision that inspired him to offer unstinting support to the artists whom he patronized and to make his private art collection remarkably accessible to the public.

Cole and the other artists recognized their debt to a man who not only offered them generous financial support but moral support as well. Reed's belief in their ability to make the right choices and to execute their work well gave these developing artists in a still-new country the confidence they needed to reach their potential. Each of the artists expressed again and again the importance of Reed's liberal and unwavering encouragement of their work:

> I have this support in my labour that the person for whom I paint will look with an indulgent eye on the result.[170] —Thomas Cole, 1835

> His kindness and liberality towards me are without bounds, he is determined to make something of me . . . if ever I attain to any excellence in painting it will be more owing to him than any other cause.[171] —Asher B. Durand, 1835

> He was *indeed* a Father to me, ever ready to cheer me on.[172] —George W. Flagg, 1836

> How well he understood the feelings of the Artists.[173] —William Sidney Mount, 1836

In his support of these men, Luman Reed operated from a belief in the importance of artistic independence. His own self-confidence enabled him to trust the aesthetic judgments of the men he admired. His goal was to offer them the opportunity to improve their skills, to accomplish their highest artistic goals, and thereby to produce masterpieces of art that could rival European painting, past and present. He recognized that such independence required strong financial support, and he acted with liberal-minded generosity. In 1844, a fellow merchant, Thomas G. Cary of Boston, delivered a lecture at the Mercantile Library Association that was a tribute to the enlightened quality of Luman Reed's support for the arts. He said:

It was an act corresponding to what is called patronage in other countries; and yet it was not patronage. It was free from all claim of the irksome deference that is usually felt to be due to the patron. It was performed in the spirit which cordially acknowledged a full equivalent, in the work, for the price paid; and which leaves the spirit of the artist unshackled by dependence. It was the act, too, of one whose life, as I know, from personal acquaintance and observation, was in keeping with the spirit of it; and I avail myself of this opportunity to bear testimony to his worth, and to present his character for imitation.[174]

Samuel Ward and Jonathan Sturges were two of many collectors who imitated Reed's example in their support of contemporary American artists. While the *New-York Spectator* lamented at his death that "the arts have lost a true and valuable friend in Luman Reed," his collection survives to give witness to the importance of his contribution to the history of art and patronage in this country.[175]

THE LUMAN REED COLLECTION

PLATES

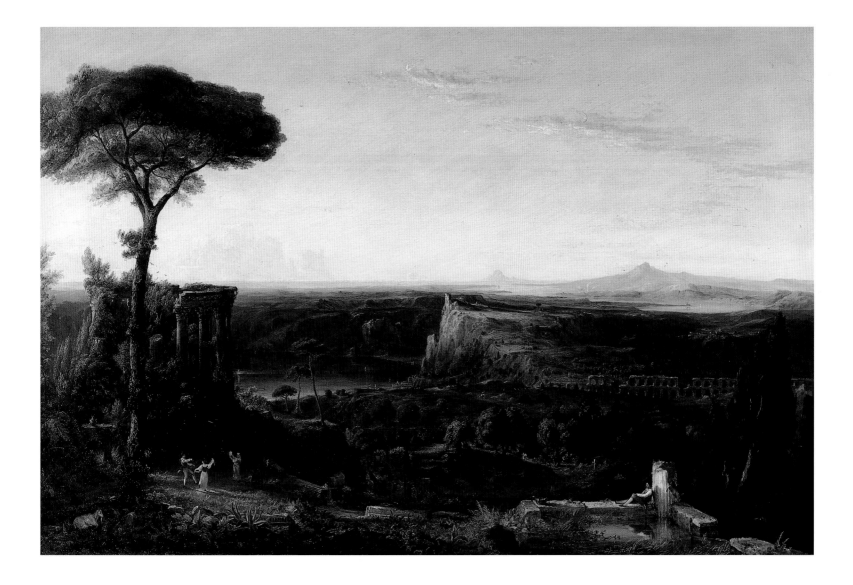

Plate 1

THOMAS COLE. *Italian Scene. Composition.* 1833

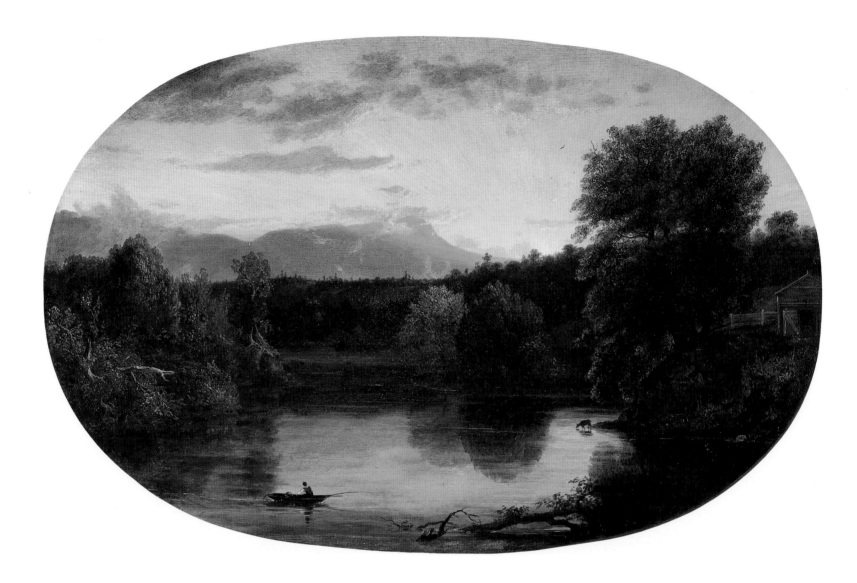

Plate 2

Thomas Cole. *Sunset, View on the Catskill.* 1833

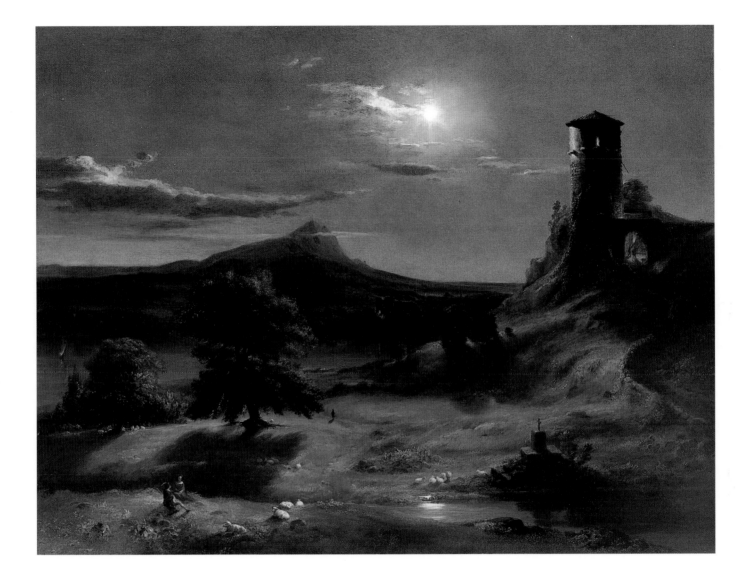

Plate 3

THOMAS COLE. *Landscape (Moonlight)*. c. 1833–34

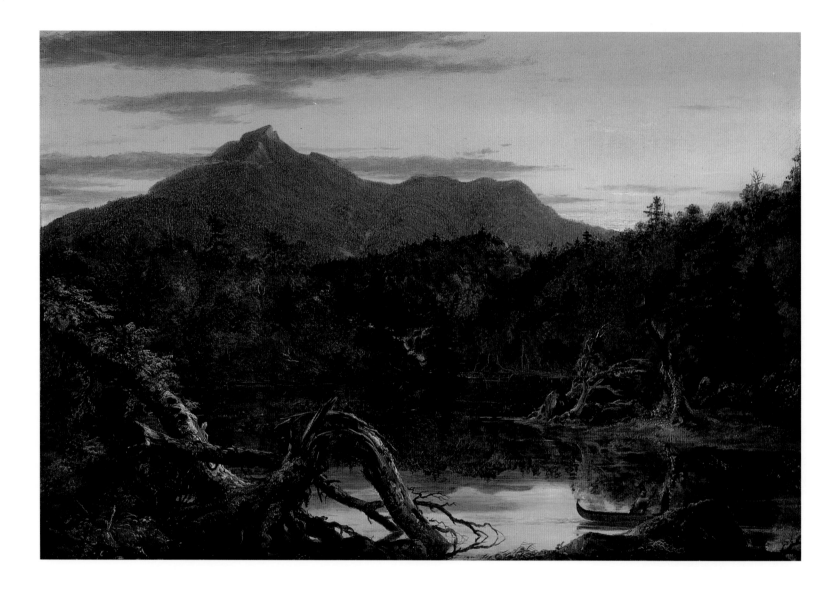

Plate 4

Thomas Cole. *Autumn Twilight,*
View of Corway Peak [Mount Chocorua], New Hampshire. 1834

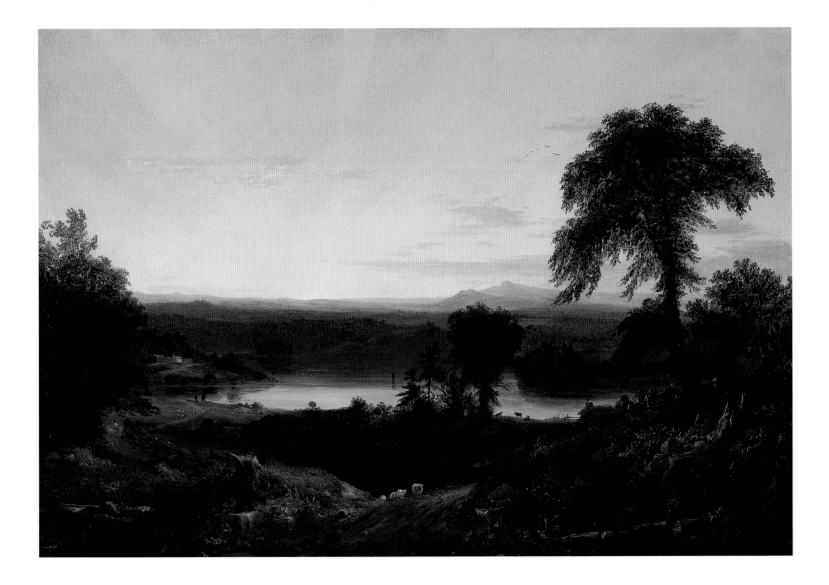

Plate 5

THOMAS COLE. *Summer Twilight,*
a Recollection of a Scene in New England. 1834

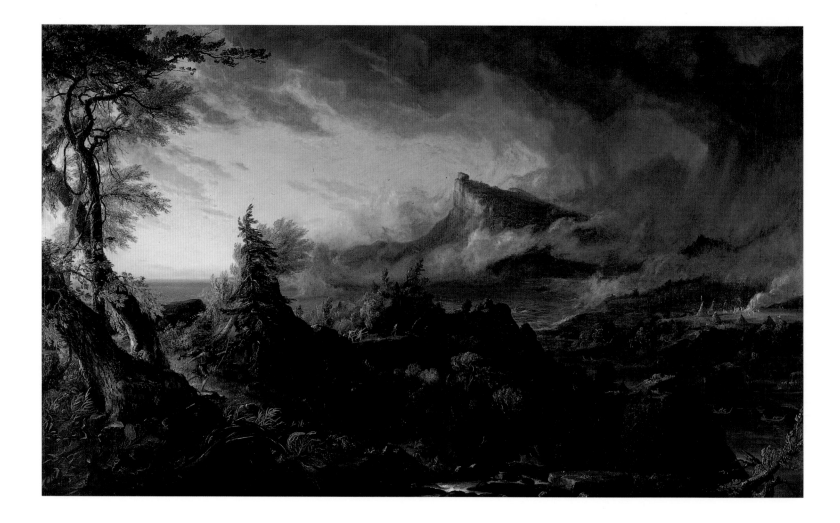

Plate 6

Thomas Cole. *The Course of Empire: The Savage State.* 1833–36

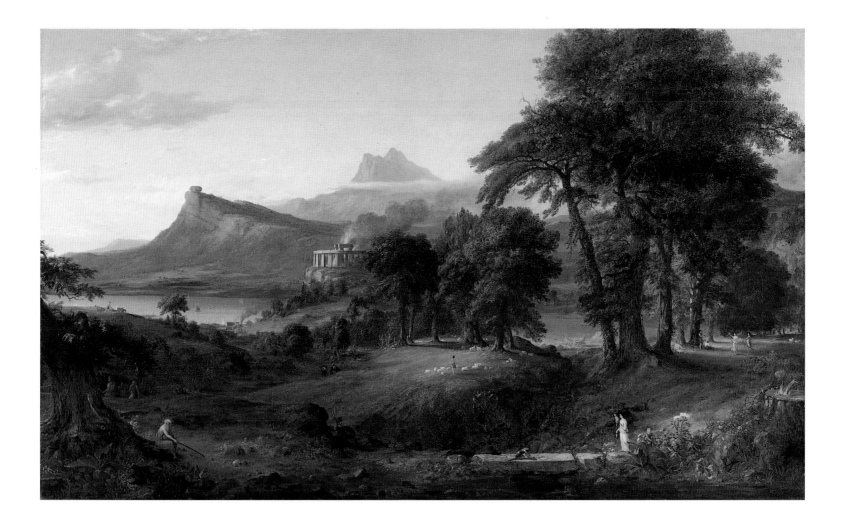

Plate 7

Thomas Cole. *The Course of Empire: The Arcadian or Pastoral State.* 1833–36

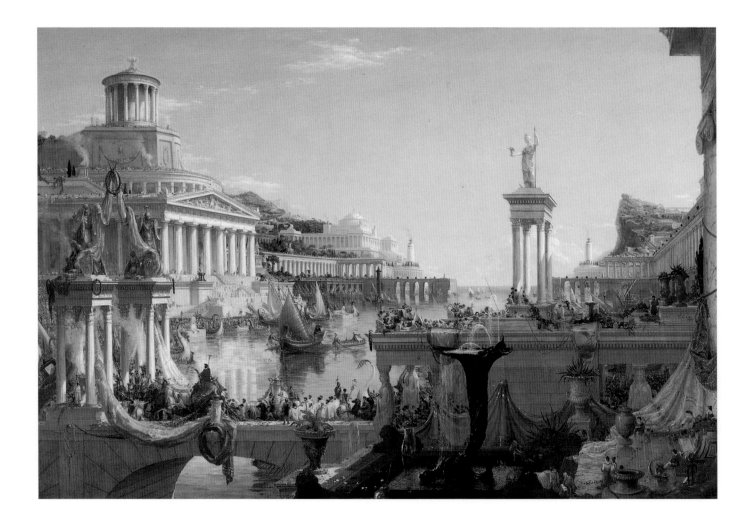

Plate 8

Thomas Cole. *The Course of Empire: The Consummation of Empire.* 1833–36

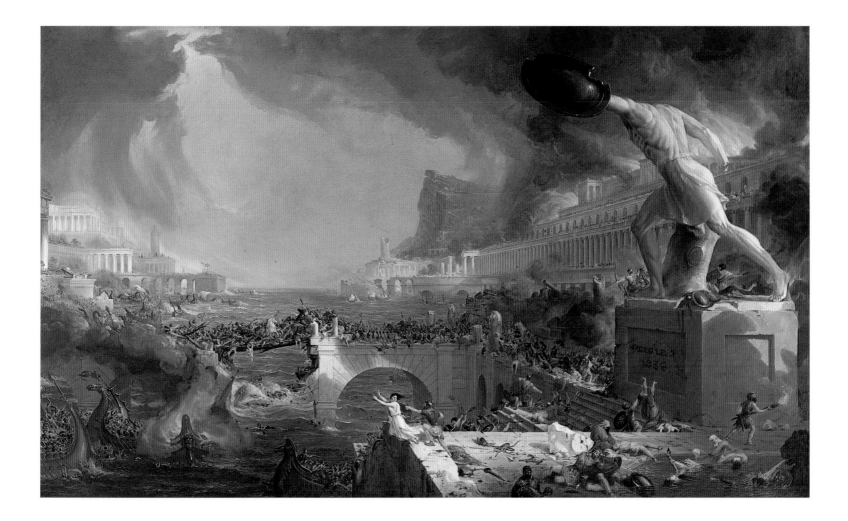

Plate 9

THOMAS COLE. *The Course of Empire: Destruction.* 1833–36

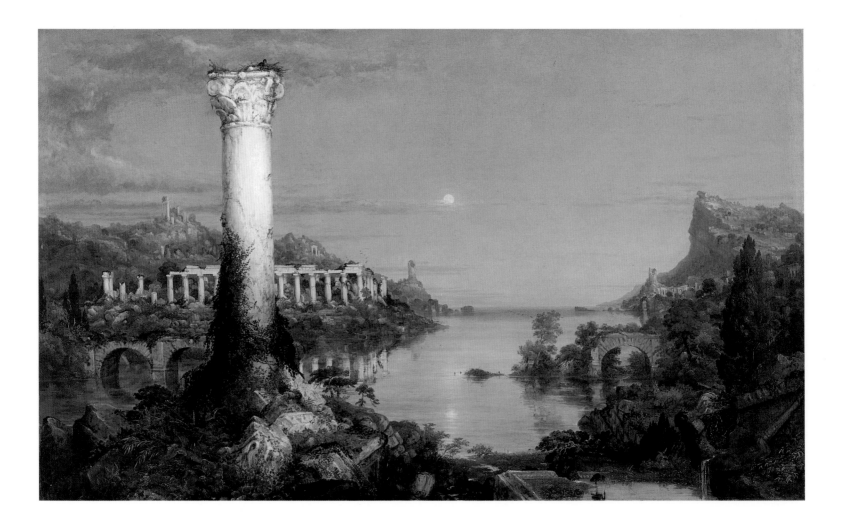

Plate 10

Thomas Cole. *The Course of Empire: Desolation.* 1833–36

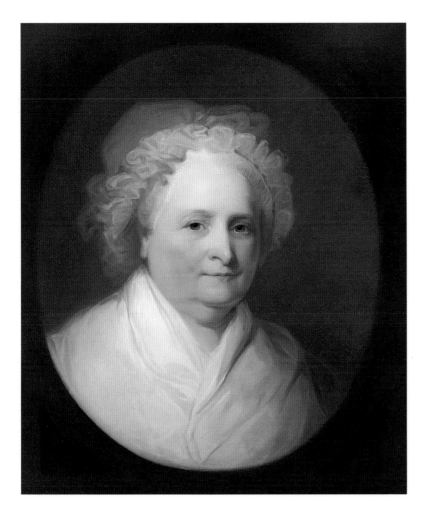

Plate 11

Asher Brown Durand (after Gilbert Stuart).
Mrs. George Washington (Martha Custis née Dandridge). 1835

Plate 12

Asher Brown Durand (after Gilbert Stuart).
George Washington. 1835

Plate 13

ASHER BROWN DURAND (after Gilbert Stuart).
John Adams. 1835

Plate 14

ASHER BROWN DURAND (after Gilbert Stuart).
Thomas Jefferson. 1835

Plate 15

Asher Brown Durand (after Gilbert Stuart).
James Madison. 1835

Plate 16

Asher Brown Durand (after Gilbert Stuart).
James Monroe. 1835

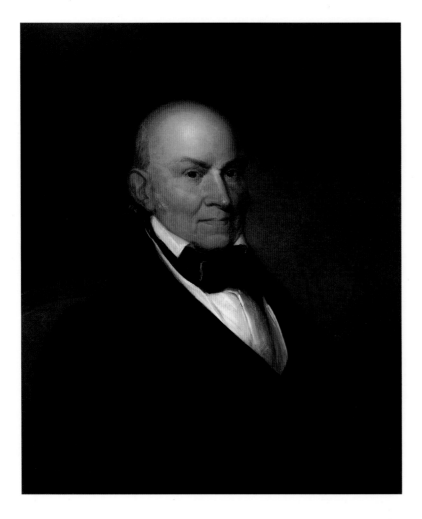

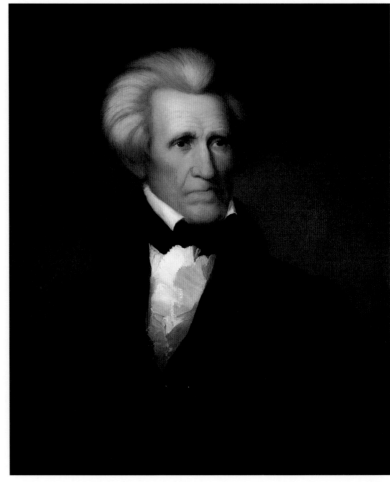

Plate 17

ASHER BROWN DURAND. *John Quincy Adams.* 1835

Plate 18

ASHER BROWN DURAND. *Andrew Jackson.* 1835

Plate 19

Asher Brown Durand. *Peter Stuyvesant and the Trumpeter*
(The Wrath of Peter Stuyvesant). 1835

Plate 20

ASHER BROWN DURAND. *The Pedler (The Pedlar Displaying His Wares).* 1835–36

Plate 21

GEORGE WHITING FLAGG. *Murder of the Princes in the Tower.* C. 1833–34

Plate 22

Georg Whiting Flagg. *Falstaff Playing King.* c. 1834

Plate 23

GEORGE WHITING FLAGG. *Portrait of a Lady Sleeping.* C. 1834

Plate 24

GEORGE WHITING FLAGG. *Lady Jane Grey Preparing for Execution.* c. 1834

Plate 25

GEORGE WHITING FLAGG. *Lady and Parrot.* c. 1835

Plate 26

GEORGE WHITING FLAGG. *The Match Girl.* 1834

Plate 27

George Whiting Flagg. *Young Woodchopper.* c. 1835

Plate 28

GEORGE WHITING FLAGG. *Savoyard Musician.* C. 1836

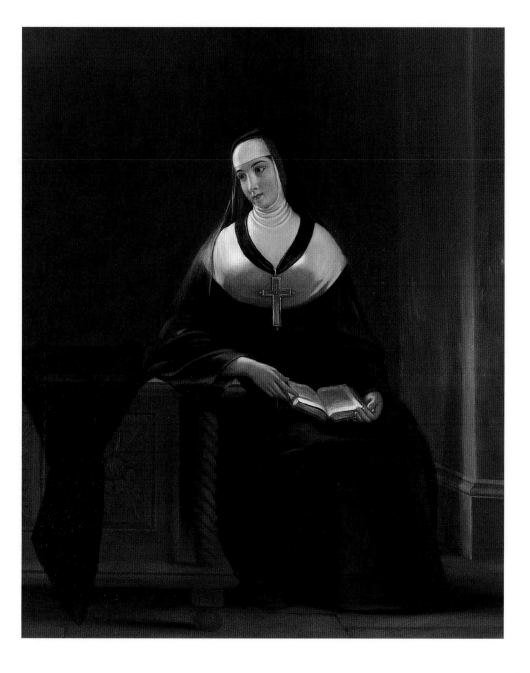

Plate 29

GEORGE WHITING FLAGG. *A Nun.* C. 1836

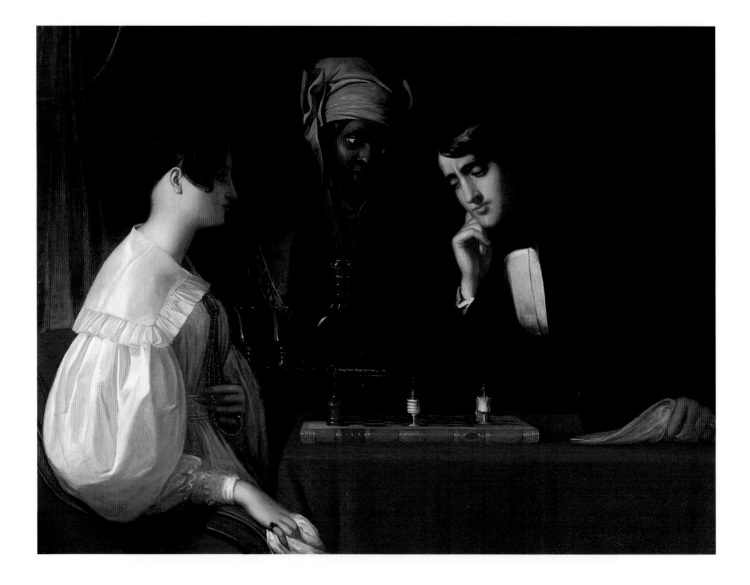

Plate 30

GEORGE WHITING FLAGG. *Chess (The Chess-Players—Check Mate)*. c. 1836

Plate 31

Frederick William Philip. *Boy Asleep.* c. 1833

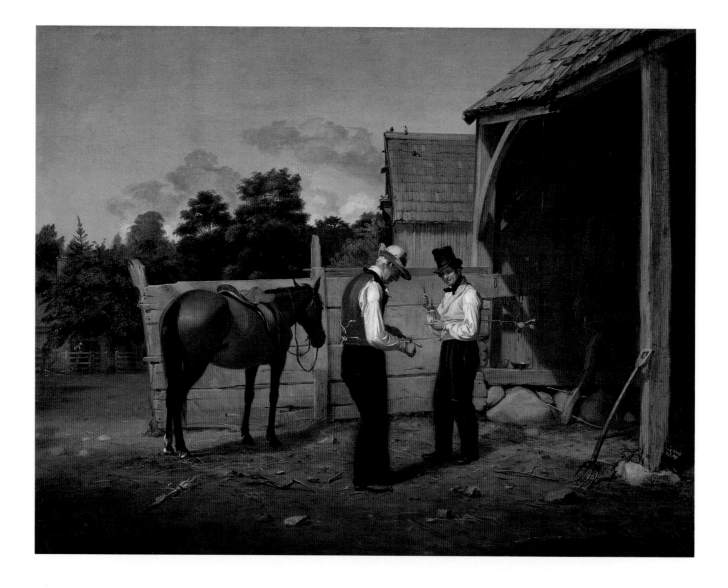

WILLIAM SIDNEY MOUNT. *Farmer's Bargaining (Bargaining for a Horse).* 1835

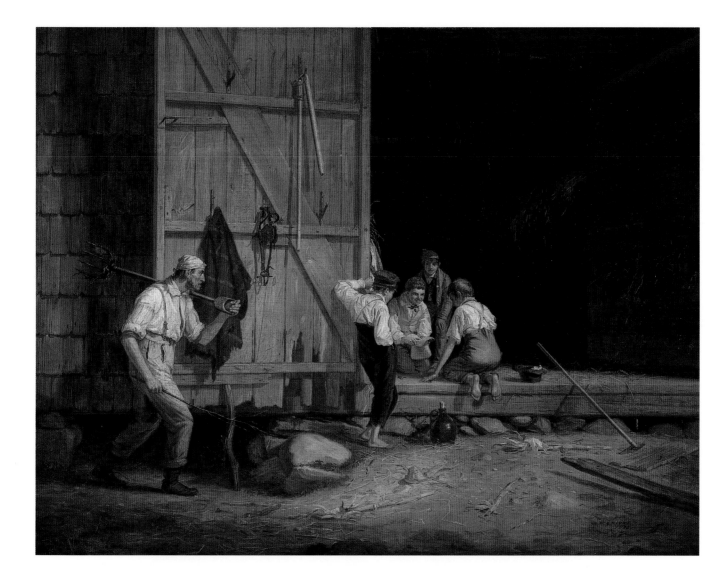

Plate 33

WILLIAM SIDNEY MOUNT. *Undutiful Boys (The Truant Gamblers).* 1835

Plate 34

Flemish School. *Madonna and Child.* c. 1575–1600

Plate 35

FLEMISH SCHOOL. *The Judgement of Midas*. C. 1615

Plate 36

FLEMISH SCHOOL. *Wreath of Flowers Encircling the Holy Family.* c. 1620–40

FLEMISH SCHOOL. *The Mystic Marriage of Saint Catherine.* c. 1625–50

Plate 38

Unidentified Artist (after Jan Fyt).
The Huntsman's Tent—Game and Dogs After a Hunt. c. 1700

Plate 39

Flemish School. *An Allegory—Death and Immortality.* c. 1675–1725

Plate 40

GERMAN SCHOOL. *Portrait of a Young Lady.* 1608

Plate 41

UNIDENTIFIED ARTIST (after Willem Kalf).
Still-Life with Chinese Sugarbowl, Nautilus Cup, Glasses, and Fruit. c. 1675–1700

Plate 44

GERMAN SCHOOL.
Man and Woman with a Child Drinking Water. c. 1750

Plate 45

GERMAN SCHOOL.
Shepherd Drinking at a Waterfall. c. 1750

Plate 46

Unidentified Artist (after Antonio Allegri, called Correggio).
Saint Mary Magdalen Reading. c. 1775–1825

Plate 47

———————

UNIDENTIFIED ARTIST (after Francesco Albani).
The Assumption of the Virgin. c. 1775–1825

Plate 48

George Morland. *Dogs Fighting.* 1783 or later

Plate 49

George Morland. *Old English Sportsman.* c. 1790–1804

Plate 50

Andrew Richardson. *View From Froster Hill, Gloucestershire, England.* c. 1833

Plate 51

Andrew Richardson. *View Near Bridgeport, Connecticut.* c. 1831–36

THE DOOR PANELS

See page 222 for documentation of each panel

THOMAS COLE

The Mullein Stalk

The Ruined Castle

Seascape with a Waterspout

Balloon Ascension

ASHER BROWN DURAND

Woman Churning Butter

Blind Man's Bluff

Barn Builders

School Let Out

THE DOOR PANELS

See page 222 for documentation of each panel

ASHER BROWN DURAND

Right:

Man Reading at a Table *Woodchopper*

Boy Riding a Horse *Haying Scene*

Above:

Boy Chasing Pig (att. to Durand)

Left:

Boys Playing Marbles

THE LUMAN REED COLLECTION

CATALOGUE

Plate 1

THOMAS COLE (1801–1848)

Italian Scene. Composition. 1833

Oil on canvas (lined), 27½ × 54½″

Signed lower left center: T. C.

Gift of the New-York Gallery of the Fine Arts, 1858.19

According to his friend and biographer Louis L. Noble, Thomas Cole first met Luman Reed sometime after Cole returned from his first European trip in November of 1832.[1] Although he had made his reputation in New York in 1825, his return to the city fortuitously coincided with Reed's growing interest in American art and the recent completion of his house and art gallery.[2] Reed offered Cole a commission, and *Italian Scene. Composition,* painted during the summer of 1833, was the first of at least ten works that Cole painted for Reed.[3] According to the painter and historian William Dunlap, Reed was so pleased with this landscape that he paid five hundred dollars for it (even though Cole was prepared to accept three hundred), and also commissioned *The Course of Empire.*[4]

In 1832, Cole had fulfilled a commission for Rufus L. Lord by painting *Landscape Composition, Italian Scenery* (Memorial Art Gallery,

University of Rochester, New York), which was exhibited at the National Academy of Design in 1833. As a critic for the *New-York Mirror* observed, this work was "not a view of individual Italian scenery, but a combination from the poetical mind of the artist, of images there impressed by objects and views seen during his residence in the land of oranges and arts."[5] The same may be said of the *Italian Scene. Composition,* painted for Reed. It, too, represents an idealized conception of Italy, and incorporates landscape and archeological elements from both the Mediterranean coast and the Roman countryside. As early as 1826, Cole expressed an interest in such "compositions," writing to his patron Robert Gilmor, Jr., of Baltimore:

> If I am not misinformed, the first pictures which have been produced, both historical and landscapes, have been compositions; Raphael's pictures, those of all the great painters are something more than imitations of nature as they found it.[6]

While Washington Allston's work provided an American precedent for idealized Italian landscapes, Cole's admiration for imaginary compositions was reinforced during his European trip of 1829–32. He was particularly impressed by the works of Claude Lorrain, of whom he wrote: "Claude, to me, is the greatest of all landscape painters, and indeed I should rank him with Raphael or Michel Angelo."[7]

Italian Scene. Composition reveals the influence that European art and the Italian landscape had not only on Cole's subject matter but also on his composition and handling. While the composition is still recognizably Claudian, with enframing umbrella pine and cypress trees and the pool of water in the middle ground, the greater breadth and depth of space reveal Cole's new awareness of the panoramic potential inherent in landscape painting. Similarly, the colors and the vast expanse of blue sky

reflect his experience of Mediterranean light. Cole's composition permits the viewer, like a tourist on the grand tour, to trace a path visually through the landscape. The idea of pilgrimage is accentuated by several prominent roadside shrines, including the votive shrine incorporated into the arch in the left center foreground, and by the crosses situated on the path farther down the hill and on the edge of a distant plateau. The dominant features of the landscape, however, are the ruins, including the circular temple at the left, the aqueduct traversing the landscape in the middle ground, and the castle on a distant promontory.[8] Whereas in Cole's American landscapes fallen trees often signify the transformation of the pristine "new world" wilderness by civilization, in *Italian Scene. Composition,* the fallen columns and decaying ruins symbolize the fall of "old world" civilizations and the regenerative forces of nature.

When Cole made his first trip to Europe in 1829, Italy was seen by tourists almost exclusively in terms of its past—a country in which one could find the remnants of ancient civilizations. This view of Italy is evident in the English poet Samuel Rogers's poem *Italy* (1822–28), which was quoted in the catalogue when Cole's painting was exhibited at the New-York Gallery of the Fine Arts in 1844:

> O, Italy, how beautiful thou art!
> Yet I weep, for thou art lying, alas!
> Low in the dust, and they who come admire thee,
> As we admire the beautiful in death.[9]

Italy's peasants were also perceived as having changed little over the centuries and were idealized as rustic primitives living in harmony with nature. In Cole's vision of Italy, the inhabitants of the countryside are depicted as picturesque counterparts to the landscape. At the lower left of *Italian Scene. Composition* are three dancing peasants. They are observed by a young boy leaning on a nearby column and by a peasant resting beside a pool of water at the right. A goat who seems to be searching the peasant's coat for something to eat adds a humorous note to the scene. A mule train, the only sign of actual physical labor, is relegated to a path in the distance. Cole's depiction of life in the Italian *campagna* as a pastoral paradise is in accord with his actual impression of Italy during his first European trip:

> Indeed, to speak of Italy is to recall the desire to return to it. And what I believe contributes to the enjoyment of being there, is the delightful freedom from the common cares and business of life—the vortex of politics and utilitarianism, that is for ever whirling at home.[10]

PROVENANCE: Luman Reed, New York, d. 1836; Mrs. Luman Reed, New York, 1836–44; NYGFA, 1844–58.

EXHIBITED: NAD, 1834, no. 88, *Italian Scene. Composition;* Stuyvesant Institute, New York, 1838, no. 2, *Italian Landscape. Composition;* NYGFA, 1844, no. 34, *Landscape—Composition Italian Scenery;* 1845, 1846, 1848, no. 57; 1850, no. 37; American Art-Union, 1848, no. 57 (on view at the New-York Gallery of the Fine Arts); Washington Exhib. NYGFA, 1858, no. 89, *Landscape Composition—Italian Scenery;* Metropolitan Fair in Aid of the U.S. Sanitary Commission, New York, 1864, no. 49, *Italy.*

REFERENCES: *Knickerbocker* 3 (May 1834), p. 400; *New-York Mirror* 11 (May 17, 1834), p. 367; *American Monthly Magazine* 3 (June 1, 1834), p. 282; *New York Evening Post,* June 5, 1834, p. 2; Dunlap 1834, 2, pp. 366–67; Reed Inventory 1836, "Italian Composition," $200.00; Noble 1853, pp. 175–76; Koke 1982, 1, pp. 204–5.

Plate 2

THOMAS COLE

Sunset, View on the Catskill. 1833

Oil on wood, painted oval, 16½ × 24½″

Signed and dated lower right: T. Cole / 1833. Inscribed, signed,

and dated on verso: On the Catskill / T. Cole / 1833.

Gift of the New-York Gallery of the Fine Arts, 1858.44

Thomas Cole's art and life were linked inextricably with the region surrounding the Catskill Mountains in upstate New York. In the summer of 1825, shortly after he moved to New York City, Cole made his first trip up the Hudson River, visiting the Hudson Highlands, the confluence of the Hudson and Mohawk rivers, Kaaterskill Falls, the town of Catskill, and the new Pine Orchard House hotel. During this trip, he painted several views in the Catskill Mountains, which he was allowed to display in the store window of the book and picture dealer William A. Colman in New York. When these works were discovered and publicized by the artists John Trumbull, Asher B. Durand, and William Dunlap, Cole's reputation as a landscape painter was secured.[11] Cole returned to the Catskills in 1826 and, following his European trip of 1829–32, visited

the region every summer until 1836. In that year he bought a house just north of Catskill where, except for a second trip to Europe in 1841–42, he lived the rest of his life.[12]

Prior to Cole's first visit to the Catskills in 1825, the region had been celebrated in the works of American artists and writers, notably Washington Irving's "Rip Van Winkle" (1819) and James Fenimore Cooper's *The Pioneers* (1823). Cole's trip, however, coincided with the growth of tourism in the mountains. A year earlier, in 1824, the Pine Orchard House (later renamed the Catskill Mountain House) was constructed to provide lodging for a largely urban clientele with the time, means, and inclination to indulge in mountain sight-seeing. The Catskills soon joined Niagara Falls and Saratoga Springs on the itinerary for the American equivalent of the European grand tour. Cole's views of the Catskills both documented this new interest and helped to shape it. Thus James Kirke Paulding's *The New Mirror for Travellers; and Guide to the Springs* (1828) urged "the picturesque tourist" to buy Cole's Catskill paintings to adorn his home, while Andrew T. Goodrich's *North American Tourist* (1839) described Kaaterskill Falls and other sites that "the magic touches of Cole the artist have brought to the public imagination."[13]

Sunset, View on the Catskill depicts one of Cole's most popular Catskill subjects, a view of North Mountain as seen from Catskill Creek, near the town of Catskill.[14] An oil sketch (private collection) of the site reveals that in the transition from the sketch to the finished work, Cole subtly exaggerated the topography and diminished the scale of the man in the rowboat in relation to the landscape. He also introduced a pastoral note by adding the wooden structure on the hill at the right and the animal at the water's edge. Cole's replica of this painting (Albany Institute of History and Art) served as the point of departure for a later, more

elaborate composition, *North Mountain and Catskill Creek* (Yale University Art Gallery, New Haven) of 1838. The panel supporting the latter work is inscribed with a descriptive poem by Cole that seems equally appropriate for the earlier *Sunset, View on the Catskill*:

Sunset in the Catskills

The valleys rest in shadow and the hum
Of gentle sounds and low toned melodies
Are stilled, and twilight spreads her misty wings
In broader sadness oer their happy scene
And creeps along the distant mountain sides
Until the setting sun's last lingering beams
Wreathe up in many a golden glorious ring
Around the highest Catskill peak.[15]

Cole's poem and his Catskill sunset paintings have been linked with a passage in his "Essay on American Scenery" (1835) in which he praises the restorative powers of the American landscape and its sunsets, especially for the urban viewer seeking to escape the city's turmoil:

Let him be transported to those favored regions, where the features of the earth are more varied, or yet add the sunset, that wreath of glory daily bound around the world, and he, indeed, drinks from pleasure's cup. The delight such a man experiences is not merely sensual, or selfish, that passes with the occasion leaving no trace behind; but in gazing on the pure creations of the Almighty, he feels a calm religious tone steal through his mind, and when he has turned to mingle with his fellow men, the chords which have been struck in that sweet communion cease not to vibrate.[16]

In *Sunset, View on the Catskill*, the rural fisherman serves as a surrogate for this ideal viewer, pausing from his labors at the end of the day to appreciate the spectacular sunset and the transcendent beauty of nature. Given Luman Reed's rural roots in the Hudson River town of Coxsackie, only ten miles north of Catskill Creek, Cole no doubt expected this view to elicit a similar response from his patron. It seems to have had the intended effect on a critic for the *Broadway Journal* who, while mistaking the scene for a sunrise, recognized the power of Cole's view to evoke actual experiences of nature:

It has more real merit than all of his allegorical pictures together; the pure morning sky, the still lake, the cool shadows of the dark woods, the feeling of nature over all, are unsurpassed by any landscape that has been painted in this country. A sensation of country air lingers in our memory for a whole day after seeing it.[17]

———

PROVENANCE: Luman Reed, New York, d. 1836; Mrs. Luman Reed, New York, 1836–44; NYGFA, 1844–58.

EXHIBITED: NAD, 1834, no. 36, *Sunset, View on the Catskill*; Boston Athenaeum, 1835, no. 79, *View of the Catskill at Sunset*; NYGFA, 1844, no. 65, *View on Catskill Creek*; 1845, 1846, 1848, no. 54; 1850, no. 46 or 78 (one of these works is actually Cole's *Summer Twilight*, misidentified as *View on Catskill Creek*); American Art-Union, 1848, no. 54 (on view at the New-York Gallery of the Fine Arts); Washington Exhib. NYGFA, 1853, no. 29, *Sunset— View on Catskill Creek*.

ENGRAVED: By James Smillie (1807–1885). Exhibited NAD, 1835, no. 82, *View on the Catskill*. See the *New-York Mirror* 12 (May 30, 1835), p. 379.

REFERENCES: *Knickerbocker* 3 (May 1834), p. 400; *American Monthly Magazine* 3 (May 1, 1834), p. 209; *New-York Mirror* 11 (May 17, 1834), p. 367; *New York Evening Post,* June 5, 1834, p. 2; Reed Inventory 1836, "View on Catskill Creek," $75.00; *Broadway Journal* 1 (Feb. 15, 1845), p. 103; Koke 1982, 1, pp. 190–91.

Plate 3

THOMAS COLE

Landscape (Moonlight). c. 1833–34

Oil on canvas (lined), 24⅝ × 31¾"

Gift of the New-York Gallery of the Fine Arts, 1858.31

This nocturnal landscape of about 1833–34, later known as *Moonlight,* was the second Italian subject Cole painted for Luman Reed. As is *Italian Scene. Composition,* this work is a "composition," synthesized and transformed into an ideal landscape from actual sites recorded in Cole's Italian sketchbooks of 1831–32.[18] Like other works by Cole, its subject was inspired in part by the literary works of Lord Byron. The early 1830s marked the height of Cole's fascination with Byron, and in the National Academy of Design exhibition of 1833, both *The Fountain of Egeria* (now lost) of 1831 and *Manfred* (Yale University Art Gallery, New Haven) of 1833 were accompanied by quotations from Byron.[19] When *Moonlight* was exhibited at the National Academy of Design in 1834, it was accompanied by a quotation from Lord Byron's poem "Parasina" (1816).

In his preface to the poem, Byron included the following historical account from Edward Gibbon's *Antiquities of the House of Brunswick* (1814), from which he stated his poem was derived:

> Under the reign of Nicholas III Ferrara was polluted with a domestic tragedy. By the testimony of an attendant, and his own observation, the Marquis of Este discovered the incestuous loves of his wife Parasina, and Hugo his bastard son, a beautiful and valiant youth. They were beheaded in the castle by the sentence of a father and husband, who published his shame, and survived their execution.[20]

Cole, however, omitted Byron's narrative and quoted only the first stanza of "Parasina":

> It is the hour when from the boughs
> The nightingale's high note is heard;
> It is the hour when lovers' vows
> Seem sweet in every whisper'd word;
> And gentle winds, and waters near,
> Make music to the lonely ear.
> Each flower the dews have lightly wet,
> And in the sky the stars are met,
> And on the wave is deeper blue,
> And on the leaf a browner hue,
> And in the heaven that clear obscure,
> So softly dark and pure,
> Which follows the decline of day,
> As twilight melts beneath the moon away.[21]

Cole's selection of this particular passage from "Parasina" is significant; for it is the only stanza that does not advance the narrative or mention the protagonists. In this way Cole avoided an explicit reference

to Byron's theme of incestuous love, and although the couple in the left foreground of *Moonlight* wears Renaissance-style costumes appropriate for Parasina and her lover Hugo, they also may represent the universal lovers to whom Byron refers. Thus, while Cole's use of Byron's poem enhanced the romantic aura of *Moonlight* and elevated it to the level of history painting, his primary intent seems to have been to create a pictorial equivalent of the poetic landscape that Byron described.

A similar interest in creating a romantic mood in the mind of the viewer characterizes the work of Washington Allston, whose own *Moonlight* (Museum of Fine Arts, Boston) of 1819 also was a recollection of the artist's travels abroad, and has no readily discernible narrative.[22] Both works feature prominent moons that dramatically backlight a landscape with figures, mountains, towers, and reflecting pools of water. Cole's *Moonlight* also recalls Allston's paintings in its use of music. The lute player in Cole's *Moonlight,* for example, resembles the lute player in Allston's *Italian Landscape* (Detroit Institute of Arts) of about 1828–30, in which a seated peasant youth entertains three female companions in an idealized landscape. Cole's inclusion of music in *Moonlight* reflects a romantic sensibility that perceived an analogy between art and music, as well as the belief that both were capable of evoking a specific mood. In a diary entry of November 1834, Cole referred to "the music of colours" and wrote: "I believe that colours are capable of affecting the mind, by combination, degree, and arrangement, like sound. . . . an instrument might be constructed by which colour could be played, and which would give to those, who had cultivated their taste in the art, a pleasure like that given by music."[23]

Cole's associationist aesthetic and the link between his painting and Byron's poem were acknowledged by a critic for the *American Monthly Magazine,* who quoted the stanza from Byron's "Parasina," and observed of *Moonlight:*

> This is decidedly the *chef d'oeuvre,* the gem, of the exhibition. The lines which we have quoted above are a picture, the picture which is designed from them is poetry. The coolness, keeping, freshness, and nature, of the painting, are inimitable. It is not possible to look upon the picture without feeling the very sensations, which creep into our hearts as we muse beneath an evening sky, steal over us; the tender melancholy, "the glorious sympathy with suns that set," the inclination of the spirit to love and devotion, are all called forth as we gaze upon this lovely creation of the poet's and the painter's fancy.[24]

———————————

PROVENANCE: Luman Reed, New York, d. 1836; Mrs. Luman Reed, New York, 1836–44; NYGFA, 1844–58.

EXHIBITED: NAD, 1834, no. 78, *Landscape,* with stanza from Lord Byron's "Parasina"; NYGFA, 1844, no. 70, *Moonlight;* 1845, 1846, 1848, no. 63; 1850, no. 67; American Art-Union, 1848, no. 63 (on view at the New-York Gallery of the Fine Arts); Washington Exhib. NYGFA, 1853, no. 30, *Moonlight.*

REFERENCES: *American Monthly Magazine* 3 (May 1, 1834), p. 212; *New-York Mirror* 11 (May 17, 1834), p. 367; Reed Inventory 1836, "Moonlight," $50.00; Koke 1982, 1, pp. 191–92.

Plate 4

THOMAS COLE

Autumn Twilight, View of Corway Peak [Mount Chocorua],

New Hampshire. 1834

Oil on wood, 13¾ × 19½″

Signed lower right: T. Cole. Signed, inscribed, and dated on verso: T. Cole. /

Catskill / 1834. Printed label on verso: Lewis P. [Clover] / Looking Glass and

Picture [Frame] Manufacturer. / No. 180 Fulton-Street, / New-York.

Gift of the New-York Gallery of the Fine Arts, 1858.42

Plate 5

THOMAS COLE

Summer Twilight, a Recollection of a Scene in New England. 1834

Oil on wood, 13½ × 19½″

Signed bottom left of center: T. Cole. Signed, inscribed, and dated on verso:

T.Cole / Catskill / 1834. Printed label on verso: Lewis P. Clover /

Looking Glass [and Pictu]re Frame Manufacturer. / No. 180 Fulton Street, /

New York.

Gift of the New-York Gallery of the Fine Arts, 1858.46

PROVENANCE: Luman Reed, New York, d. 1836; Mrs. Luman Reed, New York, 1836–44; NYGFA, 1844–58.

EXHIBITED: NAD, 1835, no. 37, *Autumn Twilight, View of Corway Peak, New Hampshire;* NYGFA, 1844, no. 31, *Autumn Scene—Corway Peak—White Mountains—New-Hampshire;* 1845, 1846, 1848, no. 59; 1850, no. 51; American Art-Union, 1848, no. 59 (on view at the New-York Gallery of the Fine Arts); Washington Exhib. NYGFA, 1853, no. 36, *Autumn Scene—Corway Peak White Mountains.*

REFERENCES: *New-York Mirror* 12 (Dec. 6, 1834), p. 179, and (May 16, 1835), p. 371; *American Monthly Magazine* 5 (June 1835), p. 318; Reed Inventory 1836, "Autumnal Landscape," $75.00; Koke 1982, 1, pp. 204–5.

PROVENANCE: Luman Reed, New York, d. 1836; Mrs. Luman Reed, New York, 1836–44; NYGFA, 1844–58.

EXHIBITED: NAD, 1835, no. 25, *Summer Twilight, a Recollection of a Scene in New England;* NYGFA, 1844, no. 29, *Summer Sunset;* 1845, 1846, 1848, no. 64; 1850, no. 46 or 78 (misidentified as *View on Catskill Creek*).

REFERENCES: *New-York Mirror* 12 (May 16, 1835), p. 371; *American Monthly Magazine* 5 (June 1835), p. 317; Reed Inventory 1836, "Summer Sunset," $75.00; Koke 1982, 1, pp. 203–4.

Thomas Cole made his first journey to the White Mountains of New England in 1827, on the recommendation of his patron Daniel Wadsworth of Hartford, who had made the trip the year before.[25] It was not until 1828, however, that Cole, accompanied by the artist Henry Cheever Pratt and the well-known guide Ethan Allen Crawford ("the Giant of the Mountains"), made the ascent of Mount Chocorua (also known as Corway, Corroway, or Carroway), in the Sandwich range of the White Mountains.[26] It was during this second trip that Cole learned of the local legend linking a Native American named Chocorua with the peak.[27] In his sketchbook/diary entry for October 3, 1828, Cole recorded a version of the legend in which Chocorua was chased by white settlers to the summit of this peak:

> There they gave the poor despairing and defenceless wretch the cruel choice of whether he would leap from the dreadful precipice on the top of which he stood or die beneath their rifles. The ill-fated Chocorua refused to destroy himself by that terrible leap and suffered death beneath their hands. The country round the foot of Chocorua is inimical to the raising of cattle. Such as are taken there always die by an incurable disease. This superstition was alleged to a curse which Chocorua is said to have uttered with his dying lips that "all the cattle of the white men brought onto his hunting ground should die."[28]

On his return from the White Mountains, Cole painted several views of Mount Chocorua, as well as *The Death of Chocorua* (unlocated) of 1828–29, which depicted the climactic scene of the chief's death.[29] Because few Algonquians still inhabited the White Mountains in the nineteenth century, Cole's inclusion of a Native American in *Autumn Twilight, View of Corway Peak [Mount Chocorua], New Hampshire* no doubt was intended to evoke the earlier era of the Chocorua legend.[30]

Autumn Twilight was exhibited at the National Academy of Design in 1835 with *Summer Twilight, a Recollection of a Scene in New England,* a work of identical dimensions. This pairing enabled Cole to contrast the natural disorder of the wilderness with the imposed order of a cultivated landscape. By depicting the Native American paddling a canoe in *Autumn Twilight* and the woodsman carrying an axe in *Summer Twilight,* he also set up a series of oppositions between primal Indian life and that of New England's settlers. Thus Cole contrasted a pristine landscape, in which the viewer is confronted by the Native American upon whose domain he has intruded, with a newly cleared landscape, in which the settler looking at the sunset acts as the viewer's surrogate. Similarly, the solitary Native American on Lake Chocorua passes through nature without a trace, while the settler permanently transforms the wilderness into a pastoral homestead with man-made structures. The contrast is accentuated by the implicit comparison of the trees felled by nature with those felled by man.

Cole's use of a pair of landscapes to chart the course of civilization, one wild and embodying concepts of the "sublime" and the other cultivated and representative of the "beautiful" or "picturesque," parallels *The Savage State* and *The Pastoral State* of *The Course of Empire,* with which *Autumn Twilight* and *Summer Twilight* are contemporary.[31] However, unlike the allegorical series *The Course of Empire,* which depicts the inexorable and ultimately self-destructive course of civilization, the representation of progress in the American landscapes of *Autumn Twilight* and *Summer Twilight* is ambiguous. In his "Essay on American Scenery" of 1836, Cole observed that although the presence of God and the products of creation were perhaps more apparent in the wilderness, the cultivated landscape also had positive associations:

> The cultivated must not be forgotten, for it is still more important to man in his social capacity— . . . and, though devoid of the stern sublimity of the wild, its quieter spirit steals tenderly into our bosoms mingled with a thousand domestic affections and heart-touching associations—human hands have wrought, and human deeds hallowed all around.[32]

Conversely, although it is the settler's labor that has in part created the spectacular landscape vista in *Summer Twilight,* the prominent tree stump in the left foreground suggests Cole's growing unease over "the ravages of the axe" and an American landscape "desecrated by what is called improvement."[33]

Cole's ambivalent message was largely overlooked by his contemporaries, who perceived the artist as the standard-bearer asserting the superiority of the American landscape and American art over that of Europe. While the critics had mixed opinions about the Italian scenes Cole created following his first trip to Europe in 1829–32, they chauvinistically embraced his American works. One critic wrote that *Summer Twilight* "is still in his old style, and is, therefore, beautiful," while a critic for the *New-York Mirror* observed of the same painting: "There is a 'Twilight,' by Domenichino, now exhibiting in this city, and praised as 'wonderful,' 'full of deep poetry,' 'sublime,' etc. etc. Strange as it may appear, we prefer T. Cole to Domenichino."[34]

ORIGINS

Although Thomas Cole's five paintings of *The Course of Empire* were not completed and exhibited until 1836, as early as 1829 he began recording ideas and images in his journals and notebooks for a series of allegorical paintings depicting the rise and fall of civilizations.[35] It was during Cole's first European trip of 1829–32, however, that his ideas coalesced. His friend and biographer Louis L. Noble pointed to a pivotal moment that occurred in 1832, when Cole surveyed the ruins of the Roman Empire in the midst of modern Rome:

> Returning, once, from a long walk with a few friends, he seated himself on the fragments of a column to enjoy the sunset. As its splendors faded into the twilight, all lapsed into a stillness suited to the solemn repose peculiar, at that time, to a scene of ruin. . . . After some minutes of silent, mournful pleasure, seated a little apart by a lady, Cole, a thing rather unusual with him, was the first to speak. . . . The subject was that of the future Course of Empire. In his own brief and simple way, he passed from point to point in the series, making, by many a clear and vivid outline, the liveliest impression upon the mind of his listener, until he closed with a picture that found its parallel in the melancholy desolation by which, at that moment, they were surrounded.[36]

A short time before, Cole had shipped to his patron Robert Gilmor, Jr., of Baltimore the painting *A Wild Scene* (Baltimore Museum of Art), which was "intended for the first of a series which I have long contemplated."[37] In a letter of January 31, 1832, Cole described *A Wild Scene* as "a large picture representing a romantic country, or perfect state of nature, with appropriate savage figures. It is a scene of no particular land, but a general idea of a wild."[38] By sending Gilmor this painting with a detailed description of the planned series, Cole hoped to persuade him to

commission the remainder of the series, but he openly conceded: "You will probably smile at my castles in the air, for probably they are nothing more: it is likely I shall never have the means of executing this subject."[39]

Robert Gilmor, Jr., declined Cole's proposed commission. Soon after the artist's return to New York in November 1832, however, he made the acquaintance of Luman Reed. The two men met at a propitious moment; for in August 1832, Reed had moved into his newly constructed house at 13 Greenwich Street, where he was in the process of filling his two-room, third-floor art gallery with paintings.[40] Reed's first acquisition from Cole was the *Italian Scene. Composition* of 1833. According to William Dunlap, Reed was sufficiently pleased with this work to commission the series that Cole later titled *The Course of Empire*.[41] On September 18, 1833, Cole sent Reed a version of the proposal he had sent to Robert Gilmor, Jr., enclosing drawings and "an extract from my memorandum book of what I have conceived on the subject":

> A series of pictures might be painted that should illustrate the History of a natural scene as well as be an Epitome of Man, showing the natural changes of Landscape & those affected by man in his progress from Barbarism to Civilization, to Luxury, to the Vicious state or state of destruction, and to the state of Ruin & Desolation.
>
> The philosophy of my subject is drawn from the history of the past, wherein we see how nations have risen from the Savage state to that of Power & Glory & then fallen & become extinct. Natural scenery also has its changes, the seasons of the day & of the year, sunshine & storm, these justly applied will give expression to each picture of the series I would paint. It will be well to have the same locality in each picture. This location may be identified by the introduction of some striking object in each scene, a mountain of peculiar form for instance. This will not in the least preclude variety. The scene must be composed so as to be picturesque in its wild state, appropriate for cultivation, & the site of a sea-port.

There must be the sea, a bay, rocks, waterfalls & woods. [A detailed description of the five pictures followed.]

. . . These five pictures with three smaller ones above & two others by the fire-place will occupy all that side of the room. The three high pictures will be something in character with the pictures over which they hang.[42]

Cole went on to ask $2,500 for these ten pictures and also proposed painting an additional eighteen to twenty paintings for the other three walls of the gallery for an additional $2,500. Although Reed decided for the present not to commit himself to Cole's ambitious plan in its entirety, in his reply to Cole on September 23, 1833, he enthusiastically agreed to commission *The Course of Empire*.[43]

Cole's installation diagram for *The Course of Empire* (Detroit Institute of Arts) reveals that he envisioned an arrangement of the five paintings with *The Savage State* and *The Arcadian or Pastoral State* at the upper and lower left, *The Consummation of Empire* in the center, and *Destruction* and *Desolation* at the upper and lower right. Above, he planned to place three horizontal panels depicting the times of day—sunrise, midday, and sunset—thus echoing the theme of cyclical time and events elaborated in the five narrative paintings below. Neither these three panels nor the vertical panels flanking the fireplace were completed, although the times of day were incorporated into the series itself.

PRECEDENTS

Planned for installation over a fireplace in Reed's picture gallery, *The Course of Empire* may be related to the tradition of decorative overmantels, although it was unprecedented in its scale, number of works, and ambition. The series also may be related to contemporary moving panoramas, a popular entertainment of the day that Cole attended both in London and New York.[44] Panoramas permitted the artist to overcome the temporal limitations of single paintings and to introduce a kinetic element through the use of serial imagery recording the viewer's passage through time and/or space. Cole experimented with a panoramic format in his *Italian Scenery at Four Times of Day* (4 × 49½", Albany Institute of History and Art) of about 1833–36. As Ellwood C. Parry III has noted, this work is contemporaneous with *The Course of Empire* and echoes many of its themes: "From the evidence of this panel and the diagram for the fireplace wall in Reed's gallery, it becomes clear that the perfectly overlapping time cycles—from dawn to dark, from early spring to late

winter, from the advent of man to the fall of civilization—were a fundamental part of Cole's thinking when it came to narrative pairs or sets of easel paintings."[45]

Numerous literary sources have been cited for *The Course of Empire*. Some scholars have pointed to Bishop George Berkeley's famous poem "Verses on the Prospect of Planting Arts and Learning in America" (1729) as a precedent for Cole's title and for its implicit prophecy that America would prove to be the next great empire:

Westward the course of empire takes its way;
The four first acts already past,
A fifth shall close the drama with the day:
Time's noblest offspring is the last.

One might also cite the English historian Edward Gibbon's *The History of the Decline and Fall of the Roman Empire* (1776–88), a work that, like *The Course of Empire,* was inspired by a trip to Rome. E. P. Richardson has cited the influence of Constantin-François de Chasseboeuf, comte de Volney's *Les Ruines; ou, Méditations sur les révolutions des empires* (1791), a book that helped to shape new attitudes toward the history of Western civilization.[46] Volney's description of the ruins of ancient Palmyra, which served as the introduction to his book, bears a striking resemblance to Cole's experience of ancient Rome in 1832:

The solitariness of the situation, the serenity of the evening, and the grandeur of the scene, impressed my mind with religious thoughtfulness. The view of an illustrious city deserted, the remembrance of past times, their comparison with the present state of things, all combined to raise my heart to a strain of sublime meditations. I sat down on the base of a column; and there, my elbow resting on my knee, and my head resting on my hand, sometimes turning my eyes towards the desert; and sometimes fixing them on the ruins, I fell into a profound reverie.[47]

Finally, Alan P. Wallach has argued convincingly that the best documented literary source for *The Course of Empire* was one of the most popular poems of the period, Lord Byron's *Childe Harold* (1812, 1816, 1818). He suggests that during Cole's European trip of 1829–32, the artist, like many travelers on the grand tour, probably used the fourth canto (1818) of *Childe Harold* as a "poetical guidebook." In newspaper advertisements for the exhibition of the series in 1836, Cole actually cited

the lines "first freedom, and then glory; when that fails, / Wealth, vice, corruption," drawn from a passage in the fourth canto of *Childe Harold:*

> There is the moral of all human tales;
> 'Tis but the same rehearsal of the past.
> First Freedom and then Glory—when that fails,
> Wealth, vice, corruption,—barbarism at last.
> And History, with all her volumes vast,
> Hath but *one* page.[48]

While these sources are useful in understanding the cultural forces that shaped Cole's conception of *The Course of Empire,* they also demonstrate the currency of such ideas in an era in which the cyclical aspect of history, civilizations, and even nature itself were much debated. The American Revolution, the French Revolution, and the rise and fall of the Napoleonic empire would have provided Cole with recent historical examples of the temporality of empires.

THE SAVAGE STATE

The Savage State, Cole's first painting for *The Course of Empire,* was derived from *A Wild Scene,* painted for Robert Gilmor, Jr. In reformulating *A Wild Scene* for the first painting of the series, Cole made at least two oil sketches. In the *Study for the Savage State* (Fine Arts Collection of the Hartford Steam Boiler Inspection and Insurance Co.) of about 1833–34, Cole retained the distinctive mountain peak of *A Wild Scene* and focused in the right foreground on a waterfall and an adjacent encampment of crude huts. In a second *Study for the Savage State* (Art Museum, Princeton University) of about 1834, he arrived at a composition resembling the final picture in both its landscape and its inclusion of the hunter with a bow and arrow entering from the left. Cole initially incorporated the hunter who appears at the right side of *A Wild Scene* into a similar position in *The Savage State.* He later painted over this large figure; for a *pentimento* is visible to the right of the bounding stag.

The Savage State shows the dawn of civilization, a beginning that finds its equivalent in the season depicted—early spring—and in the time of day—sunrise. The forces of creation are manifested in the violent storm sweeping over the mountains, the storm-tossed ocean waves, and the blasted tree trunk in the left foreground. The cycle of man commences at the left with a hunter clad in animal skins who has just shot an arrow into the leaping stag fleeing at the center right. In the distance the

hunter's companions pursue a pair of deer that have been cornered on a precipice by a pack of hunting dogs. Primitive canoes ply the inlet at the right, while on a plateau above is an encampment with figures performing a ritual dance around a fire. In this rudimentary hunter-gatherer state of society, men have banded together for the mutual necessities of protection, sustenance, and worship.

Cole's recent experience of the art and antiquities of Europe is evident throughout *The Course of Empire.* The pose of the hunter in *The Savage State,* for example, was derived from the Roman *Apollo Belvedere*

(Vatican, Rome), the most famous antique statue of the period, and a work that Cole described as "one of the most perfect of human productions."[49] The crude tipi-like dwellings on the hill appear to have been adapted by Cole from a plate illustrating "The Primitive Dwellings" in Sir William Chamber's *A Treaty on Civil Architecture* (1759).[50] Cole also would have been able to draw upon the Native Americans as a living "primitive" culture in order to extrapolate back to European pre-civilization for the inhabitants of *The Savage State*. Finally, *The Savage State* often has been compared with similar wild landscapes by Salvator Rosa. Cole's interest in this artist's work at this time was documented by the *New-York Mirror*, which reported that Cole had returned from his European trip in 1832 with "two original paintings by Salvator."[51]

THE ARCADIAN OR PASTORAL STATE

In *The Arcadian or Pastoral State,* Cole's second painting for *The Course of Empire,* the wilderness has been transformed into a cultivated landscape reminiscent of those painted by Claude Lorrain, prompting a critic for the *New-York Mirror* to write: "Claude never conceived any thing so truly poetick."[52] The hour and the season have progressed to early morning and early summer, changes consummate with the profuse signs of advancing civilization. The primitive tipis of *The Savage State* have been replaced by the first permanent settlement, a small harbor town with rudimentary frame buildings under construction. Similarly, the canoes have been replaced by sailing vessels (one of which is being assembled on the stocks at the right), signifying the beginnings of maritime exploration and commerce, and the two pack horses on the path at the left center suggest the commencement of inland trade. The shift from a hunter-gatherer state to an agrarian society is apparent in the farmer with a team and plow on the hilltop at the left and the shepherd tending his flock in the center. The focal point of *The Arcadian or Pastoral State* is the circular, megalithic temple enclosing a ritual fire on a promontory above the town. As Parry has observed, by incorporating a temple that was derived from contemporary reconstructions of Stonehenge, "Cole introduced a decidedly northern element into an otherwise Mediterranean world." He has suggested that Cole may have been influenced by the growth of contemporary interest in North American prehistory and megaliths.[53]

As an artist, Cole accorded prominence to the arts and sciences in *The Arcadian or Pastoral State* as necessary components in the develop-

Plate 7

The Arcadian or Pastoral State
Oil on canvas (lined), 39¼ × 63¼″
Signed bottom center: T. C. Inscribed on wood backing panel:
[Mr.?] Cole / N. York.
Gift of the New-York Gallery of the Fine Arts, 1858.2

ment of civilization. Seated at the left is a mathematician who draws diagrams on the ground and appears to be developing geometry. At the far right a boy playing a flute and a pirouetting couple holding garlands suggest the development of music and dance. Cole reserved center stage for a young boy kneeling on the footbridge. He draws a primitive stick figure of the woman holding a spinning distaff, who may have been intended as a personification of the domestic arts. The young boy himself probably symbolizes the origins of drawing and painting, which, as Parry notes, was a popular theme in an era when "many artists and patrons

were fascinated by the task of retracing the beginnings of various human activities back to the ancient world." Parry also cites the legend of Cimabue discovering Giotto as a shepherd boy drawing, which he relates to Cole's own semi-legendary discovery by John Trumbull, William Dunlap, and Asher B. Durand.[54] This interpretation would seem to be reinforced by the proximity of Cole's monogram directly beneath the young prodigy on the footbridge, suggesting his identification with this figure.

While almost every aspect of *The Arcadian or Pastoral State* landscape conveys the ideas of peace and plenty, Cole introduced several discordant notes as harbingers of the future. The first is the prominent tree stump at the lower right, which signifies both man's developing mastery of nature and his potentially destructive impact on the landscape. Second, Cole's inclusion of two goats butting heads beneath the trees may have been intended as an example of conflict in nature, presaging the human conflict of the ensuing paintings. Finally, a disquieting note is introduced by the presence of the armored soldier at the center left and the two mounted horsemen at the far left. These figures suggest a new necessity for defense against fellow men and a desire for the exploration and possible conquest of new lands. Through the juxtaposition of these figures with that of the seated mathematician, Cole contrasts the *vita activa* with the *vita contemplativa* of creative thought.

THE CONSUMMATION OF EMPIRE

In *The Consummation of Empire,* set at midday and in the early autumn, Cole depicted the spectacular apogee of the civilization that commenced in a savage state of existence and matured into a powerful empire. As foretold by the tree stump in *The Arcadian or Pastoral State,* the forces of nature have been subdued. The harbor has been enclosed and the entrance flanked by lighthouses, the water and vegetation harnessed for fountains and gardens, and the mountains terraced and covered with buildings, aqueducts, and roads. The previously wild landscape is almost completely covered by man-made structures. The fine arts, depicted in their infancy in *The Arcadian or Pastoral State,* now play a prominent role in the society, and the primitive (and by now mythic) origins of the empire are commemorated in the sculptural frieze of the Doric temple pediment at the left, which depicts a hunt scene like that seen in *The Savage State*. Cole also was careful to include the art of painting, and the

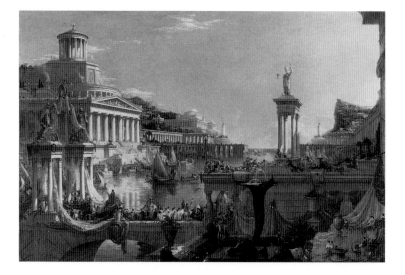

Plate 8

The Consummation of Empire

Oil on canvas (lined), 51¼ × 76″

Signed and dated right center: T. Cole / 1836. Inscribed, signed, and dated on a wood backing panel: This picture with four others constitute a series called The / Course of Empire. They were painted for Mr. Reed, / but before they were completed I had to lament his death. / Thomas Cole. / Catskill. 1836. Inscribed, signed, and dated on a paper label attached to the wood backing panel: This picture with four others constitute a / Series called The Course of Empire—they were / painted for Mr. Luman Reed of N. York; but / I had to lament his death before the work was / completed—In him I lost a noble friend & the / Fine Arts a true lover & liberal patron—/ Thomas Cole / Cedar Grove / near Catskill / Sept. 29th 1836.

Gift of the New-York Gallery of the Fine Arts, 1858.3

side wall of the temple, visible between the columns, is decorated in this medium.

Cole seems to have derived his composition from similar harbor scenes by both Claude Lorrain and J. M. W. Turner, which he could have seen during his European trip of 1829–32. Several of Claude's historical seaport scenes were on view at the National Gallery in London and the Louvre in Paris when Cole visited these museums.[55] The most relevant precedent in Turner's work was the English artist's *Dido Building Carthage; or The Rise of the Carthaginian Empire* (Tate Gallery, London) of 1815, which Cole singled out for praise after he called on Turner at his London studio in December of 1829:

> The building of Carthage is a splendid Composition & full of poetry. Magnificent piles of Architecture, some finished and some incomplete, fill the sides of the picture while the middle of it is a bay or arm of the sea that comes to the foreground, glittering in the light of the sun which rises directly over it. The figures, vessels, sea are very appropriate. The composition very much resembles some of Claude's.[56]

Parry has noted the diversity of Cole's sources for the specific architectural and sculptural elements in *The Consummation of Empire,* many of which were drawn from illustrated publications of antiquities.[57] Other elements reflect Cole's travels in Europe, which broadened both his knowledge of history and his classical vocabulary. These include the *Borghese Vase* (Louvre, Paris), which holds an agave plant on the terrace at the right, and the famous Hellenistic sculpture known as the *Diana of Versailles* (Louvre, Paris), which Cole copied for the central figure of Diana in the pediment frieze of the Doric temple.[58] As an approving critic for the *New-York Mirror* observed, Cole "has displayed not only the knowledge of a painter, but of a historian. He has shown a combination of varied and extensive science, with all the technicalities of the painter's art, and the taste of the travelled gentleman."[59]

The narrative focal point of *The Consummation of Empire* is the triumphal procession that enters from the right and is announced by trumpeters on the terrace above. The victorious leader, dressed in royal purple and standing in a chariot drawn by an elephant, has returned from a foreign campaign and is about to pass beneath a triumphal arch crowned with martial attributes. He has just passed another columned structure that supports a statue of Athena/Minerva holding a winged victory figure in her outstretched right hand. The grand entry is observed by thousands of spectators, including a noblewoman who sits enthroned at the right, surrounded by an entourage of attendants. Among them is a seated scholar with a scroll who seems to be recording the history of the empire. On the terrace above, just in front of two potted plants, a bearded philosopher stands with his arms folded, contemplating the significance of the events unfolding before him. His proximity to Cole's signature may reflect the artist's self-identification with this figure who ponders the course of the empire. At the edge of the large fountain in the foreground, the means by which the empire's glory was achieved, as well as a portent of impending doom, is conveyed by two fighting boys, one of whom is in the process of sinking his smaller companion's toy ship.[60] The moral of *The Consummation of Empire* was not lost on a critic for the *New-York Mirror,* who wrote:

> This splendid picture represents man's attainment of a high state of comparative perfection: but we see the causes of *decline* and *fall* upon the face of it. Mingled with the triumph of art is the triumph of the conqueror, and with the emblems of peace and religion we see the signs of war and display of pride and vanity. The ostentatious display of riches has succeeded to the efforts of virtuous industry, and the study of nature and truth. We see that man has attained power without the knowledge of its true *use;* and has already abused it.[61]

The Consummation of Empire proved to be the most difficult of the series for Cole, and he even made a chalk sketch for a new version on a large canvas in his studio.[62] On February 19, 1836, Cole wrote that he was considering moving on to the last picture of the series as he was "tired of the gaud & glitter of the large picture & not quite in the humour for the tumult of the fourth."[63] Recognizing Cole's need of a respite from the series, Reed suggested that he paint a picture expressly for exhibition and sale at the National Academy of Design.[64] Cole agreed, and the result was his *View from Mount Holyoke, Northampton, Massachusetts, after a Thunderstorm (The Oxbow)* (Metropolitan Museum of Art, New York), which was painted over the new sketch for *The Consummation of Empire* and exhibited at the National Academy of Design in the spring of 1836.[65] On June 7, 1836, soon after Cole returned to work on *The Course of Empire,* Luman Reed died, and the completion of the series was jeopardized. Cole was reassured by Asher B. Durand that "it is the wish of all to accomplish as far as possible what Mr. Reed left unfinished and that they [Reed's family] expect you to finish your work accordingly."[66]

In *Destruction,* the prophecy of the two boys fighting over the toy ship in *The Consummation of Empire* has been fulfilled. The empire that previously achieved glory by conquering other civilizations is now vanquished and destroyed in its turn. The human agents of destruction are matched by the reappearance of the forces of nature, manifested in the ominous thunderclouds, the raging fires, and the storm-tossed harbor, which have a destructive power equal to that of the battling armies. The galleys that had previously returned triumphant from conquest in *The Consummation* now burn and sink in the harbor, while the temple porch at the far left serves as the emplacement for a catapult. Finally, the bridge that had supported the victorious returning soldiers collapses under the weight of the clashing armies and serves as an appropriate symbol of the empire's fall. Surveying this scene, a critic for the *New-York Mirror* concluded: "Such is the merited downfall of all the empires which the earth has heretofore known. They have been founded in ignorance; erected by injustice; finished by tyranny; and overthrown by the causes which raised them."[67]

As with *The Consummation of Empire,* Cole appears to have drawn upon numerous sources for *Destruction.* Wolfgang Born has cited Robert Burford's panorama *Pandemonium* (which was on view when Cole was in London in 1829), pointing to the compositional similarities in the distribution of the buildings, water, figures, and the placement of a large statue at the right corner. Burford's panorama was itself based on John Martin's mezzotint illustrations to John Milton's epic poem *Paradise Lost* (1667), which were widely circulated and would also have been available to Cole.[68] Another convincing visual source for *Destruction* was Martin's mezzotint *The Fall of Babylon* (1831), which includes grand architectural elements and prominent foreground figures engaged in melodramatic acts of violence, passion, and suffering.[69] The dramatic storm that engulfs the city in *Destruction* may have been derived from another English source, Turner's *Snowstorm: Hannibal and His Army Crossing the Alps* (Tate Gallery, London) of 1812. Cole saw this painting in Turner's London studio in 1829 and especially admired its "powerful effect of chiaroscuro."[70] For the battle scenes, Cole may have been influenced by engravings after tapestries designed by Rubens and Pietro da Cortona which depicted the history of Constantine the Great.[71] Parry also has suggested that the foreground figure of a shrouded woman mourning her dead son was inspired by a similar grouping in Gericault's *The Raft of the "Medusa"* (Louvre, Paris) of 1819.[72] Finally, the man with a torch at the

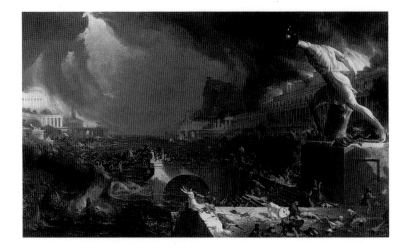

Plate 9

Destruction

Oil on canvas (lined), 39¼ × 63½"

Signed and dated bottom right: T. Cole / 1836. Inscribed on wood backing panel: Thomas Cole / N. York.

Gift of the New-York Gallery of the Fine Arts, 1858.4

base of the colossal statue appears to have been adapted from an antique frieze, reproduced in James Stuart and Nicholas Revett's *The Antiquities of Athens* (1762).[73] Even while working on *Destruction* in his Catskill studio, Cole continued to search for additional models for the painting, and on June 7, 1836, he wrote to Asher B. Durand to request several plaster casts:

I am indeed much in want of a horse. "A horse a horse a kingdom for a horse." I do not want a tame pony holding up one foot to shake hands with you; but a horse rampant, rearing. . . . If you cannot obtain a horse for me will you get a *man.* The little fighting gladiator—he or the horse I must have.[74]

These plaster casts may have served as the models for the white horse on the collapsing bridge and the colossal statue of the warrior at the right.

While in Cole's *1st Sketch for the 4th Picture of the Course of Empire* (Detroit Institute of Arts) of about 1835–36 the lower right corner is occupied by an enormous fountain in the shape of a seated lion, in the final composition this motif is reduced in scale, and the scene is dominated by the colossal statue of an armed warrior, whose pose is derived from the antique sculpture known as the *Borghese Warrior* (Louvre, Paris).[75] Significantly, the pose echoes that of the primitive hunter in *The Savage State,* thus allowing Cole to contrast the use of arms for sustenance and the glorification of their use in warfare. Cole's signature on the base of the shattered statue, inscribed in an "antique" script and placed where one might expect to find the signature of the sculptor, may have been intended to express his strong degree of identification with the arts—to which he gave such prominence in *The Pastoral or Arcadian State,* refined in *The Consummation of Empire,* and which are here destroyed by war.

Summarizing his progress on *Destruction* in a letter to Durand on August 30, 1836, Cole wrote: "For my part I have been engaged in Sacking & Burning a City ever since I saw you & I am well nigh tired of such horrid work. I have about *finished* the City & a picture at the same time. . . . I DID believe it was my best picture but I took it down stairs to day & I got out of the notion. . . . I am about commencing the fifth & last picture of the series. I hope it will not take so great a length of time as the last or I shall be ruined. The last altogether has taken me three months. I have yet to do something at the other three."[76]

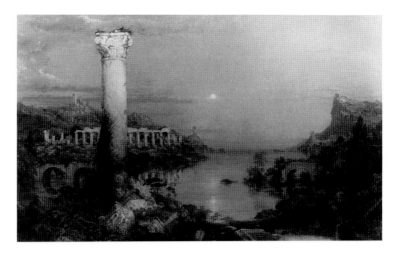

DESOLATION

Desolation, Cole's fifth and final painting for *The Course of Empire,* depicts the aftermath of the violent scene of *Destruction* and the twilight of the civilization. The remnants of the temples, bridge, lighthouses, and the other ruins of the once great empire are seen in autumn, just after sunset and illuminated by the light of the moon above the horizon. As a painting of classical ruins, *Desolation* partakes of the romantic tradition of using ruins as the focal point for reflection on the temporality of man and his works. *Desolation,* however, also reflects the influence of Cole's firsthand experience of ancient ruins in Europe, particularly as reflected in two sketches, one real and one ideal. In his sketch *Temple of Serapis, Pozzuoli* (Detroit Institute of Arts) of 1832, he depicted three ancient columns surrounded by water. As Parry has noted, these columns, scarred by ancient waterlines and mollusks, were cited and illustrated in Sir Charles Lyell's *Principles of Geology* (1830) as proof of geological change over time.[77] This theory is even more dramatically illustrated in Cole's imaginary composition *Ruins, or the Effects of Time* (Detroit Institute of Arts) of about 1832–33, which includes a whole line of columns traversing a large body of water to the horizon, as well as a pyramid, a volcano, a bridge over a dry riverbed, aqueducts, and a fountain. This sketch anticipates *Desolation* in both its general theme and composition, as well as in details, such as the prominent column in the left center foreground and the fountain flowing into a broken cistern at the lower right corner.[78]

Both Cole's sketches and the completed painting convey his belief that nature ultimately is triumphant over man, a theme that is symbolized by the juxtaposition of the crumbling ruins that are assimilated into the landscape and the enormous boulder that remains precariously balanced on a distant mountain peak throughout *The Course of Empire.* The solitary column that previously had supported a palace or a temple now has a

small lizard crawling up its face and serves as a nesting place for a pair of herons. Similarly, a buck and doe forage near the water before the remnants of the Doric temple, thus symbolically resurrecting the deer hunted down in *The Savage State* and commemorated in the pediment frieze in *The Consummation of Empire*. The presence of these creatures among the ruins offers a striking parallel with a passage describing the ruins of ancient Palmyra in Volney's *The Ruins: or a Survey of the Revolutions of Empires*:

> The palaces of the kings are become the receptacle of deer, and unclean reptiles inhabit the sanctuary of the Gods. . . . What glory is here eclipsed, and how many labours are annihilated! . . . Thus perish the works of men, and thus do nations and empires vanish away![79]

Cole's inclusion of two male and female pairs, the nesting herons and the foraging deer, also recalls the pairs of animals spared from the Biblical deluge and confirms Cole's faith in the regenerative powers of nature. Similarly, it is possible to see in the cruciform structure of the single vertical column and the horizontal temple arcade a symbolic reconsecration of the landscape by the forces of nature.

On September 12, 1836, as Cole neared completion of *The Course of Empire,* he wrote to Durand: "I wrote some time ago a short poem (if I may dignify anything I write with such a title) as a tribute to the memory of our lost friend."[80] The poem to which he referred, "Lines occasioned by the death of Mr. Luman Reed," is the most elaborate of at least three poems Cole composed as tributes to his friend and patron, and some of its imagery offers interesting parallels with *The Course of Empire*:

> For thine is not the ruthless conqueror's claim
> A proud renown inscrib'd in blood and wrong
> Upon men's hearts with wonder and fear;
> But dwelleth in our memory a living light
> To cheer art and to illumine and to guide
> Us who linger mid the shades of life—
>
> O bright example of superior worth!
> Would that the world did turn to such as thee
> T' admire and emulate and leave the gaud
> The ostentation and the baleful glare.
> Of those who mounted in Ambition's Car
> Like pestilential meteors swiftly rush

> Through the applauding multitudes of men
> To dazzle and destroy—
> Thy life of peace
> Was like the summer cloud that rose at morn
> To grace the earth and as the day advanced
> Increas'd in beauty; 'till the setting sun
> Wrapp'd it in splendour ere the night was come.[81]

Cole's imagery of "ruthless conquerors" and those "mounted in Ambition's Car" who "rush through the applauding multitudes of men to dazzle and destroy" recalls the victorious leader riding in a chariot in the triumphal procession of *The Consummation of Empire*. In contrast, his likening of Luman Reed to an element of nature, "the summer cloud" that is beautiful and transcendent, is reminiscent of the triumph of nature over conquerors and their empires in *The Course of Empire*.

Soon after composing his poem, Cole finished *The Course of Empire* and inscribed both the wood backing panel and a paper label on the back of *The Consummation of Empire* with further tributes to Reed. The paper label is inscribed:

> This picture with four others constitute a / Series called The Course of Empire—they were / painted for Mr. Luman Reed of N. York; but / I had to lament his death before the work was / completed—In him I lost a noble friend & the / Fine Arts a true lover & liberal patron—/ Thomas Cole / Cedar Grove / near Catskill / Sept 29th 1836.

Cole thus appears to have intended *The Course of Empire* to serve as a lasting memorial to Reed, both as a friend and as a patron of the fine arts.

<u>EXHIBITION</u>

After three years of work by Cole and a cost to Reed and his family of four thousand five hundred dollars, *The Course of Empire* was completed early in October of 1836.[82] Later in the same month, the five paintings were placed on public view at the National Academy of Design in Clinton Hall at the corner of Nassau and Beekman streets, where they remained until the second half of December.[83] Cole had a descriptive brochure printed, and fifty cents was charged for admission, although a "season ticket" could be purchased for one dollar.[84] As Luman Reed's son-in-law Theodore Allen reported to Cole at the end of December, the exhibition

proved to be a great financial success:

> The total receipts are the snug sum of One Thousand and two hundred & eighty nine dollars, which will clear for you nearly $1000. in cash and a Million in fame. It has been from what I can learn the most successful exhibition of the works of a single American artist, ever held in this city.[85]

As for the critical and public reception of his series, Cole previously had warned Luman Reed in May of 1836 that he would be "disappointed in the reception and notice my pictures will receive from the public. . . . Very few will understand the scheme of them, — the philosophy there may be in them." In fact, Cole was pleasantly surprised, recording in his journal on October 29, 1836, "they seem to give universal pleasure."[86]

Eight years later, when *The Course of Empire* was placed on view at the newly founded New-York Gallery of the Fine Arts, a critic for the *Broadway Journal* was an exception in criticizing the very conception of Cole's series. Contrasting *The Course of Empire* with the unaffected simplicity of Cole's *Sunset, View on the Catskill* of 1833, he argued that the series was too didactic and did not permit the viewer sufficient latitude for free association:

> The pictures in themselves are truly beautiful, but the plan of them is against nature. Their beauty is marred by being seen together. We perceive directly that we are imposed upon. Instead of looking upon beautiful landscapes, we discern that they are sermons in green paint; essays in gilt frames. . . . they affect a moral character which landscapes can never have.[87]

The writer James Fenimore Cooper, on the other hand, observed in 1849 that for America it was "quite a new thing to see landscape painting raised to a level with the heroic in historical composition." He praised Cole for his "efforts to unite the moral and intellectual in landscape painting."[88]

The majority of critics accepted the didactic nature of *The Course of Empire* as a characteristic of the grand tradition of history painting and focused their debate on its message, not its means. Many of these critics accepted as a given Bishop Berkeley's prophecy "Westard the course of empire takes its way" and believed that America was destined to replace the European powers as the next great empire on earth. Some Americans, however, resisted the implicit warning that political, moral, and ethical complacency could lead the country to the same fate as Cole's imaginary empire. In his review of *The Course of Empire* a critic for the *New-York Mirror* contrasted the inevitable fate of past empires with the unbounded future promise of the American democratic republic:

> The climax in the course of man's progress, which Mr. Cole has here represented, is *that* which *has been,* and was founded on the usurpation of the strong over the weak: the perfection which man is hereafter to attain, will be based upon a more stable foundation: political equality; the rights of man; the democratick principle; the *sovereignty of the people.*[89]

In another review, a critic for the *New-York Mirror* marshaled as allies not only democracy but also the forces of philosophy and religion to argue for the future perfectibility of mankind in America:

> [Cole] has accomplished his object: which was to show what *has been* the history of empires and of man. Will it always be so? Philosophy and religion forbid! Although such as the painter has delineated it, the fate of individuals *has been,* still the progress of the species is continued, in the road to greater *and greater* perfection.[90]

Cole's own view of America's future was more ambivalent and was expressed not only in the cyclical nature of *The Course of Empire* (he almost added the words 'sic transit gloria mundi' to his advertisements for the series),[91] but also in his private journal in August of 1836 as he neared the completion of the series:

> I often think that the dark view of things is perhaps the true one. If such a view were always presented, I doubt whether we could long survive. But heaven has granted us a sunshine of the heart, that warms these barren cold realities of existence, and dazzles and deceives, perhaps, that we may live.[92]

It was, in fact, at about this time that Cole's growing critical and financial success, enhanced by *The Course of Empire,* permitted him to retreat from the "barren cold realities of existence." With his marriage three months later to Maria Bartow, he abandoned New York to take up permanent residence in the small town of Catskill, New York.[93] Cole also joined the Episcopal church at about this time, and in the ensuing years, he sought solace in religion. His growing religious sentiments were expressed artistically in the four canvases of *The Voyage of Life* (Munson-Williams-Proctor Institute, Utica, N.Y.) of 1840, which were commissioned by the New York banker Samuel Ward and may be seen as religious counterparts to the largely secular *The Course of Empire.*[94]

PROVENANCE: Luman Reed, New York, d. 1836; Mrs. Luman Reed, New York, 1836–44; NYGFA, 1844–58.

EXHIBITED: NAD, Oct.–Dec., 1836; NYGFA, 1844, nos. 14–18, *The Course of Empire;* 1845, 1846, 1848, nos. 6–10; 1850, nos. 7–11; Boston Athenaeum, 1854, nos. 58–62, *The Course of Empire;* 1855, nos. 42–46; 1856, nos. 213–17; 1857, nos. 76–80; Washington Exhib. NYGFA, 1853, nos. 119–23, *The Course of Empire.*

REFERENCES: Dunlap, 1834, 2, p. 366; *New-York Mirror* 12 (Dec. 6, 1834), p. 179, and (April 18, 1835), p. 330; *New York Evening Star, for the Country,* March 1, 1836, p. 2; *New-York Mirror* 13 (April 2, 1836), p. 318; Reed Inventory 1836, "5 Stages of Empire (Cole)," $2,500; Thomas Cole, *Now Exhibiting at the National Academy, Clinton Hall, Cole's Pictures of the Course of Empire* (New York, 1836); *New-York Mirror* 14 (Oct. 22, 1836), p. 135, and (Oct. 29, 1836), p. 142; *Albany Argus,* Oct. 20, 1836, p. 2; *American Monthly Magazine* n.s. 2 (Nov. 1836), pp. 513–15; *Knickerbocker* 8 (Nov. 1836), pp. 629–30; *New-York Commercial Advertiser,* Nov. 2, 1836, p. 3; *New-York Mirror* 14 (Nov. 4, 1836), p. 150; *New-York Commercial Advertiser,* Nov. 5, 1836, p. 2, Nov. 7, 1836, pp. 2–3; *New-York Mirror* 14 (Nov. 12, 1836), p. 158; *New-York Mirror* 14 (Dec. 31, 1836), p. 215; James Silk Buckingham, *America, Historical, Statistic and Descriptive* (3 vols., London and Paris: Fisher, Son & Co., 1841), 1, pp. 213–16; William Cullen Bryant, *A Funeral Oration . . .* (New York: D. Appleton & Co., 1848), pp. 23–24; *Exhibition of the Paintings of the Late Thomas Cole, at the Gallery of the American Art-Union* (New York: Snowden & Prall, 1848), p. 20, no. 54 (on view at the New-York Gallery of the Fine Arts); Noble 1853, pp. 139–43, 175–79, 194, 197, 203–6, 211–23, 224–35, 353, 358; Tuckerman 1867, pp. 228, 230–31; Christopher Tunnard, "Reflections on *The Course of Empire* and Other Architectural Fantasies of Thomas Cole, N.A.," *Architectural Review* 104 (Dec. 1948), pp. 291–94. Marshall Davidson, "Whither the Course of Empire," *American Heritage* 8 (Oct. 1957), pp. 52–61, 104; Alan P. Wallach, "The Origins of Thomas Cole's *Course of Empire,*" M.A. thesis, Columbia University, 1965; Howard S. Merritt, "*A Wild Scene,* Genesis of a Painting," in Baltimore Museum of Art, *Annual II: Studies on Thomas Cole, An American Romanticist* (Baltimore: Baltimore Museum of Art, 1967); Alan P. Wallach, "Cole, Byron, and *The Course of Empire,*" *Art Bulletin* 50 (Dec. 1968), pp. 375–79; Ellwood C. Parry III, "Thomas Cole's 'The Course of Empire': A Study in Serial Imagery," Ph.D. diss., Yale University, 1970; John Hollander, "Landscape's Empire," *Prose* 2 (1977), pp. 79–93; Koke 1982, 1, pp. 192–203; Ellwood C. Parry III, "Looking at Art: A Cast of Thousands," *Art News* 82 (Oct. 1983), pp. 110–12; Parry 1988, pp. 131–187.

Plate 11

ASHER BROWN DURAND (1796–1886; after Gilbert Stuart)

Mrs. George Washington (Martha Custis née Dandridge). 1835

Oil on canvas, painted oval, 26¼ × 21½″

Gift of the New-York Gallery of the Fine Arts, 1858.38

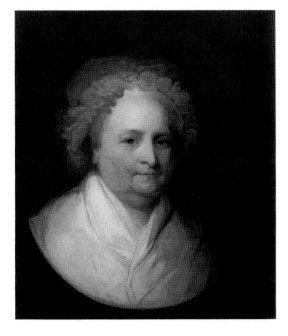

Plate 12

ASHER BROWN DURAND (after Gilbert Stuart)

George Washington. 1835

Oil on canvas, 34½ × 24″

Gift of the New-York Gallery of the Fine Arts, 1858.32

Asher B. Durand's series of oil portraits of the first seven presidents of the United States and Mrs. George Washington represented his first major commission from Luman Reed. In many respects Durand was the ideal choice for this commission; for he had considerable experience depicting the presidents. Several future presidents were included in his engraving (1820–23) after John Trumbull's *The Declaration of Independence, July 4, 1776* (Yale University Art Gallery, New Haven) of 1787–1820. The print established his reputation as an engraver. Durand later made engravings after Gilbert Stuart's "Athenaeum" portrait of *George Washington* (1833), Thomas Sully's portrait of *John Quincy Adams* (1825), and John Vanderlyn's portrait of *Andrew Jackson* (1828).[95] In 1832, George P. Morris, editor of the *New-York Mirror,* commissioned a series of presidential portraits, which were then engraved by John William Casilear and published in the *Mirror* in 1834. Durand painted three of the seven portraits: *George Washington*, after the famous portrait by Gilbert Stuart then in the Boston Athenaeum; *Thomas Jefferson,* after Thomas Sully's full-length portrait at West Point; and *James Madison,* painted from life at Montpelier, Madison's residence in Virginia.[96]

According to John Durand, the artist's son, the series of presidential portraits for Luman Reed began modestly with a commission for a portrait of Andrew Jackson. Early in 1835, when Durand went to Washington to paint a portrait of Senator Henry Clay of Kentucky, Reed wrote to President Jackson (whom he had met during a trip to Washington in 1831) and requested that he also sit for a portrait.[97] After surmounting

Plate 13

Plate 14

ASHER BROWN DURAND (after Gilbert Stuart)

John Adams. 1835

Oil on canvas, 30 × 25″

Gift of the New-York Gallery of the Fine Arts, 1858.6

ASHER BROWN DURAND (after Gilbert Stuart)

Thomas Jefferson. 1835

Oil on canvas, 30¼ × 25″

Gift of the New-York Gallery of the Fine Arts, 1858.9

the obstacles presented by the White House staff and obtaining Jackson's cooperation, Durand related further difficulties in a letter to Reed dated March 12, 1835:

> For a whole fortnight I have been able to obtain only two sittings of the President. . . . Since writing the above I have had another half-sitting, but under such unfavorable circumstances that I fear I shall not be able to satisfy myself: he smokes, reads, and writes, and attends to other business while I am painting, and the whole time of a sitting is short of one hour; but all say that I have an excellent likeness; . . . however, it is not good enough to satisfy me. The General has been part of the time in a pretty good humour, but sometimes he gets his "dander up."[98]

Alerted by Durand to the fortuitous presence of John Quincy Adams in Washington, Reed extended his original commission to include all the presidents up to that time. On March 11, he wrote:

> I am rejoiced to think that I am to have the portrait of our worthy President & hope I may not be disappointed in that of Mr. Adams. I am anxious that these two portraits should be the standard portraits of the Nation and I wish you to take every possible pains to give a perfect identity without regard to time or expense. I intend to make presents of them to one of our publick institutions of Science and Natural History. . . . I shall want you to make facsimiles of each so that both will be original & the same of all the previous Presidents from Stewart [Gilbert Stuart].[99]

Plate 15

ASHER BROWN DURAND (after Gilbert Stuart)

James Madison. 1835

Oil on canvas (lined), 30¼ × 25¼″

Gift of the New-York Gallery of the Fine Arts, 1858.10

Plate 16

ASHER BROWN DURAND (after Gilbert Stuart)

James Monroe. 1835

Oil on canvas, 30¼ × 25¼″

Gift of the New-York Gallery of the Fine Arts, 1858.8

Between March 12 and 20, 1835, Durand obtained eleven hours of sittings from John Quincy Adams, who termed the resulting portrait "perhaps the best likeness ever taken of me."[100]

In pursuit of additional presidential portraits, Reed, his son-in-law Theodore Allen, and Durand journeyed to Boston, arriving on May 31, 1835. The following day they called upon John Quincy Adams, who not only lent Durand Gilbert Stuart's portrait of John Adams (1799) but also agreed to sit for a second portrait.[101] With a letter of introduction from Thomas Cole, Reed, Durand, and Allen also called upon Washington Allston several times during their trip.[102] Reed had hoped to obtain one of Allston's paintings for his gallery, but he and Allen departed for New York on June 11 with only the artist's promise to carry out the commis-

sion after he had fulfilled his current obligations, which included the monumental *Belshazzar's Feast* (Detroit Institute of Arts) of 1817–43.[103] Durand, however, remained in Boston, and his portrait commission progressed rapidly. On June 10, 1835, he wrote:

> The head of President John Adams . . . is almost done and so is the one of John Quincy Adams which will be an entirely new portrait and I hope much better than the one I did at Washington. I shall begin those of Washington & his Lady immediately. . . . no inconvenience shall interfere in accomplishing the wishes of Mr. Reed, who seems to think of nothing else while here but to promote my best interests. You will smile to know that he assures me I shall yet be able to ride in my own carriage!!![104]

CATALOGUE · 143

Plate 17

Plate 18

ASHER BROWN DURAND

John Quincy Adams. 1835

Oil on canvas (lined), 30¼ × 25¼"

Gift of the New-York Gallery of the Fine Arts, 1858.7

ASHER BROWN DURAND

Andrew Jackson. 1835

Oil on canvas (lined), 30 × 25"

Gift of the New-York Gallery of the Fine Arts, 1858.11

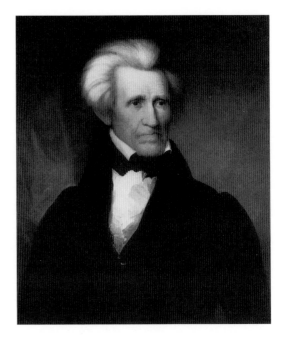

To facilitate the copying of Gilbert Stuart's famous Athenaeum portraits of George and Martha Washington, Durand rented a "chamber in the upper story" of the Boston Athenaeum.[105] Alternating between sittings at this studio and the Adams home in Quincy, Durand quickly completed the portraits of John Adams, John Quincy Adams, and Martha Washington, as well as two portraits of George Washington.[106] Before returning to New York, he also completed five life portraits, including one of John Quincy Adams's granddaughter Georgiana Frances, which was a gift from Reed to the ex-president.[107]

In the months following his work in Washington and Boston, Durand made several other trips to complete the first set of presidential portraits. His portrait of Thomas Jefferson was copied from Gilbert Stuart's life portrait of 1805, then temporarily in Philadelphia but owned by Jefferson's daughter Martha Randolph of Edgehill, a family plantation near Monticello.[108] In October of 1835, Durand copied a portrait of James Madison at Bowdoin College in Brunswick, Maine, and then set out for Baltimore, where he copied a portrait of James Monroe owned by Lloyd N. Rogers.[109]

Reed received the presidential portraits toward the end of November 1835 and spent several weeks rehanging his art gallery in order to accommodate the eight new works.[110] At about the same time, Durand completed a duplicate set of the presidential portraits (omitting the

portrait of Martha Washington), and Reed decided which of the "public institutions of Science and History" he had selected as its recipient—the United States Naval Lyceum in the New York [Brooklyn] Navy Yard. Like Reed's own collection, the lyceum housed a library as well as seashells, minerals, and other scientific collections.[111] This juxtaposition of art and science in a single museum had its most famous American precedent in Charles Willson Peale's museum in Independence Hall in Philadelphia, which housed both scientific collections and portraits of Presidents Washington, John Adams, Jefferson, John Quincy Adams, and other American notables.[112]

On December 14, 1835, Reed wrote to Commodore Charles G. Ridgely, president of the lyceum:

> I respectfully request the acceptance, by the United States' Naval Lyceum, of the accompanying portraits of the PRESIDENTS of the UNITED STATES. I shall feel honored in their reception by an institution, whose objects are so important and interesting, and whose character is so truly national.[113]

In acknowledging Reed's gift and informing him that he had been elected a corresponding member, the lyceum's secretary echoed the nationalistic sentiments that motivated Reed's gift: "the contemplation of them must preeminently contribute to give a yet loftier impulse to patriotism and a more ardent impetus to the suggestions of an ennobling ambition."[114]

PROVENANCE: Luman Reed, New York, d. 1836; Mrs. Luman Reed, New York, 1836–44; NYGFA, 1844–58.

EXHIBITED: NYGFA, 1844, no. 48, *Portrait of Mrs. Washington, wife of Washington*; 1845, 1846, 1848, no. 32; 1850, no. 26; Washington Exhib. NYGFA, 1853, no. 63, *Portrait of Mrs. Washington*; NYGFA, 1844, no. 56, *Washington*; 1845, 1846, 1848, no. 44; 1850, no. 4; Washington Exhib. NYGFA, 1853, no. 37, *Portrait of Washington*; NYGFA, 1844, no. 59, *Portrait of President Adams, (the elder)*; 1845, 1846, 1848, no. 46; 1850, no. 39; Washington Exhib. NYGFA, 1853, no. 140, *Portrait of John Adams*; NYGFA, 1844, no. 53, *Portrait of President Jefferson*; 1845, 1846, 1848, no. 61; 1850, no. 12; Washington Exhib. NYGFA, 1853, no. 128, *Portrait of Jefferson*; NYGFA, 1844, no. 39, *Portrait of President Madison*; 1845, 1846, 1848, no. 2; 1850, no. 28; Washington Exhib. NYGFA, 1853, no. 74, *Portrait of James Madison*; NYGFA, 1844, 1845, 1846, 1848, no. 12, *Portrait of President Monroe*; 1850, no. 27; NYGFA, 1844, no. 20, *Portrait of President Adams, (John Quincy)*; 1845, 1846, 1848, no. 17; 1850, no. 44; Washington Exhib. NYGFA, 1853, no. 124, *Portrait of J. Q. Adams*; NYGFA, 1844, no. 47, *Portrait of President Jackson*; 1845, 1846, 1848, no. 21; 1850, no. 19; Washington Exhib. NYGFA, 1853, no. 91, *Portrait of Andrew Jackson*.

REFERENCES: Reed Inventory 1836, "Seven portraits of the Presidents of U. States," $525.00; Durand 1894, pp. 107–14; NYHS, *Catalogue of American Portraits in The New-York Historical Society* (2 vols., New Haven: Yale University Press, 1974), 1, p. 5 (John Adams); pp. 6–7 (John Quincy Adams); pp. 386–87 (Andrew Jackson); pp. 399–400 (Thomas Jefferson); 2, p. 514 (James Madison); p. 547 (James Monroe); p. 859 (George Washington); p. 866 (Mrs. George Washington).

Plate 19

ASHER BROWN DURAND

Peter Stuyvesant and the Trumpeter (*The Wrath of Peter Stuyvesant*). 1835

Oil on canvas, 24 × 34½"

Stenciled on verso: R & M 14.48 / Prepared by / Roberson & Miller /

51 Long Acre, London.

Gift of the New-York Gallery of the Fine Arts, 1858.28

Asher B. Durand began his first genre picture for Luman Reed, *Peter Stuyvesant and the Trumpeter,* around September 1835.[115] In November, Reed reported the receipt of the painting to William Sidney Mount: "I have got home Durand's 'Peter Stuyvesant.' I consider it a great stride for the first attempt, it shows great feeling, but you must see it."[116] Durand's subject was derived from an incident that occurred during the Dutch colonial period of New York history. Ignoring prior Dutch claims to the region of the Delaware River, in 1638 a Swedish expedition erected Fort Christina on the site of the present city of Wilmington and named the territory New Sweden. In 1651, Director-General Peter Stuyvesant of

New Netherland ordered the construction of Fort Casimir at a nearby site, but the Swedes captured the Dutch fort in 1654. Under orders from the Dutch West India Company, Stuyvesant sailed from New Amsterdam in September of 1655 and forced the Swedes to surrender both forts, thus ending Sweden's attempts to colonize North America.[117]

The scene, in which Governor Stuyvesant first learns of the capture of Fort Casimir by the Swedes, was not drawn from historical documents, but rather from Washington Irving's satirical *A History of New York, from the Beginning of the World to the End of the Dutch Dynasty* (1809):

> On receiving these direful tidings, the valiant Peter started from his seat, . . . he dashed the pipe he was smoking against the back of the chimney . . . pulled up his galligaskins, and strode up and down the room, humming, as was customary with him, when in a passion a hideous north-west ditty. . . . His first measure after the paroxysm of wrath had subsided, was to stump up stairs, to a huge wooden chest, which served as his armoury, from whence he drew forth that identical suit of regimentals described in the preceding chapter. . . . Being hastily equipped, he thundered down into the parlour like a second Magog—jerked down his trusty sword, from over the fire place, where it was usually suspended. . . . Thus armed at all points . . . he . . . dispatched Anthony Van Corlear . . . summoning by sound of trumpet his trusty peers to assemble in instant council."[118]

Durand followed Irving's text closely in several respects. Above the fireplace at the left is Stuyvesant's sword, while the smashed clay pipe and an overturned footstool by the hearth convey the violent nature of the governor's wrath. Dirk Schuyler, the bearer of the bad tidings, recoils at the governor's rage, while a bemused Anthony Van Corlear stands with

his trumpet at the ready, awaiting his orders to summon the council.

In his memorial address of 1887 for the recently deceased Durand, Daniel Huntington stated that the figures of Peter Stuyvesant, Dirk Schuyler, and Anthony Van Corlear were caricatures of Reed, Durand, and Thomas Seir Cummings respectively.[119] The artist's son John Durand, however, seems to have contradicted Huntington by stating that the painting was "imaginary in all respects."[120] Durand's depiction of Stuyvesant bears little physical resemblance to his portrait of Reed (New-York Historical Society), and it seems more likely that he was inspired directly or indirectly (through Irving's description) by a full-length portrait that "still hangs up in the family mansion of the Stuyvesants." According to Irving, this portrait depicted Stuyvesant with "his face rendered exceedingly terrible and warlike by a pair of black mustachios," a "regimental coat of German blue, gorgeously decorated with a goodly shew of large brass buttons," a "sumptous pair of brimstone coloured trunk breeches," and a "wooden leg inlaid with silver."[121]

Durand's depiction of the other two protagonists also seems to follow Irving's text. Irving described the part-Indian Dirk Schuyler as "a tall, lank fellow, swift of foot and long-winded. He was generally equipped in a half Indian dress, with belt, leggings, and moccasons. His hair hung in straight gallows locks, about his ears, and added not a little to his shirking demeanor."[122] Anthony Van Corlear was described as "a jolly, fat dutch trumpeter, of a pleasant burley visage—famous for his long wind and his huge whiskers."[123] Durand's desire for accuracy also led him to include a period map of New Amsterdam on the wall, as well as several anachronistic pieces of eighteenth-century furniture that were no doubt intended to approximate an interior of the seventeenth century.

It has long been recognized that Irving's *A History of New York* was intended as a thinly veiled criticism of contemporary New York society, politics, and institutions.[124] However, such allusions were secondary in importance to the book's contributions to American culture. In a country of which Chateaubriand had written, "there is nothing old in America but the woods," both Irving's and Durand's works may be seen as attempts to create a uniquely American history (or even mythology) and thus establish a national identity independent from that of Europe. The actor James H. Hackett, whose career was made possible by Reed's financial and moral support, participated in this process by bringing Irving's *A History of New York* to the stage in 1837.[125] This growing sense of national pride and a desire to see American history accorded proper respect made a critic for the *New-York Mirror* sensitive to the fine line between humor and satire in Durand's *Peter Stuyvesant and the Trumpeter*:

This is a richly-coloured and strongly-designed picture, full of the spirit of fun which pervades the work it tends to illustrate. It is questionable with us, whether a character of historical merit . . . should be made the subject of the grotesque either in writing or painting. The expression given by the painter to the old governour is extremely fine, and the consequential trumpeter equally good; perhaps the long man in the background is rather *ultra*.[126]

Durand was sufficiently taken with Irving's portrayal of Stuyvesant to undertake a second subject, *Dance on the Battery in the Presence of Peter Stuyvesant* (Museum of the City of New York) of 1838, which was exhibited at both the National Academy of Design in 1838 and at the New-York Gallery of the Fine Arts in 1844 with a quotation from Irving's *A History of New York*. Durand's two paintings of the Dutch governor almost certainly inspired John Quidor's *Anthony Van Corlear Bro't in Presence of Peter Stuyvesant* (Munson-Williams-Proctor Institute, Utica, N.Y.), which was exhibited at the National Academy of Design in 1839.

PROVENANCE: Luman Reed, New York, d. 1836; Mrs. Luman Reed, New York, 1836–44; NYGFA, 1844–58.

EXHIBITED: NAD, 1836, no. 71, *Peter Stuyvesant and the Trumpeter*; NYGFA, 1844, no. 32, *Wrath of Peter Stuyvesant on learning the capture, by treachery, of Fort Casimir*, with a quotation from Washington Irving's *A History of New York*; 1845, 1846, 1848, no. 27; 1850, no. 42; Washington Exhib. NYGFA, 1853, no. 52, *Wrath of Peter Stuyvesant on learning the capture, by treachery, of Fort Casimir*, with a quotation from *A History of New York*.

ENGRAVED: By John William Casilear (1811–1893). Published in Henry William Herbert, ed., *The Magnolia for 1837* (New York: Bancroft & Holley, 1836), pl. opp. p. 254, with a quotation from Washington Irving's *A History of New York*. Also published in the *Knickerbocker* 13 (Jan. 1839), frontis. and p. 83 with a quotation from *A History of New York*.

REFERENCES: *New-York Mirror* 13 (April 2, 1836), p. 318; *New York Evening Post*, April 27, 1836, p. 2; *New York Herald*, May 9, 1836, p. 2; *New York Evening Post*, May 25, 1836, p. 2; *New-York Mirror* 13 (June 4, 1836), p. 390; *Knickerbocker* 8 (July 1836), p. 113; Reed Inventory 1836, "Scene from Knickerbocker," $190.00; *Albion* n. s. 12 (March 26, 1853), p. 153; *Graham's Magazine* 45 (Oct. 1854), p. 321; Tuckerman 1867, pp. 188–89, 621; Daniel Huntington, *Asher B. Durand: A Memorial Address* (New York: Century Association, 1887), p. 26; Durand 1894, pp. 120–21; Lawall 1966, 1, pp. 173, 178–87; David B. Lawall, *Asher B. Durand: A Documentary Catalogue of the Narrative and Landscape Paintings* (New York: Garland Publishing, 1978), pp. 6–7; Koke 1982, 1, pp. 300–301.

Plate 20

ASHER BROWN DURAND

The Pedler (The Pedlar Displaying His Wares). 1835–36

Oil on canvas (lined), 24 × 34½″

Gift of the New-York Gallery of the Fine Arts, 1858.26

Asher B. Durand began *The Pedler* around November 1835, and the completed painting was exhibited at the National Academy of Design in the spring of 1836.[127] For his second genre subject for Luman Reed, Durand turned from seventeenth-century New York history to a contemporary fixture of American life, the peddler. He is depicted in a rural farmhouse with his open satchel of jewelry, ribbons, buttons, and fabric. A walking stick evokes the itinerant life of travel from town to town. At the right is an adolescent girl who holds up a bolt of striped cloth to envision a new dress. She is contrasted with her mother, who stands at the left and appears preoccupied with the baby cradled in her arms. The grandmother seated at the far left seems unaffected by the excitement of the peddler's visit and continues her needlework. At the center of the composition, a young boy gestures toward his sister, who has selected a necklace from among the peddler's wares. Their father, who wears a

bemused and indulgent expression, searches his pockets for money in order to make a purchase. In the background an African American has just entered through a door, his curiosity no doubt aroused by the peddler's presence.[128]

In an era when well-stocked retail stores were rare except in cities and large towns, the peddler was a valued source of manufactured goods in many rural areas:

> A peddler was usually welcome at the home of virtually any settler. In the first place his goods were needed, his news from the city was eagerly awaited, and isolated pioneers were glad to have company. He did not have the social status of a settled merchant, but he was by no means a tramp or a ne'er-do-well—indeed most peddlers were of respectable family background.[129]

It has been estimated that in 1850, more than 10,000 peddlers were traveling on America's Indian trails, waterways, and roadways.[130] For men of ambition, peddling could provide the stepping-stone to a successful business career.[131] Durand's depiction of a peddler would have appealed to Reed, whose father, Eliakim Reed II (1752–1830), briefly supported his family by selling his homemade baskets and axe handles door-to-door.[132] Reed began his own career as a grocer in the small town of Coxsackie, New York, and often traveled down the Hudson River to New York, where he bought and sold produce and dry goods.

According to the artist's son John Durand, *The Pedler* was "a picture of local life suggested by Wilkie's treatment of similar subjects."[133] David Wilkie's scenes of rural life in Great Britain, available in the United States through prints, greatly influenced a number of early genre painters, including William Sidney Mount.[134] Wilkie's own painting of *The Pedlar* (1814) was engraved by James Stewart in 1834 and, as an engraver himself, Durand almost certainly would have known this image.[135] Both

compositions include a seated peddler, a woman holding up a bolt of fabric, and a man who reaches into his pocket to pay for the family's purchases. Other shared characteristics include the shallow, stagelike space, the friezelike array of figures, the dramatic use of light and shadow, and the use of gesture, expression, and detail to convey a narrative. However, these latter characteristics are also found in the theater, and Durand's subject and treatment may have been influenced by contemporary plays. As Joshua C. Taylor has observed, in the formative years of the American theater, indigenous character types like the peddler served the young nation's need for a national identity and were celebrated for their independence, colorful speech, manners, and attire:

> Quite early the Yankee was identified as the itinerant peddler who traveled from place to place with a load of useful and exotic items—sometimes not what he purported them to be—that he sold at a handsome but hard-won profit. He was known as "Nutmeg" in the unbelievably complicated play *The Pedlar,* which Alphonso Wetmore wrote in St. Louis in 1821, and "Hiram Dodge" in the popular *Yankee Pedlar.*[136]

The New-York Historical Society owns a small oil study for *The Pedler,* as well as a sketchbook containing studies for the figures of the mother and infant and for the young boy standing at her left.[137] Durand's painting probably inspired his friend Francis W. Edmonds to paint *The Image Pedlar* (New-York Historical Society) of about 1844. Edmonds exhibited this work at the National Academy of Design in 1844 and then donated it to the New-York Gallery of the Fine Arts about 1845.[138]

———————

PROVENANCE: Luman Reed, New York, d. 1836; Mrs. Luman Reed, New York, 1836–44; NYGFA, 1844–58.

EXHIBITED: NAD, 1836, no. 202, *The Pedler;* Stuyvesant Institute, New York, 1838, no. 4, *The Pedlar,* lent by Mrs. Luman Reed; NYGFA, 1844, no. 50, *The Pedlar displaying his Wares;* 1845, no. 35; 1846, 1848, no. 30; 1850, no. 68.

REFERENCES: *New-York Mirror* 13 (Apr. 2, 1836), p. 318; *New York Herald,* May 19, 1836, p. 1; *New York Evening Post,* May 25, 1836, p. 2; *Knickerbocker* 8 (July 1836), p. 115; Reed Inventory 1836, "The Pedlar," $150.00; Tuckerman 1867, p. 621; Daniel Huntington, *Asher B. Durand: A Memorial Address* (New York: Century Association, 1887), p. 26; Durand 1894, p. 25; Lawall 1966, 3, pp. 68–69, 280–281; David B. Lawall, *Asher B. Durand: A Documentary Catalogue of the Narrative and Landscape Paintings* (New York: Garland Publishing, 1978), p. 7; Koke 1982, 1, p. 303.

Plate 21

GEORGE WHITING FLAGG (1816–1897)
Murder of the Princes in the Tower. c. 1833–34
Oil on canvas (lined), 56 × 44″
Gift of the New-York Gallery of the Fine Arts, 1858.48

nent patronage for Flagg.[140] In an unprecedented seven-year contract dated May 1, 1834, Flagg agreed to give Reed his entire output of paintings, excepting portrait commissions from other patrons, in return for an annual salary, studio rent, and art supplies.[141] Shortly afterward, the *Murder of the Princes in the Tower* along with a second Shakespearean subject that Reed acquired, *Falstaff Playing King,* were included in the young artist's first National Academy of Design exhibition. Flagg's choice of two Shakespearean subjects, one tragic and the other comedic, may have been intended to demonstrate the breadth of his talent, as well as his ambition to gain renown as a history painter, the area in which Washington Allston had earned his reputation. Indeed, Flagg's choice of subjects may have been influenced by Allston, who was an avid fan of the theater, owned an eight-volume set of Shakespeare's plays, and was a friend of the poet Samuel Taylor Coleridge, one of the leading Shakespeare scholars of the day.[142]

The Tragedy of King Richard III was one of the most popular of Shakespeare's plays in the early nineteenth century.[143] The play recounts the political machinations of Richard, duke of Gloucester, for the throne of England. With the death of his brother Edward IV, Richard orders the murder of the rightful heirs to the throne, the young princes Edward and Richard, who are suffocated by the henchmen Dighton and Forrest in the Tower of London. In a passage from act 4, scene 3, that was included in the catalogue when Flagg's painting was exhibited at the New-York Gallery of the Fine Arts in 1844, Sir James Tyrrel recounts for Richard the assassins' description of the murder:

In 1833, George W. Flagg ended his informal apprenticeship in the Cambridgeport, Massachusetts, studio of his uncle Washington Allston and moved to New Haven, Connecticut.[139] There he painted the *Murder of the Princes in the Tower,* a large history painting derived from William Shakespeare's *The Tragedy of King Richard III.* This work was probably the first painting by Flagg that Luman Reed acquired. The art critic and historian Henry T. Tuckerman credited it with securing Reed's perma-

> Tyrrel: . . . *O thus,* quoth Dighton, *lay the gentle babes.*
> *Thus, thus,* quoth Forrest, *girdling one another*
> *Within their alabaster innocent arms:*
> *Their lips were four red roses on a stalk,*
> *Which in their summer beauty, kiss'd each other.*

A book of prayers on their pillow lay:
Which once, quoth Forrest, *almost changed my mind:*
*But, O, the Devil,—*there the villain stopp'd.
When Dighton thus told on,*—we smothered*
The most replenished sweet work of nature,
That, from the prime creation, ere she framed.[144]

The murder of the princes in the tower was the most popular subject from *Richard III* among contemporary English painters.[145] Flagg seems to have derived his composition not only from Shakespeare's text but also from James Northcote's *The Royal Children: Dighton and Forrest, the Murderers* (Petworth House, Sussex) of 1786. Northcote's painting was purchased by John Boydell and exhibited in his famous Shakespeare Gallery in London. It was well known from the engraving by Francis Legat that was included in *The Boydell Shakespeare Prints* published in 1803. Similarities include the shallow, vertical space framed by curtains, the strong chiaroscuro created by the oil lamp held by one of the assassins, the embracing children (one frontal and one in profile), a prayer book on the bed, and a striped pillow with which the sleeping children are to be smothered.[146] While Northcote's inclusion of a crucifix, a rosary, and a royal crest emphasized that the murder of the princes was a crime against both God and country, Flagg omitted these details in favor of the more elemental drama of the innocent children victimized by the evil henchmen. Flagg's attempt to capture the conflicting emotions of Dighton and Forrest transformed the scene from one of pure physical violence to one with a strong element of psychological tension. The sympathy of the viewer would have been accentuated by the angelic, almost androgynous appearance of the two princes, who were, in fact, occasionally portrayed by girls in contemporary stage productions of *Richard III.*[147]

The most extensive review of the *Murder of the Princes* during its exhibition at the National Academy of Design in 1834 focused on Flagg's use of color:

He possesses a poetical imagination, a correct eye, a considerable knowledge already of *chiaro scuro,* and is a better draughtsman than

nine tenths of our older painters. His fault is—one which we have already reprobated some dozen times in our notices of this very exhibition—gaudiness. We do not object to the crimson mantle of the murderer,—on which, by the way, the light and shade are very well managed, the edges brightening under the glare of the lamp, while the more distant draperies fall into heavy shadows,—nor to the sandy locks of the other ruffian, the dark green curtain, or the contrast of the black tresses of one of the sleeping children to the fair curls of the other; but we must condemn the addition of a blue and buff coverlid, and a pink prayer book, displayed on the white sheets, to the already marked contrast of colors.[148]

While Flagg's use of bright colors and dramatic chiaroscuro in the *Murder of the Princes* heightened the drama of his subject, many critics believed that a subdued palette was more appropriate for history painting, citing the "old masters" as a precedent. It required a perceptive observer like Thomas Cole to see through contemporary stereotypes of these works and observe:

Many old pictures have pleasing qualities, which did not exist when fresh from the hand of the artist. We see in them a mellowness and lustre, a kind of inward light which is the effect of the touchings of time, and not of the pencil, that gave them their new being on the canvass.[149]

———————————

PROVENANCE: Luman Reed, New York, d. 1836; Mrs. Luman Reed, New York, 1836–44; NYGFA, 1844–58.
EXHIBITED: NAD, 1834, no. 87, *Murder of the Princes in the Tower;* NYGFA, 1844, no. 51, *Murder of the Princes,* with a quotation from Shakespeare, *King Richard III,* act 4, scene 3; 1845, 1846, 1848, no. 45; 1850, no. 13.
REFERENCES: *American Monthly Magazine* 3 (June 1, 1834), p. 282; Dunlap 1834, 2, pp. 449–50; Reed Inventory 1836, "Murder of Princes," $50.00; Henry T. Tuckerman, *Godey's Magazine and Lady's Book* 33 (Dec. 1846), p. 254; L. A. R., *Life Illustrated* 6 (Sept. 4, 1858), p. 147; Tuckerman 1867, p. 407; *National Cyclopaedia of American Biography* 7 (1897), p. 460; Koke 1982, 2, pp. 27–28.

Plate 22

GEORGE WHITING FLAGG

Falstaff Playing King. c. 1834

Oil on canvas (lined), 36 × 29″

Stenciled on verso: Prepared / by / Dechaux & Parmentier / Brush Makers /

No. 328½ Broad Way / New York.

Gift of the New-York Gallery of the Fine Arts, 1858.16

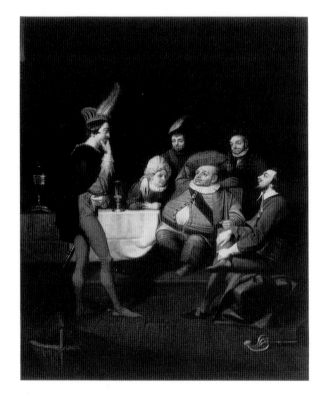

George W. Flagg's *Falstaff Playing King* of about 1834 depicts a scene from William Shakespeare's *Henry IV, Part I.* At a time when Shakespeare's reputation and popularity were in the ascendancy, Sir John Falstaff, who also appears in *Henry IV, Part II* and *The Merry Wives of Windsor,* was perhaps the most popular comic character on the English stage. Although a nobleman, Shakespeare's Falstaff is a profligate who spends most of his time in the Boar's Head Tavern, recounting martial and knightly deeds of dubious authenticity. Nonetheless, in his role as a companion for Henry, the young prince of Wales, Falstaff was a favorite with readers and audiences for the good-natured wit that provided comic relief from Shakespeare's serious themes.

Falstaff's popularity spread to America, prompting Reed's friend Washington Irving to publish a satirical essay entitled "The Boar's Head Tavern, East Cheap: A Shakespearian Research" (1819).[150] In this parody of the excesses of contemporary Shakespearean research and veneration, the narrator makes a pilgrimage to the purported site of the original Boar's Head Tavern in London and claims to have discovered an authentic relic—Falstaff's drinking cup.[151] The comic character of Falstaff was also given prominence in America by Reed's friend and protégé, the actor James H. Hackett.[152] Hackett first appeared as Falstaff in Philadelphia in 1832 and, following a successful English tour, he returned to New York, where he appeared as Falstaff in *King Henry IV, Part One* at the Park Theatre in September of 1833.[153] This performance may well have coincided with Flagg's work on his *Falstaff,* which was exhibited the following spring.

Flagg's choice of Falstaff as a subject also may have been influenced by his uncle, the artist Washington Allston, with whom he studied from 1831 to 1833.[154] Allston, an avid fan of the theater, owned an eight-volume set of Shakespeare's plays and was a friend of the poet Samuel Taylor Coleridge, one of the leading Shakespeare scholars of the day.[155] Perhaps inspired by Coleridge, Allston painted a now-lost *Falstaff Playing the Part of King* with life-size figures.[156] Flagg, however, seems to have drawn upon an earlier version of the subject painted by Robert Smirke for

John Boydell's famous Shakespeare Gallery in London. Smirke's painting (Bob Jones University Art Gallery and Museum, Greenville, S.C.) was engraved by Robert Thew and included in a published edition of *The Boydell Shakespeare Prints* in 1803.[157] The poses of both Falstaff and Prince Henry are nearly identical in Smirke's and Flagg's works.

Flagg's painting depicted act 2, scene 4 of *Henry IV, Part I,* set in the Boar's Head Tavern, where Prince Henry asks Falstaff to temporarily assume the role of his father, Henry IV:

Prince Henry: Do thou stand for my father, and examine me upon the particulars of my life.

Falstaff: Shall I? Content. This chair shall be my state, this dagger my sceptre, and this cushion my crown.

Flagg followed Shakespeare's text closely, depicting the rotund Falstaff seated at the right and surrounded by his fellow revelers. A bemused Prince Henry stands at the left and observes the impersonation. Flagg's disposition of the figures in a boxlike space lit from the front suggests the influence of theater productions, experienced either firsthand or through other works of art.

When Flagg exhibited his *Falstaff* at the National Academy of Design in 1834, the critics seemed uncomfortable with the synthesis of history painting, a category that had traditionally enjoyed the most exalted status in the fine arts, and comedy. A critic for the *New-York Mirror,* upset by the degree of caricature in Flagg's interpretation of Falstaff, argued: "The artist has mistaken the character of that fat, joyous knight. Falstaff was a gentleman by birth and education, a man of brilliant wit, and, arrant tippler as he was, not destitute of a certain species of refinement."[158] Similarly, a critic for the *American Monthly Magazine* felt that Flagg's depiction of Prince Henry lacked the decorum befitting royalty: "The figure of the Prince, is, in particular, graceless and boorish. There is none of the splendor of majesty shining through its base disguise—none of the ease or high bearing that we look for in the fifth Harry."[159]

Similar criticisms greeted Asher B. Durand's *Peter Stuyvesant and the Trumpeter* when it was exhibited at the National Academy of Design two years later.[160] However, as rustic genre subjects, William Sidney Mount's *Undutiful Boys* and *Farmer's Bargaining* were deemed appropriate for humorous treatment and were widely praised.[161] The apparent distinction made by the critics is ironic given that both Flagg's and Durand's paintings depict apocryphal scenes created by Shakespeare and Irving as comedic embellishments, not historically documented incidents. The reception of these paintings, however, may be seen as a manifestation of a transitional phase in American art in which the realism and humor of historical genre paintings threatened to undermine the status of idealized history painting in the grand manner.

PROVENANCE: Luman Reed, New York, d. 1836; Mrs. Luman Reed, New York, 1836–44; NYGFA, 1844–58.

EXHIBITED: NAD, 1834, no. 1, *Falstaff Playing King;* NYGFA, 1844, no. 41, *Falstaff, enacting Henry IV;* 1845, 1846, 1848, no. 51; 1850, no. 66.

REFERENCES: *American Monthly Magazine* 3 (May 1, 1834), p. 207; *New-York Mirror* 11 (May 10, 1834), p. 355; *New York Evening Post,* May 23, 1834, p. 2; Reed Inventory 1836, "Falstaff," $25.00; Koke 1982, 2, p. 28.

Plate 23

GEORGE WHITING FLAGG
Portrait of a Lady Sleeping. c. 1834
Oil on wood, 23¾ × 19″
Gift of the New-York Gallery of the Fine Arts, 1858.20

suggestion of impropriety, there is nonetheless a voyeuristic aspect inherent in the picture. This quality was noted in a review of the National Academy of Design exhibition of 1834 by a critic who feigned embarrassment for observing a sleeping woman in her nightshirt:

> We have still to speak of our favorite work, No. 57. Portrait of a lady sleeping—may thy dreams be pleasant lady!—so admirably is thy pouting mouth portrayed that we almost momentarily expect thy orbs of vision to unclose, and to be greeted with a blush for daring to look upon thy beauty sleeping.[162]

Flagg's painting was exhibited at the National Academy of Design with his *Murder of the Princes in the Tower,* and the two works appear to be related. The sleeping woman and the dark-haired prince have similar reclining poses, white linen nightshirts, blue ribbons tied around their necks, and Bibles on their beds. Both compositions are framed by drapery and include illuminated figures, bright colors, and strong chiaroscuro. *Portrait of a Lady Sleeping* may have inspired William Sidney Mount's nearly identical composition of 1843 entitled *Girl Asleep* (Museums at Stony Brook, New York), which was exhibited at the National Academy of Design in 1844.

While the title *Portrait of a Lady Sleeping* suggests that Flagg depicted a specific model, he did not identify her by name, and she probably should be seen as a type of female beauty. Flagg may have been encouraged in this direction by similar ideal portraits of women painted by his uncle Washington Allston. However, unlike Allston's Renaissance-inspired women, Flagg's model appears in contemporary dress. Although the woman's state of sleep and the prominent Bible serve to ameliorate any

PROVENANCE: Luman Reed, New York, d. 1836; Mrs. Luman Reed, New York, 1836–44; NYGFA, 1844–58.
EXHIBITED: NAD, 1834, no. 57, *Portrait of a Lady Sleeping;* NYGFA, 1844, no. 26, *Sleeping Female;* 1845, 1846, 1848, no. 35; 1850, no. 83; The Washington Exhib. NYGFA, 1853, no. 113, *Woman Sleeping.*
REFERENCES: *American Monthly Magazine* 3 (May 1, 1834), p. 211; *New York Evening Post,* May 23, 1834, p. 2; Reed Inventory 1836, "Sleeping Girl," $10.00; Koke 1982, 2, pp. 28–29.

Plate 24

G E O R G E W H I T I N G F L A G G

Lady Jane Grey Preparing for Execution. c. 1834

Oil on canvas, 56 × 46¼"

Gift of the New-York Gallery of the Fine Arts, 1858.36

execution in Fotheringay Castle was David Hume's *The History of England from the Invasion of Julius Caesar to the Revolution in 1688* (1754–62), a work that Flagg could have consulted in Luman Reed's library, and from which he may have derived the details of the silk and velvet dress and the blindfold that appear in his painting:

> Towards the morning, she dressed herself in a rich habit of silk and velvet, the only one which she had reserved for herself. . . . One of her maids, whom she had appointed for that purpose, covered her eyes with a handkerchief: she laid herself down without any sign of fear or trepidation; and her head was severed from her body at two strokes of the executioner.[164]

Flagg's comment that Mary was "too old" at the time of her execution "to make an interesting picture" suggests that the youth of the victim was an important element of the painting. He therefore changed the condemned woman's identity to Lady Jane Grey, who was executed when she was only seventeen. Lady Jane, the granddaughter of Henry VIII's younger sister, was by all accounts a pawn in the schemes of her father-in-law, the duke of Northumberland, who devised an illegal line of succession that placed her on the English throne following the death of Edward VI. She was queen for nine days until she was deposed by the forces of Edward's sister Mary, who was favored by the English people. Lady Jane Grey was tried for treason and beheaded in the Tower of London on February 12, 1554.

The fluidity of Flagg's creative process, which permitted him to change his subject from Mary to Lady Jane, was later identified as characteristic of his working method by his nephew, the artist Charles Noël Flagg. Describing an unfinished painting that he saw in his uncle's studio on Nantucket Island in 1890, he wrote:

In a letter dated June 16, 1834, George W. Flagg revealed to Luman Reed that his painting *Lady Jane Grey Preparing for Execution* had originally depicted Mary, the Catholic queen of Scotland: "I have changed the name of my picture to Lady Jane Gray. I find that Mary was too old at the time of her exicution [*sic*] to make an interesting picture."[163] Queen Mary, a rival for the throne held by Elizabeth I of England, was beheaded for treason in 1587 on Elizabeth's orders. The most famous historical account of Mary's

My uncle says it is to be called, "The Intercepted Letter"; but from what I know of him I am almost certain that he will change the title many times before the final completion of, not this, but some other picture upon his canvas. He works constantly and he always makes changes.[165]

In the case of his painting for Luman Reed, Flagg's change of subject suggests that his interest lay less in depicting specific historical protagonists than in capturing the romantic aura and psychological drama attending the execution of a young woman. He heightened the inherent tension of his subject by compressing the three protagonists into a tight vertical composition and by juxtaposing the executioner's gleaming axe with Lady Jane's neck. Here, as in the earlier *Murder of the Princes in the Tower,* Flagg's depiction of a young and helpless victim facing imminent death seems to have been calculated to engage the emotions and sympathy of the viewer.

Flagg's choice of subject may be attributed in part to the influence of Paul Delaroche, a French painter who enjoyed enormous success depicting scenes from the Tudor and Stuart periods in English history, and who also painted *The Execution of Lady Jane Grey* (National Gallery, London) in 1834.[166] Unlike Delaroche, who accentuated the frailty of the adolescent Lady Jane as she knelt at the chopping block, Flagg emphasized her composure, a trait noted when the painting was exhibited at the New-York Gallery of the Fine Arts in 1844 with a quotation from Hume's *The History of England:* "After uttering these words, she caused herself to be disrobed by her women; and with a *steady serene countenance* submitted herself to the executioner."[167]

Flagg's *Lady Jane Grey Preparing for Execution,* exhibited at the National Academy of Design in 1835, reveals the artist's responsiveness to criticism during this early stage of his career. Citing a review of his *Falstaff Playing King,* which was exhibited at the National Academy of Design in 1834, he wrote to Reed and reassured him that "they shant say of this picture [*Lady Jane Grey*] that there is a marvelous want of care in the finish of the picture."[168] Flagg also may have toned down his palette for *Lady Jane Grey* after reading another review of 1834 that criticized the *Murder of the Princes in the Tower* for its "gaudiness" of color.[169] The modifications of Flagg's technique were well received by the American writer Washington Irving, a friend of Reed's who provided Flagg with letters of introduction for his first trip to Europe.[170] Among these letters was one to the Scottish painter Sir David Wilkie. However, after seeing Flagg's *Lady Jane Grey,* Irving commented, "If I had seen this before I wrote to Wilkie I would have made the letter even stronger!"[171]

———————

PROVENANCE: Luman Reed, New York, d. 1836; Mrs. Luman Reed, New York, 1836–44; NYGFA, 1844–58.

EXHIBITED: NAD, 1835, no. 52, *Lady Jane Grey Preparing for Execution;* NYGFA, 1844, no. 61, *Lady Jane Grey preparing for execution,* with a quotation from David Hume's *The History of England;* 1845, 1846, 1848, no. 29; 1850, no. 17.

REFERENCES: *New-York Mirror* 12 (May 16, 1835), p. 371; *Knickerbocker* 5 (June 1835), p. 553; Reed Inventory 1836, "Lady Jane Grey," $25.00; Koke 1982, 2, pp. 29, 31–32.

Plate 25

GEORGE WHITING FLAGG

Lady and Parrot. c. 1835

Oil on canvas, 36 × 29"

Gift of the New-York Gallery of the Fine Arts, 1858.33

American Titian," and his transmission of this style to Flagg may account for the rich colors, textures, and period costume of the *Lady and Parrot*.[174] Although it is not certain whether Flagg's painting was completed before or during his first European trip (October 1834 to about June of 1835), the young artist's firsthand experience of the old masters in Europe confirmed the favorable opinion of Venetian painting that he received from Allston.[175] In a letter sent to Reed soon after his arrival in Paris, Flagg wrote of his admiration for both Titian and Veronese, terming the latter "the best painter that ever lived, for he has all the gorgeousness and truth of Rubens without any of his grossness or familiarity."[176]

During his early career as a portrait painter in Charleston and Boston, Flagg had earned a reputation for his flattering portraits of women. Years later, his friend Nathaniel Parker Willis referred to him as a "beauty-painter," and added: "He is an appreciator . . . and paints a woman as she looks to appreciators."[177] In *Lady and Parrot* Flagg accentuated his model's appeal with exotic details of costume and headdress, as well as the colorful parrot perched on her hand. Flagg's *Lady and Parrot* may have inspired a similar work by Asher B. Durand, *Il Pappagallo (The Parrot)* of about 1842, now in the collection of the New-York Historical Society. Durand's son John described *Il Pappagallo* as "an effort to treat a subject in the tone of an 'old master,'" a description that seems equally appropriate for Flagg's painting.[178]

As a "fancy" or "ideal" picture depicting a type of female beauty, George W. Flagg's *Lady and Parrot* recalls similar paintings by his uncle Washington Allston, with whom he studied from 1831 to 1833.[172] In particular, Flagg's painting resembles such works of Allston's as *Beatrice* (Museum of Fine Arts, Boston) of about 1816–19 and *Rosalie* (Society for the Preservation of New England Antiquities, Boston) of 1835, which were inspired by Venetian Renaissance compositions.[173] Allston's careful study and emulation of Venetian painting had earned him the title "the

PROVENANCE: Luman Reed, New York, d. 1836; Mrs. Luman Reed, New York, 1836–44; NYGFA, 1844–58.
EXHIBITED: NAD, 1835, no. 217, *Lady and Parrot;* NYGFA, 1844, no. 45, *Lady and Parrot;* 1845, 1846, 1848, no. 62; 1850, no. 35.
REFERENCES: *Knickerbocker* 5 (June 1835), p. 556; Reed Inventory 1836, "Lady & Parrot," $10.00; Koke 1982, 2, pp. 32–33.

Plate 26

GEORGE WHITING FLAGG
The Match Girl. 1834
Oil on canvas (lined), 30¼ × 25″
Gift of the New-York Gallery of the Fine Arts, 1858.30

cultural prejudice encountered by American artists abroad, Flagg recalled that his painting *The Match Girl* resulted directly from his meeting with Constable:

[Constable] said that my friends had made a mistake in sending me to London to work from nature. That I was too young and small for such a business. . . . Then he added insult to injury by insisting that it would have been quite as reasonable if my friends had sent a baby to a cook-shop to be fed on roast beef!

Seeing perhaps, that I looked somewhat hurt, he added, in a gentler tone, "I tell you what you had better do my boy. You go to my friend Sasses' School, and he will teach you the first principles of art." I told him that I had studied the first principles already, whereupon he still further angered me by saying, "There is no one in America capable of teaching them," and then as if incidentally, he added, "It would be better for the rest of the world if your country were sunk to the bottom of the ocean!" . . .

It was upon leaving his house that I first met the original of my picture "The Match Girl," and asked her if she would pose for me. Her dress was so beggarly that it was with difficulty that I persuaded my landlady to admit her, but this once accomplished I set to work with a new determination to do something which would convince Mr. Constable that I needed none of his friend Sasses' instruction. I worked day and night and at last showed the picture to the great painter. He complimented it highly, and his words so completely cured my gall, that when I think of him now it is as of a benefactor and friend.[181]

Funded by Luman Reed and aided by letters of introduction from Washington Irving to the painter Sir David Wilkie and Aaron Vail, the United States chargé d'affaires in London, eighteen-year-old George W. Flagg set off on his first trip to Europe in October of 1834.[179] Soon after his arrival in London, he called upon the landscape painter John Constable with a letter of introduction from "an American artist." In all probability this artist was Thomas Cole, who had met Constable during his European trip of 1829–32.[180] In an anecdote that captures some of the

The American art critic and historian Henry T. Tuckerman, no doubt thinking of Thomas Gainsborough's paintings of rural children, such as the famous *Cottage Girl with Dog and Pitcher* (collection of Sir Alfred Beit, Russborough, England) of 1785, observed that *The Match*

Girl was "just the thing which the countrymen of Gainsborough could instantly appreciate."[182] Several collectors in London attempted to purchase *The Match Girl* or commission a replica, but Flagg declined their offers, no doubt citing his seven-year contract with Reed, who received all of the artist's works other than portraits in return for his financial support.[183] After travels in France and Italy beginning in December 1834, Flagg returned to the United States about June 1835. He exhibited *The Match Girl* in 1836 at the National Academy of Design, where it was praised by a critic from the *New-York Mirror* for its "profound study of nature."[184] Reed described the painting to Thomas Cole as "an excellent picture, the best by far of any thing he has done."[185]

Although Flagg depicted a London model, the match seller was also a familiar sight in the streets of New York and was included in *The New-York Cries, in Rhyme* (1825), an early illustrated book of street vendors and their rhyming cries:

> Will you want any Matches to-day?
> Twenty bunches for 6d
> Fine Matches! good Matches!
> Will you please to have any,
> In pity do take some,
> Three bunches a penny

> To sell matches, is the employment of women and children, who make a few pence honestly by splitting pine or cedar sticks, or procuring long thin shavings, the ends of which they dip in brimstone, which, when touched by a spark, will blaze directly. — Though a small matter, it is a great convenience to house-keepers.

> This is a very humble business, but it is not to be despised on that account: better by far, thus honestly to earn a dinner of bread and cheese, than to ride in one's carriage with the gains of dishonesty or oppression.[186]

While *The New-York Cries, in Rhyme* described matchselling as an honest if humble endeavor, the author and abolitionist Lydia Maria Francis Child recorded the darker side of life in the streets and its detrimental effect on children in her *Letters from New-York* (1843). She cited an encounter with a young mother and daughter from whom she purchased "a store of matches for a year," and observed that "the child grabbed at the money, with a hungry avarice, that made my very heart ache. Hardship, privation, and perchance severity, had changed the genial heart-warmth, the gladsome thoughtlessness of childhood, into the grasping sensuality of a world-trodden soul."[187] Flagg, too, appears to have been sympathetic to the plight of his subject. The closed doorway, paving stones, iron sewer grate, and hitching post accentuate the fact that *The Match Girl* plies her trade in an inhospitable urban environment. Her laceless and tattered shoes, stooped appearance, and soulful expression are calculated to elicit the sympathy of the viewer.

Although Flagg's original model was English, the appeal of *The Match Girl* for a wealthy patron like Reed may seem problematic, given the presence of similar street vendors in New York and their harsh existence.[188] However, works like *The Match Girl* that elevated common city types to the realm of the fine arts may be perceived as urban counterparts to the picturesque rural characters depicted in the works of William Sidney Mount. These works documented the diverse and colorful social strata that characterized urban existence, and perhaps also served as reminders of the less fortunate and an impetus for charity. For Flagg, the challenge lay in depicting these subjects realistically without making them appear degraded. Flagg's *The Match Girl* and his other paintings of idealized street waifs provided a precedent for the sentimental images of the urban poor produced by later artists, such as John George Brown.

PROVENANCE: Luman Reed, New York, d. 1836; Mrs. Luman Reed, New York, 1836–44; NYGFA, 1844–58.

EXHIBITED: NAD, 1836, no. 207, *The Match Girl*; Stuyvesant Institute, New York, 1838, no. 1, *The Match Girl*; NYGFA, 1844, no. 23, *The Match Girl (London)*; 1845, 1846, 1848, no. 66; 1850, no. 25; Washington Exhib. NYGFA, 1853, no. 48, *The Match Girl—London*; Metropolitan Fair in Aid of the U.S. Sanitary Commission, New York, 1864, no. 46, *The Match Girl—London*.

REFERENCES: *New York Evening Post*, May 25, 1836, p. 2; *New-York Mirror* 13 (June 25, 1836), p. 414; Reed Inventory 1836, "Match Girl," $50.00; Henry T. Tuckerman, "Our Artists—No. V," *Godey's Magazine and Lady's Book* 33 (Dec. 1846), pp. 253–54; Tuckerman 1867, p. 406; Koke 1982, 2, pp. 29–30.

Plate 27

GEORGE WHITING FLAGG

Young Woodchopper. c. 1835

Oil on canvas, 30 × 24 in.

Gift of the New-York Gallery of the Fine Arts, 1858.27

As an idealized image of rural childhood, George W. Flagg's *Young Woodchopper* partakes of a well-established European tradition whose exponents included Thomas Gainsborough and William Wordsworth. Even prior to his first European trip of 1834–35, Flagg would have known Gainsborough's paintings through the medium of prints, while Wordsworth's romantic writings glorifying the union of nature and childhood have been cited as a source of influence for the works of Flagg's uncle Washington Allston.[189] Flagg studied with his uncle from 1831 to 1833, and the *Young Woodchopper*, with a single male figure in a dense

forest setting and a small stream in the background, is reminiscent of Allston's *Italian Shepherd Boy* (Detroit Institute of Arts) of 1819.[190] However, while Allston's shepherd wears a tunic and sandals and was intended to evoke an ideal classical world, Flagg's prosaic woodchopper appears in contemporary dress and was tempered with the rural realism of William Sidney Mount.[191]

The *Young Woodchopper* and another work in Reed's collection, the *Savoyard Musician,* appear to depict the same model and were probably products of Flagg's European travels from 1834 to 1835.[192] Although the two works differ in their dimensions and were exhibited separately, they may be seen as a pair, contrasting contemporary rural and urban childhood. The woodchopper occupies a sunlit, sylvan glade and is accompanied by his faithful dog, while the Savoyard is depicted in an inhospitable urban environment. Similarly, while the woodchopper is shown at work gathering a bundle of kindling, he exhibits none of the Savoyard's signs of fatigue. His productive labor does not raise the issue of a class reliant upon charity for its existence. While both young boys wear worn and patched clothing, the natural environment surrounding the woodchopper transforms this feature from a sign of urban poverty to one of rural picturesqueness.

Flagg's *Young Woodchopper* may be seen as an image of the barefoot boy, an ideal type that came to symbolize rural childhood innocence and a harmonious relationship with nature.[193] In the nineteenth century, the barefoot boy was a recurring motif in American art and literature, particularly as the country was transformed from a predominantly agrarian society to one dominated by large commercial cities. Flagg's image would have had personal associations for Reed, for his older brother Abijah recalled that during their childhood in the small Hudson River town of Coxsackie, New York, Luman's clothes were "entirely home made manufactured & made up in the family. he had not yet haid [sic] a pair of shoes staid [sic] in the house most winters & ran out summers barefoot."[194] Thus, Flagg's *Young Woodchopper* would have served as a reminder of Reed's rural beginnings.

PROVENANCE: Luman Reed, New York, d. 1836; Mrs. Luman Reed, New York, 1836–44; NYGFA, 1844–58.
EXHIBITED: NAD, 1835, no. 229, *Young Woodchopper;* NYGFA, 1844, no. 19, *The Wood-Chopper's Boy;* 1845, 1846, 1848, no. 3; 1850, no. 57.
REFERENCES: Reed Inventory 1836, "Wood chopper," $5.00; Koke 1982, 2, pp. 32, 34.

Plate 28

Ｇ Ｅ Ｏ Ｒ Ｇ Ｅ Ｗ Ｈ Ｉ Ｔ Ｉ Ｎ Ｇ Ｆ Ｌ Ａ Ｇ Ｇ

Savoyard Musician. c. 1836

Oil on wood, 22 × 17⅞″

Gift of the New-York Gallery of the Fine Arts, 1858.21

George W. Flagg's *Savoyard Musician* depicts a street musician holding a hurdy-gurdy, a stringed instrument of late medieval or early Renaissance origin that later became a trademark of peddlers and beggars. Flagg had previously exhibited a painting entitled *Beggar Boy* at the Boston Athenaeum in 1832, and the favorable reception of *The Match Girl* in London during his European trip of 1834–35 may have encouraged him to seek out similar urban subjects. The Savoyard's distinctive hat, the stoneware jar by his feet, and the gargoyle fountain clearly identify the scene as European. Flagg traveled from London to Paris in December of 1834 and

from Paris to Italy in February of 1835, and *Savoyard Musician* was probably inspired by a street character he encountered during this trip.[195]

A poem entitled "The Savoyard's Song" by Charles Sprague, published in Boston in 1830 and in New York in 1831, included the following stanzas that capture contemporary perceptions of the Savoyard:

> Far away, far away,
> From the haunts of our childhood in scorn we were driven;
> Reft of kindred and home,
> The wide earth we must roam,
> No hope but in you, and no trust but in Heaven—
> Far away.
>
> Far away, far away,
> The poor Savoyard orphans tomorrow must go;
> Then pity, kind strangers,
> The world's friendless rangers,
> And bless with your bounty our journey of wo—
> Far away.[196]

Like Sprague's poem, Flagg's painting evokes the arduous life of the Savoyard. The exhausted musician rests by a fountain and dozes with his hands still resting on the handle and keys of his hurdy-gurdy. His fatigue and the prominent patch on his pants attest to the physical and financial hardship of life on the streets. However, the image is slightly idealized and sentimental, characteristics discerned in another Flagg painting of a street waif, *The Mouse-Boy*, about which the American art critic Henry T. Tuckerman wrote:

> There is a class of subjects between the high ideal and the homely true . . . which are admirably calculated to enlist universal sympathy. . . . This picture of Flagg's belongs essentially to the same school. It aptly combines nature with sentiment, and thus gives a true glimpse of what may be called the poetry of humble life.[197]

Ｐｒｏｖｅｎａｎｃｅ: Luman Reed, New York, d. 1836; Mrs. Luman Reed, New York, 1836–44; NYGFA, 1844–58.

Ｅｘｈｉｂｉｔｅｄ: NAD, 1836, no. 167, *Savoyard Musician;* NYGFA, 1844, no. 57, *The Little Savoyard;* 1845, 1846, 1848, no. 49; 1850, no. 61.

Ｒｅｆｅｒｅｎｃｅｓ: *New York Herald,* May 17, 1836, p. 1; *New York Evening Post,* May 25, 1836, p. 2; *Knickerbocker* 8 (July 1836), p. 115; Reed Inventory 1836, "Savoyard," $5.00; Koke 1982, 2, p. 34.

GEORGE W. FLAGG

Hubert and Arthur, c. 1836

Location unknown, not reproduced.

Flagg's *Hubert and Arthur* was exhibited at the National Academy of Design in the spring of 1836 and was listed in the estate inventory of Luman Reed's gallery completed the following October, but the current location of the painting is unknown.[198] The subject, however, almost certainly was drawn from act 4, scene 1, of Shakespeare's *The Life and Death of King John,* in which Hubert de Burgh is ordered by John to put out the eyes of Arthur, the king's nephew and potential rival for the throne. In the emotional confrontation that ensues in the castle where the prince is being held captive, Hubert is torn between his duty to the king and his affection for Arthur, who pleads for mercy:

> *Hubert:* I have sworn to do it;
> And with hot irons must I burn them out.
>
> *Arthur:* Ah, none but in this iron age would do it!
> The iron of itself, though heat red-hot,
> Approaching near these eyes, would drink my tears,
> And quench his fiery indignation
> Even in the matter of mine innocence;
> Nay, after that, consume away in rust
> But for containing fire to harm mine eye.
> Are you more stubborn-hard than hammer'd iron?

Moved by Arthur's eloquence, Hubert spares him and circulates a false report of his death. The prince is subsequently killed while trying to escape, and his death contributes to the downfall and death of King John.

The pictorial and dramatic potential inherent in the encounter between Hubert and Arthur made this scene popular with both British and American artists in the eighteenth and nineteenth centuries. Some idea of the appearance of Flagg's painting may be deduced from James Northcote's painting of 1789 (Royal Shakespeare Theatre, Stratford-upon-Avon) for John Boydell's famous Shakespeare Gallery in London. Flagg would have known Robert Thew's engraving after Northcote's painting, which was included in a published volume of *The Boydell Shakespeare Prints* (1803). Indeed, a critic for the *New York Evening Post*

may have been referring to Thew's engraving when he suggested that Flagg had derived his *Hubert and Arthur* from a print of the subject that was then available in New York.[199] Flagg also may have been influenced by productions of *King John* staged in New York in the early 1830s.[200]

Like the *Murder of the Princes* that he exhibited at the National Academy of Design in 1834, Flagg's *Hubert and Arthur* very likely capitalized on the contrast between the childhood innocence of the prince and the evil intent of the henchman assigned to carry out a brutal act. While the exact appearance of Flagg's *Hubert and Arthur* remains a mystery, two contemporary reviews provide some clues and are representative of the range of critical opinion that Flagg's works elicited. A critic for the *Knickerbocker,* for example, felt that Flagg's choice of subject was overly ambitious and criticized his technique:

> There is merit in the composition of this picture, but very little in the execution. The attitude and expression of Hubert are good; Arthur is common-place, and might have been made a prettier boy, without violating history and Shakespeare. As for the execution, it would do very well for a sign, but wants grace, finish, keeping, and in short almost every thing essential in a picture.[201]

Conversely, the critic for the *New-York Mirror* praised Flagg's work and expressed surprise that the artist had not been made a member of the National Academy of Design:

> Mr. Flagg has finely conceived this portion of poetical history, and given a bold delineation to a pathetick scene. The merit of this artist's pictures has caused surprise that neither A[ssociate]. nor N[ational]. A[cademician]. is appended to his name. On inquiry we find that youth alone is the objection. The laws of the academy requiring twenty-one years residence in this world of probation before its honors are bestowed. . . . In the historical work before us, Hubert is fine. . . . The prince has true expression, but appears to us wanting in beauty, and we are not quite satisfied with the colour of the shadows.[202]

PROVENANCE: Luman Reed, New York, d. 1836.
EXHIBITED: NAD, 1836, no. 53, *Hubert and Arthur.*
REFERENCES: *New York Herald,* May 9, 1836, p. 2; *New York Evening Post,* May 25, 1836, p. 2; June 4, 1836, p. 2; *New-York Mirror* 13 (June 4, 1836), p. 390; *Knickerbocker* 8 (July 1836), p. 113; Reed Inventory 1836, "Hubert & Arthur," $20.00.

Plate 29

GEORGE WHITING FLAGG

A Nun. c. 1836

Oil on canvas (lined), 30 × 24″

Gift of the New-York Gallery of the Fine Arts, 1858.34

Flagg's *A Nun,* like the *Lady and Parrot* exhibited at the National Academy of Design in 1835, may be interpreted as an ideal portrait, albeit one emphasizing spiritual rather than temporal beauty. The thematic differences between the two paintings are accentuated by the contrast between the open Bible and the exotic parrot, the cross and the pearl necklace, the habit and the silk headdress, and even the solid wood table and the plush satin cushion. A study of a head entitled *The Nun* (private collection), painted in oil on wood, appears to depict the same model and may have served as a preliminary study for this painting.

Although America's strong Protestant tradition initially bred indifference toward religious art, by Reed's day the growing prominence of old master religious paintings, combined with the desire to achieve cultural parity with Europe, fostered a more receptive environment for this type of subject. Reed's art collection included a *Madonna and Child* attributed to Raphael, a *Magdalen* after Correggio, an *Assumption of the Virgin* attributed to Annibale Carracci, a *Wreath of Flowers Encircling the Holy Family,* and a *Mystic Marriage of Saint Catherine.*[203] He also owned numerous prints of religious subjects, including a series after Michelangelo's Sistine Chapel *Last Judgement.*[204]

PROVENANCE: Luman Reed, New York, d. 1836; Mrs. Luman Reed, New York, 1836–44; NYGFA, 1844–58.

EXHIBITED: NAD, 1836, no. 170, *A Nun;* NYGFA, 1844, no. 22, *The Nun;* 1845, 1846, 1848, no. 67; 1850, no. 59.

REFERENCES: *New York Evening Post,* May 25, 1836, p. 2; Reed Inventory 1836, "Nun," $5.00; Koke 1982, 2, p. 35.

Plate 30

GEORGE WHITING FLAGG

Chess (The Chess-Players — Check Mate). c. 1836

Oil on canvas (lined), 43¾ × 56″

Gift of the New-York Gallery of the Fine Arts, 1858.12

Chess was a popular pastime among New Yorkers in the late 1820s and early 1830s, perhaps in part due to the public exhibition of a famous automaton chess player that regularly defeated its human opponents.[205] Luman Reed may have been among the devotees of chess, for the inventory of his estate lists "1 Case of Chessmen & c.," valued at the considerable sum of twenty-five dollars, in the parlor of his Greenwich Street mansion.[206] Flagg's *Chess,* exhibited at the National Academy of Design in 1836, thus was a timely subject for a domestic genre scene. As the later title *The Chess-Players — Check Mate* suggests, the painting depicts the climactic moment in a game of chess between a young man and woman. The outcome of the match is apparent from the man's pained expression and the sympathetic gaze of the female servant who has just

entered bearing a tray with a decanter and two glasses. The victorious woman toys with her amber necklace while patiently waiting for her opponent to concede defeat.

Although it is not possible to state with certainty that Flagg's two protagonists are courting, the game of chess as a metaphor for love and courtship dates from medieval times, as does the belief that the loser of the game would be lucky in love.[207] Flagg's *Chess* also resembles a popular type of American courtship painting that depicted the male suitor in a humorous predicament, a theme that appears in contemporaneous works by William Sidney Mount.[208] In Mount's *The Sportsman's Last Visit* (Museums at Stony Brook, New York) of 1835, a perplexed country beau realizes that he is in danger of being supplanted by his more sophisticated urban rival. In *Winding Up (Courtship)* (Nelson-Atkins Museum of Art, Kansas City, Mo.) of 1836, in which a suitor holds a skein of yarn as his sweetheart winds it into a ball, Mount conveyed a double meaning through his title, suggesting that both the ball of yarn and the courtship were "winding up" or close to completion. In Flagg's painting, there is, perhaps, a similar intimation that the woman has outmaneuvered her companion, not only in the game of chess but in their courtship as well.

The analogy between life and chess was articulated in America as early as 1786 by Benjamin Franklin in an article that was published in the *Columbian Magazine:* "For Life is a kind of Chess, in which we often have Points to gain, & Competitors or Adversaries to contend with; and in which there is a vast variety of good and ill Events."[209] The connection between life and chess is also apparent in an etching by the German illustrator Moritz Retzsch entitled *The Chess Player,* in which a young man plays chess with the devil.[210] Retzsch's work was popular in the United States, and Reed, for example, owned his published illustrations for Shakespeare's *Hamlet* and *Macbeth.*[211] *The Chess Player* appears to have

served as a point of departure for Flagg's painting. Compositional similarities include the shallow interior space, the placement of the figures in relation to the table and the chessboard, and the pose of the young man at the right, with his right hand to his head and his left hand resting on the table.

 Chess is perhaps most remarkable for the prominent presence of an African American woman. Flagg may have been inspired in part by his own acquaintance with African Americans, for his family owned plantations and slaves in South Carolina.[212] Although Mount had pioneered in the depiction of African Americans in American genre painting with his *Rustic Dance After a Sleigh Ride* (Museum of Fine Arts, Boston) of 1830 and *The Breakdown* (Art Institute of Chicago) of 1835, in neither of these works are the participants as prominent as is the figure in Flagg's large

genre scene.[213] While the woman's tray, decanter, and glasses make clear her status as a servant, she is nonetheless depicted in a dignified manner, and the humor of the situation is enjoyed at the expense of one of the white protagonists.

———————————

PROVENANCE: Luman Reed, New York, d. 1836; Mrs. Luman Reed, New York, 1836–44; NYGFA, 1844–58.
EXHIBITED: NAD, 1836, no. 199, *Chess;* NYGFA, 1844, no. 28, *The Chess Players—Check Mate;* 1845, 1846, 1848, no. 69; 1850, no. 38.
REFERENCES: *New York Herald,* May 19, 1836, p. 1; *New York Evening Post,* May 25, 1836, p. 2; Reed Inventory 1836, "Chess players," $25.00; Lawall 1966, pp. 208–14; Koke 1982, 2, pp. 35–36.

Plate 31

———————————

FREDERICK WILLIAM PHILIP (1814–1841)

Boy Asleep. c. 1833

Oil on wood, 12⅞ × 10⅝″

Inscribed on verso with a white chalk sketch of a seated figure.

Gift of the New-York Gallery of the Fine Arts, 1858.67

———————————

Little biographical data has survived regarding Frederick William Philip, who was born in Brooklyn on November 17, 1814.[214] According to the historian William Dunlap, Philip was "a young gentleman of distinguished talent" and a pupil at the National Academy of Design, where he was elected an associate member in 1833.[215] In the same year he exhibited *Boy Asleep* at the American Academy of the Fine Arts.[216] Reed, who believed that American artists should "make something of ourselves out of our own materials," would have seen Philip as an appropriate candidate for his patronage.[217] By 1834, however, Philip was pursuing his studies in Europe, and in that year Reed signed a seven-year contract

that promised his support to another talented young American artist, George W. Flagg.[218] By 1840 Philip had returned to New York, but he died on March 25, 1841, and was eulogized at a National Academy of Design meeting as "an artist of promise."[219]

 Boy Asleep depicts a young boy in a frock who has fallen asleep in his high chair at the dinner table.[220] Although his fork is still clenched in his left hand, his head has tilted forward and his meal remains unfinished on his plate. As a sympathetic image of childhood, *Boy Asleep* reflected the changing perceptions of children in nineteenth-century America. Influenced in part by European concepts of childhood innocence articulated

by John Locke and Jean Jacques Rousseau, later American writers idealized childhood as a precious natural state to be valued and insulated from the artificiality and sinfulness of the adult world. The American educator and child-rearing authority William A. Alcott, for example, devoted a whole chapter in his book *The Young Wife* (1837) to the "Love of Infancy and Childhood."[221] The *Boy Asleep* also may be seen as a precursor of the "naughty boy" genre of art that not only accepted childhood foibles but embraced them as natural and humorous subjects. Luman Reed was "particularly fond of young persons and their society," and Philip's painting and the door panels in his gallery depicting *Blind Man's Buff, School Let Out,* and *Boys Playing Marbles* may reflect Reed's personal taste as well as the increasing popularity of childhood as a subject in the fine arts.[222]

PROVENANCE: Luman Reed, New York, d. 1836; Mrs. Luman Reed, New York, 1836–44; NYGFA, 1844–58.

EXHIBITIONS: American Academy of the Fine Arts, 1833, no. 116, *Boy asleep;* NYGFA, 1844, no. 8, *Boy Fallen Asleep Over His Dinner;* 1845, 1846, 1848, no. 38; 1850, no. 2; Washington Exhib. NYGFA, 1853, no. 17, *The Young Gourmand.*

REFERENCE: Reed Inventory 1836, "Sleeping boy (Philips)," $5.00.

Plate 32

WILLIAM SIDNEY MOUNT (1807–1868)
Farmer's Bargaining (Bargaining for a Horse). 1835
Oil on canvas, 24 × 30″
Signed and dated lower left: Wm. S. Mount / 1835.
Gift of the New-York Gallery of the Fine Arts, 1858.59

William Sidney Mount began *Farmer's Bargaining,* the first picture he was to paint for Luman Reed, at the end of June 1835.[223] Although a fictional newspaper account, intended as a compliment to both Mount's talent and Reed's renowned generosity, stated that Mount was paid a thousand dollars, he actually received two hundred for the commission.[224] Reed acknowledged receipt of the completed painting on September 24 and wrote Mount enthusiastically about it:

> I called on Durand & a few other friends immediately after the picture was taken out of the Box & we all pronounced it the best thing we had seen from your pencil. . . . in the picture just rec'd you have hit off the character to a charm, it is useless for me to

particularize merits. . . . the horse has no equal in any picture that I ever saw.[225]

The site of *Farmer's Bargaining* was the west side of the barn behind the Mount homestead in Stony Brook, New York.[226] Mount, who declined Reed's offer to provide him with a studio in his New York house and to fund a trip to Europe, was a native of Long Island and lived there most of his life.[227] With the keen eye of a local, he recorded a wealth of detail in *Farmer's Bargaining,* including the meticulously rendered horse admired by Reed, the rustic clothes of the two protagonists, the shed with its broken support beam, a pitchfork, an ox yoke, a metal pan and chain, discarded cornstalks, and a corn crib with roosting pigeons. The Mount house is visible in the distance. Mount painted his canvas outdoors, and the sculptor Horatio Greenough was particularly struck by its "clear, bright, American atmosphere and harmony of colour."[228]

According to Reed, another admirer of *Farmer's Bargaining* was Washington Irving, who saw the picture in Reed's gallery:

> Mr. Irving called on me & I showed him your Picture of the "Bargain" with which he was very much delighted & says he wants to become acquainted with [you] and I promised to let him know the first time you came in Town. he desired me to thank you for the pleasure he derived from seeing the Picture. Mr. I is a particular friend of Wilkie's.[229]

It is revealing that Irving, America's great storyteller who celebrated the history and legends of rural New York in his own work, felt a particular affinity for Mount's scene of country life. Reed's mention of the Scottish painter Sir David Wilkie also was appropriate; for Mount was often called "The American Wilkie" by his contemporaries. Like Wilkie, Mount ele-

vated rural life, values, and character types to the realm of high art. In America, this trend can be traced in part to Thomas Jefferson, who articulated the idea of the farmer as a national symbol:

> Those who labor in the earth are the chosen people of God, if ever he had a chosen people, whose breasts he had made his peculiar deposit for substantial and genuine virtue. It is the focus in which he keeps alive that sacred fire, which otherwise might escape from the face of the earth.[230]

The veneration of the farmer reached new heights in the era of Jacksonian Democracy, particularly as the country began to shift from an agrarian nation to an urban, mercantile, and manufacturing one. For Reed, who had moved in 1815 from the Hudson River town of Coxsackie to New York, Mount's painting of rural farmers would have served as a nostalgic reminder of his origins.

Unlike some American paintings of the period that were based on literary sources, *Farmer's Bargaining* reversed the process and inspired a literary account. A month after receiving the painting, Reed sent Mount a recent newspaper article from the *New-York Gazette* in which the author described an imaginary visit to "Downingville," the home of "Joshua" or "Jack Downing," a fictitious Yankee sage created by the Maine newspaper editor Seba Smith as a means of commenting on major issues of the day.[231] No doubt perceiving an affinity between the homespun Jack Downing and Mount's rural character types, the author of the *Gazette* article used the imagery of *Farmer's Bargaining* as the basis for his narrative. He created an imaginary dialogue between "Seth Sprague" (on the right) and "Uncle Joshua" (on the left) in which they argue respectively for and against the partisan system of political patronage. Numerous details in Mount's painting were incorporated into the *Gazette* narrative, and Mount, who observed that the author must have studied the painting closely, was "delighted" with the article.[232]

Although the author of the *Gazette* article gave them specific identities, each of the protagonists in *Farmer's Bargaining* would have been recognized by contemporaries as an American character of almost legendary shrewdness in driving a bargain—the Yankee trader.[233] Horses played an essential role on American farms as all-purpose draft and transportation animals, and horse traders were particularly noted for their shrewd practices.[234] When Mount's painting was exhibited at the National Academy of Design in 1836, his humorous treatment of this Yankee type was praised by a critic for the *New York Herald*:

This is an image of pure Yankeeism, and full of wholesome humor. Both of the yeomen seem to be "reckoning," both whittling, both delaying. The horse, which is the object of their crafty equivocations, stands tied as "sleek as a whistle," waiting for a change of owners.[235]

In 1854, Mount painted *Coming to the Point, A Variation of "Bargaining for a Horse"* at the "particular request" of Mr. Adam R. Smith of Troy, New York.[236] In *Coming to the Point* Mount retained the central motif of two whittling and bargaining male protagonists but added the figure of a woman eavesdropping from the second story of a shed that shelters the horse. The painting was bought in 1863 by the wealthy New York sugar refiner, philanthropist, and art collector Robert L. Stuart and is now on permanent loan to the New-York Historical Society.[237] Mount's two paintings of horse traders were almost certainly the source of inspiration for Eastman Johnson's *The Horse Trade (Whittling in the Barn)* (Deerfield Academy, Deerfield, Mass.) of 1866, which also depicts two men whittling as they negotiate.[238]

PROVENANCE: Luman Reed, New York, d. 1836; Mrs. Luman Reed, New York, 1836–44; NYGFA, 1844–58.

EXHIBITED: NAD, 1836, no. 155, *Farmer's Bargaining;* NYGFA, 1844, no. 62, *The Bargaining,* with a quotation from *Jack Downing's Journal;* 1845, 1846, 1848, no. 22; 1850, no. 30; Washington Exhib. NYGFA, 1853, no. 118, *Bargaining for a Horse.*

ENGRAVED: By Joseph Andrews (1806–1873). Published in Miss Eliza Leslie, ed., *The Gift: A Christmas and New Year's Present for 1840* (Philadelphia: Carey & Hart, 1839), pl. opp. p. 256. Also engraved by Charles Kennedy Burt (1823–1892) for the American Art Union in 1851.

REFERENCES: *New-York Mirror* 13 (April 2, 1836), p. 318; *New York Evening Post,* Apr. 27, 1836, p. 2; *New York Herald,* May 17, 1836, p. 1; *New York Evening Post,* May 25, 1836, p. 2; *New-York Mirror* 13 (June 25, 1836), p. 414; *Knickerbocker* 8 (July 1836), p. 115; Reed Inventory 1836, "the bargaining," $150.00; Charles Lanman, *Letters From a Landscape Painter* (Boston: James Munroe & Co., 1845), pp. 244–45; W. Alfred Jones, "A Sketch of the Life and Character of William Sidney Mount," *American Whig Review* 14 (August 1851), pp. 124–25; Thomas Seir Cummings, *Historic Annals of the National Academy of Design . . . From 1825 to the Present Time* (Philadelphia: George W. Childs, 1865), pp. 140–41; Edward P. Buffet, "William Sidney Mount: A Biography," *Port Jefferson Times,* Dec. 1, 1923–June 12, 1924, Chapter 11, p. 16; Lawall 1966, 1, pp. 211–14, 3, fig. 68; Frankenstein 1975, pp. 27, 69–70, 72, 74–76, 117, 149, 153, 158, 164, 166, 168, 177–78, 184–85, 200, 249, 266–67, 469, 473, 480, 483, pl. 94; Koke 1982, 2, pp. 394–96.

Plate 33

WILLIAM SIDNEY MOUNT

Undutiful Boys (The Truant Gamblers). 1835

Oil on canvas, 24 × 30″

Signed and dated lower right: Wm. S. Mount / 1835.

Gift of the New-York Gallery of the Fine Arts, 1858.23

William Sidney Mount began his second painting for Luman Reed, the *Undutiful Boys*, at the end of August 1835.[239] While the painting was in progress, Reed wrote to Mount requesting that he refuse further commissions and added: "the fact is I must have the best pictures in the Country, & yourself & a few others are the only artists that paint to suit my taste."[240] Reed acknowledged receipt of the work on December 11, 1835:

> I yesterday rec'd your much valued letter of 4th Instant with your beautifull Picture of the "Undutifull Boys." To say that this Picture is satisfactory is not enough & the least I can say is that it pleases me exceedingly. It is a beautifull specimen of the art. The interior of the Barn is far superior to any thing of the kind I have ever seen. . . .

Mr. Durand who I called on this morning has seen the "Boys" he likes it much.[241]

Like Mount's *Farmer's Bargaining,* the *Undutiful Boys* was painted outdoors on the Mount farm in Stony Brook, Long Island.[242] Mount used the barn, which appears in several of his most famous paintings, as a stage on which he deployed his characters and outlined his narrative.[243] At the right are the four truant gamblers of the title. They have abandoned their farm chores and are gathered in a circle "hustling coppers," or pennies, on the barn floor.[244] Mount carefully differentiated the characters of the four boys, including the passive spectator who leans on the barn door, the boy holding his hat who has an avaricious gleam in his eye, his eager partner, and finally the young boy who is distracted from the game by the farmer's approach. The farmer, who enters from the left, appears with his shirt sleeves rolled up, a kerchief on his head for protection against the sun, and a pitchfork over his left shoulder. He has been hard at work and seems determined to punish the truant boys with the switch in his right hand.

As in the *Farmer's Bargaining,* Mount's faithful depiction of the ambience and details of country life, dress, and manners was no doubt enhanced by his childhood experience as a "farmer boy" and his long residence in a farming community.[245] However, the *Undutiful Boys* also should be seen in the context of a larger national trend to celebrate American rural life and childhood. The majority of Mount's contemporaries, including Reed, had grown up in farming communities. Mount's works thus had an inherent appeal for urban dwellers nostalgic for their rural childhood.[246]

The *Undutiful Boys* also seems to contrast industry with indolence. When the painting was exhibited in the New-York Gallery of the Fine Arts in 1844, this theme was discerned by a critic for the *Broadway Journal:*

The surly farmer with the switch in his hand, and a world of ill-nature, which mankind have agreed to dignify with the name of prudent industry, concentrated in his features, will bear a comparison with the finest things in Hogarth. The contrast between the happy abandonment of the boys, whose whole souls are given up to their game, and the small ferocity of the farmer, who will have nobody at play, because he is at work, is a happy stroke of genius.[247]

To some extent, the *Undutiful Boys* owes a debt to earlier genre scenes with a moralizing theme. The critic for the *Broadway Journal* cited the eighteenth-century English artist William Hogarth, while Reed linked Mount's painting to seventeenth-century works produced by the Dutch artist Adriaen van Ostade and the Flemish artist David Teniers, writing: "I do not believe that Ostade or Teniers ever did anything better than some parts of this picture."[248] In works by these artists, childhood transgressions often are depicted as a prelude to adult sins. In the *Undutiful Boys* gambling is linked with indolence (signified by the presence of the abandoned hoe) and is contrasted with industry (signified by the farmer with a pitchfork).

Mount explored a similar theme in *Boys Caught Napping in a Field* (Brooklyn Museum) of 1848, in which three farm boys also have abandoned their chores (a pitchfork rests nearby) and are caught by an old man as they rest under a tree. As one of the boys warns his sleeping comrade, he simultaneously attempts to conceal a deck of playing cards. It has been suggested that, in this context, a skull hanging in the tree may have been intended as a symbol of human mortality and the spiritual corruption engendered by sloth and gambling.[249] Striking the proper balance between work and play is a persistent theme in Mount's diaries. For example on December 23, 1849, Mount wrote, "All work and no play makes *Jack* a dull *boy*," and yet three days later he noted "To be *idle* is *wicked* and should be so considered."[250] In both paintings, however, the truant boys are portrayed sympathetically, and the moralizing message is tempered by humor. Mount apparently characterized the *Undutiful Boys* as a humorous subject, and Reed responded enthusiastically: "The subject 'comick' is a pleasing one & I would rather laugh than cry any time."[251]

The *Undutiful Boys* is notable among Reed's commissioned paintings, in that Reed made two requests that caused Mount to alter both his technique and the composition of the finished painting. First, Reed asked Mount to leave his painting unvarnished, adding: "I have not had my pictures by Cole varnished and the first one looks better today than the day I rec'd it. The blending of the colors gives it a richness and softness

that it had not at first."[252] Mount, who had already incorporated varnishes into his glazes as part of his technique, agreed to the request.[253] Reed also suggested a compositional change in the *Undutiful Boys,* although he emphasized that the proposed alteration was left entirely to Mount's discretion.[254] Mount made the change, and Reed rewarded him with an additional fifty dollars beyond the purchase price of $220. The nature of the alteration is not disclosed in the extant correspondence or by a visual examination of the painting, and this is the only recorded instance in which Reed requested the modification of an artwork that he had commissioned.[256]

In 1842 the Philadelphia publisher Edward L. Carey asked Mount to make a sketch of the *Undutiful Boys* so that it could be engraved for his annual publication *The Gift,* but Mount refused, citing the mediocrity of engravings produced from a sketch instead of from an original oil painting.[257] As an alternative, Carey commissioned Mount to paint *The Disagreeable Surprise* (private collection, Boston) of 1843, a variant of Reed's painting in which the farmer is replaced by an old woman who is about to punish the truant children.[258] The painting was exhibited at the National Academy of Design in 1844 with the title *Boys Hustling Coppers.* It was engraved by Joseph Ives Pease and published in *The Gift* with a poem by Charles West Thomson entitled "The Disagreeable Surprise."[259]

PROVENANCE: Luman Reed, New York, d. 1836; Mrs. Luman Reed, New York, 1836–44; NYGFA, 1844–58.

EXHIBITED: NAD, 1836, no. 147, *Undutiful Boys;* Stuyvesant Institute, New York, 1838, no. 3, *Undutiful Boys;* NYGFA, 1844, no. 33, *The Truant Gamblers;* 1845, 1846, 1848, no. 18; 1850, no. 41; Washington Exhib. NYGFA, 1853, no. 117, *The Truant Gamblers.*

ENGRAVED: By Smithwick & French. Published in S. G. W. Benjamin, "Fifty Years of American Art," *Harper's New Monthly Magazine* 59 (July 1879), p. 250 and pl. p. 251; and *Art in America: A Critical and Historical Sketch* (New York: Harper & Brothers, 1880), p. 52 and pl. p. 55.

REFERENCES: *New-York Mirror* 13 (April 2, 1836), p. 318; *New York Evening Post,* April 27, 1836, p. 2; *New York Herald,* May 12, 1836, p. 1; *New York Evening Post,* May 25, 1836, p. 2; *New-York Mirror* 13 (June 18, 1836), p. 406; *Knickerbocker* 8 (July 1836), p. 115; Reed Inventory 1836, "The Undutiful boys," $150.00; "World of Science and Art. Our New-York Painters. Mount," *New World* 8 (Feb. 10, 1844), p. 187; *Broadway Journal* 1 (Feb. 15, 1845), p. 103; Lawall 1966, pp. 173, 177–78, 180–81, 189; Frankenstein 1975, pp. 27, 68–72, 74, 75, 76, 99, 177, 249, 267, 469, 483, pl. 27; Koke 1982, 2, pp. 396–98.

Plate 34

FLEMISH SCHOOL

Madonna and Child. c. 1575–1600

Oil on wood, 23 × 16¼″

Stamped on verso with the Antwerp guild mark of two hands, the initials *SD,*

and an illegible studio mark.

Gift of the New-York Gallery of the Fine Arts, 1858.18

enclosed garden, a traditional symbol of Mary's Immaculate Conception and fertility. Similarly, the water flowing from the fountain at the left symbolizes purity, a spiritual life, and salvation. The two roses at the upper left are also traditional Marian symbols—the Virgin, lacking sin, was called the "rose without thorns." Despite the attribution to Raphael, this composition was derived from Flemish examples of the late fifteenth and early sixteenth centuries and probably dates from the last quarter of the sixteenth century.[261] Robert Gilmor, Jr., of Baltimore, a contemporary of Reed who owned perhaps the most extensive collection of paintings in the United States, also owned a *Madonna and Child* attributed to Raphael which has since been reattributed to a Flemish painter.[262]

In Luman Reed's day, Raphael was almost universally acclaimed the greatest artist in history, but there were then no authentic works by him in America.[263] His reputation in this country thus was established entirely through the accounts of travelers, misattributed "originals," acknowledged copies, and prints. These were the only means of exposure for Reed, who never traveled to Europe.[264] In a letter to William Sidney Mount dated October 29, 1835, Reed recounted his visit to a collection of paintings located in White Street where he saw "copies of four of Raffaelle's Frescos which are very fine indeed. . . . they give me a better idea of Raffaelle's paintings than any thing I have seen."[265] Reed's library included a lavish folio of engravings depicting *Raphael's Hours,* while his print collection included engravings after other works by Raphael in the Vatican.[266]

Although this work was listed simply as a "Madonna" in the 1836 inventory of Luman Reed's estate, his son-in-law Theodore Allen referred to it in 1844 as "Rafael's Madonna," and in the same year the New-York Gallery of the Fine Arts catalogue attributed it to the "Early style of Raphael."[260] The painting depicts the Virgin seated in a garden and embraced by the Christ Child in her lap. The cross-shaped portions of wood fence behind her identify the site as the *hortus conclusus,* or

PROVENANCE: Luman Reed, New York, d. 1836; Mrs. Luman Reed, New York, 1836–44; NYGFA, 1844–58.

EXHIBITED: NYGFA, 1844, no. 55, *Madonna and Infant,* Early style of Raphael; 1845, 1846, 1848, no. 37; 1850, no. 54.

REFERENCE: Reed Inventory 1836, "Madonna," $150.00.

Plate 35

FLEMISH SCHOOL

The Judgement of Midas. c. 1615

Oil on wood, 28½ × 24"

Paper label on verso inscribed: No. 150 / Paysage historique / Figures.

Jugement de / Midas.

Gift of the New-York Gallery of the Fine Arts, 1858.25

of prints with captions also contributed to the proliferation of such subjects.[268] The Dutch artist Hendrik Goltzius's engraving *The Judgement of Midas* (1590), for example, served as the compositional prototype for many subsequent depictions of the theme, including, perhaps indirectly, the *Judgement of Midas* that Reed acquired.[269] This painting, attributed to Goltzius in the New-York Gallery of the Fine Arts catalogue of 1844, is probably by a Flemish painter, possibly a follower of the Antwerp painter Hendrick van Balen (1575–1632).[270]

The subject of *The Judgement of Midas* is derived from *Metamorphoses* (11.147–180), in which a musical competition between Apollo and Pan is described. The contest is decided by King Tmolus in Apollo's favor but disputed by King Midas:

> Then Pan made music on his rustic pipes, and with his rude notes quite charmed King Midas, for he chanced to hear the strains. After Pan was done, venerable Tmolus turned his face towards Phoebus [Apollo]; and his forest turned with his face. Phoebus' golden head was wreathed with laurel of Parnassus, and his mantle, dipped in Tyrian dye, swept the ground. His lyre, inlaid with gems and Indian ivory, he held in his left hand, while his right hand held the plectrum. His very pose was that of an artist. Then with trained thumb he plucked the strings and, charmed by those sweet strains, Tmolus ordered Pan to lower his reeds before the lyre.
>
> All approved the judgement of the sacred mountain-god. And yet it was challenged and called unjust by Midas' voice alone. The Delian god did not suffer ears so dull to keep their human form, but lengthened them out and filled them with shaggy, grey hair; he also made them unstable at the base and gave them power of motion. Human in all else, in this one feature was he punished, and wore the ears of a slow-moving ass.[271]

In the seventeenth century, Ovid's *Metamorphoses* served as the major textual source for Dutch and Flemish paintings that depicted themes from classical mythology. Many of these works were inspired by the numerous illustrated editions of Johannes Florianus's Dutch translation (1552) of *Metamorphoses* that were published in the sixteenth and seventeenth centuries.[267] Individually published engravings and small books

When acquired by Reed, the panel depicting *The Judgement of Midas* had been cut down at the left, leaving half of what would have been a horizontal composition. Remnants of Apollo's outstretched left arm holding a violin were painted over with foliage, and a reclining satyr in the foreground was transformed into a tree stump.[272] Nonetheless, the remaining imagery follows Ovid's text closely. Pan, half man and half goat, is depicted with his reed pipes at the right. King Tmolus appears in the center and has just rendered his decision in favor of Apollo. Between and slightly behind these two figures is King Midas, who prefers Pan's pipes to Apollo's strings and is punished by being given the ears of an ass. Several peripheral figures appear in the composition, including some of the muses traditionally included in this scene. While many seventeenth-century paintings derived from Ovid's *Metamorphoses* featured a dramatic confrontation or noble deeds, the Judgement of Midas was a popular theme that carried a moralistic message of prudence versus folly, while exploiting the humor of the narrative at Midas's expense.

———————

PROVENANCE: Luman Reed, New York, d. 1836; Mrs. Luman Reed, New York, 1836–44; NYGFA, 1844–58.
EXHIBITED: NYGFA, 1844, no. 13, *Pan and Midas*, Goltzius; 1845, 1846, 1848, no. 52; 1850, no. 65.
REFERENCE: Reed Inventory 1836, "Pan & Midas," $50.00.

Plate 36

———————

FLEMISH SCHOOL

Wreath of Flowers Encircling the Holy Family. c. 1620–40

Oil on copper, 12¼ × 10½″

Embossed on verso with a maker's mark consisting of four characters

oriented at the ends of a cross: 4 / M / two interlocking Vs

(one upright and one inverted) / I.

Gift of the New-York Gallery of the Fine Arts, 1858.51

———————

Flower garlands were a traditional and popular way of adorning and honoring religious images, and many sixteenth- and seventeenth-century engravings of the Madonna depicted her surrounded by a wreath of roses. The motif also appeared in popular religious literature, and Jean Mielot's fifteenth-century *Miracles de Nostre Dame* recounts the story of a miraculous image of the Virgin that produced its own garland of roses. The first documented Flemish paintings of Madonnas encircled by flower wreaths or garlands, however, were produced by Jan Brueghel the Elder, in collaboration with Hendrik van Balen or Peter Paul Rubens.[273] The motif of the Madonna or other religious subjects surrounded by a flower garland was widely imitated, and the *Wreath of Flowers Encircling the Holy Family*, while less sophisticated, was probably derived from similar works by Frans Francken II (1581–1642) and Andries Danielsz (c. 1580–1635 or later), who occasionally collaborated in the production of such images.[274]

David Freedberg has explained the appearance of Madonnas in flower garlands as a reaction during the Counter-Reformation to the destruction of religious images by Protestant iconoclasts during the second half of the sixteenth century in the Netherlands:

With the memory of these events still fresh, and in a climate of continuing controversy about images, the flower garlands—in ad-

and handbooks of the Counter-Reformation also juxtaposed traditional religious subjects with decorative flowers, putti, fruit, birds, and hearts. He concluded that such images were the product of "the standard *Cinquecento* idea, derived from Horace, that one smears the cup with honey in order to make the nourishment it contains more palatable."[276]

The *Wreath of Flowers Encircling the Holy Family* depicts the Holy Family as if set within a trompe-l'oeil frame. The Virgin Mary is enthroned in heaven and holds the Christ Child in her lap, while Joseph appears at the left holding the Old Testament. At the right an angel kneels in adoration, and above the Holy Spirit sheds a divine light, while a winged putto gathers up the Virgin's robe. The wreath of flowers encircling this devotional image includes the rose, peony, pimpernel, jasmine, pink, mustard, lychnis, pansy, wood sorrel, adonis, barbary, ranunculus, lilac, lily of the valley, forget-me-not, and daffodil.[277] This flower wreath would not only have enhanced the devotional image that it enframes but also would have served as a carrier of religious symbolism. For example, brides traditionally wore flower garlands; the Virgin was the bride of Christ. More specifically, the rose and peony are attributes of the Virgin, and the pimpernel, which was considered to have medicinal powers, is a symbol of Redemption. In addition, flowers with ternate leaves or petals, such as the pansy or wood sorrel, symbolize the Holy Trinity, as do flowers arranged in groups of three, such as the daffodils at the left center of the composition.[278] In this religious context, the prominent butterfly (previously a caterpillar) and the dragonfly (once a naiad) at the upper left and right of the composition may be interpreted as symbols of rebirth and the resurrection of the soul, which has been liberated from earthly desires and ascends to eternal life.[279]

dition to whatever other pictorial functions they may have had to fulfill—would have served to enhance the value of the images they contain. The paintings of Madonnas in Flower Garlands are painted statements of the preciousness and worth of images of the Virgin, pictorial equivalents, one could almost say, of the emphasis on the value of all images which had formed so fundamental an aspect of every Catholic treatise on art during the great debate about images during the sixteenth century.[275]

Freedberg also noted the "sentimentality" that characterizes many of the Madonnas in flower garlands and observed that many devotional prints

PROVENANCE: Luman Reed, New York, d. 1836; Mrs. Luman Reed, New York, 1836–44; NYGFA, 1844–58.
EXHIBITED: NYGFA, 1844, no. 63, *Wreath of Flowers encircling Holy Family—Antique,* Italian School; 1845, 1846, 1848, no. 48; 1850, no. 1.
REFERENCES: Reed Inventory 1836, "Flower piece (small)," $5.00.

Plate 37

FLEMISH SCHOOL

The Mystic Marriage of Saint Catherine. c. 1625–50

Oil on wood, 28½ × 29½"

Gift of the New-York Gallery of the Fine Arts, 1858.29

Attributed in the New-York Gallery of the Fine Arts catalogue of 1844 to the Italian School, this is a Flemish work, dating from about 1625–50, although it may be based on an earlier composition.[280] Although the painting was identified in the same catalogue as *Madonna, Infant and St. Ann,* it depicts the mystic marriage of St. Catherine of Alexandria, a virgin queen martyred by the Roman emperor Maxentius early in the fourth century. According to the *Golden Legend,* Catherine was converted to Christianity and baptized by a desert hermit. She later experienced a vision in which she was married to Christ. Other sources state that the hermit gave her a devotional image of the Virgin and Child. Catherine's prayers caused the infant Christ to turn his face toward her and later to place a ring on her finger. In Reed's painting, the Virgin Mary holds the Christ Child in her lap as he places a ring on the finger of the kneeling Saint Catherine. Joseph, relegated to the background of the painting's sylvan setting, observes the event from over Mary's shoulder. The theme of Catherine's mystic marriage with Christ was traditionally seen as a metaphor for spiritual betrothal to God.

PROVENANCE: Luman Reed, New York, d. 1836; Mrs. Luman Reed, New York, 1836–44; NYGFA, 1844–58.

EXHIBITED: NYGFA, 1844, no. 9, *Madonna, Infant and St. Ann,* Italian School; 1845, 1846, 1848, no. 4; 1850, no. 74.

REFERENCE: Reed Inventory 1836, "Marriage of St. Catharine," $15.00.

Plate 38

———————

UNIDENTIFIED ARTIST (after Jan Fyt)

The Huntsman's Tent—Game and Dogs After a Hunt. c. 1700

Oil on canvas (lined), 60¾ × 49⅞″ (after removal of an added piece of

canvas 3 × 49⅞″ from the top of the painting)

Gift of the New-York Gallery of the Fine Arts, 1858.40

———————

Jan Fyt, the son of a wealthy Antwerp merchant, studied with the painters Hans van den Berch and Frans Snyders, and was admitted to the painters' guild of Saint Luke in 1629.[281] He subsequently traveled to France and Italy, but by 1641 he had returned to Antwerp, where he painted still-life and animal compositions almost exclusively, occasionally in collaboration with figure painters. *The Huntsman's Tent— Game and Dogs After a Hunt* is typical of Fyt's work in that it does not depict the hunt itself but its aftermath, with the hunting dogs at rest and

their quarry artfully arranged into a still life. The composition, however, is a synthesis of elements copied from Fyt's *Diana and Her Hunting Dogs with Dead Game* (Gemäldegalerie, West Berlin) and compressed into a vertical format.[282] The copyist omitted the figure of Diana and the landscape background that appear in the original painting and added a narrative note with the confrontation between one of the dogs and the cat perched in a tree at the upper left of the painting.[283] Although Fyt occasionally incorporated similar compositional motifs in different works, the synthetic nature of *Game and Dogs* and its somewhat mechanical brushwork suggest that it is the work of one of Fyt's numerous followers.[284] *Game and Dogs* belongs to a genre of hunting and game pictures popular throughout Europe in the seventeenth century, many of which served to decorate the houses and hunting lodges of the upper classes.

It is not known where Luman Reed purchased *Game and Dogs,* although two works depicting this subject and attributed to Fyt were in a collection of old masters exhibited by the Englishman John Watkins Brett at the Boston Athenaeum in 1833 and the American Academy of the Fine Arts in New York in the spring of 1835.[285] Another Fyt painting of *Dead Game and Dogs* was auctioned from the collection of the bookseller William A. Colman in 1832 and could have been on the market again in 1835.[286] In a letter of March 9, 1835, to his protege George W. Flagg, Reed wrote:

> I bo[ugh]t a picture a few days ago by one of the old masters Fyt,
> subject, "Dogs and Game," figures the size of life. a first rate
> specimen of the art & I must say I never knew what could be done
> in painting before. the subject I do not admire, but as a work of art
> it is very first rate. I am now a believer in the old masters.[287]

Reed's favorable opinion of this work apparently was shared by his contemporaries. In the inventory of his estate, the *Game and Dogs* and Jacob Marrell's *Wreath of Flowers Encircling the Coat-of-Arms and Miniature of the Holy Roman Emperor Leopold I* were each appraised at $250, the highest valuations given to the European paintings in the collection.[288]

———————

PROVENANCE: Luman Reed, New York, d. 1836; Mrs. Luman Reed, New York, 1836–44; NYGFA, 1844–58.

EXHIBITED: NYGFA, 1844, no. 43, *The Huntsman's Tent—game and dogs after a hunt,* Fyt; 1845, 1846, 1848, no. 20; 1850, no. 36.

REFERENCE: Reed Inventory 1836, "Dogs and Game (Fyt)," $250.00.

Plate 39

FLEMISH SCHOOL

An Allegory—Death and Immortality. c. 1675–1725

Oil on wood, 14⅛ × 18¾″

Printed label on verso: PARKER & CLOVER, / LOOKING GLASS / AND / PICTURE
FRAME MAKERS, / 180 FULTON STREET, / OPPOSITE CANAL STREET, / NEW YORK.

Gift of the New-York Gallery of the Fine Arts, 1858.17

and seventeenth-century artists, who drew upon them for such commonly illustrated themes as the seasons, months, elements, senses, temperaments, and the ages of man. The first Dutch translation (1644) of Cesare Ripa's *Iconologia,* perhaps the most famous emblem book, was described explicitly on one of the title pages as "a work that is useful to all orators, poets, painters, sculptors, draughtsmen, and all other art lovers and devotees of learning and true knowledge."[290] The crude nature of many emblem book illustrations may account in part for the inaccuracies of drawing and the discrepancies of scale that characterize this painting.

An Allegory—Death and Immortality is a "vanitas" still life, whose theme is described accurately in its nineteenth-century title. Thus, the hourglass, snake, skull, and crossed bones on the tombstone and the gravediggers' tools nearby all symbolize the inexorable passage of time and the inevitability of death and decay. The seasonal wheat and flowers at the right and the sunset glow on the horizon also are indicative of the brevity of life. Although the oil lamp burning atop the obelisk has memorial connotations and the ivy, being evergreen, signifies eternal life, they are contrasted with classical ruins and with what appear to be an Italian Renaissance campanile and a Christian church. These elements serve as reminders of the temporal nature of fame and the works of man.

Although attributed to the Italian School in the New-York Gallery of the Fine Arts catalogue of 1844, both the technique and the linden wood support of this painting suggest that it was produced by a northern artist in the late seventeenth or early eighteenth century.[289] While the mountains suggest that the artist may have traveled through the Alps, the landscape is imaginary, and the source for this composition was probably an image from an emblem book. Emblem books comprised prints, mottoes, and explanatory texts that attempted to codify classical, Christian, and humanist iconography. They were widely used by sixteenth-

PROVENANCE: Luman Reed, New York, d. 1836; Mrs. Luman Reed, New York, 1836–44; NYGFA, 1844–58.
EXHIBITED: NYGFA, 1844, no. 3, *An Allegory—Death and Immortality—Antique,* Italian School; 1845, 1846, 1848, no. 68; 1850, no. 96.
REFERENCE : Reed Inventory 1836, "Allegorical piece," $15.00.

Plate 40

GERMAN SCHOOL

Portrait of a Young Lady. 1608

Oil on wood, 33½ × 26½″

Inscribed upper left: AETATIS SUAE. 18. / ANNO 1608 / IK.

Gift of the New-York Gallery of the Fine Arts, 1858.39

Although attributed to the Flemish School in the New-York Gallery of the Fine Arts catalogue of 1844, this early seventeenth-century portrait was probably painted in East Friesland, an area of northern Germany bordering on the North Sea.[291] The subject, an eighteen-year-old woman according to the panel inscription, is depicted wearing a black checked dress and a black cap over a long ponytail. The white ruff and cuffs of imported Venetian reticella lace, the elaborately decorated purse, and the gold necklace and jewelry attest to her wealth and social status. This portrait may have been commissioned to commemorate the sitter's marriage, and was probably a companion portrait to that of her husband. As the product of the provincial Friesian School, which was isolated from major art centers, this portrait is somewhat retardataire, but it may have appealed to Reed for its period costume and documented age.

PROVENANCE: Luman Reed, New York, d. 1836; Mrs. Luman Reed, New York, 1836–44; NYGFA, 1844–58.

EXHIBITED: NYGFA, 1844, no. 27, *Portrait of a Young Lady, taken in 1608,* Flemish School; 1845, 1846, 1848, no. 36; 1850, no. 73.

REFERENCE: Reed Inventory 1836, "Portrait 1608," $20.00.

Plate 41

———————

UNIDENTIFIED ARTIST (after Willem Kalf)

Still Life with Chinese Sugarbowl, Nautilus Cup, Glasses, and Fruit.

c. 1675–1700

Oil on canvas (lined), 32 × 27″

Gift of the New-York Gallery of the Fine Arts, 1858.15

———————

specialized in painting *pronk* still lifes that incorporated precious objects, such as the porcelain bowl and the nautilus cup in this composition. Kalf's still lifes, which synthesized Rembrandt's dramatic chiaroscuro and Vermeer's palette, were especially popular with the wealthy classes of Amsterdam.[294] The attribution of Kalf's works is often problematic because both he and his students replicated his work. The still life owned by Reed probably was painted by a follower of Kalf such as van Aelst, or perhaps by a later copyist.[295]

Kalf's Amsterdam still lifes, comprising objects of material luxury and sensory indulgence, may be interpreted as presenting the viewer with an implicit choice between the transient, worldly possessions depicted and the eternal rewards of the spiritual realm.[296] Kalf's *Still Life with Porcelain Bowl* (Gemäldegalerie, West Berlin) includes a pocket watch that symbolizes the passage of time, while the exotic fruit in *Still Life with Chinese Sugarbowl* that soon will decay may have a similar connotation.[297] Reed may not have been aware of this type of symbolism, but as a patron of the fine arts, he certainly would have appreciated the beauty of the painting and the objects that it contains. These objects, arranged on a marble table set into a wall niche, have been identified as a Chinese sugar bowl from the period of the Emperor Wan-Li (1573–1619), decorated with a Fo dog and applied figures representing the Immortals of Taoism; a polished nautilus-shell cup, crowned by a figure of Neptune with his trident and depicting Jonah fleeing from the whale's mouth; a tall, wine-filled glass with a lid, produced in Holland after a Venetian model; and a Persian carpet, possibly a Herat.[298] Also shown are two smaller wineglasses, a silver platter, an agate-handled knife, a partially peeled lemon (often used to enhance the taste of sweet white wine), an orange, and several seashells. The lemon and orange were costly imported novelties, as were the seashells, which were avidly collected in the seventeenth century.[299]

Attributed to the Dutch still-life painter Willem van Aelst (1627–after 1683) in the New-York Gallery of the Fine Arts catalogue of 1844, this work is a copy of Willem Kalf's *Still Life with Chinese Sugar Bowl, Nautilus Cup, Glasses, and Fruit* (Thyssen-Bornemizsa collection, Lugano) of 1662.[292] Kalf was born in Rotterdam in 1619, and in the early 1640s worked in France. There he painted scenes of peasant life, kitchen interiors, and still lifes.[293] After 1653 he lived in Amsterdam, where he

American critics would have admired the execution of Reed's still life, but the comments of a writer in the *Knickerbocker* in 1839 summarized the prevailing critical attitude toward the subjects embraced by Dutch art:

> The Dutch have a very decided school of their own, but it is of an inferior order; embracing none of the exalted attributes of art, with the exception of that good coloring. Grandeur of conception, or poetic feeling, is rarely discernible in their works; but it must be acknowledged, that in what they aim at, a correct mechanical imitation of nature, they are eminently successful. In fruit, flowers, etc., the Dutch painters are unrivalled.[300]

Reed, however, took a somewhat different view, crystallized in comments to his protege George W. Flagg, who was studying in Paris at Reed's expense: "pure simple nature is the school, after all . . . a cat well painted is better than a Venus badly done."[301]

————————

PROVENANCE: Luman Reed, New York, d. 1836; Mrs. Luman Reed, New York, 1836–44; NYGFA, 1844–58.
EXHIBITED: NYGFA, 1844, no. 35, *Goblet and Lemon,* by W. van Aelst; 1845, 1846, 1848, no. 70; 1850, no. 63.
REFERENCE: Reed Inventory 1836, "Goblet & Bowl," $75.00.

Plate 42

DUTCH SCHOOL

Interior—Dutch Apothecary Shop. c. 1775–1800

Oil on wood, 18 × 24⅝″

Signed or inscribed, lower center: RP

Gift of the New-York Gallery of the Fine Arts, 1858.24

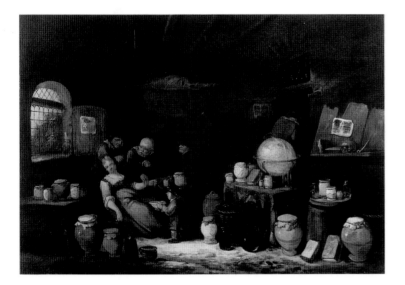

In the 1915 catalogue of the New-York Historical Society's collections this work was attributed to Roelof Pietersz, presumably on the basis of the initials RP that appear on the covered apothecary jar in the foreground of the painting.[302] Although there was a Roelof Pietersz who was active as an artist in Utrecht in the early sixteenth century, the bright colors and anachronistic dress reveal this work to be a late eighteenth- or early nineteenth-century pastiche.[303] The subject and period details of the painting, however, were derived from seventeenth-century Dutch genre paintings.[304] In the expanding market for Dutch paintings in the early nineteenth century, works of this type were sold both as acknowledged copies and occasionally as originals to undiscerning collectors.[305] Dutch genre subjects like the *Interior—Dutch Apothecary Shop* were especially popular among American collectors, although they often were faulted by critics for their subject matter:

The Dutch paint nature, but it is nature in its lower and more degraded forms. What must we think of the taste that leads an artist to labor for a month in making a facsimile of a cabbage or a herring?—or which induces him to choose a set of boors, carousing in an inn, as a favorite subject of his pencil? And this is the character of Dutch art. These subjects are certainly executed with a truth and power perfectly marvellous; but this fact only leads us the more to regret the perversity of taste that can thus desecrate genius.[306]

Reed, however, was especially fond of genre painting, and in 1835 he wrote to William Sidney Mount, "Every day Scenes where the picture tells the story are the kinds most pleasing to me and must be to every true lover of the art."[307]

The setting of the *Interior—Dutch Apothecary Shop* is filled with stoneware jars and traditional attributes of learning, such as the zodiacal globe, books, and a skull. The subject of the painting, however, is the "quack" doctor plying his profession, a popular theme among Dutch artists in the seventeenth century. Although seventeenth-century Dutch physicians made major contributions to the science of medicine, most rural doctors were traveling barber-surgeons with only rudimentary medical training. Their treatment by Dutch artists offered numerous opportunities for depictions of deception and gullibility.[308] The doctor in this painting is bleeding his female patient, a treatment once commonly prescribed. Illuminated by the light of the window at the left, he has made an incision in the left arm of his understandably squeamish patient, and a stream of blood pours forth into the basin, held by a young boy. The doctor also is assisted by two boors, whose caricatured expressions underscore the questionable abilities of the doctor and the gullibility of his patient.

The medical practice of bleeding patients still was common in early nineteenth-century America. Mrs. Jonathan Sturges, the wife of Reed's business partner, recounted that Reed, who certainly could have afforded the best medical care available in New York, was subjected to this treatment during his last illness in May and June of 1836. Reed died on June 7, 1836, and his widow later blamed his doctors for her husband's death.[309]

PROVENANCE: Luman Reed, New York, d. 1836; Mrs. Luman Reed, New York, 1836–44; NYGFA, 1844–58.
EXHIBITED: NYGFA, 1844, no. 11, *Interior—Dutch Apothecary Shop,* Dutch School; 1845, 1846, 1848, no. 28; 1850, no. 80.
REFERENCE: Reed Inventory 1836, "Doctor's shop," $10.00.

Plate 43

JACOB MARRELL (1613/14–1681)

Wreath of Flowers Encircling the Coat-of-Arms and Miniature of the Holy

Roman Emperor Leopold I. 1658

Oil on canvas (lined), 33 × 46″

Signed, dated, and inscribed lower left: J. Marrell fecit / AN[NO] 1658 / fforth.

Gift of the New-York Gallery of the Fine Arts, 1858.35

wreaths of the Flemish painters Jan Brueghel the Elder and Andries Danielsz.[311] Many cartouche flower paintings were collaborations, and the portrait medallion of Leopold I may have been painted by another artist, although Marrell could have copied it from an official court portrait. Comparable works by Marrell include the *Flower Decorated Cartouche with a View of Frankfurt* of 1651 (Historisches Museum, Frankfurt), and the *Wreath of Flowers Encircling a Grotto* (Hessisches Landesmuseum, Darmstadt) of 1655.[312] The painting owned by Reed is inscribed "fforth," an abbreviation for Frankfurt (often Latinized as "Francoforti" in the seventeenth century), the city where the artist lived and worked from 1651 until his death.[313]

The focal point of Marrell's composition is a portrait of Leopold I (1640–1705), who was crowned Holy Roman Emperor in Frankfurt in 1658. This event may have prompted the commissioning of Marrell's painting, which bears the date 1658. Leopold, who had initially been educated for the Church and was renowned for his piety, wears an armor breastplate and ecclesiastical vestments signifying his status as defender of the Catholic faith. In 1683, under Leopold's reign, the Ottoman Turks were defeated during the siege of Vienna, and Austria emerged as a great European power.[314] Leopold wears the noble Burgundian Order of the Golden Fleece, which also enframes his portrait, as do nine coats of arms representing his domains, including that of the archduchy of Austria at the top center. This elaborate ensemble is superimposed on the double-headed Hapsburg eagle, which clutches a sword, scepter, and orb in its talons and is surmounted with the crown of the Holy Roman Emperor.[315] At the apex of Marrell's wreath is a red crown imperial, a rare and valuable flower popular with Dutch and Flemish still-life painters for its size, bright color, and symmetrical form.[316] The floral wreath itself is a

Jacob Marrell was born at Frankenthal on the Rhine, and became a pupil of Georg Flegel at Frankfurt in 1627. During the 1630s he moved to Utrecht, where he studied with the Dutch still-life painter Jan Davidsz de Heem.[310] Marrell specialized in still lifes of flowers, and the *Wreath of Flowers Encircling the Coat-of-Arms and Miniature of the Holy Roman Emperor Leopold I* is a characteristic composition, derived from the flower

traditional means of paying homage, and it must have seemed particularly appropriate to include a crown imperial in this work depicting the recently crowned Holy Roman Emperor.

While Leopold's portrait is the centerpiece of Marrell's composition, it nonetheless is almost overwhelmed by the spectacular depiction of more than twenty distinct species of flowers and a profusion of insect life that includes butterflies, dragonflies, moths, caterpillars, and beetles.[317] In addition to the imperial crown, the flowers include the lily, tulip, peony, snowball tree, narcissus, Spanish and German iris, runuculus, auricula, rose, Turk's cap, forget-me-not, avens, Japanese quince, orange blossom, cornflower, love-in-a-mist, pink, scilla, anemone, and wallflower.[318] Especially prominent are the dramatic variegated tulips that resulted from the alteration of monochrome tulips by viruses. Earlier in his career Marrell had made "tulip books" containing watercolors of tulips and other flowers. (An example is in the Print Cabinet, Rijksmuseum, Amsterdam.) Such books were used as reference works by tulip merchants and collectors during the tulipomania that swept Holland in the early seventeenth century.[319] Although wild speculation and exorbitant prices led to the collapse of the tulip market in 1637, the premium placed on the accurate rendition of distinct species in these books undoubtedly influenced Marrell's later oil paintings. This influence, as well as the use of preexisting studies for the depiction of flowers and insects that were not in season, may account for the appearance of Marrell's composition as a grouping of distinct parts, arranged and illuminated for maximum legibility.

The American response to paintings like Marrell's was based almost entirely upon their naturalism and technical brilliance, which prompted a critic for the *Portfolio* to write: "The Dutch and Flemish schools, for faithful representations of nature, have never been excelled."[320] This naturalism appealed to American sensibilities and may account in part for the fact that, in the inventory of Reed's estate, Marrell's *Wreath of Flowers Encircling the Coat-of-Arms and Miniature of the Holy Roman Emperor Leopold I* and the *Game and Dogs* attributed to Jan Fyt were each appraised at $250, the highest valuations given to European paintings in the collection.[321] Marrell's painting, however, would have appealed to Reed not only for its technique, but also for its floral content. Reed's fondness for flowers was documented by one of his contemporaries, who wrote that Reed even planted flowers in the yard behind his warehouse at 125–127 Front Street.[322]

PROVENANCE: Luman Reed, New York, d. 1836; Mrs. Luman Reed, New York, 1836–44; NYGFA, 1844–58.

EXHIBITED: NYGFA, 1844, no. 69, *Wreath of Flowers, encircling Coat of Arms and Miniature of Duke of Austria, (1658)*, F. Marrell; 1845, 1846, 1848, no. 50; 1850, no. 20.

REFERENCE: Reed Inventory 1836, "Flower piece (Marell)," $250.00.

Plate 44

GERMAN SCHOOL

Man and Woman with a Child Drinking Water. c. 1750

Enamel on copper, 2⅜ × 3″

Gift of the New-York Gallery of the Fine Arts, 1858.49

Plate 45

GERMAN SCHOOL

Shepherd Drinking at a Waterfall. c. 1750

Enamel on copper, 2½ × 3½″

Gift of the New-York Gallery of the Fine Arts, 1858.53

These enamels were identified in the New-York Gallery of the Fine Arts catalogue of 1844 as "Dutch," a designation which in the nineteenth century referred not only to the Netherlands but also to the Germanic regions of Europe. The stylistic evidence suggests that these works were produced in a German enamel studio in the mid-eighteenth century, either for snuffbox lids or other bibelots or as decorative plaques suitable for framing.[323] Their subjects are characteristic of the scenes of rural life that were popular in mid-eighteenth-century art, and such scenes often were copied by enamel studios from original compositions or from prints. In one enamel, a man and a woman wearing contemporary dress pause beside a picturesque mountain lake and share a drink of water with a young child. In the second, a rustic shepherd wearing seventeenth-century dress and accompanied by his flock drinks from a waterfall.

Twelve enamels of identical dimensions by the same artist, mounted in a metal jewel box, are now in the Metropolitan Museum of Art, New York.[324] These enamels, like the *Man and Woman with a Child Drinking Water* and the *Shepherd Drinking at a Waterfall,* depict figures in rural landscape settings, pursuing such pastimes as fishing, music-making, drinking, courting, and eating. Both the jewel casket and the framed enamels owned by Reed probably were produced for sale to such tourists and collectors as Reed's son-in-law Theodore Allen, who made the grand tour of Europe in 1836.[325]

PROVENANCE: Luman Reed, New York, d. 1836; Mrs. Luman Reed, New York, 1836–44; NYGFA, 1844–58.

EXHIBITED: NYGFA, 1844, no. 24, *Miniature—Dutch Enamel*; no. 38, *Miniature—Dutch Enamel*; 1845, 1846, 1848, nos. 73, 74; 1850, nos. 69, 77.

REFERENCE: Reed Inventory 1836, "2 small Dutch Enamels," $5.00.

Plate 46

UNIDENTIFIED ARTIST (after Antonio Allegri, called Correggio)

Saint Mary Magdalen Reading. c. 1775–1825

Oil on canvas (lined), 14¼ × 18″

Gift of the New-York Gallery of the Fine Arts, 1858.54

This work is a slightly enlarged copy after Correggio's *Saint Mary Magdalene Reading* (c. 1525; formerly Dresden Gallery).[326] Born in the town from which he took his name, Correggio is thought to have studied with Francesco Bianchi Ferrari of Modena or possibly Andrea Mantegna, although his mature work reveals such diverse influences as Leonardo, Michelangelo, Giorgione, and Raphael. Because he spent most of his career in his native province of Lombardy and produced no known school or students, Correggio's lasting reputation was rescued only through the influence of Annibale and Lodovico Carracci, who rediscovered his works in the late sixteenth century.[327]

By the late eighteenth and early nineteenth centuries, Correggio was ranked by many prominent figures as one of the greatest painters who had ever lived.[328] In a comparison of the two artists in one of his famous "Discourses" delivered before the Royal Academy in London, Sir Joshua Reynolds even faulted Raphael, who "never acquired that nicety of taste in colours, that breadth of light and shadow, that art and management of uniting light to light, and shadow to shadow, so as to make the object rise out of the ground with that plentitude of effect so much admired in the works of Correggio."[329]

Correggio's *Saint Mary Magdalene Reading* depicted the penitent, bare-shouldered Magdalene reclining in a landscape and reading the Bible. She was surrounded by her traditional attributes, which include an urn, a snake, a skull, and a crucifix, symbolizing her meditations on sin, death, and resurrection. This synthesis of religion, sentiment, and sensuality made Correggio's *Magdalene* one of the most famous paintings of the Romantic era.[330] It figures prominently in the Danish poet and dramatist Adam Gottlob Oehlenschlager's *Correggio: A Tragedy* (1811), one of the numerous fictitious and romanticized accounts of the artist's life published in the nineteenth century.[331] The painting was also famous in the United States. The artist Daniel Huntington wrote, "Without having seen this gem, it is impossible to conceive what magic power resides in the painter's Art."[332] It was one of the most copied works of the period, and Thomas Sully reported seeing "a fine copy of Correggio's *Magdalene*" at Richard Abraham's exhibition of old masters at the American Academy of the Fine Arts in New York in 1830.[333] Reed would have known that the painting in his collection was a copy, but no doubt the fame and beauty of Correggio's original made this work a valuable addition to his gallery.

PROVENANCE: Luman Reed, New York, d. 1836; Mrs. Luman Reed, New York, 1836–44; NYGFA, 1844–58.
EXHIBITED: NYGFA, 1844, no. 2, *A Magdalen,* after Correggio; 1845, 1846, 1848, no. 72; 1850, no. 94.
REFERENCE: Reed Inventory 1836, "Magdalen," $200.00.

Plate 47

UNIDENTIFIED ARTIST (after Francesco Albani)

The Assumption of the Virgin. c. 1775–1825

Oil on canvas (lined), 18¾ × 24¾″

Gift of the New-York Gallery of the Fine Arts, 1858.37

of the Virgin lunette, attributed to Annibale Carracci in Luman Reed's day, may have been designed by Carracci, but currently it is ascribed to Francesco Albani.[335] *The Assumption of the Virgin* in Reed's collection was probably the work of an eighteenth- or nineteenth-century copyist, who omitted the apostles gathered around Mary's empty tomb in the original painting and altered the surrounding landscape.

The demand for Annibale Carracci's works in the United States resulted in the production of numerous copies for the art market. The artist Robert W. Weir is said to have painted, for his own "amusement," a copy of an unspecified Carracci work, which he artificially aged. Some time later, upon discovering a fellow artist assiduously copying this "undoubted original," Weir learned that the painting had been bought by the notorious New York picture dealer Michael Paff and attributed as an original Carracci.[336] Weir's anecdote reveals the pitfalls awaiting collectors like Reed, who also purchased old master paintings from Paff before turning to the work of contemporary American artists.[337]

This small oil painting of *The Assumption of the Virgin* was copied from one of six much larger lunette oil paintings commissioned from Annibale Carracci by Cardinal Pietro Aldobrandini in about 1603 or 1604.[334] Originally installed in a chapel in the Aldobrandini (now Doria-Pamphili) Palace in Rome, the six lunettes were moved to the Villa Aldobrandini on the Quirinal in the seventeenth century. *The Assumption*

PROVENANCE: Luman Reed, New York, d. 1836; Mrs. Luman Reed, New York, 1836–44; NYGFA, 1844–58.

EXHIBITED: NYGFA, 1844, no. 21, *Assumption of the Virgin,* Annibale Caracci [*sic*]; 1845, 1846, 1848, no. 19; 1850, no. 60.

REFERENCE: Reed Inventory 1836, "Assumption," $40.00.

Plate 48

GEORGE MORLAND (1763–1804)

Dogs Fighting. 1783 or later

Oil on canvas, 16 × 20¾″

Signed center left: G. Morland

Gift of the New-York Gallery of the Fine Arts, 1858.43

backdrop for the fierce canine conflict in the foreground. As the owners attempt to separate their dogs, two bemused children watch from the safety of the cottage. As a genre scene of lower-class rural life, *Dogs Fighting* reflects the influence of the seventeenth-century Dutch and Flemish genre paintings that Morland copied during his apprenticeship with his father.[340] While Morland was proficient at capturing rural atmosphere and detail, such as the horseshoe attached to the doorstep of the cottage, his picturesque scenes did not show the harsh realities of life for the rural poor in nineteenth-century England.[341] This sanitized version of rural life was praised by contemporary critics, who compared Morland's work favorably with the more earthy realism of the Dutch School:

> He does not attempt to exceed what he has seen; he delineates faithfully all that rural simplicity which we are accustomed to meet; and, if he omits anything, it is the gross and disgusting impurities of the Dutch school.[342]

George Morland was born in London and studied with his father, Henry Robert Morland, who painted portraits and domestic scenes, engraved mezzotints, restored pictures, and manufactured and sold artists' materials.[338] The younger Morland began exhibiting at the Royal Academy at the age of ten, and completed his apprenticeship with his father at the age of twenty-one, at which time he declined a further apprenticeship with George Romney.[339] In spite of a profligate life-style that was complicated by alcoholism and perennial debt, Morland had a productive career and specialized in painting rural genre scenes and sporting pictures.

Like the majority of Morland's works, *Dogs Fighting* is set in rural England. A rustic thatched cottage and a village church provide the

Morland enjoyed a reputation as a masterful painter of canine anatomy and character, and his choice of fighting dogs as a subject may have been influenced by personal experience, for his house in London had a menagerie that included "dogs of all kinds."[343] A contemporary observer noted that the artist also was not above creating the type of scene he depicted in *Dogs Fighting*: "To be the instigator of a quarrel between quadrapeds [sic] or bipeds, was a matter of equal indifference to Morland."[344] However, the immediate source for several of Morland's paintings of dogs was Thomas Gainsborough's *Two Shepherd Boys with Dogs Fighting* (Kenwood House, London), which he exhibited at the Royal Academy in 1783. According to one of his biographers, Morland "once

made a sketch of Gainsborough's *Fighting Dogs* and from this memorandum painted several pictures."[345]

The *Dogs Fighting* in Luman Reed's collection appears to be one of Morland's variations on Gainsborough's painting; for both works depict a dog lunging for the throat of its adversary in a picturesque rural setting. The two works also share a similar pair of human figures, one of whom raises his arm to beat off the attacking dog while being restrained by his companion. Another Morland painting of *Fighting Dogs* that may have been derived from Gainsborough's painting was among the thirty-six works that comprised the English artist and publisher John Raphael Smith's "Morland Gallery."[346] A Morland sketch of fighting dogs that was reproduced in a biography of 1806 differs significantly from Reed's painting only in the addition of a third dog who observes the combatants.[347]

PROVENANCE: Luman Reed, New York, d. 1836; Mrs. Luman Reed, New York, 1836–44; NYGFA, 1844–58.
EXHIBITED: NYGFA, 1844, no. 49, *Dogs Fighting,* Morland; 1845, 1846, 1848, no. 53; 1850, no. 47; Washington Exhib. NYGFA, 1853, no. 95, *Dogs Fighting.*
REFERENCE: Reed Inventory 1836, "Dogs fighting," $100.00.

Plate 49

GEORGE MORLAND

Old English Sportsman. c. 1790–1804

Oil on canvas (lined), 19 × 24″

Gift of the New-York Gallery of the Fine Arts, 1858.47

This painting attributed to George Morland belongs to a well-established English tradition of sporting paintings that depicted such rural pastimes as hunting, racing, coaching, and shooting. Although this work was titled *Old English Sportsman* in the New-York Gallery of the Fine Arts catalogue of 1844, it was listed simply as "Gunner" in the 1836 inventory of Reed's estate. There is no pictorial evidence to suggest that it depicts a historical subject rather than a contemporary scene recorded by the artist.[348] The focus of the composition is a solitary hunter who has dismounted from his horse in a landscape of rolling hills and scrub brush. He shoulders a shotgun and takes aim at the four partridges that have just been flushed from their ground cover by a spaniel. The white horse was a characteristic feature of Morland's paintings, and a contemporary biographer noted that

in "almost every subject of Morland's, where there are horses, one is sure to be a white one."[349] Several Morland sketches reproduced in an 1806 biography of the artist, including two of a hunter in a nearly identical pose, may have served as studies for this painting.[350]

Hunting and shooting scenes like *Old English Sportsman* formed a distinct category within Morland's work. Occasionally he participated in such sports, although largely for artistic reasons:

> Morland, upon one occasion, attached himself to a shooting party, in which the writer of this made one; eternally restless after he had fulfilled his desires, or rather his study, it was no entertainment to him beyond this point. Upon the second morning, therefore, finding him impatient, we presented him with the result of the preceding day's sport, and wished him a good journey to town. From this short peregrination, he painted four very beautiful pictures.[351]

This series of four paintings, or a similar series by Morland, was the basis for numerous prints depicting *Duck Shooting, Partridge Shooting, Snipe Shooting,* and *Pheasant Shooting* published in the late eighteenth and early nineteenth centuries.[352] Morland's sporting subjects were sufficiently popular to inspire four satirical prints of 1790–91 by Thomas Rowlandson, "burlesquing the sports of the field."[353]

PROVENANCE: Luman Reed, New York, d. 1836; Mrs. Luman Reed, New York, 1836–44; NYGFA, 1844–58.
EXHIBITED: NYGFA, 1844, no. 72, *Old English Sportsman,* Morland; 1845, 1846, 1848, no. 65; 1850, no. 50.
REFERENCE: Reed Inventory 1836, "Gunner," $20.00.

Plate 50

ANDREW RICHARDSON (1799–1876)

View From Froster Hill, Gloucestershire, England. c. 1833

Oil on canvas (lined), 18 × 24″

Gift of the New-York Gallery of the Fine Arts, 1858.14

works were singled out for praise by a critic for the *American Monthly Magazine:*

> View from Froster Hill, Gloucestershire, England, by the same artist, is still more beautiful than the foregoing;—the two are intended as companions. Nothing can surpass the extent and richness of this scene, which the artist has executed in the most chaste and skilful manner,—no gaudy tints, but delicate grays are the chief colors, and there is a soft haziness that is very impressive to the imagination. The two are in truth the finest pieces of landscape in the whole exhibition.[357]

Richardson's landscape depicts a site in Gloucestershire, in the southwest of England. The view from Froster Hill is enjoyed by five picnickers, who have selected a spot in the foreground that affords a beautiful vista of the Severn River and the surrounding countryside. Three cows on the hill at the left, a flock of sheep in the meadow below, and a cottage nestled among the hills in the middle ground complete this pastoral scene.

The picnickers on the hill and the pleasure boats on the river below document the presence of a thriving tourist industry. The late eighteenth and early nineteenth centuries were characterized by the proliferation of literature promoting picturesque travel, including works by Sir Uvedale Price and the Reverend William Gilpin. These writers glorified travel and encouraged their readers to search out the natural and man-made splendors of the landscape. This phenomenon also was characterized by the appearance of numerous illustrated guidebooks, one of which described the scene depicted in Richardson's view from Froster ("Frocester") Hill:

> Frocester, anciently written Frouecestre, is a small village, situated at the bottom of a high hill, which screens it on the east, and from its summit commands a very beautiful prospect. "On the left is

Andrew Richardson was born in Edinburgh, where early in his career he exhibited at the Royal Scottish Academy.[354] He emigrated to the United States in 1831, and the first paintings that he exhibited in that year at the National Academy of Design were European landscapes that he had brought with him to America. In 1832 he was elected both a member of the Sketch Club and an associate of the National Academy of Design, and in the following year he was elected an academician.[355] Richardson exhibited European subjects in America throughout his career, even during his second residence in Scotland, between 1841 and 1856. His *View From Froster Hill, Gloucestershire, England* was shown in 1833 at the National Academy of Design, where it was paired with a Scottish landscape, *Dryburgh Abbey, the Burial Place of Sir Walter Scott.*[356] The two

Camley Pike, of a volcanic shape, and the bold projecting head of Stinchcombe; in the foreground, two expanded reaches of the Severn; the intermediate distances between the Forest Hills, the blue mountains of Malvern, and the turrets of Glocester, are filled with cultivated fields, village churches, and buildings of various descriptions, among which the Castle and tower of Berkeley, with their lofty battlements, are easily distinguished."[358]

The area surrounding Froster Hill thus was renowned both for its natural beauty and for the historical associations of such man-made structures as Gloucester Cathedral and Berkeley Castle, the site of the murder of Edward II in 1327.[359] Richardson's painting would have appealed to the

tourists who visited these sites as well as to urban patrons such as Reed who could enjoy such picturesque landscapes vicariously.

———————————

PROVENANCE: Luman Reed, New York, d. 1836; Mrs. Luman Reed, New York, 1836–44; NYGFA, 1844–58.
EXHIBITED: NAD, 1833, no. 96, *View From Gloucestershire, England*, lent by Luman Reed; NYGFA, 1844, no. 4, *View From Froster Hill, England*, A. Richardson; 1845, 1846, 1848, no. 58; 1850, no. 82.
REFERENCES: *New-York Mirror* 10 (June 15, 1833), p. 398; *American Monthly Magazine* 1 (July 1, 1833), p. 333; Reed Inventory 1836, "Landscape (Richardson)," $20.00.

Plate 51

———————————

ANDREW RICHARDSON

View Near Bridgeport, Connecticut. c. 1831–36

Oil on composition board, 13 × 19"

Printed label on verso: Improved / Flemish Ground Milled Boards, /
Prepared by / Rowney & Forster, / Artists' Coulourmen, / 51, Rathbone Place,
London. / Prepared Canvass with or without absorbent grounds. / An
improved White for Oil Painting / Also, extra fine bladder Colour. / Superior
Mastic Varnish, Asphaltum, and fine light Drying Oil. / A new and improved
quick Dryer, warranted not to crack or injure / the Colours. / With every
other material for Oil Painting, of very superior qualities. Printed label on
verso of frame: []r, / Looking Glass & Picture / frame Maker, / 18½ Maiden
Lane, / (Entry by Little Green St.) / New-York.
Gift of the New-York Gallery of the Fine Arts 1858.55

———————————

Soon after his arrival in America in 1831, the Scottish artist Andrew Richardson began depicting and exhibiting indigenous scenes for his new American market.[360] His *View Near Bridgeport, Connecticut* nonetheless reflects the influence of a well-established European tradition of the topographic landscape and city view. As such, it incorporates such conventions of the picturesque landscape as the enframing tree and the

centrally placed body of water, while still providing a small-scale, unpretentious record of the prominent natural and man-made features of a specific site. Richardson's view corresponds to that from present-day Lookout Point in Beardsley Park, with the Pequonnock River meandering southwest toward downtown Bridgeport, which is demarcated by the silhouettes of several church steeples, and Long Island Sound.

The most prominent feature of *View Near Bridgeport, Connecticut* is the group of mill buildings in the foreground, which were erected by Daniel Thatcher, a wealthy druggist from Philadelphia. Thatcher purchased a site on Mill Pond in 1828, where he founded the Daniel Thatcher Woolen Factory and erected large mill buildings for the manufacture of wool, cotton, and linen cloth. He also constructed a series of small cottages for the mill workers (visible to the right of the main buildings), and the thriving community became known as Thatchersville.[361] Between 1832 and 1843, Thatcher gradually sold his interest in the mill to the Bunnell family of New York. They incorporated it as the Pequonnock Manufacturing Company, built a mansion on an adjacent hill, and gave Bunnell Pond its present name.[362]

Richardson's painting is notable for its synthesis of the natural beauty of the picturesque landscape with the industrial and commercial achievement represented by Daniel Thatcher's factory and the distant city of Bridgeport. At a time when much of the country was still untamed wilderness, there was an understandable curiosity and pride associated with the cultivated landscape and established settlements as visible manifestations of America's progress. Mills were an increasingly important feature of the American landscape at this date, and they began to rival churches as the most prominent landmarks of prosperous towns and cities. Charles Dickens made a special trip to see the textile mills of Lowell, Massachusetts, during his American travels in 1842. Although he noted that the young women worked twelve-hour days, he compared the working conditions favorably with those of their English counterparts.[363] Richardson's idyllic view of the peaceful and prosperous coexistence of manufacturing and the rural landscape predates the systematic abuses that later characterized the mill system.

PROVENANCE: Luman Reed, New York, d. 1836; Mrs. Luman Reed, New York, 1836–44; NYGFA, 1844–58.

EXHIBITED: NYGFA, 1844, no. 73, *View near Bridgeport, Connecticut,* Richardson; 1845, 1846, 1848, no. 60; 1850, no. 86.

REFERENCE: Reed Inventory 1836, "View of Bridgeport Richardson," $20.00.

LUMAN REED:
A FAMILY MEMOIR

MARGARET PRESTON SYMONDS

The grandchildren of Mr. and Mrs. Luman Reed at Norland, Dudley Barber Fuller and Mary Reed Fuller house
in Hyde Park, New York, c. 1860

Luman Reed was my great-great-grandfather. In my youth, all I knew about him was that he had been considered a person of significance and influence in New York business and art circles in the early nineteenth century. In the late twenties my father and mother and my brothers and sister and I went to live with my mother's parents, the Charles Dudley Fullers, at their house at 25 West 9th Street in New York. My grandfather, Luman Reed's grandson, was one of nine children, most of whom settled in New York City, Long Island, New Jersey, and Connecticut. Therefore we knew them intimately and heard a lot about the many uncles and aunts and cousins. In the dining room of the Fuller house was an Asher B. Durand portrait of Luman Reed, my grandfather's mother's father, and a Samuel F. B. Morse portrait of Desire Barber Fuller, my grandfather's father's mother. This, we were taught, was an easy way to remember the relationships.

I remember being present in 1920 at my grandparents' fiftieth wedding anniversary reception at their house on Ninth Street, and that my grandmother wore for this occasion her wedding dress, which seemed very grand to us. I later learned that this dress had been made for her by Charles Frederick Worth, who established the first couture house in Paris. Another thing that particularly interested us concerning the family was hearing about the Allen cousins. Luman Reed's older daughter, Catharine, married the New York attorney Theodore Allen in 1834, and at their untimely deaths in 1850 eight of their ten children survived them. Luman Reed's younger daughter, Mary, and her husband Dudley Barber Fuller "adopted" them all and brought them up with their own nine. To make room for this large family, which included Mrs. Luman Reed ("Grandma Reed"), a wing was added to their house in Hyde Park, New York, where they spent the summers. Seventeen children in one family made a lasting impression on us. I also clearly remember my grandfather Charles Dudley Fuller in 1927, when his eyesight was failing him, dictating his memoirs (covering the period 1841–1893) to his wife Anna Pendleton Rogers Fuller.[1]

It wasn't until I had been married and had children of my own that I became interested in exploring how all of Luman Reed's descendants fit into the family picture; I soon began to record and collect the information. At this time I knew little about the Allen family and nothing at all about Luman Reed's son Charles. Therefore, I decided to start with Luman Reed and his wife, Mary Barker Reed, thence through their younger daughter, Mary Reed Fuller (from whom I am directly descended), and her husband, Dudley Barber Fuller, down to the present day (my grandchildren)—seven generations. This was quite a challenge,

and it took four years, from 1968 to 1972, to complete the genealogical chart of the Fuller branch of Luman Reed's descendants. The chart measures twenty-eight by eighteen inches and includes inserts tracing both the Reed and the Fuller families back to England. The Fuller relatives and my father's comprehensive genealogy were of enormous help.

As I was about to embark on the making of the chart, my mother, Sarah Fuller Preston, died, in 1967. It was allotted to me to take charge of two large cardboard boxes bulging with photographs, letters, records, newspaper clippings, and other memorabilia. Little did I expect to find the treasures that emerged. Most important were a number of letters exchanged between Luman Reed and the painters Thomas Cole, Asher B. Durand, and George Flagg, as well as the actor James H. Hackett.[2] This was really my first introduction to the scope of Luman Reed's interests, accomplishments, and stature.

In the past twenty years there has been a resurgence of interest in Luman Reed on the part of scholars of American culture. It was through my contact with a number of these scholars that I was able to trace the Allen family down to one lone survivor, Professor Miranda Marvin, who provided me with important letters, diaries, and memorabilia.[3] Finally, with the discovery of new information pertaining to Luman Reed's only son, Charles, I was able to complete a genealogical chart that included all of Luman Reed's descendants. The new materials also greatly enhanced the emerging portrait of my great-great-grandfather as a man as well as a distinguished patron of the fine arts.

In 1792, Eliakim Reed with his wife, Rebecca Fitch Reed, and six children, the youngest of whom was Luman Reed, moved from Austerlitz, in Greene County, New York, where Luman had been born in 1785, to a farm in Coxsackie, New York, one mile west of the Hudson River. Luman and his older brother Abijah became inseparable companions, and years later, after Luman's death, Abijah wrote that "Luman was not only my brother but my best friend." Abijah also judged that "if anything in his [Luman's] bringing up contributed to his after career it was the constant example of care economy industry & perseverance of his parents." The brothers were sent to school two miles away at an early age and later attended different district schools "of rather a common cast." Abijah later recalled their carefree, happy childhood, wearing homemade clothes and going barefoot most of the time. The boys created their own amusement and were disturbed by no one. They enjoyed swimming in the river in the summer and skating in the winter—even sliding barefoot on the ice. As Luman grew older, he became interested in

activities beyond the family circle, seeking odd jobs around the docks on the Hudson River, running errands, "travelling a mile or more for a penny," and doing "anything for a small compensation." He was said to be very shrewd in his dealings, being naturally bright, energetic, and a good judge of character.[4]

In 1804, Mr. Ralph Barker, who conducted a river trading business from a wharf and warehouse at "Reed's Landing" on the Hudson, engaged Luman Reed as a clerk, for which he gave him room and board. Here, until 1809, Reed learned the business of river trading, applying himself eagerly.[5] Quick to learn, he benefited through his association with men older and more experienced than he. Mr. Barker and Reed developed an attachment and friendship that lasted all their lives and extended to their respective families.[6] In addition, Reed was drawn to the dancing and conviviality of the old Dutch ballrooms, where he especially enjoyed the violin playing of local black musicians.[7]

On April 30, 1808, Reed married Mary (Polly) Barker, the younger sister of his employer, in the Reformed Church in Coxsackie.[8] It proved to be a warm and happy marriage. Shortly thereafter Eliakim Reed, who owned woodland on the Delaware River, sent his son for two successive seasons (1809–10) to cut timber and raft it down the river to market during the spring floods. "The toils of a lumberman and the perils of a raftsman" required bold decisions and quick actions, qualities that remained with Reed in his future career.[9] The Reeds' first child, Catharine, was born in 1809, and their second daughter, Mary, in 1811. A son, Charles, was born in 1824. Young Charlie's early years were spent in the city with his family, but later he was sent to a "country seat," probably in the care of a family member.[10] Eventually he married and settled in Salt Point, not far from his family in Hyde Park, New York.

Reed's horizons were broadened when he went into partnership with Theron Skeel. The firm of Reed & Skeel shipped produce and freight between Coxsackie and New York, and Reed served as captain and supercargo.[11] Thus he had ample opportunity to enjoy the spectacular scenery along the Hudson River during the changing seasons, just as he had during his youth. No doubt this contributed in later years to his interest in landscape paintings of the Hudson Valley.

In 1815, Reed established himself and his family in New York City. During the ensuing years he formed a number of partnerships, all concerned with the business of wholesale dry goods, which he conducted from stores and warehouses near the East River waterfront in lower Manhattan. Reed always seemed to be the guiding force and dominant partner in these various firms. The final partnership in Luman Reed's lifetime was that of Reed & Sturges, Jonathan Sturges having been a trusted clerk for a number of years. The personal attachment of the two men and their unlimited confidence in each other made this partnership rewarding in more than just a business sense. The families became intimate friends and Mr. and Mrs. Sturges were welcomed at the Reed house as though they were Reed's own children. The Sturgeses, a cultivated and musical family, shared their frequent musical evenings with Reed. When Reed took his son, Charles, to call on Mrs. Sturges, she would play marches for him to beat time on his little drum. Mrs. Sturges also recalled her husband telling of rivalry among the young clerks to be on hand when the cargoes of tea, coffee, and sugar came in from foreign ports: "We went onto the docks to bore into the sugar hogshead, or went into the tea and coffee warehouses drawing samples for testing to be ready for the auction sales."[12]

Life in New York was far more cosmopolitan than that to which Reed had been exposed heretofore, and his interests broadened considerably. He made friends easily and associated freely with artists and literary people. He was one of the few nonprofessional men elected to the Sketch Club, comprising a group of artists and writers who met once a week and were often entertained at dinner at one of the member's homes.[13] Reed also became a close friend and patron of the artists Thomas Cole, Asher B. Durand, William Sidney Mount, and George W. Flagg. Around 1831 Reed conceived of the plan to incorporate a gallery into the third floor of the new house that he was building at 13 Greenwich Street, in order to house his collection of paintings, prints, shells, and minerals.

Luman Reed's dedication to his business and to his art collection in no way diminished his love of family and domestic life. He had a ready smile and a way with him that endeared him to those who worked for him, and he took special pains to help young men in starting their careers. He walked to his store every day, often before breakfast. His counting room was furnished with stained pine desks and heated by open fires.[14] A flower garden sometimes watered by him flourished behind the store, and a store dog was Reed's constant companion.[15] Simple and unfashionable in dress, he wore broad, straight-toed boots, instead of rights and lefts, so, as he said "to change them every morning."[16] He chose not to keep a horse and carriage, feeling that it would be too ostentatious.[17] But no expense was spared in the building of his house. The best available materials were used, and gas lighting was installed.[18] Mrs. Reed and their daughters eagerly shared in the planning. Luman Reed enjoyed entertaining his friends and family in style, often using a "beautiful dinner set in French china," according to Mrs. Jonathan

Sturges. Reed and her husband frequently served as hosts to the winter evening entertainments of the Sketch Club, of which they were members.[19] In May of 1831, to broaden the experiences of his daughters, Luman Reed took them and Dudley Barber Fuller (his future son-in-law) on a trip to Philadelphia, Baltimore, and Washington. One of the highlights of the trip was a call they made on the president of the United States, Andrew Jackson. In spite of its being past the usual hours for the president to see visitors, Catharine Reed recorded that "he very politely received us and said he would not ask my sister how she felt as she looked the very picture of health."[20]

Mary Reed, the younger daughter, was married to Dudley Barber Fuller in Grace Church in New York on November 22, 1831, with her sister, Catharine, as bridesmaid, and Mr. Fuller's brother, Horace, as groomsman.[21] The bride and groom and their attendants and their cousin George Barker set out on a honeymoon trip that took them south by coach and steamboat to Philadelphia, Baltimore, Washington, Norfolk, Raleigh, Charleston, and Savannah. They were a lively and congenial group. Through friends of Mr. Reed and Mr. Fuller, the party was entertained at different points en route, and they enjoyed sightseeing and shopping expeditions. There seemed to be a special bond between the two daughters and their father. Although letters were written to both parents, it was mainly Luman Reed who seemed to be the correspondent from home, and Catharine was the prolific writer and diarist on the trip. Reed, receiving a card from Mary with her new name, wrote that "we have had the honor to receive [a card] from Mrs. D. B. Fuller she flourishes as large as any other Mrs. on paper & why not?"[22] Mary, the family musician, played in the evening for the group whenever a piano was available, while Catharine and brother-in-law Dudley waltzed. In one of Mr. Reed's letters to Catharine, he wrote, "I am obliged to make my own music, have not heard a note but of my own making (except in church) since Mary left, the fact is I see no other way now but that you must learn Music, so you may as well begin to train your fingures [sic] first as last & try & coax into your head a few semi breve, & semi Demi Demi quavers &c."[23] Reading aloud in the evenings was another pastime, and on occasion at dinner simple little games enlivened the party: "[We] peeled almonds and divided them wrote some favorite name, put them in our wine if they sank or swam fatal consequences would ensue."[24] Dropping raisins in their champagne to watch them float to the surface also amused them. One of the last communications to their father during this trip announced that young George Barker had become so polite that there would be no necessity of sending him to Paris. Catharine's final observation was that "Mr. Fuller says I am travelling for information, Mary and himself for pleasure, & George for his health."[25]

Catharine Reed and Theodore Allen were married on January 21, 1834, and lived for a number of years with her parents at 13 Greenwich Street.[26] Mr. Allen was knowledgeable about art in general and was a collector. He helped his father-in-law in the acquisition of his collections. While traveling abroad in 1836, Allen gathered objects of interest, such as prints, seashells, and temple models, and sent them home.[27] It was at this time, in May, that Luman Reed became seriously ill, and within a few weeks he died, on June 7, 1836. He was mourned by his family, close friends, and particularly by the artists, who felt a great personal loss, not only of a valued patron but of a special friend. Thomas Cole wrote a poem about Reed during his illness and later two more in his memory.[28] After a funeral at Grace Church on June 9, Luman Reed was buried in Vault No. 123 of the New York Marble Cemetery, located in the interior of the block between East Second and East Third streets and Second Avenue and the Bowery.[29]

I am proud to be a direct descendant of Luman Reed. I admire his character above all else. It is extraordinary that with his humble upbringing and with his keen business sense, he became, seemingly by osmosis, a connoisseur and patron of the arts. Apparently in his early years he gained a confidence that guided him to take advantage of different situations and to seek out new experiences. In addition, his judgment of character and attractive personality drew people to him. To have sought out artists on his own and to have conceived of the idea of a gallery in his house, which was an unusual thing to do at that time, was more than anything else a fitting fulfillment of his character.

NOTES

Frequently cited works in the notes are abbreviated with the following short titles:

Cole Papers Thomas Cole Papers. New York State Library, Albany, New York.

Dunlap 1834 William Dunlap. *The History of the Rise and Progress of the Arts of Design in the United States.* 2 vols., New York: George P. Scott & Co., 1834.

Asher B. Durand Papers Asher B. Durand Papers. New York Public Library.

Durand 1894 John Durand. *The Life and Times of A. B. Durand.* New York: Charles Scribner's Sons, 1894.

Frankenstein 1975 Alfred Frankenstein. *William Sidney Mount.* New York: Harry N. Abrams, 1975.

Koke 1982 Richard J. Koke et al. *American Landscape and Genre Paintings in the New-York Historical Society; A Catalogue of the Collection, Including Historical, Narrative, and Marine Art.* 3 vols., New York: New-York Historical Society, in association with G. K. Hall & Co., Boston, 1982.

Lawall 1966 David B. Lawall. "Asher B. Durand: His Art and Theory in Relation to His Times." Ph. D. diss., Princeton University, 1966.

Mount Papers William Sidney Mount Papers. Museums at Stony Brook, New York.

Noble 1853 Louis Legrand Noble. *The Course of Empire, Voyage of Life and Other Pictures of Thomas Cole, N. A., with Selections From His Letters and Miscellaneous Writings: Illustrative of His Life, Character and Genius.* New York: Cornish, Lamport & Co., 1853.

NYGFA 1844 *Catalogue of the Exhibition of the New-York Gallery of the Fine Arts.* New York: James van Norden & Co., 1844.

NYGFA 1845 *Catalogue of the Exhibition of the New-York Gallery of the Fine Arts.* New York: E. B. Clayton & Sons, 1845.

NYGFA 1846 *Catalogue of the Exhibition of the New-York Gallery of the Fine Arts.* New York: E. B. Clayton & Sons, 1846.

NYGFA 1848 *Catalogue of the Exhibition of the New-York Gallery of the Fine Arts.* New York: E. B. Clayton & Sons, 1848.

NYGFA 1850 *Catalogue of the Exhibition of the New-York Gallery of the Fine Arts.* New York: E. B. Clayton & Sons, 1850.

Parry 1988 Ellwood C. Parry III. *The Art of Thomas Cole: Ambition and Imagination.* Newark, Del.: University of Delaware Press, 1988.

Reed Inventory 1836 Luman Reed Inventory. Joseph Downs Collection of Manuscripts and Printed Ephemera, Henry Francis du Pont Winterthur Museum Library, Winterthur, Delaware.

Reed Papers Luman Reed Papers. New-York Historical Society.

Reed Papers, supplement Luman Reed Papers, Supplement. New-York Historical Society.

Sturges 1894 Mrs. Jonathan Sturges (Mary Pemberton Cady). *Reminiscences of a Long Life.* New York: F. E. Parrish, 1894.

Tuckerman 1867 Henry T. Tuckerman. *Book of the Artists.* 2 vols., New York: G. P. Putnam & Son, 1867.

Washington Exhib. NYGFA 1853 *Washington Exhibition, in Aid of the New-York Gallery of the Fine Arts, at the American Art-Union Gallery, 497 Broadway.* New York: John F. Trow, Printer, 1853.

PATRONAGE AND COLLECTING IN AMERICA, 1800–1835

1. Gulian C. Verplanck Papers, NYHS.

2. L. H. Butterfield et al., eds., *Adams Family Correspondence* (4 vols., Cambridge, Mass.: Belknap Press of Harvard University Press, 1963–73), 3, p. 342. For further discussion of Adams's attitude toward the fine arts, see Andrew Oliver, *Portraits of John and Abigail Adams* (Cambridge, Mass.: Belknap Press of Harvard University Press, 1967), pp. xii–xvi.

3. Frances Trollope, *Domestic Manners of the Americans,* (2nd ed., 2 vols., London: Whittaker, Treacher, & Co., 1832), 2, p. 203.

4. Ibid., 2, p. 281.

5. Alexis de Tocqueville, *Democracy in America,* ed. Phillips Bradley (2 vols., New York: Alfred A. Knopf, 1963), 2, p. 51.

6. Harriet Martineau, *Society in America* (2 vols., Paris: Baudry's European Library, 1837), 2, p. 124.

7. Nathaniel Appleton Haven, *The Remains of Nathaniel Appleton Haven, with a Memoir of his Life by George Ticknor* (Cambridge, Mass.: Metcalf & Co., 1827), pp. 298–301.

8. Carl Seaburg and Stanley Paterson, *Merchant Prince of Boston, Colonel T. H. Perkins, 1764–1854* (Cambridge, Mass.: Harvard University Press, 1971), p. 397.

9. Allan Nevins, ed., *The Diary of Philip Hone,* (2 vols., New York: Library Editions, 1970), 1, p. 359.

10. William Henry Shelton, *The Jumel Mansion* (Boston: Houghton Mifflin Co., 1916), pp. 151–52.

11. Gulian C. Verplanck, *An Address Delivered at the Opening of the Tenth Exhibition of the American Academy of the Fine Arts* (2nd ed., New York: G. & P. Carvill, 1825), p. 6.

12. Ibid., pp. 9, 37, 39.

13. See Robert July, *The Essential New Yorker, Gulian Crommelin Verplanck* (Durham, N.C.: Duke University Press, 1951).

14. Quoted from Anna Wells Rutledge, "One Early American's Precocious Taste," *Art News* 48 (March 1949), pp. 28–29, 51. See also Rutledge, "Robert Gilmor, Jr., Baltimore Collector," *Journal of the Walters Art Gallery* 12 (1949), pp. 18–39.

15. Dunlap 1834, 2, p. 461.

16. Francis Booth Greenough, ed., *Letters of Horatio Greenough to his Brother, Henry Greenough* (Boston: Ticknor and Company, 1887), p. 36.

17. Ibid., p. 39.

18. Asher B. Durand Papers.

19. Dunlap 1834, 2, pp. 139–40.

20. Ibid., 1, pp. 305–6.

21. Ibid., 2, p. 462.

22. See Sturges 1894, pp. 158–59.

23. Dunlap 1834, 2, p. 462.

24. Ibid., pp. 462–64.

25. Nevins, ed., 1970, 1, pp. xviii–xix.

26. Ibid., pp. 92–3.

27. See the section on this matter in Lillian B. Miller, *Patrons and Patriotism: The Encouragement of the Fine Arts in the United States, 1790–1860* (Chicago: University of Chicago Press, 1966), pp. 146–51. On the subject of the enormous influence of seventeenth-century Dutch pictures on American genre painting, see H. Nichols B. Clark, "The Impact of Seventeenth-Century Dutch and Flemish Genre Painting on American Genre Painting, 1800–1865," Ph. D. diss., University of Delaware, 1982.

28. For information on Wadsworth, see Richard Saunders with Helen Raye, *Daniel Wadsworth, Patron of the Arts* (Hartford: Wadsworth Atheneum, 1981), and J. Bard McNulty, ed., *The Correspondence of Thomas Cole and Daniel Wadsworth: Letters in the Watkinson Library, Trinity College, Hartford, and in the New York State Library, Albany, New York* (Hartford: Connecticut Historical Society, 1983).

LUMAN REED: NEW YORK PATRON AND HIS PICTURE GALLERY

1. Durand 1894, pp. 126, 130. The Reed collection had not been completely forgotten during the 1890s. In an article called "Art Growth in New York," in the September 25, 1895, issue of the *Home Journal*, vol. 39, p. 1, the following tribute to Reed and his collection appeared: "Everyone familiar with the art history of this city will award the palm of a Maecenas to Luman Reed. To call him a patron of art in the usual acceptation of the word is to give a feeble idea of his usefulness and of the spirit which animated him. He aimed to smooth the path of art for those who travelled it by letting them pursue it as most agreeable to themselves. Although not possessing an educated judgment, he was gifted with a natural pictorial perception that was generally found sympathetic with the more extended knowledge of artistic friends."

2. *The Historical Magazine* 1 (Dec. 1857), p. 369.

3. The history of the New-York Gallery of the Fine Arts is documented in Maybelle Mann, "The New-York Gallery of Fine Arts: A Source of Refinement," *Am. Art Jour.* 11 (Jan. 1979), pp. 76–86, and Abigail Booth Gerdts, "The Newly Discovered Records of the New-York Gallery of the Fine Arts," *Arch. Am. Art Jour.* 21 (1981), no. 4, pp. 2–9. In 1844, Reed's house at 13 Greenwich Street was sold for $20,000 to Amos Eno, a partner in the dry-goods firm of Eno & Phelps.

4. "Remarks," NYGFA 1844, pp. 3–4.

5. Francis W. Edmonds to Asher B. Durand, Sept. 16, 1844, Asher B. Durand Papers.

6. See, for example, "Picture Buying," *New York Herald*, reprinted in the *Crayon* 1 (Feb. 14, 1855), p. 100, which offered the following advice to potential collectors: "1. Always prefer a modern to an old picture. 2. Never buy an old picture which pretends to bear a distinguished name, for you will certainly be cheated. . . . 6. If you have ever been deluded into making great bargains in Titians, Vandykes, Claudes, or any other old masters' works, burn them up at once."

7. The cause of the gallery's demise is explored in Mann 1979, p. 86, and Gerdts 1981, pp. 2–9. In March, 1858, one writer noted that "we should have preferred to have seen the gallery an independent institution; but in recognizing the impossibility of such a thing at the present era of our civilization we are only too glad to find the ideas embodied in the principle of its organization [at] . . . the Historical Society. The city now possesses a *free public gallery of works of Art.* . . . The idea of a free gallery of Art in this city grew out of a collection of paintings . . . of Luman Reed." Quoted in Mann 1979, p. 86.

 Official Agreement Between the New York Gallery of the Fine Arts and the New York Historical Society, June 22, 1858, Manuscripts Division, NYHS, stated: "It is hereby mutually covenanted and agreed by and between the said Parties hereto, that the said New York Gallery of the Fine Arts shall and will deposit and doth hereby deposit in perpetuity the said collection of Art, in the said Gallery thus provided for its reception, future preservation and proper exhibition, by the said New York Historical Society in their new fire proof Library Edifice on the corner of Second Avenue and Eleventh Street, there to remain for *Ever,* in the charge and under the exclusive control and management of the said New York Historical Society."

8. Diary of George Templeton Strong, May 3, 1858, fol. 227, NYHS.

9. Principal sources relating to the history of the New-York Historical Society and its collections are: R. W. G. Vail, *Knickerbocker Birthday: A Sesqui-Centennial History of The New-York Historical Society, 1804–1954* (New York: New-York Historical Society, 1954), and Koke 1982.

10. The minutes of the New-York Gallery, NYHS (formerly at the National Academy of Design), record many of the works that were donated to the gallery; for example, an entry on Sept. 10, 1844, notes that "Mr Theodore Allen, on behalf of Mrs Reed and family, stated to the Committee . . . that she wished to bestow upon the Society, a collection of rare Engravings purchased in Europe at great expense, among which are specimens of the most celebrated Engravers."

11. *Catalogue of the Museum and Gallery of Art of the New-York Historical Society* (New York: New-York Historical Society, 1862), p. 7.

12. "Any notice of this collection [New York Gallery of Fine Arts] would be deficient which should fail to commemorate the name of Luman Reed, Patron of American Art," recorded the preface to the *Catalogue of the Gallery of Art of the New-York Historical Society* (New York: New-York Historical Society, 1915), p. vii.

13. For early and informed discussions of Luman Reed's collection, see Lillian B. Miller, *Patrons and Patriotism: The Encouragement of the Fine Arts in the United States, 1790–1860* (Chicago: University of Chicago Press, 1966), and Wayne Craven, "Luman Reed, Patron: His Collection and Gallery," *Am. Art Jour.* 12 (Spring 1980), pp. 40–59.

14. Reed Inventory 1836.

15. Philip Hone Diary, vol. 11, p. 393, NYHS. While various birthdates for Luman Reed appear in manuscript and published sources, 1785 is convincingly supported by the obituary in the *New York Sun* for June 9, 1836, p. 3: "On Tuesday last, Luman Reed, aged 51 years. The friends of the family are invited to attend the funeral from 13 Greenwich St., to Grace Church, this afternoon at 4 o'clock." A photocopy from the New York Marble Cemetery Burial Records, Manuscripts Division, NYHS, corroborates 1785 as the correct birthdate.

16. Abijah Reed to Theodore Allen, Feb. 26, 1844, Document 45, Reed Papers, supplement.

17. Ibid.

18. Ibid. Biographical information about Luman Reed is culled from a variety of published and manuscript sources. See *History of Greene County, New York, with Biographical Sketches of its Prominent Men* (New York: J. B. Beers, 1884); "Luman Reed—He Made American Artists the Fashion," *Quarterly Journal; A Publication of the Greene County Historical Society,* (Summer 1978), pp. 4–7; Longworth's *New York City Directory;* Reed Papers.

19. Durand 1894, pp. 105–6. Durand emphasizes that this strict discipline, which Reed applied to himself as well as his subordinates, was always accompanied by consideration and generosity.

20. John Durand, Biography of Luman Reed, John Durand Papers, NYPL.

21. Philip Hone Diary, vol. 11, p. 122, NYHS.

22. "Memento" biography, dated 1884, signed B. [George Barker, Mrs. Luman Reed's nephew], p. 34, Reed Papers.

23. Ibid., p. 35.

24. Using New York City tax assessment records, Edward Pessen constructed a list of the sixty wealthiest New Yorkers in 1828 whose worth was assessed at $100,000 or over, and Luman Reed's name is on the list. Within that group, nine had fortunes of $250,000 or more, and two (John Jacob Astor and John G. Coster) had more than $500,000. Edward Pessen, "The Wealthiest New Yorkers of the Jacksonian Era: A New List," *NYHS Quart.* 54 (April 1970), p. 155.

25. James H. Hackett to Charles M. Leupp, quoted in Durand 1894, p. 117.

26. "Mr. Hackett," *New-York Mirror* 11 (July 20, 1833), p. 22.

27. On June 16, 1833, for example, he wrote: "Your substantial & undeviating kindness towards me, warrants the belief that you still retain an interest in the fortunes, of your very grateful & respectful friend." Hackett to Luman Reed, Reed Papers.

28. Hackett to Reed, New Orleans, Jan. 8, 1835, ibid. The Italian Opera House Association Papers and Minutes (NYHS) include the original seating diagram for the boxes in the second tier and the records of the drawing of lots.

29. Philip Hone Diary, vol. 7, p. 285.

30. Sturges 1894, p. 162.

31. National Academy of Design Minutes, May 7, 1834 (NAD Archives), record that Asher B. Durand was elected secretary and Thomas Cole was elected a member of the council at the same meeting at which Reed became an honorary member. Reed is listed as a Sketch Club member in John Durand, *Prehistoric Notes of the Century Club* (New York, 1882), pp. 21–22. James T. Callow, *Kindred Spirits: Knickerbocker Writers and American Artists, 1807–1855* (Chapel Hill: University of North Carolina Press, 1967), p. 15, identifies Luman Reed, Jonathan Sturges, and Charles Leupp as merchants included in the Sketch Club during its early years. He also notes that the minutes for the club from 1833 to 1844 are no longer extant. According to Professor Callow, Reed was probably a member of the Sketch Club by May, 1834, since memberships in the

Twenty One usually preceded honorary membership in the National Academy of Design. Reed was not the first nonartist member of the Sketch Club. From the earliest extant minutes of 1829, the rosters included men in other fields with an interest in art. (This information was kindly provided [June 16, 1989] to me by Professor Callow from the manuscript of his forthcoming volumes on the history of the Sketch Club.)

32. Durand, 1882, p. 10. See Callow 1967, pp. 12–29.

33. According to Sturges 1894, p. 173, both Jonathan Sturges and Reed "were members of the old 'Sketch Club,' and every winter the club met at their houses. Sometimes the artists would draw sketches which were presented to their entertainer on their departure. This practice, however, was not a universal one, and was afterwards discontinued."

34. Callow 1967, pp. 15–29.

35. Albert H. Marckwardt, "The Chronology and Personnel of the Bread and Cheese Club," *American Literature* 6 (Jan. 1935), pp. 389–99. See Philip Hone Diary, entry for May 31, 1830, vol. 3, p. 24, for an expression of anti-Jacksonian sentiment.

36. David Hammack, professor of history at Case Western Reserve University, in an interview, 1989, provided me with an excellent synopsis of the complex politics in nineteenth-century New York. I am grateful to him and to Deborah Gardner, managing editor of the *Encyclopedia of New York City,* for suggesting the following relevant sources on the topic of the political party platforms and affiliations during the Jacksonian period. See: Amy Bridges, *A City in the Republic* (Cambridge: Cambridge University Press, 1984); Robert Greenhalgh Albion, *The Rise of New York Port* (New York: Charles Scribner's Sons, 1939); David C. Hammack, *Power and Society: Greater New York at the Turn of the Century* (New York: Russell Sage Foundation, 1982); Bray Hammond, *Banks and Politics in America: From the Revolution to the Civil War* (Princeton: Princeton University Press, 1957); Marvin Meyers, *The Jacksonian Persuasion: Politics and Belief* (Stanford: Stanford University Press, 1957).

37. The meaning of the terms liberal and conservative in relation to the Democratic and Whig parties during the Jacksonian period is explored in Frank Otto Gatell, "Money and Party in Jacksonian America: A Quantitative Look at New York City's Men of Quality," *Political Science Quarterly* 82 (June 1967), pp. 235–52. See also: Alan Wallach, "Thomas Cole and the Aristocracy," *Arts Magazine* 56 (Nov. 1981), pp. 104–106; [George Barker], "Memento" biography, Reed Papers, NYHS, p. 50.

38. Catharine Reed Diary, May 26, 1831, Document 32, Reed Papers, supplement. Reed to Asher B. Durand, March 10, 1835, Asher B. Durand Papers and Durand to Reed, March 12, 1835, quoted in Durand 1894, p. 108.

39. [George Barker], "Memento" biography, p. 11, Reed Papers.

40. Joseph A. Scoville [Walter Barrett], *The Old Merchants of New York City* (5 vols., New York: George W. Carleton, 1863–70), 4, p. 48.

41. In 1829, A. J. Davis had gone into partnership with Ithiel Town, and the firm of Town and Davis was responsible for the design of numerous important public and private buildings in the United States, including outstanding examples of every fashionable style. It was early in his career when A. J. Davis made the drawing of Luman Reed's facade. He had made a name for himself making drawings of distinguished buildings in Boston for publication. It was his drafting talent that led proprietors and builders to engage Davis to furnish plans, elevations, and perspective views for their projects. See Tuckerman 1867, 2, p. 409.

42. It was thanks to Jane B. Davies, author of a forthcoming monograph on A. J. Davis, that the sketch of the facade for Reed's house was identified and located. It is the only image of the house as it looked in Reed's day that has been found. It appears in Alexander Jackson Davis, "Diary"/ Daybook, vol. 1 (1827–1853), A. J. Davis Papers, NYPL.

43. See *Longworth's Directory, City Register and Almanac, for the Fifty-seventh Year of American Independence, 1832–33.*

44. The Atlantic Garden was built on the site of the historic City Arms Tavern, better known as

Burns' Tavern. During pre-Revolutionary War days, it served as a political meeting place for merchants opposed to the Stamp Act, as well as a fashionable tavern of its day. Scoville 1863–1870, 4, pp. 48–49.

45. "A year this day since we first moved into our mansion," Catharine Reed wrote in her diary, August 4, 1833, Document 34A, Reed Papers, supplement. According to George Barker, the drain pipes leading to the Hudson River were too level and not adequate which choked the flow of water. "It was subsequently intimated that this effect and a back flow, fouled the air of the house and worried him much; for in the summer of 1836, he fell prey to a fatal fever, and died, although that evil was not proclaimed to the public." "Memento" biography, p. 51, Reed Papers.

46. Scoville 1863–1870, 4, p. 49.

47. Allen to Reed, c. Jan.–Aug. 1836, Document 143, Reed Papers, supplement.

48. "Recollections of Mary Eno Pinchot," Gifford Pinchot Papers, Library of Congress, Washington, D.C., in Nancy Jean Carrs, "Madison Square, the Eno Family and the Fifth Avenue Hotel," unpublished ms., 1891, quoted in M. Christine Boyer, *Manhattan Manners: Architecture and Style, 1850–1900* (New York: Rizzoli International Publications, 1985), p. 44. Mary Jane Eno was the daughter of Amos Richards Eno, who purchased Reed's house at 13 Greenwich Street in 1844 for $20,000.

49. Durand 1894, pp. 121–22.

50. Luman Reed to Catharine Reed, Dec. 4, 1831, Document 24, and Catharine Reed to Luman Reed, Dec. 27, 1831, Document 16, Reed Papers, supplement.

51. Sturges 1894, pp. 139–40.

52. Ibid.

53. Catharine Reed Diary, entry July 31, 1833, Document 34A, Reed Papers, supplement.

54. A photocopy in the Joseph Downs Collection of Manuscripts and Printed Ephemera, Winterthur Museum Library, Winterthur, Delaware, of an unlocated Duncan Phyfe account book page reads: "Rec. New York. 12 Mch 1833 from Mr. L. Reed Nine hundred & ten Dollars in ful $910 = [?] D. Phyfe [and] Rec'd New York 26 March 1833 from Mr. Luman Reed Four hundred dollars."

55. Durand 1894, pp. 121–22.

56. *Home Journal* quoted in Nathaniel Parker Willis, *The Rag-Bag, A Collection of Ephemera* (New York: Charles Scribner, 1855), p. 114. John Durand (Durand 1894, pp. 121–22) writes: "Another detail of this gallery must be recorded—it was open one day in the week to visitors." It was opened "once a week to everyone," according to Scoville 1863–70, 4, p. 50. "His pictures were very fine, and many were the visitors to see them on certain days when he threw his house open to receive them," wrote R. W. Newman, "Around and Near the Battery. Paper XIII.," one of a series of articles in a bound volume at the NYHS entitled "Old New York. The City in '32. Its People and Public Institutions," that appeared in the [*New York*] *Evening Mail* in 1873. "Luman Reed," according to Benson Lossing, "had a picture-gallery more extensive and valuable than any in the city, which was open to public view one day in each week." From *History of New York City, Embracing an Outline Sketch of Events From 1609 to 1830, and a Full Account of Its Development From 1830 to 1884.* (2 vols., New York: The Perine Engraving and Publishing Company, 1884), 2, pp. 614–15. James Silk Buckingham, *America: Historical, Statistic and Descriptive* (3 vols., London: Fisher, Son & Co., 1841), 1, pp. 213–14, recorded that Mr. Reed had a "very interesting gallery, which he opens to all persons properly introduced, on Thursday in each week, and to whom we had the pleasure of being presented." Buckingham left England for America in September, 1837, about fifteen months after Luman Reed died.

57. What constituted "the Public" to whom access was provided varied in England. Prior to the opening of the National Gallery in London, in 1824, it was certainly not the general public. According to John Britton, the marquis of Stafford was the first in London who "appropriated one day in the week (Wednesday, from the hours of 12 to 5 o'clock) during the months of May, June, and July, for the Public to view the pictures in his spacious Gallery. . . . This took place in May 1806." However, the marquis also provided a list of regulations "in order to accommodate more pleasantly those persons who visit this splendid collection for the express purpose of examining the paintings. . . . No person can [be] permitted to view the Gallery without a ticket. To obtain which it is necessary that the applicant be known to the Marquis, or to some one of the family; otherwise he or she must have a recommendation from a person who is . . . in England, where ignorance, vulgarity, or some thing worse, are the characteristics of the lower orders, and where frivolity, affectation, and insolence, are the leading traits in a class of lounging persons, who haunt most public places, it would be the excess of folly for gentlemen who possess valuable museums, to give unlimited admission to the public." See "Notice Respecting Tickets of Admission to the Cleveland-House Gallery," pp. iii–iv, and Preface, pp. vi–vii, in John Britton, *Catalogue Raisonné of the Pictures Belonging to the Most Honourable The Marquis of Stafford, in the Gallery of Cleveland House. Comprising a List of the Pictures, with illustrative Anecdotes, and descriptive Accounts of the Execution, Composition, and characteristic Merits of the principal Paintings* (London: Printed for Longman, Hurst, Rees, and Orme, and for the author, 1808). For this and a number of other sources of information regarding the accessibility of private galleries, I am very grateful to Frances L. Preston, Ph.D., Columbia University.

58. Tuckerman 1867, 1, p. 228.

59. Horatio Greenough to John Gorham Palfrey, Oct. 3, 1836, in *Letters of Horatio Greenough, American Sculptor,* ed. Nathalia Wright (Madison: University of Wisconsin Press, 1972), p. 205.

Adams wrote in his diary, Nov. 20, 1840: "I went with Mrs. De Windt and Mr. and Mrs. Downing to the house of the late Mr. Luman Reed whose collection of pictures is still kept by his widow and family." Quoted in Andrew Oliver, *Portraits of John Quincy Adams and his Wife* (Cambridge, Mass.: Harvard University Press, 1970), p. 179.

60. The Reed Inventory provides much of the information about the contents of the picture gallery. Luman Reed to William Sidney Mount, Nov. 23, 1835, Mount Papers.

61. Sturges 1894, pp. 159–60.

62. Thomas Cole to Reed, Catskill, N.Y., Sept. 23, 1833, Cole Papers. Cole was suggesting some form of chain construction that would allow viewers to rotate paintings into the light for better visibility.

63. Sturges 1894, p. 160.

64. "A Collection of Minerals consisting of 1600 specimens at -$800." Receipt dated March 20, 1835, New York, from Baron Louis Lederer to Luman Reed, Document 109, Reed Papers, supplement. See: Francis Stanton to Reed, June 12, 1833; David Rogers to Reed, Sept. 24, 1834; D. E. Cotheal to Reed, April 25, 1835, Reed Papers. Theodore Allen to Reed, c. Jan.–Aug. 1836, Document 143, Reed Papers, supplement.

65. For sources on European *Wunderkammern,* see Niels von Holst, *Creators, Collectors, and Connoisseurs: The Anatomy of Artistic Taste from Antiquity to the Present Day,* trans. Brian Battershaw (New York: G. P. Putnam's Sons, 1967), and Julius von Schlosser, *Die Kunst- und Wunder-kammern der Spätrenaissance* (Leipzig: Klinkhardt & Biermann, 1908). Frank Herrmann, *The English as Collectors: A Documentary Chrestomathy* (London: Chatto & Windus, 1972), p. 9, fn 1.

66. *Pennsylvania Packet,* July 7, 1786, quoted in Charles Coleman Sellers, *Mr. Peale's Museum: Charles Willson Peale and the First Popular Museum of Natural Science and Art* (New York: W. W. Norton & Company, 1980), pp. 23–24.

67. Sources on early museum ventures in New York include: Edward P. Alexander, "The American Museum Chooses Education," *Curator* 31 (Jan. 1988), pp. 61–80; Robert M. and Gale S. McClung, "Tammany's Remarkable Gardiner Baker," *NYHS Quart.* 42 (April 1958), pp. 142–69; Rita Susswein Gottesman, "New York's First Major Art Show as Reviewed by its First Newspaper Critic in 1802 and 1803," ibid. 43 (July 1959), pp. 289–305.

68. Allen to Reed, c. Jan.–Aug. 1836, Document 143, Reed Papers, supplement.

69. Writing to Luman Reed from Paris on Feb. 8, 1836, Theodore Allen recorded a visit with the prominent French engraver [Alphonse or Louis] Preilly: "He has offered many assistance in the purchase & selection of engravings, . . . He introduced me to one of the first engravers in Paris Mr. Foster who likewise proffered his services." Document 141, ibid.

70. A list of engravings from the Reed collection was published in NYGFA 1844, pp. 17–20. Some of the engravings donated to the New-York Gallery of the Fine Arts had been acquired by the family after Reed's death. For the opening exhibit of the gallery at the National Academy of Design, Francis W. Edmonds wrote Asher B. Durand that "Mrs. Reed has contributed $500 and about $500's worth of engravings." Sept. 16, 1844, Asher B. Durand Papers.

71. The history and the role of reproductive engraving in the history of art and taste is documented in David Alexander and Richard T. Godfrey, *Painters and Engraving: The Reproductive Print from Hogarth to Wilkie* (New Haven: Yale Center for British Art, 1980). I am very grateful to Robert Rainwater, Miriam and Ira B. Wallach Curator of Art, Prints and Photographs, NYPL, who offered valuable insights into the collection of engravings acquired by Luman Reed.

72. "Picture Buying," *New York Herald,* reprinted in the *Crayon* I (Feb. 14, 1855), p. 100.

73. George Palmer Putnam, *American Facts. Notes and Statistics Related to the Government, Resources, Engagements, Manufactures, Commerce, Religion, Education, Literature, Fine Arts, Manners and Customs of the United States of America* (London: Wiley & Putnam, 1845), p. 127. Allen to Reed, c. Jan.–Aug. 1836, Document 143, Reed Papers, supplement.

74. Ibid. Probably some titles were omitted from the Reed Inventory and others may not yet have been unpacked. "I left at Naples to be forwarded to you one box containing the work on Herculaneum in 9 vols. and a very large folio volume of engravings of the frescoes and mosaic pavements of Pompeii," Allen wrote to Reed in 1836, ibid.

75. This unsourced reference was published in Jared Bradley Flagg, *The Life and Letters of Washington Allston* (New York: Charles Scribner's Sons, 1892), p. 40.

76. Sir Joshua Reynolds, *Discourses Delivered at the Royal Academy* (Boston: Wells and Lilly, 1821), vol. 1, p. 12.

77. Reed to Mount, Feb. 29, 1836, Mount Papers: "I was much gratified by the receipt of your letter of the 13th Instant and I am happy to hear that you find 'Burnett on painting' interesting to you, such feeling for the art as you possess is sure to lead to excellence." The remark suggests that Reed has sent a copy of the book or mentioned it to Mount in an earlier letter.

78. John Burnet, *A Practical Treatise on Painting. In Three Parts. Consisting of Hints on Composition, Chiaroscuro, and Colouring. The Whole Illustrated by Examples from the Italian, Venetian, Flemish, and Dutch Schools* (new ed., 3 parts in 1 vol., London: Printed for the proprietor and sold by Carpenter, 1830), part 1, p. 7.

79. Ibid., p. 11.

80. Ibid., title page. For the influence of Sir Joshua Reynolds's ideas on the history of American art, see Barbara Novak, *American Painting of the Nineteenth Century* (New York: Praeger Publishers, 1969), pp. 38–41.

81. J. Durand, Biography of Luman Reed, John Durand Papers.

82. Luman Reed referred to Michael Paff in a letter to Asher B. Durand, March 12, 1835, Asher B. Durand Papers, NYPL. He told the artist that Paff admired the portrait of Reed that Durand painted for Jonathan Sturges. "Paff says it is first rate," noted Reed, "and he you know spares nobody but the old masters." Noble 1853, p. 176. It is possible that Reed purchased *Boy Asleep* by the American artist F. W. Philip at the same time or slightly earlier than Cole's *Landscape Composition, Italian Scenery.* Philip's work was exhibited at the American Academy of the Fine Arts in the spring of 1833.

83. Reed to Mount, Oct. 29, 1835, Mount Papers.

84. Durand 1894, p. 107. In John Durand's manuscript biography of Reed there is no mention of the disposal of European paintings: "He commenced his education as an amateur in a practical way; his first lesson consisted of a course of 'old masters' at the end of this he realized the meretriciousness of counterfeit works, the hypocrisy and knavery of picture-dealers and the delusion of those who survived in darkness." J. Durand, Biography of Luman Reed, John Durand Papers, p. 8. Among other sources where Durand's story of the sale of European pictures is

repeated is Russell Lynes, *Art-makers of the Nineteenth Century* (New York: Atheneum, 1970), p. 197.

85. Reed to George W. Flagg, March 9, 1835, Asher B. Durand Papers.

86. The publications of Lillian B. Miller and Neil Harris provide scholarly and insightful surveys of the development of patronage in America. See Miller 1966; and Neil Harris, *The Artist in American Society: The Formative Years, 1790–1860* (New York: George Braziller, 1966). Much work remains to be done in gathering and analyzing specific information about individual collectors and their holdings.

87. Asher B. Durand to Mary Durand, Oct. 19, 1835, Asher B. Durand Papers. *An Illustrated Handbook of the Bowdoin College Museum of Fine Arts in the Walker Art Building, Brunswick, Maine* (5th ed., Brunswick, Maine: Bowdoin College, 1950), pp. 5, 24. See also Marvin S. Sadik, *Colonial and Federal Portraits at Bowdoin College* (Brunswick, Me.: Bowdoin College Museum of Art, 1966).

88. Seymour Howard, "Thomas Jefferson's Art Gallery for Monticello," *Art Bulletin* 59 (Dec. 1977), 4, pp. 583–600.

89. In 1782, the year that Jefferson was planning to go abroad, he put a note in his building notebook which said: "Bellini tells me that historical paintings on canvas 6 f. by 12 f. will cost £15 sterl. if copied by a good hand." Fiske Kimball, "Jefferson and the Arts," *Proceedings of the American Philosophical Society* 87 (July 14, 1943), 3, pp. 241–42. Kimball also cites Jonathan Richardson's critical work on the statues and paintings of Italy, first published in 1722, as the chief source of Jefferson's selections.

90. Eleanor Davidson Berman, *Thomas Jefferson among the Arts: An Essay in Early American Esthetics* (New York: Philosophical Library, 1947), pp. 51–52.

91. *Catalogue of Valuable Oil Paintings, Many of them by the Old Masters, and All Choice Pictures, Being The Collection of the Late President Jefferson . . . at Mr. Harding's Gallery, School St.,* (Boston: 1833).

92. "The collection, as finally completed, was very different from the one Jefferson had dreamed of as a young man. In Paris he had learned the value of the original work of art as compared to a copy.

Gone was the heroic antique sculpture and in its place were modern busts of distinguished contemporaries, largely from the chisel of Houdon." Marie Kimball, "Jefferson's Works of Art at Monticello," *Magazine Antiques* 59 (April 1951), p. 297; Kimball 1943, pp. 242–43.

93. Quote is in Berman 1947, p. 82; see also p. 79.

94. Reed to Asher B. Durand, March 12, 1835, Asher B. Durand Papers.

95. Reed to Flagg, March 9, 1835, ibid.

96. *An Illustrated Handbook of the Bowdoin College Museum of Fine Arts* 1950, p. 5.

97. *Dictionary of American Biography,* ed. Allen Johnson and Dumas Malone (20 vols., New York: Charles Scribner's Sons, 1928–36), s.v. Bowdoin, James, III.

98. Ibid., s.v. Jefferson, Thomas.

99. These men are listed in the *Catalogue of the First Exhibition of Paintings, in the Athenaeum Gallery: Consisting of Specimens by American Artists, and a Selection of the Works of the Old Masters, from the Various Cabinets in this City and its Vicinity* (Boston: May 10, 1827), and the *Catalogue of the Second Exhibition of Paintings in the Athenaeum Gallery: Consisting of Specimens by American Artists, and a Selection From the Works of the Old Masters* (Boston: May 1, 1828). The proprietors, for the most part, had collections of old master paintings, but in exhibiting them at the Athenaeum, they were not only educating the public but also supporting American artists. The profits from the exhibitions were used to buy works of native artists. Harris 1966, p. 104. See Charles Stimson, *Boston Directory* (Boston: D. Clapp, 1834), p. 120, and *The Boston Directory* (Boston: Edward Cotton, 1805), p. 10. Thomas Cary, *Memoir of Thomas Handasyd Perkins* (Boston: Little, Brown and Co., 1856).

100. For a discussion of the private world of New York City's elite during the second quarter of the nineteenth century, see Edward Pessen, "Philip Hone's Set: The Social World of the New York City Elite in the 'Age of Egalitarianism,'" *NYHS Quart.* 56 (Oct. 1972), pp. 285–308.

101. *Dictionary of American Biography,* s.v. Ward, Samuel.

102. The former owners of the Ward property are recorded, but undocumented, in Louise Hall

Tharp, *Three Saints and a Sinner* (Boston: Little, Brown & Co., 1956), p. 9. Additional information about ownership of lots in this area is provided by Charles Lockwood, "The Bond Street Area," *NYHS Quart.* 56 (Oct. 1972), pp. 309–20. From May to December 1831, entries in Samuel Ward's checkbook record payments to I. G. Pearson, Samuel Ward Papers, NYPL. Davis, "Diary"/Daybook, vol. 1, p. 493, A. J. Davis Papers, NYPL.

103. Rufus Prime was quoting the advice of Samuel Ward's friend, a Mr. Olmsted, whom Prime described as "a great amateur of paintings & as *he* thinks connoisseur also." Prime to Samuel Ward, Jr., March 3, 1829, Box 3, Samuel Ward Papers. Samuel Ward's father and his son also had the same name. While his son is most often termed "Jr.," it is clear that Prime was not addressing the fifteen-year-old son of his partner in this letter.

104. Marius Schoonmaker, *John Vanderlyn: Artist, 1775–1852* (Kingston, New York: Senate House Association, 1950), p. 44.

105. Philip Hone Diary, April 23, 1829, vol. 2, p. 14: "I bought this day at a Sale of Pictures at the Academy 2 Pictures said to be copies from Salvator Rosa which I consider very good for $158 the pair."

106. Reed to Flagg, March 9, 1835, Asher B. Durand Papers.

107. "The Fine Arts. The Old Paintings," *Knickerbocker* 5 (May 1835), p. 465; "Picture Buying," *New York Herald,* reprinted in the *Crayon* 1 (Feb. 14, 1855), p. 100.

108. E. H. Ludlow & Co., *Inventory of Paintings, Statuary, Medals [of Philip Hone] to be sold at Auction* (New York: 1852). On February 9, 1834, Dunlap recorded: "Received a very friendly note from P. Hone in answer to my request for a Catalogue of his pictures and the Catalogue by himself. Write on Hist: Art." Dorothy C. Barck, ed., *Diary of William Dunlap 1766–1839: Memoirs of a Dramatist, Theatrical Manager, Painter, Critic, Novelist, and Historian* (3 vols., New York: New-York Historical Society, 1930), 3, pp. 772–73. Dunlap 1834, 2, pp. 462–64.

109. Putnam 1845, p. 126.

110. Freeman Hunt, editor of the *Merchants' Magazine,* applauded Luman Reed's role as a patron of

the fine arts when he quoted an 1844 lecture on the subject by Thomas G. Cary of Boston in *Worth and Wealth: A Collection of Maxims, Morals and Miscellanies for Merchants and Men of Business* (New York: Stringer & Townsend, 1856), pp. 91–95. In another publication of the same year, Hunt devoted an entire chapter to the life of Samuel Ward but never mentioned his art collection. Freeman Hunt, *Lives of American Merchants,* (2 vols., New York: Office of Hunt's Merchants' Magazine, 1856), 1, pp. 296–306.

111. Tharp 1956, p. 74. See also Mary Bartlett Cowdrey, comp., *National Academy of Design Exhibition Record, 1826–1860* (2 vols., New York: New-York Historical Society, 1943), 2, owner entries, 1829, 1832, 1837, 1839; and *Boston Atheneum Art Exhibition Index, 1827–1874,* comp. and ed. by Robert F. Perkins and William J. Gavin III (Boston: Library of the Boston Atheneum, 1980), owner index, p. 226.

112. Noble 1853, pp. 273, 277.

113. Samuel Ward's daughter recalled that her father "desired to give us the best educational opportunities, the best and most expensive masters. He filled his art gallery with the finest pictures that money could command in the New York of that day." Julia Ward Howe, *Reminiscences 1819–1899* (Boston: Houghton Mifflin & Co., 1899), p. 46. Philip Hone Diary, vol. 16, pp. 109, 111. Hone recorded Ward's death on Wednesday, November 27, 1839, and noted that he officiated at the funeral as a pallbearer on the following Sunday.

114. Samuel Ward's daughter recalled a dispute between her father and her brother: "'Sir,' said my brother, 'you do not keep in view the importance of the social tie.' 'The social what?' asked my father. 'The social tie, sir.' 'I make small account of that,' said the elder gentleman." Howe 1899, p. 46. Philip Hone Diary, Nov. 27, 1839, vol. 16, p. 109.

115. Ibid., Sept. 15, 1828, vol. 1, pp. 134–35.

116. Ibid., March 17, 1830, vol. 2, p. 281. After visiting an exhibition at the National Academy of Design, Hone wrote in his diary (May 15, 1829, vol. 2, p. 36): "Cole has one or two good Pictures, but I was sorry to find that this, my Favorite artist has not added to his reputation by his recent Productions."

117. Ibid., Nov. 6, 1829, vol. 2, p. 177.

118. Burnet 1830, part 3, p. 55. Luman Reed referred to "Burnett on painting" in a letter to Mount, Feb. 29, 1836, Mount Papers.

119. Reed to Flagg, March 9, 1835, Asher B. Durand Papers.

120. Robert L. Sands, "The Legend of the Devil's Pulpit," *The Talisman* 1 (New York: Elam Bliss, 1827), pp. 230, 232.

121. Mount to Luman Reed, Nov. 12, 1835, Mount Papers. This letter records that Reed admired some copies of frescoes by Raphael and a copy of *The School of Athens* in a collection [unidentified] that he visited in White Street.

122. Allen referred to "Rafaels Madonna" in a letter addressed "My Dear Sir," Feb. 21, 1844 (Document 84, Reed Papers, supplement).

123. See "Discourse 4," Reynolds 1821, pp. 67–96.

124. Philip Hone Diary, June 11, 1838, vol. 14, p. 199.

125. Flagg to Reed, Paris, Feb. 8, 1835, Reed Papers.

126. Reed to Durand, June 18, 1835, Asher B. Durand Papers. Durand responded to Reed's letter saying that "perhaps this result is the principal advantage gain[e]d by a *visit* to Europe—the conviction that *that* is not absolutely necessary. We are taught to believe that the Old Masters have attain[e]d perfection and that it is hopeless for us to attempt to rival them. What can we do under such impressions but look at them and despair. Doubtless the road by which they pass[e]d to eminence is still open to us and the goal may be attain[e]d without other guide than was known to them." Asher B. Durand to Luman Reed, June 22, 1835, Reed Papers.

127. Reed to Durand, June 18, 1835, Asher B. Durand Papers.

128. Noble 1853, p. 175. This is one of a number of stories about the first meeting between Reed and Cole that is repeated and examined in Parry 1988, pp. 131–32.

129. An undated manuscript to a person unknown, Cole Papers, quoted in Barbara Novak, "Thomas Cole and Robert Gilmor," *Art Quarterly* 25 (Spring 1962), no. 1, p. 44.

130. Thomas Cole, "Essay on American Scenery," *American Monthly Magazine,* new series, 1 (Jan. 1836), p. 4.

131. Asher B. Durand to John W. Casilear, June 14, 1835, Asher B. Durand Papers, NYPL.

132. Cole 1836, p. 11.

133. In contrast see Novak 1962, pp. 41–53, for a study of the relationship between Cole and Gilmor. Cole to Reed, Sept. 18, 1833, Cole Papers.

134. Notebook of Thomas Cole, 1825, Cole Papers. Typescript, NYHS, cited paintings of specific scenes that had been requested by Colonel Trumbull, Mr. Verplanck, Mr. Gilmor, Daniel Wadsworth, and Dr. Hosack.

135. Robert Gilmor to Cole, Dec. 13, 1826, Cole Papers, quoted in Novak 1962, p. 43. Reed to Flagg, March 9, 1835, Asher B. Durand Papers.

136. Cole to Reed, Sept. 18, 1833, and Reed to Cole, Sept. 23, 1833, Cole Papers.

137. Cole to Reed, May 24, 1835, and June 22, 1835, Reed Papers. Reed to Cole, Nov. 21, 1835, Cole Papers, quoted in Parry 1988, p. 171, where the supportive correspondence with Reed relating to *The Course of Empire* is explored in detail. See chapter 4, "Luman Reed's Gallery and The Course of Empire," pp. 131–70. Professor Parry kindly provided me with a photocopy of this chapter before the book was available.

138. Reed to Cole, March 3, 1836, Cole Papers: "I have on another occasion requested them to keep my name out of their paper & have just penned a note to the same purport to the Editors [of the Evening Star]." Cole to Reed, March 6, 1836, ibid.

139. "Mr. Reed's encouragement of the artist's efforts at portraiture, . . . led him to abandon engraving entirely," wrote John Durand (Durand 1894, p. 120) about his father.

140. Reed to Durand, March 10, 1835, Asher B. Durand Papers.

141. Reed to Durand, March 11, 1835, ibid. "U.S. Naval Lyceum," *Naval Magazine* 1 (Jan. 1836), pp. 8–9.

142. Durand to Reed, June 18, 1835, Reed Papers.

143. *Naval Magazine* 1 (Jan. 1836), on page 9, printed this letter from Luman Reed to the president of the lyceum: "The portraits of Washington, the elder Adams, Jefferson, Madison, and Monroe, are copies made by Asher B. Durand, Esq., of this city, from originals by Gilbert Stuart; that of Washington, from the one now in the possession

of the Boston Athenaeum; that of the elder Adams, from the one in the possession of his son, the Hon. John Quincy Adams; that of Jefferson, in the possession of his daughter, Mrs. Randolph; that of Madison, in the possession of Bowdoin College; and that of Monroe, in the possession of Lloyd N. Rogers, Esq., of Baltimore. The portraits of the Hon. John Quincy Adams, and President Jackson, are originals, painted by Durand in the month of March, of the present year."

144. Reed to Durand, May 1835, quoted in Durand 1894, p. 116; Asher B. Durand to his wife, Mary Durand, June 10, 1835, Asher B. Durand Papers.

145. Reed to Mount, Sept. 24, 1835, Mount Papers: "Durand has a picture in hand for me but I have not seen it nor do I know the subject."

146. "Mr. Irving called on me and I showed him your Picture of the 'Bargain' with which he was very much delighted and says he wants to become acquainted with [you] and I promised to let him know the first time you came in Town," Reed to Mount, Dec. 11, 1835, Mount Papers.

 Reed's library contained an edition of Washington Irving, William Irving, and James Kirke Paulding, *Salmagundi; or, The Whim-whams and Opinions of Lancelot Langstall, esq. and Others* (New York: D. Longworth at the Shakespeare Gallery, 1808). Reed Inventory 1836. This humorous collection of prose and verse was published during the decade of unusual productivity among the "Knickerbockers," the early generation of writers in New York who made the city into the literary capital of America. See Callow 1967, p. 6.

147. See William H. Gerdts and Theodore Stebbins, Jr., *"A Man of Genius": The Art of Washington Allston, (1779–1843)* (Boston: Museum of Fine Arts, 1979), p. 136.

148. Over the seven-year period, Reed offered a salary that started at $350 per year and increased by increments to $1,000 in the final year. Reed to Flagg, May 1, 1834, Reed Papers. "Recognising his [George Flagg's] talent and wishing to afford a young beginner every educational facility, he at once adopted him, as it were, and sent him to Europe, defraying all his expenses," recalled John Durand (Durand 1894, p. 114).

149. Reed to Flagg, March 9, 1835, Asher B. Durand

Papers. Flagg to Reed, Dec. 9, 1834, Reed Papers.

150. A recent publication on this subject is William H. Gerdts and Mark Thistlethwaite, *Grand Illusions: History Painting in America* (Fort Worth: Amon Carter Museum, 1988). For an unpublished but thorough study of American history painting, see Wendy Greenhouse, "The American Portrayal of Tudor and Stuart History, 1835–1865," Ph.D. diss., Yale University, New Haven, 1989.

151. Reed to Flagg, March 9, 1835, Asher B. Durand Papers.

152. Reed to Cole, Feb. 17, 1836, Cole Papers.

153. Bernard Wishy, *The Child and the Republic: The Dawn of Modern American Child Nurture* (Philadelphia: University of Pennsylvania Press, 1967), p. 4.

154. Reed to Durand, June 18, 1835, Asher B. Durand Papers.

155. Reed to Mount, Dec. 11, 1835, Mount Papers.

156. Reed to Mount, Sept. 24, 1835, ibid.

157. *New-York Mirror* (June 25, 1836), p. 414.

158. Reed to Flagg, March 9, 1835, Asher B. Durand Papers. Reed to Mount, Sept. 24, 1835, Mount Papers.

159. "I have not had my pictures by Cole varnished and the first one looks better today than the day I rec'd it," wrote Reed to Mount, Nov. 25, 1835, Mount Papers. Reed went on to say that he feared cracking as the result of varnish.

160. Reed to Mount, Dec. 26, 1835, Mount Papers, and Reed to Flagg, Dec. 30, 1835, Asher B. Durand Papers. In Burnet 1830, part 1, pp. 11–12, which Reed read and recommended to Mount, the works of the Dutch artist Adriaen van Ostade (1610–1684) and the Flemish artist David Teniers (1610–1690) were held in high regard: "A small etching by Ostade, ought to be in the possession of every artist, for its beautiful arrangement of light and shade, and the skillful way in which they are woven together."

161. Reed to Mount, Nov. 23, 1835, Mount Papers.

162. Ibid.; see also Reed to Mount, Feb. 29, 1836.

163. Reed to Mount, Feb. 29, 1836, ibid. Reed says that work on the doors has stopped until Cole can come to town, but so far the following work has been accomplished: "The two small doors in the front Gallery have the figures painted in, one by Flagg & the other by Durand & the stiles are

to be ornamented by your Brother [probably Henry rather than Shepard Alonzo]. Durand has painted four pannels [*sic*] on the large doors. All these by the way are sketches. . . . Cole has engaged to paint one of the large Doors & when he comes Durand will go on with the other. I am pleased with the effect."

164. Ellwood C. Parry III, "Thomas Cole's Ideas for Mr. Reed's Doors," *Am. Art Jour.* 12 (Summer 1980), pp. 33–45.

165. "I have not told you what subjects Durand has painted on the large Door, one is a Woman Churning under a Shed with a Child on the floor & Landscape in the distance. . . . Another . . . is a School let out with school house & Landscape. The third is Farmers eating dinner under a tree. The fourth, Interior & Children playing blind man's b[l]uff. The six pannels [*sic*] on the small Door are all rural scenery." Reed to Cole, Feb. 17, 1836, Cole Papers.

166. Frankenstein 1975, p. 68; David Lawall, *Asher B. Durand: A Documentary Catalogue of the Narrative and Landscape Paintings* (New York: Garland Publishing, Inc., 1978), cat. no. 9, pp. 8–10; Parry 1980, p. 45.

167. Richard Gallerani, conservator of paintings at the New-York Historical Society, who had formerly worked at the Detroit Institute of Art, remembered this horse image from the Durand painting, and I am very grateful to him for his sharp eye and good memory. Titled *Morning Ride,* this painting is documented in Lawall 1978, cat. no. 23, fig. 27.

168. Since Reed's letter to Mount of May 4, 1836, indicated that Mount had not yet worked on the doors, and Reed became ill within the week, it seemed unlikely that Mount could have come to New York in the interim. Deborah Johnson, curator at the Museums at Stony Brook, kindly reviewed Mount's diaries and notes during the period and found no mention of a trip to Reed's gallery to paint the doors. She said that Mount was such a prodigious record keeper that he would surely have noted the work if he had done it. The rustic scenes that have been formerly attributed to Mount, mostly because of the nature of their subject, are now through iconographic and stylistic evidence considered clearly

the work of Asher B. Durand.

169. Parry 1980, pp. 33–45. Reed to Cole, Dec. 29, 1835, Cole Papers.

170. Cole to Reed, June 22, 1835, Reed Papers.

171. Durand to John W. Casilear, June 14, 1835, Asher B. Durand Papers.

172. Flagg to Durand, June 12, 1836, Asher B. Durand Papers.

173. Mount to Durand, June 13, 1836, ibid.

174. "The Merchant Patron of the Fine Arts," *Merchant's Magazine and Commercial Review* 15 (July 1846), p. 80.

175. "Death of Luman Reed Esq.," *New-York Spectator*, June 13, 1836, p. 1.

THE LUMAN REED COLLECTION: CATALOGUE

1. Noble 1853, p. 175.

2. The Reed family moved into their new house on August 4, 1832. See Catharine Reed's diary, August 4, 1833, Document 34A, Reed Papers, supplement.

3. Noble 1853, p. 176. In a diary entry of November 30, 1833, William Dunlap noted that Cole's *Italian Scene. Composition* was "painted this summer." Dorothy C. Barck, ed., *Diary of William Dunlap (1766–1839): The Memoirs of a Dramatist, Theatrical Manager, Painter, Critic, Novelist, and Historian* (3 vols., New York: New-York Historical Society, 1930), 3, p. 760.

4. Dunlap 1834, 2, p. 367.

5. *New-York Mirror* 10 (June 8, 1833), p. 387.

6. Thomas Cole to Robert Gilmor, Jr., Dec. 26, 1826, Cole Papers, NYSL.

7. Dunlap 1834, 2, p. 365. For comparable works by Allston, see his *Italian Landscape* (Addison Gallery of American Art, Phillips Academy, Andover, Mass.) of about 1805, and his *Italian Landscape* (Toledo Museum of Art) of 1814.

8. Ellwood C. Parry III has suggested that Cole derived the circular temple from the Temple of the Sibyl at Tivoli. See "Thomas Cole's 'The Course of Empire': A Study in Serial Imagery," Ph. D. diss., Yale University, 1970, p. 57.

9. NYGFA 1844, p. 11, no. 34.

10. Dunlap 1834, 2, pp. 363–64.

11. Ellwood C. Parry III, "Thomas Cole's Early Career: 1818–1829," in Edward J. Nygren, Bruce Robertson et al., *Views and Visions: American Landscape before 1830* (Washington, D.C.: Corcoran Gallery of Art, 1986), pp. 167, 169–70.

12. Kenneth Myers et al., *The Catskills: Painters, Writers, and Tourists in the Mountains, 1820–1895* (Hanover, N.H.: University Press of New England, 1987), p. 117.

13. Ibid., pp. 31, 33–36, 38, 49.

14. For a list of other paintings by Cole of this site, see ibid., p. 117.

15. See David Steinberg, "Thomas Cole's North Mountain and Catskill Creek," *Yale University Art Gallery Bulletin* 39 (Winter 1986), pp. 24–26. Steinberg reproduces Cole's small oil sketch of North Mountain and Catskill Creek.

16. Ibid., pp. 28–29, and Thomas Cole, "Essay on American Scenery," *American Monthly Magazine* 7 (Jan. 1836), p. 3.

17. *Broadway Journal* 1 (Feb. 15, 1845), p. 103.

18. The tower, for example, appears to be Cole's reconstruction of a partly ruined tower depicted in his sketch *Ruined Castle by a Bay* (Detroit Institute of Arts) of about 1832, illustrated in Howard S. Merritt, *Thomas Cole* (Rochester, N.Y.: University of Rochester, 1969), p. 113, no. 72.

19. Perhaps influenced by Cole, Reed acquired a volume of Byron's work for his library. See the Reed Inventory 1836.

20. *The Poetical Works of Lord Byron* (London: Oxford University Press, 1960), p. 330.

21. *American Monthly Magazine* 3 (May 1, 1834), p. 212.

22. Cole may have known not only Allston's painting but also the three poems published by Henry Pickering in 1822, 1828, and 1830 as tributes to this particular work. See William H. Gerdts and Theodore E. Stebbins, Jr., *"A Man of Genius": The Art of Washington Allston (1779–1843)* (Boston: Museum of Fine Arts, 1979), pp. 144–46.

23. Noble 1853, p. 191.

24. *American Monthly Magazine* 3 (May 1, 1834), p. 212.

25. Donald D. Keyes et al., *The White Mountains: Place and Perceptions* (Hanover, N.H.: University Press of New England, 1980), p. 42.

26. Catherine H. Campbell, "Two's Company: The Diaries of Thomas Cole and Henry Cheever Pratt on Their Walk through Crawford Notch, 1828," *Historical New Hampshire* 33 (Winter 1978), pp. 109–33. For two of Cole's sketches of Chocorua, see *Chocorua Peak and Pond* and *Chocorua, New Hampshire* (both, Detroit Institute of Arts), reproduced in Howard S. Merritt, *To Walk With Nature: The Drawings of Thomas Cole* (Yonkers, N.Y.: Hudson River Museum, 1981), pp. 32–33.

27. The legend of Chocorua first appeared in print in the elegiac poem "Jeckoyva" by Henry Wadsworth Longfellow. See *The United States Literary Gazette* 2 (August 1, 1825), p. 348, cited in Lawrence Shaw Mayo, "The History of the Leg-

end of Chocorua," *New England Quarterly* 19 (Sept. 1946), p. 303.

28. Noble 1853, rev. ed. by Elliot S. Vesell, *The Life and Works of Thomas Cole* (Cambridge, Mass.: Belknap Press of Harvard University Press, 1964), p. xxxix.

29. For an earlier view of Mount Chocorua that is similar to Reed's painting, see Cole's *Autumn Landscape with Melancholy Figure* (private collection) of about 1827–28, reproduced in Edward J. Nygren, Bruce Robertson et al., *Views and Visions: American Landscape Before 1830* (Washington, D.C.: Corcoran Gallery of Art, 1986), p. 180. *The Death of Chocorua* was engraved and published in a gift book with a narrative by Lydia Maria Francis. See Lydia Maria Francis, "Chocorua's Curse," in S. G. Goodrich, ed., *The Token: A Christmas and New Year's Present* (Boston: Carter & Hendee, 1830), pp. 257–65, and pl. opp. p. 257.

30. Keyes et al. 1980, p. 43.

31. William Dunlap saw all four pictures at Cole's studio on November 15, 1834. Barck, ed., 1930, 3, p. 837.

32. Cole, Jan. 1836, p. 6.

33. Ibid., p. 12.

34. *American Monthly Magazine* 5 (June 1835), p. 317; *New-York Mirror* 12 (May 16, 1835), p. 371.

35. A Cole sketchbook begun in 1827 (Cole Papers, NYSL), has entries (probably dating from 1829) describing a series of paintings depicting "the mutation of earthly things" and "an illustration of man and the progress of mankind." In another sketchbook of 1829 (Cole Papers, NYSL), he outlined a cycle depicting "the mutation of Terrestrial things," and "The Epitome of Man." These entries are transcribed in Parry 1970, pp. 184–87.

36. Noble 1853, p. 155.

37. Thomas Cole to Robert Gilmor, Jr., Jan. 29, 1832, Cole Papers.

38. Cole to John Ludlow Morton, Jan. 31, 1832, in Noble 1853, p. 139.

39. Cole to Gilmor, Jan. 29, 1832, Cole Papers.

40. Catharine Reed's diary, August 4, 1833, Document 34A, Reed Papers, supplement, in which she states that the family had occupied the house exactly one year before.

41. Dunlap 1834, 2, p. 367. In a journal entry of July 28, 1835, Cole wrote: "I have had some little trouble in finding at once a comprehensive and appropriate title for the Series of pictures I am now painting for Luman Reed. The one which I have at last adopted, although some may consider it lofty and ostentatious, appears very well to me. I call it 'The Course of Empire.'" Noble 1853, pp. 203–4.

42. Cole to Luman Reed, Sept. 18, 1833, Cole Papers.

43. Reed to Cole, Sept. 23, 1836, Cole Papers, Detroit Institute of Arts Library.

44. See Esther I. Seaver, *Thomas Cole, 1801–1848, One Hundred Years Later: A Loan Exhibition* (Hartford: Wadsworth Atheneum; New York: Whitney Museum of American Art, 1948), p. 7: "From the number of programs of panoramas of London and New York bearing the artist's signature that still remain in his Catskill home it is reasonable to conclude that he frequented these spectacles."

45. Parry 1988, p. 148.

46. Edgar P. Richardson, *Painting in America* (New York: Thomas Y. Crowell Co., 1956), p. 167.

47. Constantin-François de Chasseboeuf, comte de Volney, *The Ruins: or a Survey of the Revolutions of Empires* (New York: William A. Davis, 1796), p. 16.

48. Alan P. Wallach, "Cole, Byron, and *The Course of Empire*," *Art Bulletin* 50 (Dec. 1968), pp. 377–78.

49. See Parry 1988, p. 157, and Cole's journal entry, May 14, 1832, cited in Noble 1853, p. 162.

50. Parry 1988, p. 154.

51. "Exhibition at Mr. Cole's Rooms," *New-York Mirror* 10 (Jan. 12, 1833), p. 219.

52. *New-York Mirror* 12 (April 18, 1835), p. 330. During his stay in Rome in 1832, Cole stayed in a studio traditionally said to have been Claude's. Noble 1853, p. 145.

53. Parry 1988, pp. 158–59, cites John Finch's article "On the Celtic Antiquities of America," published in the *American Journal of Science* in 1824.

54. In his 1827 sketchbook, under the heading "List of Subjects for Pictures," Cole wrote: "Cimabue the painter discovering Giotto as a shepherd boy drawing—see [Giorgio] Vasari." Parry 1988, pp. 160–62.

55. See Claude's *Seaport with the Embarkation of St. Ursula* of 1641, *Seaport with the Embarkation of the Queen of Sheba* of 1648 (both, National Gallery, London), and *Sunrise; The Landing of Cleopatra* (Louvre, Paris) of 1642.

56. Cole's London sketchbook of 1829, Cole Papers.

57. Parry 1988, p. 169: "A list would have to include *The Ruins of Palmyra* by Wood and Dawkins (for the column-supported pedestals), *The Antiquities of Athens* by Stuart and Revett (for the Parthenonic temple, the circular monument above it, and the building with caryatids on the right), J. N. L. Durand's *Receuil et parallele des Edifices de tout genre* (for the huge palace with a golden dome in the background), and Piranesi's *Vasi, Candelabri, Cippi* for the marble and terracotta vases spotted around in the foreground."

58. Ibid., p. 170, notes that both of these antique works appear in Samuel F. B. Morse's painting of the *Exhibition Gallery of the Louvre* (Terra Museum of American Art, Evanston, Ill.) of 1831–33, which was exhibited in New York in 1833.

59. "The Third of Mr. Cole's Five Pictures," *New York Mirror* 14 (Nov. 4, 1836), p. 150.

60. Parry 1988, pp. 169–70, links Cole's use of this anecdote to Turner's *Dido Building Carthage; or, The Rise of the Carthaginian Empire,* in which a similar pair of boys "have launched a toy ship onto the waters of the bay, thereby alluding to the future naval prowess of the Carthaginian Empire."

61. "The Third of Mr. Cole's Five Pictures," *New-York Mirror* 14 (Nov. 4, 1836), p. 150.

62. Cole wrote: "In another picture I would paint the objects larger and fewer, with the horizon lower. It would be easier and grander." Thomas Cole to Luman Reed, Feb. 18, 1836, Cole Papers.

63. Thomas Cole to Luman Reed, Feb. 19, 1836, ibid.

64. Luman Reed to Thomas Cole, Feb. 17, 1836, ibid.

65. Thomas Cole to Luman Reed, Mar. 2, 1836, ibid. Cole's initial thought of exhibiting the last picture of *The Course of Empire* was discarded when he was reminded by Reed that the National Academy of Design rules prohibited showing paintings twice, which would thus preclude a future showing of the complete series. See Reed to Cole,

Feb. 26, 1836, ibid.

66. Asher B. Durand to Thomas Cole, June 19, 1836, Asher B. Durand Papers.

67. "Mr. Cole's Fourth and Fifth Pictures," *New-York Mirror* 14 (Nov. 4, 1836), p. 158.

68. Wolfgang Born, *American Landscape Painting: An Interpretation* (New Haven: Yale University Press, 1948), pp. 81–83.

69. See William Feaver, *The Art of John Martin* (Oxford: Clarendon Press, 1975), pp. 45–46, fig. 27.

70. Noble 1853, pp. 114–15.

71. Parry 1988, p. 180.

72. Ibid., pp. 181–83.

73. Ibid., pp. 182–83.

74. Thomas Cole to Asher B. Durand, June 7, 1836, Asher B. Durand Papers.

75. Parry 1988, p. 180. The scale of this statue may have been influenced by the fragments of the colossal statue of Constantine that Cole could have seen in Rome.

76. Thomas Cole to Asher B. Durand, Aug. 30, 1836, Asher B. Durand Papers.

77. Parry 1988, p. 144.

78. In a letter of May 24, 1836, Cole noted the suggestion of Reed's son-in-law Theodore Allen that he include a "tomb with savage inhabitants" but decided not to incorporate this motif in the painting. Thomas Cole to Asher B. Durand, Asher B. Durand Papers. There is an oil sketch for *Desolation* (formerly with Kennedy Galleries New York) that closely resembles the final composition.

79. Chasseboeuf 1796, p. 18.

80. Cole to Asher B. Durand, Sept. 12, 1836, Asher B. Durand Papers.

81. For the three poems inspired by Reed, see Marshall B. Tymn, ed., *Thomas Cole's Poetry* (York, Pa.: Liberty Cap Books, 1972), pp. 81–86.

82. *The Course of Empire* was valued at $2,500 in the Reed Inventory 1836. However, in 1844 Cole stated that he had received $4,500 from Reed. See Thomas Cole to Maria Cole, March 15, 1844, Cole Papers.

83. For the resolution to rent the National Academy of Design schoolroom to Cole for his exhibition of *The Course of Empire,* see the Minutes, Oct. 14, 1836, Archives of the National Academy of Design.

84. The text of the descriptive brochure was reproduced in its entirety in several reviews. See "The Fine Arts," *Knickerbocker* 8 (Nov. 1836), pp. 29–30. For one of Cole's advertisements, see "Cole's Pictures," *New-York Commercial Advertiser,* Nov. 2, 1836, p. 3.

85. Theodore Allen to Cole, Dec. 27, 1836, Cole Papers.

86. Cole to Reed, March 26, 1836, cited in Noble 1853, p. 217. Cole journal, Oct. 29, 1836, cited in ibid., p. 223.

87. "The New York Gallery of the Fine Arts," *Broadway Journal* 1 (Feb. 15, 1845), p. 103.

88. Noble 1853, pp. 224–26.

89. "The Third of Mr. Cole's Five Pictures," *New-York Mirror* 14 (Nov. 4, 1836), p. 150.

90. "Mr. Cole's Five Pictures," ibid. (Oct. 22, 1836), p. 135.

91. Wallach 1968, pp. 377–78.

92. Noble 1853, p. 221.

93. Ibid., pp. 235–36.

94. For Cole's description of *The Voyage of Life,* see Noble 1853, pp. 287–89.

95. *Catalogue of the Engraved Work of Asher B. Durand* (New York: Grolier Club, 1895), pp. 15, 37–38, and 60–62, and Hudson River Museum, *Asher B. Durand: An Engraver's and a Farmer's Art* (Yonkers, N.Y., 1983), pp. 26–27, 35, 40–41.

96. *New-York Mirror* 12 (August 9, 1834), p. 41 and pl. opp. Durand's portrait of Madison is now in the collection of the New-York Historical Society.

97. Luman Reed to Andrew Jackson, Feb. 21, 1835, Andrew Jackson Papers, Manuscripts Division, Library of Congress. For the portrait of Clay commissioned by Charles Augustus Davis, see Durand 1894, pp. 107–8. For Reed's meeting with Andrew Jackson, see Catharine Reed's diary, May 26, 1831, Document 32, Reed Papers, supplement.

98. Quoted in Durand 1894, p. 108. Durand's portrait of Jackson was exhibited at the National Academy of Design in 1835, and prompted one critic to write: "He has not hitherto succeeded so well with the smoothness, grace, and delicacy of youthful beauty, but his old faces are admirable. This portrait of the President is not merely a likeness, but a facsimile." *Knickerbocker* 5 (June 1835), p. 552.

99. Reed to Durand, March 11, 1835, Asher B. Durand Papers. Reed's decision to present a set of portraits to a public institution occurred only after Durand had left for Washington. See Reed to Durand, March 12, 1835, ibid.

100. Andrew Oliver, *Portraits of John Quincy Adams and His Wife* (Cambridge, Mass.: Belknap Press of Harvard University Press, 1970), p. 169. Durand's first portrait of John Quincy Adams was exhibited at the National Academy of Design in 1835, and reviewed with the single word "perfect" by one critic. *Knickerbocker* 5 (June 1835), p. 553. The painting was engraved by John Wesley Paradise for James B. Longacre and James Herring, eds., *The National Portrait Gallery of Distinguished Americans* (4 vols., Philadelphia and New York, 1840), 4, pl. opp. p. 1, and purchased from the artist by the Century Association in 1870. A replica of this portrait was exhibited at the Boston Athenaeum in 1835 and is now in the collection of Harvard University. Oliver 1970, pp. 169–70.

101. Asher B. Durand to Mary Durand, June 3, 1835, Asher B. Durand Papers, NYPL, and Oliver 1970, p. 171.

102. For Cole's letter of introduction to Allston, see Cole to Reed, May 24, 1835, Reed Papers. Also see Reed's letters to Cole of May 26 and June 16, 1836, Cole Papers.

103. Durand to John William Casilear, June 14, 1835, Asher B. Durand Papers.

104. Asher B. Durand to Mary Durand, June 10, 1835, ibid.

105. Oliver 1970, p. 174.

106. "I have also begun a second Washington in order to have both direct from the original. . . ." Durand to Reed, June 22, 1835, Reed Papers.

107. Asher B. Durand to Mary Durand, June 17 and 23, 1835, Asher B. Durand Papers, and Oliver 1970, pp. 173–74. On November 20, 1840, five years after he sat for his portrait, John Quincy Adams visited Reed's gallery during a trip to New York and observed: "The first seven presidents of the United States are ranged in their order, myself and Jackson painted by Durand; and the rest good copies by him from Stuart." Oliver 1970, p. 179.

108. "I have assurance of obtaining the Original Por-

trait of Jefferson as I return it being in Phila. & the owner Mrs. Randolph of this place & Daughter of Jefferson gives me permission to take it with me to New York." Durand to Reed, March 15, 1835, Reed Papers.

109. In order to retain the visual unity of the series, Durand copied only the head and shoulders of the three-quarter-length portrait of Madison given to Bowdoin College by James Bowdoin. See Asher B. Durand to Mary Durand, Oct. 19, 1835, Asher B. Durand Papers. On October 29, 1835, Luman Reed reported to William Sidney Mount: "Durand has been home since you was here and bro[ugh]t with him the portrait of Madison and he has now gone to Baltimore to copy Stewart's [Gilbert Stuart's] head of Monroe which completes the series." Mount Papers.

110. See Reed to Cole, Dec. 29, 1835, Cole Papers, NYSL.

111. *Naval Magazine* 1 (Jan. 1836), pp. 8–9.

112. For an illustration of the presidential portraits *in situ* with scientific exhibits in the Long Room of Independence Hall in Philadelphia, see the watercolor view of 1822 by Peale and his son Titian Ramsay Peale II and Peale's painting *The Artist in His Museum* of the same year, in Edgar P. Richardson, Brooke Hindle, Lillian B. Miller, and Charles Coleman Sellers, *Charles Willson Peale and His World* (New York: Harry N. Abrams, Inc., 1982), pp. 82–83, 105.

113. *Naval Magazine* 1 (Jan. 1836), pp. 8–9. Also see *Knickerbocker* 8 (July 1836), p. 120.

114. Charles Handy to Reed, Dec. 16, 1835, Letter Book of the U.S. Naval Lyceum, Dec. 10, 1833–Nov. 2, 1871, Manuscripts Division, United States Naval Academy, Annapolis. The U.S. Lyceum was disbanded in 1888, and its collections were transferred to the Naval Academy at Annapolis. For Durand's presidential portraits, see *United States Naval Academy Museum, Catalogue of Paintings* (Annapolis, Md., 1954), p. 11, nos. 175, 177–82.

115. On September 24, 1835, Reed wrote to William Sidney Mount: "Durand has a picture in hand for me but I have not seen it nor do I know the subject." On October 29, Reed offered Mount a progress report: "Durand's picture of Peter Stuyvesant and his Trumpeter and Dirk Schuyler

is very excellent & I know it will please you. . . . I feel much gratified with my prospects of getting fine pictures to fill my Gallery." Mount Papers.

116. Reed to Mount, Nov. 23, 1835, ibid.

117. Koke 1982, 1, p. 300.

118. Diedrich Knickerbocker [Washington Irving], *A History of New York, from the Beginning of the World to the End of the Dutch Dynasty* (2 vols., New York: Inskeep & Bradford, 1809), 2, pp. 88–89.

119. Daniel Huntington, *Asher B. Durand: A Memorial Address* (New York: Century Association, 1887), p. 26.

120. Durand 1894, p. 121.

121. Knickerbocker [Irving] 1809, 2, p. 70. The appearance of this unlocated portrait may be approximated by a bust-length portrait of *Peter Stuyvesant* (New-York Historical Society) of about 1660, also owned by the Stuyvesant family in the nineteenth century.

122. Ibid. 2, p. 85

123. Ibid. 1, p. 215.

124. See Mary Weatherspoon Bowden, "Knickerbocker's History and the 'Enlightened' Men of New York City," *American Literature: A Journal of Literary History, Criticism, and Bibliography* 47 (May 1975), pp 159–72.

125. For Reed's support of Hackett, see Durand 1894, pp. 116–18. Hackett's drama had been conceived as early as 1834, and Durand may have known of it firsthand or through descriptions that appeared in the press prior to the actual premiere: "The third act introduces Peter the Headstrong [Stuyvesant], with those inseparable accompaniments, his trumpeter and wooden-leg. It gives to view the principal events of his stormy reign, including the marshalling of that host, with all its varities of costumes and equipment, at whose head he triumphed over the Swedes." *New-York Mirror* 11 (Feb. 1, 1834), p. 247. For the premiere of Hackett's play, see ibid. 15 (Sept. 2, 1837), p. 80.

126. Ibid. 13 (June 4, 1836), p. 390. The critic for the *Knickerbocker* worried about the lack of dignity in Durand's depiction of Stuyvesant: "The gallant Hard Koppig Piet [i.e., "hard-headed Peter" Stuyvesant] wants something; either dignity, or the lofty, chivalrous bearing which we cannot but

ascribe to him, and which accords with his character, even in the humorous delineation of the Dutch historian. Mr. Durand, as it seems to us, has made him merely an old soldier; he looks more like a crippled sergeant or corporal, than like the gallant governor Peter." *Knickerbocker* 8 (July 1836), p. 113.

127. See Luman Reed to William Sidney Mount, Nov. 23, 1835, Mount Papers.

128. Durand may have derived the compositional motif of the black man entering the room from William Sidney Mount's *Rustic Dance After a Sleigh Ride* (Museum of Fine Arts, Boston) of 1830. This work also would have provided a model for the boxlike interior space of *The Pedler.*

129. J. R. Dolan, *The Yankee Peddlers of Early America* (New York: Clarkson N. Potter, 1964), p. 67.

130. Ibid., p. 231.

131. For a survey of successful entrepreneurs who began their careers as peddlers, see ibid., pp. 242–65.

132. See Abijah Reed to Theodore Allen, Feb. 26, 1844, Document 45, Reed Papers, supplement.

133. Durand 1894, p. 120. Wilkie's influence on Durand's *The Pedler* was also noted by the American sculptor Horatio Greenough, who visited Reed's gallery in the fall of 1836 and saw Durand's "picture of an Itinerant Merchant in the Wilkie style." Horatio Greenough to John Gorham Palfrey, Oct. 3, 1836, in Nathalia Wright, ed., *Letters of Horatio Greenough, American Sculptor* (Madison: University of Wisconsin Press, 1972), pp. 205–6. Durand later visited Wilkie in London during his European trip of 1840–41. See Huntington 1887, pp. 29–30.

134. Catherine Hoover, "The Influence of David Wilkie's Prints on the Genre Paintings of William Sidney Mount," *Am. Art Jour.* 13 (Summer 1981), pp. 4–33.

135. Ibid., pp. 32–33.

136. Joshua C. Taylor, ed., *America as Art* (Washington, D.C.: Smithsonian Institution Press, 1976), p. 47.

137. See Durand sketchbook, NYHS (1918.57), fol. 41 verso, and fol. 44 recto, the latter incorrectly inscribed "Study for picture of / Dance on the Battery."

138. See NYGFA 1845, p. 6, no. 41.

139. For Flagg's study with Allston from 1831–33, see Gerdts and Stebbins 1979, p. 136. Flagg apparently boarded with the family of William Ellery Channing. See H. S. W., "Obituary. George W. Flagg, Jan. 5th, 1897," *Nantucket Inquirer and Mirror,* Jan. 9, 1897.

140. Tuckerman 1867, p. 407. Henry W. French attributed Reed's patronage of Flagg to the intercession of Thomas Cole and the New Haven painter and engraver Nathaniel Jocelyn, and he cited a different painting as the crucial work: "The piece to which he owed this good fortune was 'The Ghost-Story,' told by an old hag, listened to by a frightened boy." H. W. French, *Art and Artists in Connecticut* (Boston: Lee & Shepard; New York: Charles T. Dillingham, 1879), p. 91. However, Reed does not appear to have purchased *The Ghost Story,* which was exhibited at the Boston Athenaeum in 1833 (no. 34), for the work does not appear in the Reed Inventory 1836.

141. See Luman Reed to George W. Flagg, May 1, 1834, and Flagg to Reed, May 19, 1834, Reed Papers, NYHS.

142. Gerdts and Stebbins, Jr., 1979, pp. 53–54.

143. For the popularity of *Richard III* in nineteenth-century England, see Richard D. Altick, *Paintings from Books: Art and Literature in Britain, 1760–1900* (Columbus: Ohio State University Press, 1985), pp. 281–83.

144. See NYGFA 1844, pp. 13–14.

145. Altick 1985, p. 282.

146. For the dramatic chiaroscuro created by the brilliant oil lamp, Flagg may also have been influenced by Allston's now-lost *Spalatro's Vision of the Bloody Hand* of 1831, painted shortly before or during Flagg's period of informal study in Allston's Cambridgeport studio (1831–33). The painting was exhibited at the National Academy of Design in 1832, and critics cited the oil lamp as one of the finest depictions of fire ever created. Gerdts and Stebbins, Jr., 1979, pp. 151–52 and 237–38, reproduce both an engraving after the painting and a pencil study of the hand with the oil lamp.

147. Altick 1985, p. 282.

148. *American Monthly Magazine* 3 (June 1, 1834), p. 282.

149. Noble 1853, p. 116.

150. For Reed's friendship with Irving, see Reed to Mount, Dec. 11, 1835, Mount Papers, and Tuckerman 1867, p. 228.

151. Washington Irving, "The Boar's Head Tavern, East Cheap. A Shakespearian Research," in *The Sketchbook of Geoffrey Crayon, Gent.* (7 vols., New York: C. S. van Winkle, 1819), 3, pp. 219–42.

152. Following Hackett's bankruptcy as a Front Street merchant in 1825–26, Reed's generous and timely loan of one thousand dollars alleviated his financial troubles and permitted him to pursue a new career on the stage. See Durand 1894, pp. 116–18.

153. See Charles J. Foster, "Sketch of James H. Hackett," in James Henry Hackett, *Notes, Criticisms, and Correspondence Upon Shakespeare's Plays and Actors* (New York: Carleton, 1863), pp. 14, 333, 340–41, and George C. D. Odell, *Annals of the New York Stage* (15 vols., New York: Columbia University Press, 1927–49), 3, p. 657.

154. For Flagg's study with Allston, see Gerdts and Stebbins, Jr., 1979, p. 136.

155. Ibid., pp. 53–54.

156. Allston also painted a *Falstaff Enlisting His Ragged Regiment* (Wadsworth Atheneum, Hartford) of c. 1803–8, illustrating Shakespeare's *Henry IV, Part II.* See Henry H. Hawley, "Allston's Falstaff Enlisting His Ragged Regiment," *Wadsworth Atheneum Bulletin* 3 (Winter 1957), pp. 13–16.

157. See *The Boydell Shakespeare Prints* (reprint, New York: Benjamin Blom, 1986), n. p.

158. *New-York Mirror* 11 (May 10, 1834), p. 355.

159. *American Monthly Magazine* 3 (May 1, 1834), p. 207. For similar criticisms of Flagg's depiction of Falstaff and Prince Henry, see the *New York Evening Post,* May 23, 1834, p. 2.

160. *New-York Mirror* 13 (June 4, 1836), p. 390, and *Knickerbocker* 8 (July 1836), p. 113.

161. Reviewing Mount's *Undutiful Boys,* for example, one critic observed that "Mount has a fine feeling of the humorous in this rustic line." *Knickerbocker* 8 (July 1836), p. 115.

162. *New York Evening Post,* May 23, 1834, p. 2.

163. George W. Flagg to Luman Reed, June 16, 1834, Reed Papers.

164. David Hume, *The History of England From the Invasion of Julius Caesar to the Revolution in 1688* . . . (13 vols., London: G. Cowie & Co., 1825), 5, pp. 246, 251. Hume's *History of England* is listed in the Reed Inventory 1836.

165. Charles Noël Flagg, "Talks With My Uncle George: Nantucket," Hartford, 1911, pp. 30–31, unpublished typescript, property of Mr. Peter Flagg Maxson, Austin, Texas.

166. See William H. Gerdts and Mark Thistlethwaite, *Grand Illusions: History Painting in America* (Fort Worth: Amon Carter Museum, 1988), pp. 97–99.

167. NYGFA 1844, p. 15.

168. *New-York Mirror* 11 (May 10, 1834), p. 355, and Flagg to Reed, June 16, 1834, Reed Papers.

169. *American Monthly Magazine* 3 (June 1, 1834), p. 282.

170. For Reed's friendship with Irving, see Tuckerman 1867, p. 228, and Reed to William Sidney Mount, Sept. 11, 1835, Mount Papers. For one of the letters of introduction, see Washington Irving to Aaron Vail, American chargé d'affaires in London, Oct. 15, 1834, in Ralph M. Aderman, Herbert L. Kleinfeld, and Jenifer Banks, eds., *Washington Irving: Letters* (4 vols., Boston: Twayne Publishers, 1979), 2, p. 801.

171. *The National Cyclopaedia of American Biography* (63 vols., New York: James T. White & Co., 1893–1984), 7, p. 460.

172. For Flagg's study with Allston, see Gerdts and Stebbins, Jr., 1979, p. 136. For Flagg's use of the terms "fancy" and "ideal," see his advertisement for the auction of eighteen of his paintings in the *Charleston Courier,* May 25, 1859.

173. Gerdts and Stebbins, Jr., 1979, pp. 134–35 and 142–43.

174. Allston first was called "the American Titian" by a group of German artists during his stay in Rome (1804–1808). Ibid., p. 42.

175. For the dates of Flagg's trip to Europe, see George W. Flagg to Luman Reed, Sept. 28, 1834, Reed Papers, and Reed to Asher B. Durand, June 18, 1835, Asher B. Durand Papers.

176. Flagg to Reed, probably Dec. 1834 or Jan. 1835, Jonathan Sturges Papers, microfilm roll 2672, frames 295–298, Archives of American Art.

177. Nathaniel Parker Willis, *The Rag-Bag, A Collection of Ephemera* (New York: Charles Scribner, 1855), pp. 337–38.

178. Durand 1894, pp. 163–64.

179. For Reed's funding of Flagg's European trip, see Tuckerman 1867, p. 407. For Irving's letter to Wilkie, see *The National Cyclopaedia of American Biography* 1893–1894, 7, p. 460. Irving's letter to Vail reads: "This will be handed to you by Mr. Flagg, a young gentleman who has already attained reputation as a painter, and intends residing some time in London to improve himself in his art. Any Services you can render to him during his residence there will be considered as favors rendered to Yours ever very truly Washington Irving." Irving to Vail, Oct. 15, 1834, in Aderman, Kleinfeld, and Banks, eds., 2, p. 801. For Flagg's departure for Europe, see his letter to Reed, Sept. 28, 1834, Reed Papers, in which he plans to sail from Boston in three weeks.

180. Noble 1853, p. 118.

181. Charles Noël Flagg 1911, For an earlier, abbreviated account of Flagg's encounter with Constable, see French 1879, p. 92.

182. Tuckerman 1867, p. 406.

183. For the success of *The Match Girl*, see French 1879, p. 92, and Theodore Allen to Reed, Feb. 6, 1836, Reed Papers. For the contract between Reed and Flagg, see Reed to Henry C. Flagg, May 1, 1834; Reed to George W. Flagg, May 1, 1834; George W. Flagg to Reed, May 19, 1834, ibid.

184. *New-York Mirror* 13 (June 25, 1836), p. 414. For Flagg's departure from London, see George W. Flagg to Reed, Dec. 9, 1834, Reed Papers. On Flagg's return from Europe, Luman Reed wrote to Asher B. Durand, June 18, 1835 (Asher B. Durand Papers, NYPL): "My young friend Flagg has returned from Europe brim full of enthusiasm & says America is the place [for] him & wants no better nature than we have to study from, now I like this, let us make something of ourselves out of our own materials & we shall then be independent of others, it is all nonsense to say that we have not got the materials."

185. Reed to Thomas Cole, Feb. 17, 1836, Cole Papers.

186. Mahlon Day, *The New-York Cries, in Rhyme* (New York: Mahlon Day & Co., 1825), p. 20.

187. Lydia Maria Francis Child, *Letters from New-York* (New York: Charles S. Francis & Co.; Boston: James Munroe & Co., 1843), p. 182.

188. Ibid., p. 181, noted the pervasiveness of street beggars and observed: "I wish I could walk abroad without having misery forced on my notice, which I have no power to relieve."

189. See Gerdts and Stebbins, Jr., 1979, pp. 132–33.

190. For Flagg's study with Allston, see ibid., p. 136.

191. According to Mount, his *Boys Quarreling After School* (Museums at Stony Brook, New York) of 1830 inspired Flagg to become a professional artist. Mount, autobiographical fragment, Jan., 1854, cited in Frankenstein 1975, p. 25. Flagg probably saw Mount's painting at the National Academy of Design in New York about July of 1831, when he traveled from South Carolina to Boston to study with his uncle Washington Allston. Although Flagg had already commenced his career as a portrait painter in South Carolina, Mount's painting may have encouraged him to specialize in genre painting.

192. For Flagg's European trip, see George W. Flagg to Luman Reed, Sept. 28, 1834, Dec. 9, 1834, and Feb. 8, 1835, Reed Papers, NYHS. Also see Horatio Greenough to Washington Allston, March 7, 1835, in Wright, ed., 1972, pp. 185–89.

193. For a discussion of the barefoot boy as a symbol, see Sarah Burns, "Barefoot Boys and Other Country Children: Sentiment and Ideology in Nineteenth-Century American Art," *Am. Art Jour.* 20, no. 1 (1988), pp. 25–50.

194. Abijah Reed to Theodore Allen, Feb. 26, 1844, Document 45, Reed Papers, supplement.

195. Flagg's departures from London and Paris are noted in George W. Flagg to Luman Reed, Dec. 9, 1834, and Feb. 8, 1835, Reed Papers, NYHS. For Flagg's arrival in Florence, see Horatio Greenough to Washington Allston, March 7, 1835, in Wright, ed., 1972, pp. 185–89.

196. Charles Sprague, "The Savoyard's Song," *Youth's Keepsake; A Christmas and New Year's Gift for Young People* (Boston: Carter & Hendee, 1830), pp. 127–28, pl. opp. p. 127. The poem also was printed in the *New-York Mirror* 8 (March 12, 1831), p. 287.

197. Tuckerman 1867, pp. 405–6.

198. "Hubert & Arthur," $20.00, Reed Inventory 1836.

199. *New York Evening Post*, May 25, 1836, p. 2, June 4, 1836, p. 2. For Thew's print of Hubert and Arthur, see *The Boydell Shakespeare Prints* 1986, n. p.

200. See Odell 1927–49, 3, pp. 512, 524, 527, 562, 567, 607, 684; 4, pp. 28–29.

201. *Knickerbocker* 8 (July 1836), p. 113.

202. *New-York Mirror* 13 (June 4, 1836), p. 390.

203. Reed Inventory 1836.

204. NYGFA 1844. Reed's collection of prints is housed in the Prints and Photographs Department, NYHS.

205. For the exhibition of the so-called automaton chess player by a Mr. Maelzel, see Odell 1927–49, 3, pp. 224, 294, 368, 427, 475, 527, 594–95. The automaton was almost certainly a fraud, as was convincingly argued by Edgar Allan Poe in 1836. See *Edgar Allan Poe: Essays and Reviews* (New York: Library of America, 1984), pp. 1253–76.

206. Reed Inventory 1836.

207. See, for example, *The Game of Chess* by the Renaissance artist Lucas van Leyden in *Masterworks of the Gemäldegalerie, Berlin* (New York: Harry N Abrams, 1985), pp. 170–71.

208. For a survey of the genre, see Sarah Burns, "Yankee Romance: The Comic Courtship Scene in Nineteenth-Century American Art," *Am. Art Jour.* 18 (no. 4, 1986), pp. 51–75.

209. E. P. Richardson, "Benjamin Franklin's Chessmen," ibid. 11 (Jan. 1979), p. 59.

210. See Peter Gay, *The Bourgeois Experience Victoria to Freud: The Tender Passion* (New York and Oxford: Oxford University Press, 1986), pl. following p. 172.

211. Reed Inventory 1836.

212. George Flagg's father, Henry Collins Flagg, Jr., inherited his parents' plantation and slaves in 1839. Barbara K. Nord, *The Flagg Family in South Carolina: The Nineteenth Century* (Austin: Peripatetic Press, 1984), pp. 30–31.

213. See Karen M. Adams, "The Black Image in the Paintings of William Sidney Mount," *Am. Art Jour.* 7 (Nov. 1975), pp. 42–59.

214. See George C. Groce and David H. Wallace, *The New-York Historical Society's Dictionary of Artists in America, 1564–1860* (New Haven: Yale University Press, 1957), pp. 503–4, and Koke 1982, 3, p. 69.

215. Dunlap 1834, 2, p. 472.

216. Mary Bartlett Cowdrey, *American Academy of Fine Arts and American Art Union Exhibition Record, 1816–1852* (2 vols., New York: New-York Historical Society, 1953), 2, p. 287.

217. See Luman Reed to Asher B. Durand, June 18, 1835, Asher B. Durand Papers, NYPL.

218. Dunlap 1834, 2, p. 472. For the seven-year contract, see Reed to George W. Flagg, May 1, 1834, Reed Papers.

219. *New York Evening Post,* March 26, 1841, p. 3, and Thomas Seir Cummings, *Historic Annals of the National Academy of Design, . . . from 1825 to the Present Time* (Philadelphia: George W. Childs, 1865), p. 168.

220. In his book *The Young Mother, or, Management of Children in Regard to Health* (1839), William A. Alcott complained that most American children of the period did not have high chairs or child-sized eating utensils. See Mary Lynn Stevens Heininger et al., *A Century of Childhood, 1820–1920* (Rochester, N.Y.: Margaret Woodbury Strong Museum, 1984), p. 45.

221. Heininger et al. 1984, pp. 2, 10–11.

222. For Reed's love of children, see the manuscript by "B" [George Barker], June 1884, p. 46, Reed Papers.

223. William Sidney Mount, Diary, June 19, 1847, cited by Frankenstein 1975, pp. 177–78. Mount made a detailed record of the materials and techniques he employed: "Oils used in painting the Bargain picture — in the dead colouring I painted the sky with mastic varnish and turpentine mixed together. In the board fence and crib I used magilp. In the roof of the shed I used nut oil. Fore ground and interior of the shed I painted with magilp, the horse finished with nut oil. The farmers finished with mastic varnish and turpentine mixed together." Unsigned and undated note, Mount Papers, NYHS.

224. The fictional account appeared in the *New York Weekly Universe* (August 4, 1849), cited in Frankenstein 1975, p. 200. For a refutation of the story, see Cummings 1865, pp. 140–41. For Mount's actual fee, see "Catalogue of Portraits and Pictures Painted by William Sidney Mount," under "Year 1925," cited in Frankenstein 1975, p. 469.

225. Luman Reed to William Sidney Mount, Sept. 24, 1835, Mount Papers.

226. Edward P. Buffet, "William Sidney Mount: A Biography," *Port Jefferson Times,* Dec. 1, 1923–June 12, 1924, Chapter 11, p. 16.

227. "The late Luman Reed (his name is pleasant to remember) offered to build me a studio in his house and was also anxious to send me to Europe at his own expense." William Sidney Mount, autobiographical fragment, "Year 1853," cited in Frankenstein 1975, p. 32.

228. "Farmers bargaining painted out of doors," Mount Diary, Nov. 14, 1852, cited in Frankenstein 1975, p. 249. Horatio Greenough to John Gorham Palfrey, Oct. 3, 1836, in Wright, ed., 1972, pp. 205–6.

229. Reed to Mount, Dec. 11, 1835, Mount Papers.

230. Thomas Jefferson, *Notes on the State of Virginia* (London: John Stockdale, 1787), p. 274.

231. Reed to Mount, Oct. 29, 1835, Mount Papers, and "A Leaf From the Journal of a Tourist," *New-York Gazette and General Advertiser,* Oct. 28, 1835, p. 2. For the origins of Jack Downing, see Taylor, ed., 1976, pp. 47–49.

232. Mount to Reed, Nov. 12, 1835, Mount Papers. When *Farmer's Bargaining* was exhibited at the New-York Gallery of the Fine Arts beginning in 1844, it was listed in the first and all subsequent catalogues (presumably with Mount's knowledge) with this quotation from the *New-York Gazette* article: "Seth suspended for a moment the whittling [of] his twig, and there seemed a crisis in the argument — a *silent pause* — when a shrill voice from the front gate adjourned the meeting instanter. It was the voice of Aunt Nabby herself, breathing authority and hospitality — Joshua, come to dinner, and bring the folks along with you. *Jack Downing's Journal — N.Y. Gazette,* Oct. 28, 1835." NYGFA 1844.

233. Taylor, ed., 1976, p. 47.

234. The stereotype of the wily horse trader was sufficiently current to appear in a children's encyclopedia in 1849. In a section entitled "The Horse Dealer's Bargain," the dealer employs the concept of a geometric progression to obtain an exorbitant price for his horse. *The Boy's Own Book; A Complete Encyclopedia of All the Diversions Athletic, Scientific, and Recreative of Boyhood and Youth*

(Boston: Munroe & Francis, 1849), p. 106.

235. *New York Herald,* May 17, 1836, p. 1. During his visit to Reed's gallery in the fall of 1836, Horatio Greenough noted that Mount had "a tact of hitting off yankee character." Horatio Greenough to John Gorham Palfrey, in Wright, ed., 1972, pp. 205–6.

236. Mount, autobiographical fragment, "Year 1853," and "Catalogue of Portraits and Pictures Painted by William Sidney Mount," under "Year 1854," cited in Frankenstein 1975, pp. 32, 473.

237. See Koke 1982, 2, pp. 399–402.

238. Mount's *Farmer's Bargaining* also apparently inspired Otis A. Bullard's *Trading Horses* (unlocated) which was exhibited at the National Academy of Design in 1847 and described by one critic as a "palpable and absurd imitation of Mount." *Literary World* 1 (May 1, 1847), p. 304.

239. William Sidney Mount, Diary, June 19, 1847, cited in Frankenstein 1975, p. 177. Mount noted: "when I painted the Bargaining and Undutiful Boys in 1835 . . . I was lame and had to use crutches . . . Confinement fixed my mind upon my work." Mount, Diary, June 14, 1853, cited in ibid., p. 267.

240. Luman Reed to William Sidney Mount, Sept. 24, 1835, Mount Papers.

241. Reed to Mount, Dec. 11, 1835, ibid.

242. "Farmers bargaining painted out of doors. Undutiful Boys — also." William Sidney Mount, Diary, Nov. 14, 1852, cited in Frankenstein 1975, p. 249.

243. Mount employed the same view in *Dancing on the Barn Floor* (Museums at Stony Brook, New York) of 1831. For a photograph of the barn see "William Sidney Mount: Painter Made Long Island his Italy," *Life Magazine* 18 (June 25, 1945), p. 64.

244. Mount to Reed, Dec. 4, 1835, Mount Papers.

245. Mount wrote that he was a "farmer boy" from 1814 to 1824. Mount, autobiographical fragment, cited in Frankenstein 1975, p. 16.

246. See Burns 1988, pp. 24–50.

247. *Broadway Journal* 1 (Feb. 15, 1845), p. 103.

248. Reed to George W. Flagg, letter postmarked Dec. 30, 1835, Asher B. Durand Papers.

249. Donald D. Keyes, "William Sidney Mount Reconsidered," *American Art Review* 4 (Aug. 1977), p. 120.

250. Mount, Diary, Dec. 23, 26, 1849, cited in Frankenstein 1975, p. 200.

251. Reed to Mount, Sept. 24, 1835, Mount Papers.

252. Reed also made his argument on technical grounds: "In my last I forgot to mention that I prefered [sic] you would not varnish the picture you are now painting for me if equally agreeable to you. what I fear is that it may crack as there is more body in the paint than in the varnish the former when dry will contract & by that means leave cracks in the picture." Reed to Mount, Nov. 25, 1835, Mount Papers.

253. Mount to Reed, Dec. 4, 1835, Mount Papers.

254. "If there was any thing that could have made my attachment to you any stronger it was that generous and prompt proposition of yours to make the alteration in the picture that I suggested, that willingness to gratify me in an alteration when the picture was good enough & perfectly satisfactory without. I assume you took fast hold of my good feelings. If the alteration when made does not please you, I hope you will restore it to its original state & send it back again. I consider this picture the very gem of my collection. I have taxed your generosity which I cannot pay, but your time I must make remuneration for. Please accept the enclosed." Reed to Mount, Dec. 26, 1835, Mount Papers.

255. "Undutiful Boys. . . . $220.00. For an improvement which I made afterwards in the above picture Mr. Reed generously sent me 50 dollars. I mentioned to him that I did not expect extra pay as I had done no more than my duty. 'Well,' he says, 'I am desirous of doing the same'—extra pay. Mr. Reed said he would like to hire me by the year." William Sidney Mount, "Catalogue of Portraits and Pictures Painted by William Sidney Mount," under "Year 1835," cited in Frankenstein 1975, p. 469.

256. There is only one extant letter that may offer a clue as to the nature of the change made by Mount: "I have rec'd your much esteemed favor of 7th Instant and also the Picture of the "Undutifull Boys," it is improved & I am delighted with it. I have now one live Man, four live Boys, the inside and outside of a Barn with the Barn door nearly swung back, & what is left for the imagination is really pleasing that the hens & chickens have all run under the Barn at the approach of the old man, & you may easily imagine them there, as the depth under the Barn cannot be seen." Reed to Mount, Jan. 11, 1836, Mount Papers.

257. Mount wrote: "It is a favorite picture of mine and I should like to see an engraving of it from the original, but I can not say I like the plan of following a pencil sketch or any off hand sketch in oil colours however well done." Mount to Edward L. Carey, Jan. 9, 1842, cited in Frankenstein 1975, pp. 76–77. At a meeting of the Sketch Club on December 29, 1842, Reed's former business partner Jonathan Sturges proposed that the Apollo Association publish an engraving of the Undutiful Boys, but the project never came to fruition. See Sturges to Mount, Dec. 30, 1842, cited in Frankenstein 1975, p. 99.

258. "Catalogue of Portraits and Pictures Painted by William Sidney Mount," under "Year 1843," cited in Frankenstein 1975, p. 470.

259. See The Gift: A Christmas and New Year's Present. MDCCCXLIV. (Philadelphia: Carey & Hart, 1844), pl. opp. p. 184, and pp. 184–85.

260. Reed Inventory 1836; Theodore Allen to Mary Reed Fuller, Feb. 17, 1844, Document 84, Reed Papers, supplement, and NYGFA 1844, p. 14, no. 55.

261. This attribution was made by Egbert Haverkamp-Begemann. For similar compositions by Adriaen Isenbrandt, see Max J. Friedlander, Early Netherlandish Painting: The Antwerp Mannerists; Adriaen Isenbrandt, tr. by Heinz Norden (14 vols., Leyden: A. W. Sijthoff; Brussels: La Connaissance, 1967–76), 11, nos. 190 and 190a.

262. Anna Wells Rutledge, "Robert Gilmor, Jr., Baltimore Collector," Journal of the Walters Art Gallery 12 (1949), pp. 21–22.

263. David Alan Brown, Raphael and America (Washington: National Gallery of Art, 1983), p. 28. Numerous works were sold as originals by Raphael and accompanied by glowing descriptions of their merits: "The Virgin and Child. — The colouring rich, and at the same time clear and transparent, and the figures full of sweetness and dignity. The expression is very fine and light, extremely well managed, and the whole of a beautiful effect, painted by Raphael, who was born at Urbino, 1483, died 1520." See Blake & Cunningham, Gallery of Paintings. Descriptive Catalogue of Original Cabinet Paintings; Being a Truly Splendid and Valuable Collection, Selected With Great Care and Expense From the Various Cabinets of Rome, Naples, Florence, Amsterdam, Paris and London. Comprising the Works of the Great Masters, From the 14th Century to the Present Time. The Whole in Elegant Frames. This Collection of Paintings, Will be Sold at Auction, on Thursday, December 28th, 1820, at 10 o'clock, a.m. (Boston: W. W. Clapp, 1820), p. 10, no. 77.

264. Jared Bradley Flagg, The Life and Letters of Washington Allston (New York: Charles Scribner's Sons, 1892), p. 59.

265. Luman Reed to William Sidney Mount, Oct. 29, 1835, Mount Papers.

266. For the contents of Reed's library, see the Reed Inventory 1836. The folio of Raphael's Hours and the prints after Raphael's Vatican frescoes are in the New-York Historical Society collections. For a partial list of the prints, see NYGFA 1844, pp. 17–20, nos. 89–107.

267. Eric Jan Sluijter, De "Heydensche Fabulen" in de Noordnederlandse Schilderkunst circa 1590–1670 (The Hague: Eric Jan Sluijter, 1986), pp. 585–86.

268. Ibid., p. 576.

269. See Walter L. Strauss, ed., Hendrik Goltzius 1558–1617: The Complete Engravings and Woodcuts (2 vols., New York: Abaris Books, 1977), pp. 504–5, no. 285.

270. See NYGFA 1844, p. 8, no. 13. The attribution to a follower of van Balen is by Egbert Haverkamp-Begemann. David Freedberg has suggested an attribution to Otto van Veen. A similar composition is found in Hendrick de Clerck II's The Contest Between Apollo and Marsyas (Rijksmuseum, Amsterdam). See Pieter J. J. van Theil et al., All the Paintings of the Rijksmuseum in Amsterdam: A Completely Illustrated Catalogue (Amsterdam: Rijksmuseum; Maarssen: Gary Schwartz, 1976), p. 169, no. A621.

271. Ovid, Metamorphoses, tr. by Frank Justus Miller (2 vols., Cambridge, Mass.: Harvard University Press; London: William Heinemann, 1976), 2, pp. 130–33.

272. These alterations were revealed during the conservation of the painting by Richard Gallerani at the New-York Historical Society.

273. David Freedberg, "The Origins and Rise of the Flemish Madonnas in Flower Garlands: Decoration and Devotion," *Münchner Jahrbuch der Bildenden Kunst* 32 (1981), pp. 118, 122, 125–26, 128.

274. See, for example, Danielsz's *Garland of Flowers with the Holy Family and Two Angels* (Lorenzelli Gallery, Bergamo) and Francken's *Wreath of Flowers Around a Medallion of the Virgin and Child in a Landscape* (De Meulemeester Collection, Brussels), reproduced in Marie-Louise Hairs, *The Flemish Flower Painters of the XVIIth Century* (Brussels: Lefebvre & Gillet, 1985), pls. 79, 81. For Danielsz's biography, see pp. 253–58.

275. Freedberg 1981, p. 123. On p. 126, he notes that in the early seventeenth century some flower paintings had a higher monetary value than many religous paintings: "In a very real way, therefore, the flower garlands surrounding the images of the Madonna added enormously to their value."

276. Ibid., pp. 131–32.

277. For the identification of these flowers I am indebted to Dr. Rupert Barneby of the New York Botanical Garden.

278. Sam Segal, *A Flowery Past: A Survey of Dutch and Flemish Flower Painting from 1600 until the Present* (Amsterdam: Gallery P. de Boer, 1982), pp. 4–5, 46, 97.

279. Sam Segal, *A Fruitful Past: A Survey of the Fruit Still Lifes of the Northern and Southern Netherlands from Brueghel till Van Gogh* (Amsterdam: Gallery P. de Boer, 1983), p. 40.

280. See NYGFA 1844, p. 8, no. 9. This attribution was made by Egbert Haverkamp-Begemann.

281. For a brief account of Fyt and his followers, see Edith Greindl, *Les peintres flamands de nature morte au XVII ͤ siècle* (Brussels: Elsevier, 1956), pp. 75–96, and "Jan Fyt, peintre de fleurs," in *Miscellanea Leo van Puyvelde* (Brussels: Editions de la Connaissance, 1949), pp. 163–65.

282. See *Katalog der ausgestellten Gemälde des 13.–18. Jahrhunderts* (Berlin: Gemäldegalerie, 1975), p. 160.

283. According to Greindl 1956, p. 76, Fyt often introduced cats into his compositions.

284. See, for example, Fyt's *Dead Game with Weasels* (Detroit Institute of Arts) and the nearly identical *Dead Game with a Cat* (private collection, Belgium), reproduced in Scott A. Sullivan, "Frans Snyders: Still Life With Fruit, Vegetables and Dead Game," *Bulletin of the Detroit Institute of Arts* 59 (Spring 1981), pp. 36–37. The attribution to a follower of Fyt was made by Egbert Haverkamp-Begemann.

285. See Mabel Munson Swan, *The Athenaeum Gallery 1827–1873: The Boston Athenaeum as an Early Patron of Art* (Boston: Boston Athenaeum, 1940), pp. 95–98; *Catalogue of the Seventh Exhibition of Paintings in the Athenaeum Gallery* (Boston: John H. Eastburn, 1833), pp. 13, 17; and *Knickerbocker* 5 (May 1835), pp. 465–68. The Athenaeum catalogue for 1833 lists Fyt's *Dogs and Game* (no. 24, 58 × 47″) and *Dogs and Hares* (no. 31, 62 × 45″). Reed's canvas formerly measured 63¾ × 49⅞″ and currently measures 60¾ × 49⅞″ after the removal, during conservation, of an added piece of canvas 3 × 49⅞ in.

286. *To Be Sold at Auction, Park Place House, No. 239 Broadway, on Friday the 8th of June, 1832, at ¼ Before 10 O'clock, A. M., Wm. A. Colman's Collection of About 300 Superior Oil Paintings, All of Which are Framed* (New York: Sleight & Robinson, 1832), p. 6, no. 33.

287. Luman Reed to George W. Flagg, Mar. 9, 1835, Asher B. Durand Papers.

288. Reed Inventory 1836.

289. See NYGFA 1844, p. 7, no. 3. The attribution to a northern artist was made by Egbert Haverkamp-Begemann.

290. Christopher Brown, *Scenes of Everyday Life: Dutch Genre Painting of the Seventeenth Century* (London: Faber & Faber, 1984), p. 43.

291. See NYGFA 1844, p. 10, no. 27. This attribution was provided by J. A. Bosmans, Curator of Painting and Sculpture at the Fries Museum in Leeuwarden, the Netherlands. Related works are illustrated in Abraham Wassenbergh, *De portretkunst in Friesland in de zeventiende eeuw* (Lochem: de Tijdstroom, 1967).

292. NYGFA 1844, p. 11, no. 35. See Gertrude Borghero, ed. *Thyssen-Bornemisza Collection: Catalogue Raisonné of the Exhibited Works of Art* (printed for Collection Thyssen-Bornemisza, Lugano, by Electa, Milan, 1986), p. 162. There are variants of Kalf's painting in the Gotesborgs Konstmuseum in Sweden, and in the Bank voor Handel en Scheepvart in Rotterdam. See Lucius Grisebach, *Willem Kalf, 1619–1693* (West Berlin: Gebr. Mann Verlag, 1974), pp. 266–67, and pl. 128.

293. For an account of Kalf and his followers, see Ingvar Bergstrom, *Dutch Still-Life Painting in the Seventeenth Century*, tr. by Christina Hedstrom and Gerald Taylor (London: Faber & Faber, 1956), pp. 260–90.

294. For a discussion of the influence of Vermeer and Rembrandt upon Kalf, see ibid., pp. 279–82.

295. The attribution of this work to a follower of Kalf was made by Dr. Walter A. Liedtke, Curator of Dutch and Flemish Painting at the Metropolitan Museum of Art, and Egbert Haverkamp-Begemann. Dr. Lucius Grisebach, chief curator of the Nationalgalerie, West Berlin, and author of the monograph on Kalf cited above, thinks that the painting owned by Reed may be a later copy.

296. Sam Segal, *A Prosperous Past: The Sumptuous Still Life in the Netherlands, 1600–1700* (The Hague: S.D.U. Publishers, 1988), pp. 180–96. Segal, p. 33, writes of "pronk" still-life symbolism: "The lesson to be drawn from these works, even when they are vanitas still lifes, is that one has to make a *choice* in life. This can be a choice between earthly and heavenly, material and spiritual, or transient and eternal values, between lack of freedom and redemption, between vice and virtue. At the root of choice is the biblical story (Genesis 3) in which Eve tempts Adam in Paradise to eat the forbidden fruit of the Tree of Knowledge of Good and Evil."

297. *Masterworks of the Gemäldegalerie* 1985, pp. 262–63. For the vanitas connotation of citrus fruit, see Segal 1983, pp. 35–36.

298. Borghero, ed., 1986, p. 162.

299. Segal 1983, pp. 35–36, notes that only in the second half of the seventeenth century were some citrus fruits cultivated in orangeries in Holland. For seashells as a collectors' commodity, see ibid., p. 55.

300. Thomas R. Hofland, "The Fine Arts in the United States, With a Sketch of Their Present and Past

History in Europe," *Knickerbocker* 14 (July 1839), p. 42.

301. Luman Reed to George W. Flagg, March 9, 1835, Asher B. Durand Papers, NYPL.

302. *Catalogue of the Gallery of Art of the New-York Historical Society* (New York: New-York Historical Society, 1915), p. 6, no. 24.

303. This attribution was made by Egbert Haverkamp-Begemann. For Roelof Pietersz, see Emmanuel Benezit, *Dictionnaire critique et documentaire des Peintres, Sculpteurs, Dessinateurs et Graveurs* . . . (8 vols., Paris: Librairie Grund, 1966), 6, p. 676.

304. The globe and hourglass on the table at the right and the fish suspended from the ceiling, for example, appear to be derived from David Teniers the Younger's *The Alchemist* (Herzog Anton Ulrich Museum, Braunschweig). Jane P. Davidson, *David Teniers the Younger* (Boulder, Col.: Westview Press, 1979), pp. 33, 97.

305. The artist and dealer William Harris Jones, for example, went to Amsterdam in 1834 with a team of ten to fifteen artists in an effort to obtain copies of famous Dutch pictures and then exhibit them in America. His request was initially hindered by the director of the Rijksmuseum, who noted that copies of these works could be purchased from Dutch artists. See Henry Nichols Blake Clark, "The Impact of Seventeenth-Century Dutch and Flemish Genre Painting on American Genre Painting, 1800–1865," Ph. D. diss., University of Delaware, 1982, pp. 173–74.

306. Thomas R. Hofland, "The Fine Arts in the United States, with a Sketch of Their Present and Past History in Europe," *Knickerbocker* 14 (July 1839), p. 42.

307. Luman Reed to William Sidney Mount, July 25, 1835, Mount Papers.

308. Christopher Brown, *Scenes of Everyday Life: Dutch Genre Painting of the Seventeenth Century* (London: Faber & Faber, 1984), p. 94.

309. Sturges 1894, pp. 166–67.

310. Segal 1982, pp. 36, 40, and Segal 1983, p. 57.

311. See Freedberg 1981, pp. 115–50.

312. For a comparable portrait within a flower wreath, see *Prince William of Orange* (Palais Saint-Pierre, Lyon) by Marrell's teacher de Heem, reproduced in Bergstrom 1956, pp. 207–10.

313. This information was provided by Egbert Haverkamp-Bergman.

314. For a short biography, see Warren E. Preece, ed., *The New Encyclopaedia Britannica* (30 vols., Chicago: Helen Hemingway Benton, 1974), s.v. Leopold I.

315. Heraldic information was provided by Istvan Deák, Professor of History, Institute on East Central Europe, Columbia University.

316. Segal 1982, p. 44, notes that the crown imperial sold for the equivalent of one year's income in the late sixteenth and early seventeenth centuries.

317. In his book *Musaeum* (1625), Federigo Borromeo, the archbishop of Milan, observed this phenomenon in a flower garland painting in his own collection: "There is no point in saying anything about the image enclosed in the garland, for like a lesser light it is outshone by all the splendours surrounding it." Freedberg 1981, pp. 120–21.

318. For the identification of these flowers I am indebted to Dr. Rupert Barneby of the New York Botanical Garden.

319. See Tom Lodewijk, *The Book of Tulips* (New York: Vendome Press, 1979), pp. 42–58, and Wilfrid Blunt, *Tulips and Tulipomania* (London: Basilisk Press, 1977), pp. 22–32.

320. George Murray, "Notice of the Fourth Annual Exhibition in the Academy of the Fine Arts," *Portfolio* 3 (June 1814), p. 569.

321. Reed Inventory 1836.

322. See manuscript biography by "B" [George Barker], p. 48, Reed Papers.

323. The identification of these enamels as German was made by Clare LeCorbeiller, Associate Curator, European Sculpture and Decorative Arts, Metropolitan Museum of Art.

324. Five enamels are mounted on the lid of the jewel casket (Metropolitan accession no. 64.101.405), and two on each of the four sides. The central enamel on the lid is by a different artist. See Yvonne Hackenbroch, *Meissen and Other Continental Porcelain, Faience, and Enamel in the Irwin Untermyer Collection* (Cambridge, Mass.: Harvard University Press, 1961), p. 252, and fig. 240, pl. 158.

325. For documentation of some of Theodore Allen's purchases during his European trip of 1836, see Theodore Allen to Luman Reed, c. Jan.–Aug., 1836, Document 143, Reed Papers, supplement.

326. Cecil Gould, *The Paintings of Correggio* (Ithaca, N.Y.: Cornell University Press, 1976), pp. 93–94, 279–80.

327. Diane Degrazia and Eugenio Riccomini, *Correggio and His Legacy: Sixteenth-Century Emilian Drawings* (Washington, D.C.: National Gallery of Art, 1984), pp. 34–35, 62.

328. Gould 1976, pp. 21, 93–94; Degrazia and Riccomini 1984, pp. 31–32, 45, 49.

329. Joshua Reynolds, *Sir Joshua Reynolds: Discourses on Art*, ed. Robert R. Wark (New Haven: Yale University Press, 1975), p. 81. Reed may have known this quote; for his library contained a copy of "Sir Joshua Reynolds's works." See Reed Inventory 1836.

330. Gould 1976, pp. 93–94.

331. See "Correggio: A Tragedy by Adam Oehlenschlager," tr. by Theodore Martin in the *Crayon* 2 (Oct. 17, 24, 31, Nov. 7, 14, 21, 28, Dec. 5, 12, 19, 1855), pp. 242–43, 257–59, 273–75, 287–89, 307–9, 325–27, 339–41, 355–57, 372–74, 383–84.

332. Daniel Huntington, "Sketches of the Old Masters," ibid. 1 (Feb. 21, 1855), pp. 113–16.

333. Thomas Sully to William Dunlap, May 1830, in Dunlap 1834, 2, pp. 139–40. See also *A Catalogue of Italian, Flemish, Spanish, Dutch, French, and English Pictures; Which Have Been Collected in Europe and Brought to This Country by Mr. Richard Abraham of New Bond Street, London, And Are Now Exhibiting at the American Academy of the Fine Arts* (New York: Christian Brown, 1830), p. 19, no. 12, *A Magdalene Reading*, attributed to Lodovico Carracci.

334. Howard Hibbard, "The Date of the Aldobrandini Lunettes," *Burlington Magazine* 106 (April 1964), pp. 183–84.

335. Donald Posner, *Annibale Carracci: A Study in the Reform of Italian Painting Around 1590* (2 vols., New York: Phaidon Publishers, 1971), 2, pp. 60, 66–68, pls. 145–50.

336. Dunlap 1834, 2, p. 388.

337. Sturges 1894, pp. 158–59.

338. George Dawe, *The Life of George Morland* (London: Dickinson's, 1904), p. xx.

339. William Collins, *Memoirs of a Painter: Being a*

Genuine Biographical Sketch of That Celebrated Original and Eccentric Genius, The Late Mr. George Morland . . . (London: C. Stower, 1805), p. 54. For Morland's exhibition record at the Royal Academy, see Algernon Graves, *The Royal Academy of Arts: A Complete Dictionary of Contributors and Their Work From Its Foundation in 1769 to 1904* (London: Henry Graves & Co. Ltd. and George Bell & Sons, 1906), pp. 294–95.

340. Some of Morland's early copies after Dutch and Flemish paintings were later sold as originals. See Collins 1805, pp. 9–11, 14–15.

341. See John Barrell, *The Dark Side of the Landscape: The Rural Poor in English Painting 1730–1840* (New York: Cambridge University Press, 1980).

342. John Hassell, *Memoirs of the Life of George Morland; With Critical and Descriptive Observations on the Whole of His Works Hitherto Before the Public* (London: Albion Press Ltd., 1806), p. 57.

343. Dawe 1904, p. 58. Morland's reputation as a painter of dogs reached America, where a critic observed of an *Interior* by Morland exhibited in 1833: "the dogs painted as no one but Morland could have done." *American Monthly Magazine* 1 (August 1, 1833), p. 402.

344. Hassell 1806, p. 134.

345. Dawe 1904, p. 6.

346. Smith published Morland's *Fighting Dogs* as a

mezzotint in 1794. See George C. Williamson, *George Morland: His Life and Works* (London: George Bell & Sons, 1904), p. 95.

347. See Francis William Blagdon, *Authentic Memoirs of the Late George Morland, With Remarks on His Abilities and Progress as an Artist: In Which are Interspersed a Variety of Anecdotes Never Before Published; Together With a Fac-Simile of His Writing, Specimens of His Hieroglyphical Sketches, &c. &c. The Whole Collected From Numerous Manuscript Communications* (London: Barnard & Sultzer, 1806), pl. 22.

348. See NYGFA 1844, p. 16, no. 72; and the Reed Inventory 1836.

349. Hassell 1806, p. 87.

350. See Blagdon 1806, pls. 13, 33, and 39.

351. Hassell 1806, p. 125. Dawe 1904 (p. 120) recorded a *Landscape—Sportsman Shooting* in the London collection of Alexander Davidson.

352. See Dudley Snelgrove, *British Sporting and Animal Prints 1658–1874* (New Haven: Yale Center for British Art, 1981), pp. 121–22.

353. Hassell 1806, pp. 68, 166–67, and Dawe 1904, p. 151.

354. Information supplied by the National Gallery of Scotland.

355. Minutes, May 5, 1833, National Academy of Design, New York, and Minutes, Jan. 19, Feb. 3,

1832, Sketch Club Papers, Century Association, New York.

356. Cowdrey 1943, 2, pp. 96–98.

357. *American Monthly Magazine* 1 (July 1, 1833), p. 333.

358. Edward Wedlake Brayley and John Britton, *The Beauties of England and Wales; or, Delineations, Topographical, Historical, and Descriptive, of Each County. Embellished With Engravings* (25 vols., London: Vernor & Hood; Longman & Rees; Cuthell & Martin; J. & A. Arch; W. J. and J. Richardson; J. Harris; B. Crosby, 1803), 5, pp. 583–84.

359. Ibid., pp. 723–24.

360. Cowdrey 1943, 2, pp. 96–98.

361. See *Bridgeport Land Records,* 2, pp. 276, 341; 3, p. 378; and H.S.W., "Obituary [Daniel Thatcher]," *Bridgeport Evening Standard,* Oct. 31, 1867, p. 2.

362. See *Bridgeport Land Records,* 4, p. 623; and 10, p. 704. Also see Helen Harrison, "Lamont Mansion and Mills," and William W. Roberts, "Nativity's Cloisters Look Upon a Vanished Village," *Bridgeport Sunday Post,* July 19, 1925, p. 24, and Dec. 16, 1934, p. B5.

363. Charles Dickens, *American Notes for General Circulation* (New York: Harper & Brothers, 1842), pp. 26–29.

LUMAN REED: A FAMILY MEMOIR

1. This memoir has been donated to the New-York Historical Society.

2. These manuscript materials have been donated to the New-York Historical Society.

3. Ibid.

4. The information in this paragraph is drawn from Abijah Reed's recollections of his brother. See Abijah Reed to Theodore Allen, Feb. 26, 1844, Document 45, Reed Papers, supplement.

5. See p. 5 of the "B" [George Barker] manuscript biography of Reed, June 1884, Reed Papers.

6. Ibid., p. 7.

7. Ibid., p. 10.

8. Arthur C. M. Kelly, *Marriage Record of 1st and 2nd*

Reformed Churches of Coxsackie, New York 1797–1899 (Rhinebeck, N. Y.: Arthur C. M. Kelly, 1977), p. 7.

9. [Barker] 1884, p. 7.

10. Ibid., p. 26.

11. Ibid., p. 12.

12. For the close relationship between the Reed and Sturges families, see Sturges 1894, pp. 91, 120–21, 123, 125–27, 145, 155–73.

13. Ibid., p. 173.

14. [Barker] 1884, p. 31.

15. Ibid., p. 48.

16. Ibid., p. 31.

17. Ibid., p. 50.

18. Ibid., p. 51.

19. Sturges 1894, pp. 160, 173.

20. Catharine Reed's diary, May 26, 1831, Document 32, Reed Papers, supplement.

21. Ibid., Nov. 22, 1831, Document 1.

22. Luman Reed to Catharine Reed, dated Nov. 4 (actually Dec. 4), 1831, Document 24, Reed Papers, supplement.

23. Ibid.

24. Catharine Reed's, diary, Nov. 27, 1831, Document 1, Reed Papers, supplement.

25. Catharine Reed to Luman Reed, Dec. 11, 1831, Document 13, ibid.

26. See the list of persons present at the marriage of Theodore Allen to Catharine Reed, Jan. 21, 1834, Document 38, ibid.

27. See Theodore Allen to Luman Reed, c. spring of 1836, Document 143, ibid.

28. See Marshall B. Tymn, ed., *Thomas Cole's Poetry* (York, Pa.: Liberty Cap Books, 1972), pp. 81–86.

29. See the New York Marble Cemetery Records NYHS.

SELECT BIBLIOGRAPHY

COMPILED BY

TIMOTHY ANGLIN BURGARD

MANUSCRIPT MATERIAL

Adams Papers, Massachusetts Historical Society, Boston.

Bastedo, Russell. "Luman Reed (1786–1836), New York City Merchant and Patron of American Artists." Unpublished typescript, Reed Papers, The New-York Historical Society.

Thomas Cole Papers. Albany Institute of History and Art, Albany.

————. Archives of American Art, Washington, D.C.

————. Detroit Institute of Arts, Detroit.

————. New York State Library, Albany.

Columbia County Historical Society Archives, Kinderhook, New York.

Alexander Jackson Davis Papers. Department of Prints and Photographs, The Metropolitan Museum of Art, New York.

————. The New York Public Library.

Asher B. Durand Papers. The New York Public Library.

John Durand Papers. The New York Public Library.

Flagg, Charles Noël. "Talks With my Uncle George: Nantucket." Hartford, 1911. Typescript in the collection of Mr. Peter Flagg Maxson, Austin.

Robert Gilmor, Jr., Papers. Maryland Historical Society, Baltimore.

Grace Church Archives, New York.

Greene County Historical Society Archives, Catskill, New York.

Philip Hone Diary, 1828–1851. 28 vols. The New-York Historical Society.

Andrew Jackson Papers. Library of Congress, Washington, D.C.

William Sidney Mount Papers. Museums at Stony Brook, New York.

————. The New-York Historical Society.

William Sidney Mount. *Setauket Scrapbook.* Emma S. Clark Memorial Public Library, Setauket, New York.

National Academy of Design Minutes. National Academy of Design, New York.

New York Athenaeum Papers. The New-York Historical Society.

New York City Lyceum and Stuyvesant Institute Papers. The New-York Historical Society.

New-York Gallery of the Fine Arts *Agreement and Catalogue, 1858; Lectures, 1858,* bound together with the New-York Historical Society, *By-Laws; Report on Seth Grosvenor's Will.* The New-York Historical Society.

New-York Gallery of the Fine Arts Minutes, 1844–1858, and Subscriptions, 1844–1858. The New-York Historical Society.

New-York Marble Cemetery Papers. The New-York Historical Society.

Nord, Barbara K. "George Whiting Flagg (1816–1897)." Unpublished typescript, Manuscripts Division, The New-York Historical Society.

Pinchot, Mary Jane Eno. "Recollections of Mary Eno Pinchot," Gifford Pinchot Papers, series IV, container 41. Library of Congress, Washington, D.C.

Luman Reed Inventory. Joseph Downs Collection of Manuscripts and Printed Ephemera, Henry Francis du Pont Winterthur Museum Library, Winterthur, Delaware.

Luman Reed Papers. The New-York Historical Society.

Sketch Club Papers. Century Association, New York.

Samuel Ward Papers. The New York Public Library.

PUBLISHED MATERIAL

———

"The American Merchant. In Two Parts." *Knickerbocker* 14 (July 1839): 1–15 and (August 1839): 112–21.

"Auction Sales." *New York Evening Post*, Feb. 8, 1844, p. 3.

Baekland, Frederick. "Collectors of American Painting, 1813–1913." *American Art Review* 3 (Nov.–Dec. 1976): 120–66.

Barck, Dorothy C., ed. *Diary of William Dunlap (1766–1839): The Memoirs of a Dramatist, Theatrical Manager, Painter, Critic, Novelist, and Historian.* 3 vols., New York: The New-York Historical Society, 1930.

Barrett, Walter, Clerk [pseud. of Joseph A. Scoville]. *The Old Merchants of New York City.* 5 vols., New York: Carleton, 1863–1870.

Beach, Moses Yale. *Wealth and Biography of the Wealthy Citizens of New York City.* New York: New York Sun, 1845.

Beecher, Raymond. "Luman Reed—He Made American Artists the Fashion." *Quarterly Journal* [Greene County Historical Society] 2 (Summer 1978): 1, 5–6, 8.

———. *Out to Greenville and Beyond: Historical Sketches of Greene County.* Cornwallville, New York: Hope Farm Press, 1977.

———. "Roswell Reed's 'Speculative Opportunities.'" *Greene County Historical Journal* 9 (Spring 1985): 1–5.

J. B. Beers and Co. *History of Greene County, New York, With Biographical Sketches of Its Prominent Men.* New York: J. B. Beers & Co., 1884.

Berman, Eleanor Davidson. *Thomas Jefferson Among the Arts: An Essay in Early American Esthetics.* New York: Philosophical Library, 1947.

Blake & Cunningham, Auctioneers, Catalogue. *Gallery of Paintings. Descriptive Catalogue of Original Cabinet Paintings; being a truly Splendid and Valuable Collection, selected with great care and expense from the various cabinets of Rome, Naples, Florence, Amsterdam, Paris, and London. Compromising the works of the Great Masters, from the 14th Century to the Present Times. The Whole in Elegant Frames.* Boston: 1820.

Boston Athenaeum. *A Climate for Art: The History of the Boston Athenaeum Gallery, 1827–1873.* Boston: Boston Athenaeum, 1980.

"Brown's Studio." *Bulletin of the American Art Union* 2 (April 1849): 17–20.

Bryant, William Cullen. *A Funeral Oration, Occasioned by the Death of Thomas Cole, Delivered Before the National Academy of Design, New York, May 4, 1848.* New York: D. Appleton & Co., 1848.

Buckingham, James Silk, Esq. *America, Historical, Statistic and Descriptive.* 3 vols., London and Paris: Fisher, Son & Co., 1841.

Buffet, Edward P. "William Sidney Mount, A Biography," *Port Jefferson [New York] Times* (Dec. 1, 1923–June 12, 1924). Newspaper clippings, Library, The New-York Historical Society.

C., E. "The Fine Arts, Versus The Spirit of the Age." *American Monthly Magazine* 4 (Jan. 1, 1835): 242–47.

Callow, James T. "American Art in the Collection of Charles M. Leupp." *Antiques* 118 (Nov. 1980): 998–1009.

———. *Kindred Spirits: Knickerbocker Writers and American Artists, 1807–1855.* Chapel Hill: University of North Carolina Press, 1967.

Cary, Thomas Greaves. *The Dependence of the Fine Arts for Encouragement, in a Republic, on the Security of Property; With an Enquiry into the Causes of Frequent Failure Among Men of Business: An Address Delivered Before the Boston Mercantile Library Association.* Boston: Charles C. Little & James Brown, 1845.

Cassedy, David, and Gail Shrott. *William Sidney Mount: Annotated Bibliography and Listings of Archival Holdings of the Museums at Stony Brook.* Stony Brook, New York: Museums at Stony Brook, 1983.

Catalogue of the Art Exhibition at the Metropolitan Fair, in Aid of the U.S. Sanitary Commission. New York: J. F. Trow, 1864.

Catalogue of the Exhibition of the New-York Gallery of the Fine Arts. New York: James van Norden & Co., 1844.

———. New York: E. B. Clayton & Sons, 1845.

———. New York: E. B. Clayton & Sons, 1846.

———. New York: E. B. Clayton & Sons, 1848.

———. New York: E. B. Clayton & Sons, 1850.

Catalogue of the Gallery of Art of the New-York Historical Society. New York: Printed for the Society, 1915.

Catalogue of Italian, Flemish, Spanish, Dutch, French, and English Pictures; Which Have Been Collected in Europe and Brought to This Country by Mr. Richard Abraham, of New Bond Street, London, and are Now Exhibiting at the American Academy of Fine Arts. New York: Christian Brown, 1830.

Catalogue of the Library of the Late Robert Gilmor. Baltimore: Joseph Robinson, 1849.

Catalogue of M. Paff's Gallery of Paintings. New York: 1812.

Catalogue of the Museum and Gallery of Art of the New-York Historical Society. New York: The New-York Historical Society, 1862.

Catalogue of Paintings, by the Great Masters, including Specimens of the First Class, of the Italian, Venetian, Spanish, Flemish, Dutch, French, and English Schools. Boston: John H. Eastburn, 1833.

Catalogue of Paintings; by the Most Eminent Flemish, Dutch, and Italian Masters. New York: J. C. Spear, 1826.

Catalogue of the Paintings in the Wadsworth Gallery, Hartford. Hartford: E. Gleason, 1849.

Chadwick, George Halcott, and Mrs. Jessie van Vechten Vedder, eds. *The "Old Times" Corner, First Series, 1929–1930.* Catskill, New York: Greene County Historical Society, 1932.

Chamber of Commerce of the State of New York. *Catalogue of Portraits in the Chamber of Commerce of the State of New York, with Foreword, Biographical Sketches and List of Artists.* New York: Chamber of Commerce of the State of New York, 1924.

Clark, Delber W., comp. *Ye Olden Time, as Compiled from the Coxsackie News of 1889, Written by Robert Henry van Bergen.* Coxsackie, New York: Francis A. Hallenbeck, 1935.

Clarke, Eliot Candle. *History of the National Academy of Design, 1825–1953.* New York: Columbia University Press, 1954.

Cohn, Marjorie B. *Francis Calley Gray and Art Collecting for America.* Cambridge, Massachusetts: Harvard University Press, 1986.

Cole, Thomas. "Essay on American Scenery." *American Monthly Magazine,* n. s. 1 (Jan. 1836): 1–12.

———. *Now Exhibiting at the National Academy, Clinton Hall, Cole's Pictures of the Course of Empire.* New York: 1836.

———. *The Collected Essays and Prose Sketches.* Mar-

shall B. Tymn, ed. St. Paul, Minnesota: John Colet Press, 1980.

———. *Thomas Cole's Poetry: The Collected Poems of America's Foremost Painter of the Hudson River School Reflecting His Feelings For Nature and the Romantic Spirit of the Nineteenth Century.* Marshall B. Tymn, ed. York, Pennsylvania: Liberty Cap Books, 1972.

Constable, William George. *Art Collecting in the United States of America, An Outline of a History.* London: Thomas Nelson & Sons, 1963.

Cowdrey, Mary Bartlett, ed. *American Academy of Fine Arts and American Art Union, 1816–1852.* 2 vols., New York: The New-York Historical Society, 1953.

———. *National Academy of Design Exhibition Record, 1826–1860.* 2 vols. New York: The New-York Historical Society, 1943.

Craven, Wayne. "Luman Reed, Patron: His Collection and Gallery." *American Art Journal* 12 (Spring 1980): 40–59.

Cummings, Thomas Seir. *Historic Annals of the National Academy of Design, New York Drawing Association, Etc., with Occasional Dotings by the Way-Side from 1825 to the Present Time.* Philadelphia: George W. Childs, 1865.

"Death of Luman Reed Esq." *New-York Spectator* 39 (June 19, 1836): 1.

Degraw, John W. "Early New York. Further Recollections of an Old Merchant—Religious Controversies and Social Customs." One of a series of articles entitled "Recollections of Early New York" that appeared in the *New York Evening Post* in 1882. A bound volume of this series is in the Library of the New-York Historical Society.

Deutsch, Barbara Novak. "Cole and Durand: Criticism and Patronage (A Study of American Taste in Landscape, 1825–1865)." Ph.D. diss., Radcliffe College, 1957.

Dickson, Harold Edward, ed. *Observations on American Art: Selections From the Writings of John Neal (1793–1876).* State College, Pennsylvania: Pennsylvania State College, 1943.

Downs, Arthur Channing, Jr. "Clues and Footnotes: Luman Reed's Innovative Art Gallery." *Antiques* 112 (July 1977): 134.

Dunlap, William. *The History of the Rise and Progress of the Arts of Design in the United States.* 2 vols., New York: George P. Scott & Co., 1834.

Durand, John. "Souvenirs of Hackett the Actor." *Galaxy* 14 (Oct. 1872): 550–56.

———. *The Life and Times of A. B. Durand.* New York: Charles Scribner's Sons, 1894.

"Exhibition of Paintings, Collected in Spain by the Late Richard W. Meade, Esq., During the Revolution in that Country." *New-York Mirror* 9 (Sept. 17, 1831): 86–87.

Exhibition of the Paintings of the Late Thomas Cole, at the Gallery of the American Art-Union. Exhib. cat. New York: Snowden & Prall, 1848.

"Fine Arts." *[New York] Evening Star, for the Country,* March 4, 1836, p. 2.

"The Fine Arts. National Academy of Design. Concluded." *New-York Mirror* 13 (June 25, 1836): 414.

"The Fine Arts. The National Gallery at the Rotunda." *Broadway Journal* 2 (Sept. 13, 1845): 153–54.

"The Fine Arts. The Pencil. Private Galleries." *New-York Mirror* 17 (March 7, 1840): 294.

George W. Flagg Obituary. *Nantucket [Massachusetts] Inquirer and Mirror,* Jan. 9, 1897, p. 5.

Flagg, Jared Bradley. *The Life and Letters of Washington Allston.* New York: Charles Scribner's Sons, 1892.

Frankenstein, Alfred. *William Sidney Mount.* New York: Harry N. Abrams, Inc., 1975.

French, Henry Willard. *Art and Artists in Connecticut.* Boston: Lee & Shepard; New York: Charles T. Dillingham, 1879.

Fries, Waldemar H. *The Double Elephant Folio: The Story of Audubon's Birds of America.* Chicago: American Library Association, 1973.

"The Gallery of the Fine Arts." *New York Evening Post,* Feb. 11, 1845, p. 2.

Gerdts, Abigail Booth. "Newly Discovered Records of the New-York Gallery of the Fine Arts." *Archives of American Art Journal* 21 (no. 4): 2–9.

Gerdts, William H., and Theodore E. Stebbins, Jr., *"A Man of Genius": The Art of Washington Allston (1779–1843).* Exhib. cat. Boston: Museum of Fine Arts; Charlottesville, University Press of Virginia, 1979.

Gerdts, William H., and Mark Thistlethwaite. *Grand Illusions: History Painting in America.* Exhib. cat. Fort Worth: Amon Carter Museum, 1988.

Gilmor, Robert, Jr. *Memoir, or Sketch of the History of Robert Gilmor of Baltimore.* Baltimore: privately printed, 1840.

Gottesman, Rita Susswein. *The Arts and Crafts in New York, 1726–1776: Advertisements and News Items From New York City Newspapers.* New York: The New-York Historical Society, 1938.

———. *The Arts And Crafts in New York, 1777–1799: Advertisements and News Items From New York City Newspapers.* New York: The New-York Historical Society, 1954.

———. "New York's First Major Art Show, as Reviewed by Its First Newspaper Critic." *New-York Historical Society Quarterly* 43 (July 1959): 289–305.

Groce, George C. and David H. Wallace. *The New-York Historical Society's Dictionary of Artists in America, 1564–1860.* New Haven: Yale University Press, 1957.

Haberly, Lloyd. "The American Museum from Baker to Barnum." *New-York Historical Society Quarterly* 43 (July 1959): 272–87.

Hellman, George S. *Notes on Some Original Drawings of the Old Masters . . . for a Portfolio of seventy-two reproductions of drawings selected from the Collection formed in 1811 by Joseph Green Cogswell and now in the Possession of Mortimer L. Schiff.* New York: privately printed, 1915.

Heymsfeld, Ralph Taft. "The New-York Athenaeum." *New-York Historical Society Quarterly Bulletin* 11 (April 1927): 3–16.

Hofland, Thomas R. "The Fine Arts in the United States, With a Sketch of Their Present and Past History in Europe." *Knickerbocker* 14 (July 1839): 39–52.

Howe, Winifred E. *A History of the Metropolitan Museum of Art, with a Chapter on the Early Institutions of Art in New York.* New York: The Metropolitan Museum of Art, 1913.

Hunt, Freeman. "Art X.—The Merchant Patron of the Fine Arts." *[Hunt's] Merchant Magazine and Commercial Review* 15 (July 1846): 80–81.

———. *Worth and Wealth: A Collection of Maxims, Morals and Miscellanies for Merchants and Men of Business.* New York: Stringer & Townsend, 1856.

Huntington, Daniel. *Asher B. Durand: A Memorial Address.* New York: Century Association, 1887.

"The Ideal of a Merchant. Lecture of Dr. William Adams Before the Historical Society." *New York*

Herald, Jan. 27, 1858, p. 3.

Inventory of Paintings, Medals, Statuary, etc. The Property of the Late Philip Hone to be Sold at Auction . . . by E. H. Ludlow on Wednesday, April 25, 1852. New York: P. Miller & Son, 1852.

Johnson, Allen, Dumas Malone et al., eds. *Dictionary of American Biography.* 22 vols., New York: Charles Scribner's Sons, 1928–1958.

Kallen, H. M. "The Arts and Thomas Jefferson." *Ethics* 53 (July 1943): 269–83.

Kelly, Arthur C. M. *Marriage Record of the 1st and 2nd Reformed Churches of Coxsackie, New York 1797–1899.* Rhinebeck, New York: Arthur C. M. Kelly, 1977.

Kershaw, Gordon E., and R. Peter Mooz. *James Bowdoin: Patriot and Man of the Enlightenment.* Brunswick, Maine: Bowdoin College Museum of Art, 1976.

Klitzke, Theodore E. "Alexis de Tocqueville and the Arts in America." In *Festschrift Ulrich Middeldorf,* ed. by Antje Kosegarten and Peter Tigler. 2 vols., Berlin: De Gruyter, 1968, pp. 553–58.

Koke, Richard J. et al. *American Landscape and Genre Paintings in the New-York Historical Society; A Catalogue of the Collection, Including Historical, Narrative, and Marine Art.* 3 vols., New York: The New-York Historical Society, in association with G. K. Hall & Co., Boston, 1982.

Lancour, Harold. "American Art Auction Catalogues, 1785–1942: A Union List." *Bulletin of the New York Public Library* 47 (Jan. 1943): 3–31.

Lawall, David B. *Asher B. Durand: A Documentary Catalogue of the Narrative and Landscape Paintings.* New York and London: Garland Publishing, 1978.

———. *Asher Brown Durand: His Art and Art Theory in Relation to His Times.* Ph. D. diss., Princeton University, 1966.

Henry H. Leeds & Miner, Auctioneers, Catalogue. *Executor's Sale of Four Private Collections of Fine Ancient and Modern Pictures, By Order of the Executor's of the late Mr. Nicholas Dean, Mr. Wm. E. Lawrence, Mr. S. L. Waldo, Mr. John LaFarge, Also the Pictures of the Late J. McLenan . . . to Be Sold at Auction by Henry H. Leeds & Miner, at the "Old Dusseldorf Gallery," No. 548 Broadway on the Evenings of Wednesday, Jan. 31 and Thursday,* Feb. 1, 1866. . . . New York: 1866.

Lester, Charles Edward. *The Artist, the Merchant and the Statesman of the Age of the Medici, and of Our Own Times.* 2 vols., New York: Paine & Burgess, 1845.

A. Levy Auctioneer. *Catalogue of the Extensive and Valuable Collection of Pictures, Engravings, and Works of Art . . . Collected by Michael Paff, Esq., of this city dec'd.* New York: Vinten, 1838.

Lossing, Benson J. *History of New York City, Embracing an Outline Sketch of Events From 1609–1830, and a Full Account of Its Development From 1830–1884.* 2 vols., New York: Perine Engraving and Publishing Co., 1884.

"A Lover of the Fine Arts. For the Port Folio—The Fine Arts." *Port Folio* 5 (March 1811): 192–96.

Lynes, Russell. "Luman Reed, a New York Patron." *Apollo* 107 (Feb. 1978): 124–29.

McClung, Robert M. and Gale S. "Tammany's Remarkable Gardiner Baker: New York's First Museum Proprietor, Menagerie Keeper, and Promoter Extraordinary." *New-York Historical Society Quarterly* 42 (April 1958): 142–69.

McNulty, J. Bard, ed. *The Correspondence of Thomas Cole and Daniel Wadsworth: Letters in the Watkinson Library, Trinity College, Hartford, and in the New York State Library, Albany, New York.* Hartford: The Connecticut Historical Society, 1983.

Mann, Maybelle. "The New-York Gallery of Fine Arts: 'A Source of Refinement.'" *American Art Journal* 11 (Jan. 1979): 76–86.

Marckwardt, Albert H. "The Chronology and Personnel of the Bread and Cheese Club." *American Literature* 6 (Jan. 1935): 389–99.

Marlor, Clark S. *A History of the Brooklyn Art Association With an Index of Exhibitions.* New York: James F. Carr, 1970.

Meservey, Anne Farmer. "The Role of Art in American Life: Critics' Views of Native Art and Literature, 1830–1865." *American Art Journal* 10 (May 1978): 72–89.

Metropolitan Museum of Art, New York. *19th-Century America: Furniture and Other Decorative Arts.* New York: The Metropolitan Museum of Art, 1970.

Mifflin, J. Houston. "The Fine Arts in America, and Its Peculiar Incentives to their Cultivation." *Knickerbocker* 2 (July 1833): 30–35.

Miller, Lillian B. "Patronage, Patriotism and Taste in Mid-19th-Century America." *Magazine of Art* 45 (Nov. 1952): 322–28.

———. *Patrons and Patriotism: The Encouragement of the Fine Arts in the United States, 1790–1860.* Chicago: University of Chicago Press, 1966.

———, ed. *The Selected Papers of Charles Willson Peale and His Family.* Vol. 2, pts. 1, 2, *Charles Willson Peale: The Artist as Museum Keeper, 1791–1810.* New Haven: Yale University Press, 1988.

"National Academy of Design." *New York Evening Post,* June 10, 1836, p. 2, and June 11, 1836, p. 2.

National Cyclopedia of American Biography. 53 vols., New York, James T. White & Co., 1892–1971.

Naylor, Maria. *The National Academy of Design Exhibition Record, 1861–1900.* 2 vols., New York: Kennedy Galleries, 1973.

Nevins, Allan, ed. *The Diary of Philip Hone 1828–1851.* 2 vols., New York: Dodd, Mead & Co., 1927. Rev. ed., New York: Dodd, Mead & Co., 1936.

"The New York Gallery." *New York Evening Post,* March 6, 1845, p. 2.

"New-York Gallery of the Fine Arts." *Broadway Journal* 1 (March 22, 1845): 187.

"The New-York Gallery of The Fine Arts." *Bulletin of the American Art Union* 3 (July 1850): 65.

The New-York Historical Society. *Catalogue of American Portraits in the New-York Historical Society.* 2 vols., New Haven: published for the New-York Historical Society, Yale University Press, 1974.

Newman, R. W. "Around and Near the Battery. Paper XIII." One of a series of articles entitled "Old New York. The City in '32. Its People and Public Institutions." that appeared in *The [New York] Evening Mail* in 1873. A bound volume of this series is in the New-York Historical Society Library.

Noble, Louis Legrand. *The Course of Empire, Voyage of Life and Other Pictures of Thomas Cole, N. A. with Selections From His Letters and Miscellaneous Writings: Illustrative of His Life, Character and Genius.* New York: Cornish, Lamport & Co., 1853. Rev. ed. *The Life and Works of Thomas Cole,* ed. by Elliot S. Vesell (Cambridge, Mass.: Belknap Press of Harvard University Press, 1964.

Nord, Barbara K. "George Whiting Flagg and His South Carolina Portraits." *South Carolina Historical*

Magazine 83 (July 1982): 214–34.

————. *The Flagg Family in South Carolina: The Nineteenth Century.* Austin, Texas: Peripatetic Press, 1984.

Novak, Barbara. "Thomas Cole and Robert Gilmor." *Art Quarterly* 25 (Spring 1962): 41–55.

————. *American Painting of the Nineteenth Century: Realism, Idealism and the American Experience.* New York: Praeger Publishers, 1969.

————. *Nature and Culture: American Landscape and Painting, 1825–1875.* New York: Oxford University Press, 1980.

Odell, George Clinton Densmore. *Annals of the New York Stage.* 15 vols., New York: Columbia University Press, 1927–1949.

"The Opening of the Exhibition of The National Academy of Design." *Bulletin of the American Art-Union* 4 (May 1, 1851): 30–32.

"Opening of the New-York Gallery of the Fine Arts." *Bulletin of the American Art-Union* 3 (Oct. 1850): 117.

Parry, Ellwood C., III. *Thomas Cole: Ambition and Imagination.* Newark, Delaware: University of Delaware Press, 1988.

————. "Thomas Cole's Ideas for Mr. Reed's Doors." *American Art Journal* 12 (Summer 1980): 33–45.

————. "Thomas Cole's 'The Course of Empire': A Study in Serial Imagery." Ph. D. diss., Yale University, 1970.

————. "Thomas Cole's 'The Titan's Goblet': A Reinterpretation." *Metropolitan Museum Journal* 4 (1971): 123–40.

Perkins, Robert F., Jr., and William J. Gavin III, eds. *The Boston Athenaeum Art Exhibition Index, 1827–1874.* Boston: Library of the Boston Athenaeum, 1980.

Pessen, Edward. "Philip Hone's Set; The Social World of the New York City Elite in the 'Age of Egalitarianism.'" *New-York Historical Society Quarterly* 56 (Oct. 1972): 285–308.

————. "The Wealthiest New Yorkers of the Jacksonian Era: A New List." *New-York Historical Society Quarterly* 54 (Apr. 1970): 145–72.

Piwonka, Ruth, and Roderic H. Blackburn. *A Visible Heritage, Columbia County, New York: A History in Art and Architecture.* Kinderhook, New York: Columbia County Historical Society, 1977.

"Places Worth Visiting. The New-York Gallery of the Fine Arts." *Broadway Journal* 1 (Feb. 15, 1845): 102–3.

Putnam, George Palmer. *American Facts. Notes and Statistics Relative to the Government, Resources, Engagements, Manufactures, Commerce, Religion, Education, Literature, Fine Arts, Manners and Customs of the United States of America.* London: Wiley and Putnam, 1845.

Rambusch, Catha Grace. "Museums and Other Collections in New York City, 1790–1870." M.A. thesis, New York University, 1965.

Luman Reed obituary. *New York Evening Post,* June 8, 1836, p. 3.

————. *New York Sun,* June 9, 1836, p. 3.

————. *New York Evening Star, for the Country,* June 10, 1836, p. 3.

————. *New York Spectator* 39 (June 19, 1836): 1.

Richardson, E. P., Brooke Hindle, and Lillian B. Miller. *Charles Willson Peale and His World.* New York: Harry N. Abrams, Inc., 1982.

Robert Gilmor, Esq. Deceased, Catalogue of Rare and Valuable . . . Sold by Public Auction 8th March, 1849 by Gibson & Co. Baltimore: 1849.

"The Rotunda." *New York Evening Post,* Feb. 17, 1845, p. 2.

Rutledge, Anna Wells. *Cumulative Record of Exhibition Catalogues: The Pennsylvania Academy of Fine Arts, 1807–1870; The Society of Artists, 1800–1814; The Artists' Fund Society, 1835–45.* Philadelphia: American Philosophical Society, 1955.

————. "Robert Gilmor, Jr., Baltimore Collector." *Journal of the Walter's Art Gallery* 12 (1949): 18–39.

Saunders, Richard, with Helen Raye. *Daniel Wadsworth: Patron of the Arts.* Hartford: Wadsworth Atheneum, 1981.

Sellers, Charles Coleman. *Charles Willson Peale and the First Popular Museum of Natural Science and Art.* New York: W. W. Norton & Co., 1980.

"Sketchings. The New York Gallery of the Fine Arts." *Crayon* 2 (August 15, 1855): 105–6.

Stewart, Rev. C. S., M. A., ed. "U.S. Naval Lyceum." *Naval Magazine* 1 (Jan. 1836): 2–18.

Stokes, I. N. Phelps. *The Iconography of Manhattan Island, 1498–1909.* 6 vols., New York: Robert H. Dodd, 1915–28.

[Sturges, Jonathan]. "New York Gallery of the Fine Arts." *Broadway Journal* 1 (March 22, 1845): 187.

Sturges, Mrs. Jonathan (Mary Pemberton Cady). *Reminiscences of a Long Life.* New York: F. E. Parrish, 1894.

Swan, Mabel Munson. *The Athenaeum Gallery, 1827–1873: The Boston Athenaeum as an Early Patron of Art.* Boston: Boston Athenaeum, 1940.

Szapary, Countess Anthony, and Dara L. D. Powell. *The Flagg Family: An Artistic Legacy and the Provenance of a Collection.* Pound Ridge, New York: privately printed, 1986.

Tatham, David. "D. C. Johnston's Satiric Views of Art in Boston, 1825–1850." In *Art & Commerce: American Prints of the Nineteenth Century* (Proceedings of a Conference held in Boston, May 8–10, 1975, Museum of Fine Arts, Boston, Massachusetts). Charlottesville: University Press of Virginia, 1978.

Thies, Louis. *Catalogue of the Collection of Engravings Bequeathed to Harvard College by Francis Calley Gray.* Cambridge, Massachusetts: Welch, Bigelow, & Co., 1869.

Thorpe, Thomas Bangs. "New-York Artists Fifty Years Ago." *Appleton's Journal* 7 (May 25, 1872): 572–75.

To be Sold at Auction, at Park Place House, No. 239 Broadway, on Friday, the Eighth of June 1832, at ¼ before 10 o'clock, A.M., Wm. A. Colman's Collection of about 300 Superior Oil Paintings, All of Which are Framed. New York: Sleight & Robinson, 1832.

Tocqueville, Alexis de. *Democracy in America. 1835–40.* Trans. by Henry Reeve. 2 vols., New Rochelle, New York: Arlington House, 1966.

Trollope, Frances. *Domestic Manners of the Americans.* Donald Smalley, ed. New York: Alfred K. Knopf, 1949.

Tuckerman, Henry T. *Book of the Artists. American Artist Life, Comprising Biographical and Critical Sketches of American Artists; Preceded by an Historical Account of the Rise and Progress of Art in America.* New York: G. P. Putnam & Son, 1867. Rev. ed. New York: James F. Carr, 1967.

Verplanck, Gulian C. *An Address delivered at the Opening of the Tenth Exhibition of the American Academy of the Fine Arts.* New York: G. & P. Carvill, 1825.

Watson, Henry C. Watson. "The Fine Arts. The National Gallery at the Rotunda." *Broadway Journal*

2 (Sept. 20, 1845): 169–70, and (Oct. 11, 1845): 213–14.

Wallach, Alan. "Origins of Thomas Cole's *Course of Empire*." M.A. thesis, Columbia University, 1965.

———. "Thomas Cole and the Aristocracy." *Arts Magazine* 56 (Nov. 1981): 94–106.

The Washington Exhibition, in Aid of The New-York Gallery of the Fine Arts, at the American Art-Union Gallery, 497 Broadway. New York: John F. Trow, Printer, 1853.

Wharton, Edith. *Old New York: False Dawn (The Forties)*. New York: D. Appleton & Co., 1924.

White, Richard Grant. *Companion to the Bryan Gallery of Christian Art: containing Critical Descriptions of the Pictures and Biographical Sketches of the Painters; with an Introductory Essay, and an Index*. New York: Baker, Godwin & Co., 1853.

"World of Science and Arts. Fine Arts." *New World* 8 (April 6, 1844): 441–42, (June 29, 1844): 820, and 9 (Oct. 5, 1844): 441.

Yarnall, James L., William H. Gerdts et al. *The National Museum of American Art's Index to American Art Exhibition Catalogues*. 6 vols., Boston: G. K. Hall, 1986.

THE DOOR PANELS

See plates, pages 119 and 120

Thomas Cole. *Balloon Ascension*. 1836. Oil on wood, 19 × 12½″. The Wadsworth Atheneum, Hartford. Gift of Mr. and Mrs. Phippen Sanborn, 1978

Thomas Cole. *The Mullein Stalk*. 1836. Oil on wood, 18⁹⁄₁₆ × 12⅜″. The Wadsworth Atheneum, Hartford. Gift of Mr. and Mrs. Frederick Sturges III, 1979

Thomas Cole. *The Ruined Castle*. 1836. Oil on wood, 18⁹⁄₁₆ × 12⁵⁄₁₆″. The Wadsworth Atheneum, Hartford. Gift of Mr. and Mrs. Frederick Sturges III, 1978

Thomas Cole. *Seascape with a Waterspout*. 1836. Oil on wood, 18½ × 12⅜″. Collection Mr. Alexander Acevedo, Alexander Gallery, New York

Asher Brown Durand. *Barn Builders*. 1836. Oil on wood, 18⁹⁄₁₆ × 12½″. Collection Mr. and Mrs. Frederick Sturges III

Asher Brown Durand. *Blind Man's Bluff*. 1836. Oil on wood, 18¾ × 12¼″. The New-York Historical Society. Gift of Dudley Butler, grandson of Luman Reed

Asher Brown Durand (att.). *Boy Chasing Pig*. 1836. Oil on wood, 8⅝ × 26″. The New-York Historical Society. Gift of Dudley Butler, grandson of Luman Reed

Asher Brown Durand. *Boy Riding a Horse*. 1836. Oil on wood, 23¹⁵⁄₁₆ × 10¾″. Private collection

Asher Brown Durand. *Boys Playing Marbles*. 1836. Oil on wood, 23⅝ × 10½″. The New-York Historical Society. Gift of Dudley Butler, grandson of Luman Reed

Asher Brown Durand. *Haying Scene*. 1836. Oil on wood, 24 × 10⅞″. The New-York Historical Society. Bequest of Mrs. (Mary Fuller) Andrew Chalmers Wilson, great-granddaughter of Luman Reed

Asher Brown Durand. *Man Reading at a Table*. 1836. Oil on wood, 28⅞ × 10⁷⁄₁₆″. Collection Mrs. Ralph F. Wolff

Asher Brown Durand. *School Let Out*. 1836. Oil on wood, 18⅝ × 12³⁄₁₆″. The New-York Historical Society. Gift of Dudley Butler, grandson of Luman Reed

Asher Brown Durand. *Woman Churning Butter*. 1836. Oil on wood, 18⅝ × 12¼″. Collection Mr. and Mrs. John B. Wolff

Asher Brown Durand. *Woodchopper*. 1836. Oil on wood, 29⅝ × 11⁵⁄₁₆″. Collection Mr. and Mrs. John B. Wolff

INDEX

Numerals in *italics* indicate illustrations.